ANTIQUE TRADER BOOKS

American & European Art Pottery *Price Guide*

E
Kyl

Antique Trader Books
Dubuque, IA 52004

STAFF

Managing Editor - Books/Price GuideKyle Husfloen

Art Director .Jaro Sebek

Design Associate .Aaron Roeth

Design Assistant .Louise Paradis

Assistant Editor .Elizabeth Stephan

Editorial Assistant .Ruth Willis

Customer Service/Order FulfillmentBonnie Rojemann

ISBN: 0-930625-41-2
Library of Congress Catalog Card No. 95-76097

Other books and magazines published by Antique Trader Publications:

Antiques & Collectibles Annual Price Guide
American Pressed Glass & Bottles Price Guide
American & European Decorative & Art Glass Price Guide
American & European Furniture Price Guide
Ceramics Price Guide
The Antique Trader Weekly
Collector Magazine & Price Guide
Toy Trader Magazine
Postcard Collector Magazine
Discoveries Magazine
Big Reel Magazine
Military Trader Magazine
Baby Boomer Collectibles Magazine

To order additional copies of this book or other publications listed above, contact:

Antique Trader Publications
P.O. Box 1050
Dubuque, Iowa 52004
1-800-334-7165

Introduction

For a quarter of a century The Antique Trader has been publishing an antiques and collectibles price guide, always striving to present the most comprehensive and detailed coverage of this booming field. Our annual *Antiques & Collectibles Price Guide* has become a mainstay of the antiques marketplace and today Antique Trader Books has expanded its role by publishing a range of more specialized pricing guides. Beginning in 1994 we released three new volumes dealing in-depth with popular collecting fields. First was the *Pottery & Porcelain - Ceramics Price Guide* and this was followed shortly by the *American Pressed Glass & Bottles Price Guide* and its sequel, the *American & European Decorative & Art Glass Price Guide.* 1995 began with another notable addition to our reference library, Antique Trader Books *American & European Furniture Price Guide* and we are proud to present here our latest volume, the *American & European Art Pottery Price Guide.*

Art pottery is a unique and highly specialized segment of the ceramics collecting field which we feel deserves a collecting and pricing guide of its own. What sets "art pottery" apart from all other collectible earthenwares, utilitarian pottery and porcelain is that pieces were originally crafted as works of art with no purpose other than to please the eye and gratify the senses, much as a fine painting might. In fact, fine hand-painting is one hallmark of some of the finest examples of art pottery; the pottery piece actually became a canvas for artistic expression.

The art pottery movement originally had its origins in Europe, especially in France, and its first presentation to the American public was made at the 1876 Centennial Exhibition in Philadelphia. It was here that American ceramicists caught their first glimpse of the new and exciting wares being produced in France as well as the exotic and unique ceramic wares from the Far East, most notably Japan. Within a few short years the American art pottery movement was well established with the Rookwood Pottery in Cincinnati, Ohio leading the way.

By the turn of the century another cross-current of art was having a great affection on the American art pottery movement. The English Arts & Crafts and Aesthetic movements brought about a shift from the fussier forms and decorating of late Victorian art pottery to simpler, more naturalistic shapes and glazes. Firms such as Grueby and Teco offered simple, bold designs highlighted by rich glazes which were meant to compliment the quiet restrained interiors of early 20th century Arts & Crafts homes. The "Mission Oak" style in furniture was enhanced by a broad range of decorative accessories beside art pottery and it remained a popular trend into the 1920s. It was the Great Depression of the 1930s that really sounded the death knell of art pottery. Labor and production costs had grown tremendously and made it difficult for more expensive hand-made wares to compete with a flood of cheap, mass-produced ceramics from Europe and Japan. Only the well-heeled could afford "art for art's sake," and the majority of the American buying public was satisfied with bright and cheap pottery available at the local five-and-dime.

For the next thirty years art pottery, as a collecting field, was practically non-existant. Only a handful of collectors were much interested in the finest examples of Rookwood and a few others. Finally, in the late 1960s the market began to revive, thanks in part to the publication of important new reference books such as *The Book of Rookwood Pottery* by Hertbert Peck (1968) and Lucile Henzke's *American Art Pottery* (1970). Today, some twenty-five years later, the collecting of American and European art pottery is an important segment of the antiques marketplace with prime examples selling for many thousands of dollars. You might say The

Antique Trader Price Guide and the art pottery market have grown up together and today we're proud to present you with our special tribute to this exciting and diverse collecting field.

We have designed this volume to serve as more than just a guide to pricing. It is also a useful reference to art pottery collecting. We begin, therefore, with an in depth history of the American art pottery movement written by noted Arts & Crafts and art pottery auctioneer/dealer, Don Treadway of Cincinnati, Ohio. We've followed this with a series of sketches highlighting typical shapes you will encounter in art pottery pitchers, bowls and vases. Each category we list begins with a brief introduction to that company's history as well as a sketch of the mark or marks they may have used on their products. At the conclusion of our price listings we include a "Glossary of Terms" and several helpful appendices.

We have drawn our prices, descriptions and illustrations from a number of sources, including all the major firms who specialize in the sale of fine art pottery. Our sincere thanks to them for their cooperation and assistance with this project.

It is hoped that all our readers will find the *American & European Art Pottery Price Guide* a useful and easy-to-use guide to a fascinating and beautiful world of collecting. We're always interested in your comments and suggestions and we make every effort to respond personally, so let us here from you.

Kyle Husfloen, Editor

Please note: Though listings have been double-checked and every effort has been made to insure accuracy, neither the compilers, editors nor publisher can assume responsibility for any losses that might be incurred as a result of consulting this guide, or of errors, typographical or otherwise.

PHOTOGRAPHY CREDITS

Photographers who have contributed to this volume include: Edward Babka, East Dubuque, Illinois; and Stanley L. Baker, Minneapolis, Minnesota.

For other photographs, artwork, data or permission to photograph in their shops, we sincerely express appreciation to the following auctioneers, galleries, museums, individuals and shops:

Scott Brown Auction Company, Greensburg, Kansas; Christie's, New York, New York; Cincinnati Art Galleries, Cincinnati, Ohio; James Lehnhardt, Galena, Illinois; Dave Rago, Lambertville, New Jersey; Skinner, Inc., Bolton, Massachusetts; Sotheby's, New York, New York; Temples Antiques, Minneapolis, Minnesota; and The Don Treadway Gallery, Cincinnati, Ohio.

ON THE COVER:	Upper left - a Newcomb College Pottery vase with pine cones; bottom left - rare Grueby Pottery vase; bottom right - the famous Cowan "Jazz" bowl.
Back Cover:	Left - a Newcomb College Pottery vase with daisy-like flowers; right - a grouping of fine Rookwood Pottery vases. All color photos courtesy of Don Treadway Gallery, Cincinnati, Ohio.
Cover Design:	Jaro Sebek.

Special Feature

The Evolution of the American Art Pottery Movement

by Don Treadway

After the introduction of European art pottery at the 1876 Centennial Exposition in Philadelphia, American ceramicists developed numerous styles of decoration. Designs from the Victorian era and Aesthetic Movement gave way to those of the Arts & Crafts period which blended with Art Nouveau and eventually evolved into a modern decoration. Artistic merit reached its peak at the turn of the century.

The Limoges style, Haviland's trademark and named because it came from Limoges, France, was very influential. Serving as a backdrop for floral and scenic painting, the smeared and blended background colors were often found on broad and narrow forms utilized like canvasses. This style of artwork was not original to the French potters as exemplified by the paintings of Corot and others. Cincinnati potters like McLaughlin, T.J. Wheatley and numerous artists at Rookwood were the main proponents of this style in the United States. The New Jersey ceramic artist Charles Volkmar was the East Coast's principle purveyor of the Limoges style.

The pottery of William Grueby of Boston followed a distinctly different route than those influenced by the Philadelphia display. Grueby noted the work of French potters including Auguste Delaherche and Ernest Chaplet and by combining thrown forms with sculpted and applied work, offered the ultimate in Arts & Crafts pottery. Matt glazes, which he excelled at but didn't originate, covered most of his pots and his popular style was eventually copied by others.

The Northeast region of the United States had several pottery producers with a distinctive Arts & Crafts

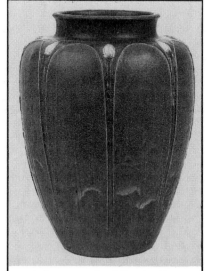

A fine example of Grueby Pottery, ca. 1900. They produced the best of Arts & Crafts ceramics.

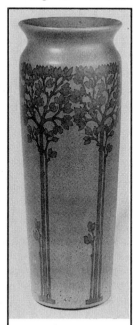

A rare and important example of the Arts & Crafts ceramics produced by the Marblehead Pottery, ca. 1910.

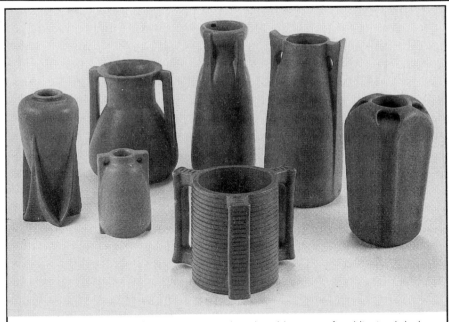

Teco Pottery, from the Chicago area, produced a wide range of architectural designs around the turn of the century.

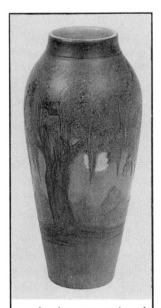

A nice example of Newcomb College Pottery with their trade-mark Spanish moss and moonlight landscape, ca. 1915.

influence. Marblehead made primarily hand thrown and decorated ware often utilizing geometric and stylized designs with muted matt glazes. Single colored vases of various hues and shades were most common. Marblehead was in business for a short period of time but produced a consistent product that is quite popular today with Arts & Crafts collectors. The immediate area around Boston found several fine examples of Arts & Crafts ceramics in S.E.G., Paul Revere and Merrimac. All of these potteries are popular today but their work is in relatively short supply.

In the Midwest, Teco Pottery of Terra Cotta, Illinois was quite innovative in their production of pottery designed by architects. Radical new forms with organic, streamline and futuristic designs were covered mostly with matt glazes. The use of pierced bodies, cut-out and swirling applied handles was unlike anything American pottery companies had produced. As with Grueby, Teco made architectural work for outdoor and interior use and also found some of their designs to be imitated by others.

Further south in New Orleans, a school for women produced pottery with an Arts & Crafts fla-

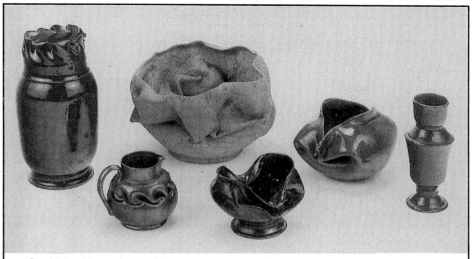

Combining bizarre forms with exceptional glazes, George Ohr created a pure American art form. These varied pieces date from around 1900.

vor. Around 1895, Newcomb College offered painted and carved forms usually hand-thrown by men. Their earliest work was primarily covered with a clear high-glaze over locally inspired floral and landscape designs. Their trademark was a scene of moss-laden trees in front of a bright moon. Around 1910, Newcomb College began to almost exclusively produce matt glaze examples of these earlier designs. Production continued through the 1940s with the school eventually joining the established Tulane University located next door.

George Ohr was another Southern ceramic artist who began his work in the 1880s. A true innovator with little or no influence from the European or Asian potters, Ohr produced wonderful pots of assorted size which blended wafer thin walls with original forms. His glazes were varied, from multicolored high gloss to one-color to volcanic textured matts, and covered shapes sometimes simple, often tortured and almost always hand thrown. Ohr stopped making pots in 1909 and died in 1918 though over 6000 pieces of his work were kept in an attic until their dispersal in the 1970s.

At the turn of the century, Rookwood's Artus Van Briggle returned from his study abroad to introduce America's purest form of Art Nouveau ceramics. Before he left Cincinnati for this study, Artus had started

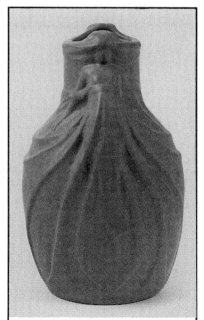

A fine example of Art Nouveau design in American ceramics, this vase was created by the Van Briggle Pottery, ca. 1907.

The influence of Japanese art is apparent in this early example of Rookwood Pottery, ca. 1880s.

This vase featuring a combination of metal and pottery was executed for Rookwood by Kataro Shirayamadani around 1900.

to experiment with carved figures and floral subjects, a change from the Victorian style of portrait and floral painting found in Rookwood's Standard glaze examples. By the time he relocated to Colorado Springs to rehabilitate from a lung disorder, it became his main design approach. His carved forms were covered almost exclusively with matt glazes, the majority of which were single-colored. The period leading up to his death in 1904 found his ware to include the most supreme examples of Art Nouveau ceramics ever produced in this country. His work was also appreciated in Europe where he received numerous awards at international expositions. The Van Briggle Pottery continued production after Artus' death, making some of their finest examples of suspended glazes between 1907 and 1912. This was a matt glaze which seemed to have spots or groups of solid glaze suspended in a more translucent one. No American pottery could match Van Briggles glazes at this time. After 1912, the company fell into the traps of commercialism, which sapped their creative efforts.

The most varied and successful ceramic of America's art pottery movement was Cincinnati's Rookwood Pottery. Beginning with the Limoges style seen at the Centennial, Rookwood employed different Victorian era and Aesthetic Movement influenced designs. These dark smeared glazes gave way to lighter bisque type finishes, heavily influenced by Japanese pottery. The 1890s found Rookwood experimenting with darker high glazes called

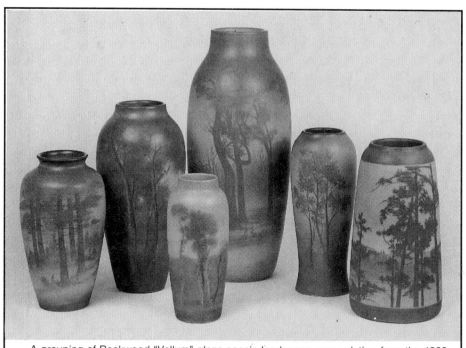

A grouping of Rookwood "Vellum" glaze scenic landscape vases dating from the 1900-1920 period.

"Standard Ware," which led to the accidental "Tiger Eye" glaze that won the award at the Paris Exposition in the late 1890s. Next, Rookwood began experimenting with translucent and tinted high glazes called "Iris," "Aerial Blue" and "Sea Green." These glazes covered examples that ranged from Victorian to Aesthetic to Japonisme to Arts & Crafts or Art Nouveau design. Such variety was an attempt to remain economically successful; Rookwood strove to produce something for everyone. The turn of the century found Rookwood producing carved and painted matts though problems of production and expense created only limited success. The introduction of the Vellum glaze in the early 1900s made for a boost in sales and became Rookwood's new claim to fame. Floral and landscape designs in this glaze were perfected over the next 20-30 years. The result was a flawless union of clay and glaze and uncrazed pieces unlike anything else in the ceramic world. The 1920s through 1940s found Rookwood producing porcelains with a variety of glazes and subject matters. Modern designs were popular and were best portrayed by Jens Jensen and W. E. Hentschel. Also throughout the century, Rookwood produced a nationally successful line of garden and architectural pottery. The company closed and was moved to Mississippi in the late 1960s but never returned to the success they once enjoyed.

Cincinnati was the center of a good deal of pottery production prior to the turn of the century. Companies like Wheatley, Dallas, Cincinnati Art Pottery, Losanti, Coultry and Rettig-Valentien produced the Limoges and European Faience style of decoration until it fell out of vogue. Wheatley continued by

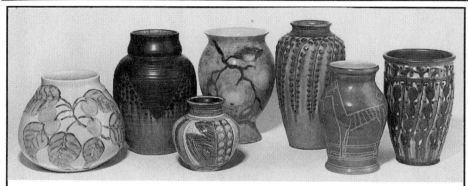

Changing tastes and styles are reflected in these modern style pieces produced by Rookwood from about 1930 to 1950.

making gardenware and Arts & Crafts pots after designs by Teco and Grueby. Ohio was undoubtedly the largest pottery producing area with commercially successful companies like Roseville, Weller, Clewell and Cowan turning out quality work for many years. Roseville and Weller's early years saw innovative new designs that ran the gamut from Victorian to Art Nouveau to Arts & Crafts. Later, they both turned to mass-produced wares that kept them financially solvent. Clewell produced a unique pottery covered with copper that usually carried a colorful patina of orange, blue and green color. They utilized pottery shapes made by other companies and sometimes created inlaid or etched work. Cowan made some of this country's finest Art Deco pottery. The work of Cowan artist Viktor Schreckengost is very highly regarded and includes probably the best example of Art Deco pottery made in America, the "Jazz" bowl.

Art Pottery thrived on the West Coast as well, particularly in California. Arequipa, under the direction of Frederick Rhead, produced Arts & Crafts pots using the squeezebag decoration that made for a simple handcrafted design. Lured by a commission from Ellen Browning Scripps to paint California's wild flowers, Albert and Anna Valentien left Rookwood for San Diego where they later opened the Valentien Pottery. Their production of Arts & Crafts ceramics with sculptural designs and matt finishes turned out to be relatively unsuccessful. A Zanesville type of art pottery was produced by the Stockton Art Pottery, one of the earliest of California companies. Roblin pottery was produced in the Bay area for a short period of time in the early 1900s. Frederick Rhead traveled from various companies throughout the United States but produced some of his best work in Santa Barbara at Rhead Pottery and was a gold medal winner at the San Diego Exposition of 1915.

The effects of depressions and world wars was reflected in the dissolution of numerous pottery companies in the United States. As expenses grew, commercialism crept into the workplace and stifled the artistic development so necessary for true art pottery lovers' discerning eye. Faience tiles, garden pottery and flower vases ruled the cash registers while artists starved and moved about the country. The 1940s through 1960s saw a big decline in the production of art pottery though a new wave of artists was discovered and is finding success up to the present day.

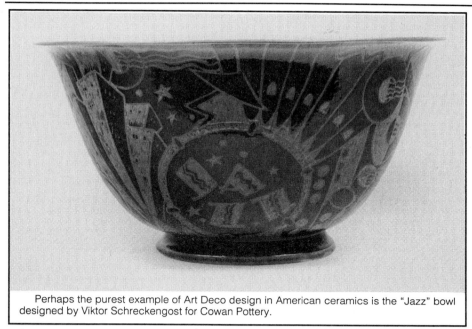

Perhaps the purest example of Art Deco design in American ceramics is the "Jazz" bowl designed by Viktor Schreckengost for Cowan Pottery.

Looking back at the production of art pottery in the United States should give all collectors and appreciators of art an insight into the marvel of art pottery production around the turn of the century. With extremely limited experience and knowledge of ceramic production, this group of artists produced the finest objects imaginable. This is reason enough for the undying desirability of this work to modern day collectors. While not totally original in concept and design, this period of ceramics was indeed special.

ABOUT THE AUTHOR

Don Treadway is co-owner of the Treadway Gallery Inc., Cincinnati, Ohio.

Treadway Gallery Inc. has been in business for over two decades and maintains an active gallery and auction business. Their specialities include: Arts & Crafts period furniture and decorative arts, American art pottery, American and European art glass, Tiffany, Handel and other quality lamps, 1950s/Modern furniture and decorative arts, Italian and Scandinavian glass.

Treadway Gallery Inc. holds several 20th Century auctions each year with the John Toomey Gallery of Oak Park, IL. In addition to these 20th Century auctions, the Treadway Gallery Inc. sells Rookwood and American art pottery at their annual "Important Rookwood Auction" in Cincinnati, and "Pottery Lovers Auction" in Zanesville, Ohio.

Don Treadway is a member of several national and international associations. These include: National Antique Dealers Association, American Art Pottery Association, International Society of Appraisers, and American Ceramic Arts Society.

TYPICAL ART POTTERY SHAPES

BOWLS

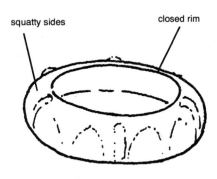

Bowl - Squatty rounded sides with wide closed rim.

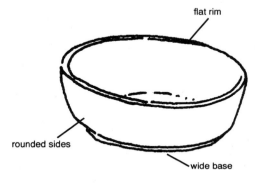

Bowl - Wide flat base and short rounded sides with a flat rim.

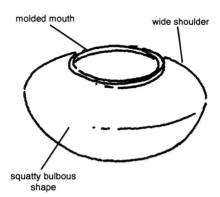

Bowl-vase - Squatty bulbous shape with a wide rounded shoulder and small molded mouth.

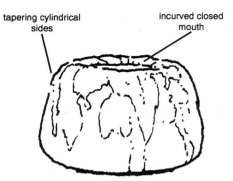

Bowl-vase - Deep slightly tapering cylindrical sides with incurved closed mouth.

TYPICAL ART POTTERY SHAPES
EWERS & PITCHERS

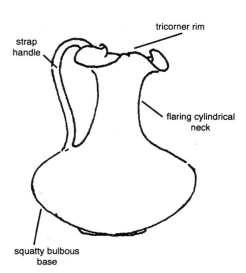

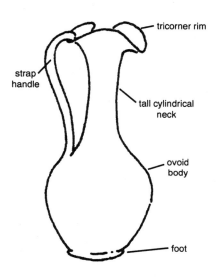

Ewer - Squatty bulbous base tapering to a flaring cylindrical neck with tricorner rim; long strap handle.

Ewer - Ovoid footed body tapering to a tall cylindrical neck with tricorner rim; long strap handle.

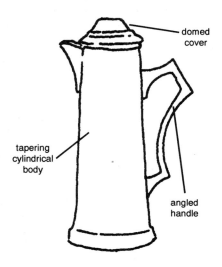

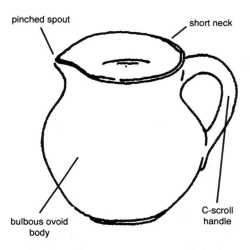

Pitcher - Tankard with domed cover; tall tapering cylindrical body; angled handle.

Pitcher - Squatty bulbous ovoid body tapering to a short cylindrical neck with pinched spout; C-scroll handle.

EWERS & PITCHERS (Continued)

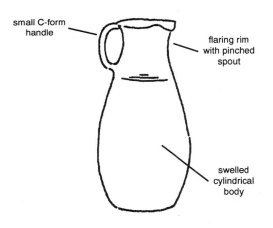

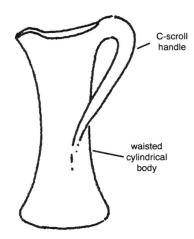

small C-form handle

flaring rim with pinched spout

swelled cylindrical body

C-scroll handle

waisted cylindrical body

Pitcher - Tankard with swelled cylindrical body tapering to a slightly flaring rim with pinched spout; small C-form handle.

Pitcher - Tankard with waisted cylindrical body; long C-scroll handle.

TYPICAL ART POTTERY SHAPES
VASES

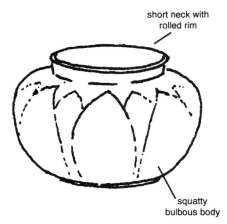

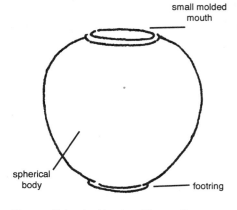

short neck with rolled rim

small molded mouth

squatty bulbous body

spherical body

footring

Vase - Squatty bulbous body with short wide neck with rolled rim.

Vase - Spherical body with small molded mouth and narrow footring.

VASES (CONTINUED)

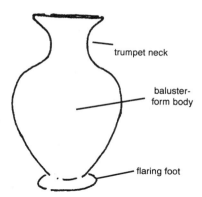

trumpet neck

baluster-form body

flaring foot

Vase - Baluster-form body with trumpet neck and flaring foot.

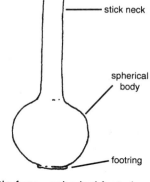

stick neck

spherical body

footring

Vase - Bottle-form - spherical footed body tapering to a tall stick neck.

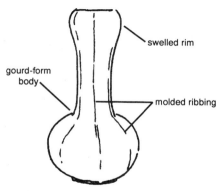

swelled rim

gourd-form body

molded ribbing

Vase - Gourd-form with swelled rim and bulbous base; molded ribbing up the sides.

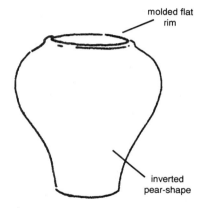

molded flat rim

inverted pear-shape

Vase - Inverted pear-shape with molded flat rim.

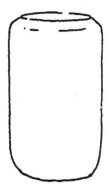

Vase - Cylindrical body with rounded shoulder and base and 'closed' rim.

Vase - Swelled cylindrical form with short flaring neck.

VASES (CONTINUED)

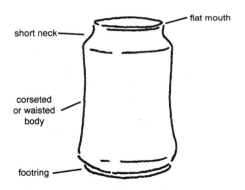

Vase - Corseted or waisted cylindrical body on a narrow footring; short tapering neck with flat mouth.

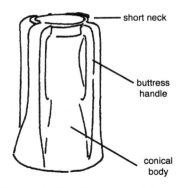

Vase - Conical body with flaring neck; four heavy buttress handles down the sides.

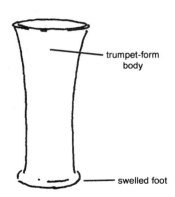

Vase - Trumpet-form with swelled foot.

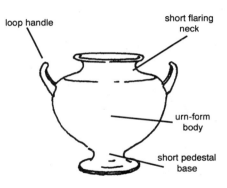

Vase - Urn-form raised on a short pedestal base; short flaring neck and loop handles at the shoulder.

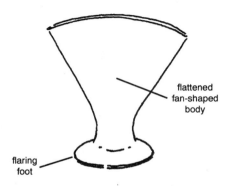

Vase - Fan-shaped flattened body on a flaring foot.

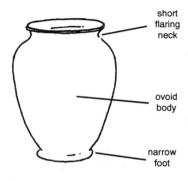

Vase - Ovoid footed body with a short flaring neck.

AREQUIPA

Dr. Philip King Brown established The Arequipa Sanitorium in Fairfax, California in the early years of the 20th century. In 1911 he set up a pottery at the facility as therapy for his female tuberculosis patients since he had been impressed with the success of the similar Marblehead pottery in Massachusetts.

The first art director was the noted ceramics designer Frederick H. Rhead who had earlier been art director at the Roseville Pottery.

In 1913 the pottery was separated from the medical facility and incorporated as The Arequipa Potteries. Later that year Rhead and his wife, Agnes, one of the pottery instructors, left Arequipa and Albert L. Solon took over as the pottery director. The corporation was dissolved in 1915 and the pottery closed in 1918 although the sanitorium remained in operation until 1957.

 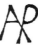

Bowl, 7½" d., 2" h., wide low incurved sides, decorated w/a patterned design of stylized stars in a rich dark brown on an aqua ground, initialed "H.H.," incised "Arequipa California 703 - 14".............................**$522.50**

Bowl, 11¾" d., 4½" h., very wide & low compressed form w/a small opening at the top center, molded around the shoulder w/three square panels incised w/stylized leaves, soft pink glossy glaze, incised "Arequipa California - 863 - CAS - 212" (rim hairline)**385.00**

Vase, 3¼" h., 3¼" d., simple ovoid body tapering to a flat mouth, overall carved stylized flowers, black glossy glaze, die-stamped mark & "PS3 - 24"..............................**220.00**

Vase, 3¼" h., 4" d., simple bulbous ovoid body w/a closed rim, hand-thrown w/modeled flowers under a fine matte grey & pink glaze, die-stamped "AREQUIPA," incised "CCR - 29-36".....................................**275.00**

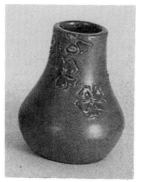

Arequipa Vase with Pansies

Vase, 4¾" h., 3¾" d., squatty bulbous base tapering to a cylindrical neck, carved w/scattered pansy blossoms in dark blue on a smooth speckled bluish grey ground, die-stamped "Arequipa California - 100 - 16 - E.M."**550.00** (Illustration)

Vase, 5" h., 3" d., ovoid body molded w/tall, narrow stylized leaves below the smooth, closed rim, light brown matte glaze, incised mark**495.00**

Vase, 5½" h., 3¾" d., wide cylindrical body w/rounded base rim & closed mouth, molded w/wide vertical ribs alternating w/narrow lines, ochre & grey matte glaze, incised mark**660.00**

Vase, 6" h., 4" d., decorated in squeeze-bag technique w/an overall pattern of curlicues & arabesques in rust & black, w/light green incised & excised

lotus blossoms, in a dead-matte glaze against a light bluish green ground, by Frederick Rhead, incised "Arequipa" (minor rim restoration)**4,840.00**

Vase, 6¼" h., 3½" d., compressed globular base & long wide neck, squeeze-bag decorated near the top w/raised stylized leaves & vines in white, cobalt blue & brown on a flowing green ground, die-stamped mark (small nick at top)**1,500.00**

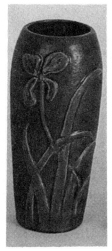

Fine Arequipa Vase

Vase, 7 ¾" h., 3¼" d., swelled cylindrical body tapering slightly to a flat mouth, deeply carved iris blooms w/swirling leaves in matte green on a matte brown ground, die-stamped "Arequipa California - 301 - 31 - BR"**4,125.00**
(Illustration)

Vase, 8½" h., 3¼" d., slender baluster-form w/short flaring neck, decorated w/a band of stylized yellow berries & leaves on a mottled green matte ground, signed "AREQUIPA - CALIFORNIA - 1913," repaired rim chip**2,090.00**
(Illustration: top next column)

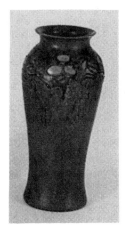

Baluster-form Arequipa Vase

Vase, 11⅜" h., tall ovoid body w/closed rim, molded overall w/stylized wisteria blossoms & vines & w/pierced accents around the upper section, matte green & black glaze, unsigned, ca. 1913 (glaze pulls at base)**495.00**

Tall Arequipa Vase

Vase, 12" h., baluster-form body w/the rim molded & pierced w/leafy vines, long flower clusters down the sides, designed by Frederick Rhead, rich forest green matte glaze**4,950.00**
(Illustration)

BOCH FRERES

The Boch Freres pottery was founded in Belgium in 1841 and continues in operation today. Their first products were stoneware art pottery of mediocre quality. Charles Catteau became the new art director in 1907 and his work influenced his fellow artisans. By the 1920s the firm was producing a unique line of wares decorated with bright Art Deco designs and it is these wares that are most highly sought today. Hand-thrown gourd-form pieces featuring earth-tone glazes were also made and are quite collectible.

Most Boch Freres pottery is marked and many pieces also carry the facsimile signature of Charles Catteau.

Bowl, 10" d., 4" h., footed, decorated w/a white crackled ground & a geometric design in sea blue & cobalt blue, glazed company mark & incised "10L9" & glazed "3 D. 1187"**$437.00**

Jardiniere, wide ovoid body w/flared mouth, decorated w/a wide band of stylized cream blossoms outlined in black against a shaded brown opaque-glazed ground, cobalt blue & cream highlights, Gres Keramis marks, ca 1890, 11" d., 9 ⅜" h.........................**825.00**

Vase, 5¼" h., 5 ¾" d., spherical body w/a small, short neck, decorated around the shoulder w/concentric rings of color above a solid color body, in shades of black, cobalt blue,

ivory, light beige & pale blue, designed by Charles Catteau, incised & stamped marks, ca. 1920**345.00**

Vase, 8" h., bulbous ovoid body w/the wide shoulder tapering to a short flaring cupped neck, the neck & shoulder decorated w/a wide band of stylized blossoms in rose & green w/black & green leaves, the lower body w/thin stripes forming panels in the yellow ground, blue ink mark**330.00**

Vase, 9" h., wide ovoid body tapering to a flaring trumpet-form neck, overall stylized florals in polychrome enamels outlined in black on an aubergine field, gilt neck band & low rippled strap handles down the sides, coarse brown neck, stamped & impressed marks, ca. 1905**172.50**

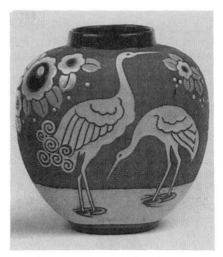

Boch Vase with Tall Birds

Vase, 9½" h., bulbous wide ovoid body w/the wide shoulder tapering to a short cylindrical neck, slightly flattened sides, decorated w/large stylized bone white cranes feeding in a pool of water among large stylized blossoms, leaves & stems in bone white w/black high-

lights against a red clay ground **1,210.00**
(Illustration: previous page)

Vase, 9½" h., bulbous ovoid body tapering to a small mouth, decorated w/vertical paneled glossy bands alternating w/undulating bands w/oval dots in aqua on a white crackled ground w/narrow black outlining, partially obscured ink mark & incised "901 - WK," impressed "106" **440.00**

Vase, 10½" h., slender ovoid body tapering to a short cylindrical neck, overall bright aqua cracked glossy glaze, ink mark & impressed "897" **121.00**

Vases, 11 ¾" h., ovoid body, incised & glazed in blue, aqua & black w/grazing deer on a cream crazed ground, company mark & impressed "895," pr. **633.00**

Vase, 12 ⅝" h., slender ovoid body tapering to a small neck w/widely flared rim, decorated w/stripes of stylized leaf & berry bands up the sides in saffron yellow, ochre & white against a ground of alternating cobalt blue & copper green horizontal bands, designed by Charles Catteau, stamped company mark & facsimile signature, ca. 1930 **1,035.00**

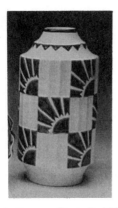

Boch Freres Paneled Vase

Vase, 12 ⅞" h., cylindrical body w/narrow fluted panels, tapering in at the base & at the stepped neck, white crackle ground decorated w/square panels of brown sunbursts outlined in black, stamp mark & impressed "1093" & inscribed "D1308 23," ca. 1922 **862.50**
(Illustration)

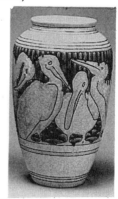

Boch Freres Pelican Vase

Vase, 13 ¾" h., slender ovoid body tapering to a short slightly rolled neck, a wide center band incised w/stylized pelicans in various positions against a striped blue & green upper section & peppled below, the remainder in yellow & cream crackle glaze, designed by Charles Catteau, signed "CH. Catteau - D984" & printed factory mark, ca. 1925 **805.00**
(Illustration)

Vase, 16" h., wide ovoid body w/stepped bands at the bottom & a rounded shoulder to the short incurved neck, a wide center band decorated w/elephants walking among palm trees, geometric borders above & below, in pale green & matte black, designed by Charles Catteau, signed "Ch. Catteau - D 1082 - B.F.K.," impressed "Gres Keramis - 1021 P,"ca. 1925 **5,750.00**
(Illustration: top next page)

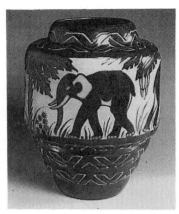

Large Boch Elephant Vase

Vase, 18" h., tall baluster-
shaped body, crackled glaze
decorated w/floral medallions
in greens & blues, designed by
Charles Catteau, printed com-
pany mark & painted
"Ch. Catteau MADE IN
BELGIUM"............................**230.00**

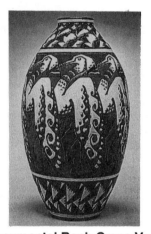

Monumental Boch Crane Vase

Vase, 35½" h., tall ovoid body
tapering to a small short cylin-
drical neck, a very wide center
band incised & enameled in
blues, white & yellow w/large
cranes, geometric border
bands above & below,
designed by Charles Catteau,
printed mark "Ch. Catteau -
KERAMIS - MADE IN BEL-

GIUM," impressed "985K" &
marked "D 988," restored,
ca. 1925**9,200.00**
(Illustration)

CALIFORNIA FAIENCE

*In 1916 Chauncey R. Thomas and
William V. Bragdon organized what
became the California Faience
Company in Berkeley, California.
The business was originally named
for the owners and then was known
as The Tile Shop until about 1924
when the California Faience name
was adopted. The small operation
concentrated on simple wares, main-
ly for the florist shop trade but also
made colorfully decorated tiles. In
the mid-1920s the firm produced
California Porcelain for the West
Coast Porcelain Manufacturers of
Millbrae, California. The Depres-
sion closed the pottery and produc-
tion ceased in 1930 although some
tiles were made for the Century of
Progress Exposition in Chicago in
1933.*

Bowl, 6" d., 2½" h., fluted,
glossy blue over turquoise
glaze exterior, turquoise glaze
interior**$165.00**

Tea tile, decorated w/large styl-
ized yellow poppies against a
turquoise ground w/a black
framing band, worked in the
squeezebag technique w/a fine
matte veined glaze, impressed
"California Faience," paper
label "CALIFORNIA FAIENCE
MADE AT THE TILE SHOP -
BERKELEY," 5½" d..............**880.00**

Tea tiles, round, each decorated
in the center w/a stylized bas-
ket of flowers in blue, green,

deep red, pink & yellow, one basket against a black ground the other against a dark blue ground, one w/a wide border band of dark blue, the other w/a wide yellow band, glossy & matte glazes, matted & framed, each 5¼" d., pr.**660.00**

Spherical California Faience Vase

Vase, 3 ¾" h., 3 ¾" d., spherical body w/the wide shoulder tapering to a small short cylindrical neck, decorated w/stylized florals in white slip-trailing on a glossy turquoise ground, decorated by Titze, incised "California Faience" painted artist signature**990.00** (Illustration)

Vase, 5½" h., bulbous, glossy turquoise glaze.....................**185.00**

Ribbed California Faience Vase

Vase, 5½" h., 3 ¾" d., wide cylindrical body w/rounded base rim & closed mouth, molded w/wide vertical ribs alternating w/narrow lines, ochre &

grey matte glaze, incised mark**660.00** (Illustration)

Vase, 5½" h., 4 ¾" d., ribbed cylindrical body w/closed rim, glossy dark rose glaze, incised "California Faience"**165.00**

Vase, 6" h., decorated w/doves, relief-molded arrows, turquoise glaze**750.00**

Tall California Faience Vase

Vase, 8" h., 4" d., tall slightly tapering cylindrical body w/a short cylindrical neck, mottled pale yellow w/a cuenca-style brightly colored floral band near the top in dark blue, red & turquoise blue, semi-gloss glaze, incised "California Faience"**1,650.00** (Illustration)

Vase, 8 x 9", persimmon decoration on two-colored blue glaze**795.00**

CLARICE CLIFF DESIGNS

English pottery designer Clarice Cliff became famous for her work at the A. J. Wilkinson, Ltd., Royal Staffordshire Pottery in Burslem,

England. This firm acquired the adjoining Newport Pottery Company whose warehouses were filled with undecorated bowls and vases and the Wilkinson firm decided to have Cliff design bright decorations for these unfinished wares. Around 1925 Cliff's Art Deco style designs were featured in lines named "Bizarre" and "Fantasque" which were applied to the stockpiled wares. These pieces were all hand-painted and carried the printed signature of the designer. These Clarice Cliff designs were produced until World War II and today they have become very popular with collectors with some examples bringing high prices.

Note: Reproductions of the Clarice Cliff "Bizarre" marking have been appearing on the market recently.

FANTASQUE
HAND PAINTED
Bizarre by
Clarice Cliff
NEWPORT POTTERY
ENGLAND

Bone dish, Tonquin patt., red ...**$18.00**

Bowl, 8" d., 3 ¾" h., "Bizarre" ware, deep gently rounded sides tapering to a foot ring, Original Bizarre patt., a wide band of block & triangles around the upper half in blue, orange, ivory & purple, purple band around the bottom section, marked**440.00**

Bowl, 8 ¾" d., Tonquin patt., red ...**18.00**

Bowl, 9" d., Alpine patt., shallow rounded sides, decorated w/a band of stylized fir trees in polychrome banded in orange, marked**207.00**

Bowl, 18" d., "Bizarre" ware, Gayday patt., decorated in polychrome w/a yellow rim band, marked**748.00**

Butter dish, cov., "Bizarre" ware, Crocus patt., a wide shallow base w/low, upright sides fitted w/a shallow, flat-sided cover w/a slightly domed top & flat button finial, the top decorated w/purple, blue & orange blossoms on an ivory-ground, marked, 4" d., 2 ¾" h.**302.50**

Candleholders, figural, modeled as a kneeling woman w/her arms raised high holding the candle socket modeled as a basket of flowers, My Garden patt., orange dress & polychrome trim, marked, 7¼" h., facing pr.**403.00**

Creamer, Bizarre ware, Gibraltar patt., flattened square form w/rounded top edges continuing to low curved loop handle, seascape decoration w/a cream & brown yacht on blue water backed by a bright yellow beach, purple & green mountains & a cream, brown & yellow sky, marked, 2½" h.**412.50**

Creamer, Bizarre ware, Spring Crocus patt., footed spherical body w/undulating rim, blossoms & buds in yellow, blue & rose among green leaves & grass, trimmed in pale blue & brown, marked, 2½" h.**77.00**

Cup & saucer, "Bizarre" ware, Coral Firs patt.**345.00**

Cup & saucer, "Bizarre" ware, Crocus patt.**135.00**

Cup & saucer, "Bizarre" ware, Moonlight patt.**295.00**

Figures, "Bizarre" ware, flat cutouts, comprising two groups of musicians & two groups of dancing couples, all highly stylized & glazed in red-orange, yellow, lime green, cream & black, printed factory marks "HAND PAINTED - Bizarre - by - Clarice Cliff - A. J. Wilkinson

Ltd. - NEWPORT POTTERY - ENGLAND,"ca. 1925, 5 ⅝" to 7" h., 4 pcs.**18,400.00**

Jam pot, cov., Secrets patt., cylindrical w/inset flat cover w/angled knob finial, polychrome landscape decoration w/quaint cottages tucked among hills, green & yellow banding on the cover, marked, 3 ¾" h.**230.00**

Jam pot, cov., "Bizarre" ware, Crocus patt...........................**225.00**

Pitcher, 6½" h., Tonquin patt., pink ..**30.00**

Pitcher, jug-type, 7" h., 6" d., "Bizarre" ware, Lotus shape, Coral Firs patt., wide ovoid body w/a wide flat rim, heavy applied loop handle, decorated w/a wide landscape band in brown, orange, yellow, brown & grey on an ivory ground, marked**770.00**

Pitcher, 7½" h., "Bizarre" ware, Delicia patt.**275.00**

Pitcher, 9 ¾" h., 8" d., "Bizarre" ware, Isis shape, Farmhouse patt., the ovoid body decorated at the top & bottom w/alternating red, orange & yellow bands, the stylized farm landscape in shades of orange, black, green & red, marked (bruise to base, some paint wear)**1,650.00**

Planter, Bizarre ware, Rhodanthe patt., wide square three-tier tapering sides, decorated w/large blossoms in orange, grey, green, yellow & tan on brown twisting stems w/grey leaves against a grey & brown ground, marked, 8"w., 3½" h. (minor flakes)**550.00**

Plate, dinner, 10" d., Tonquin patt., red**15.00**

Plate, 10 ⅜" d., Devon patt., polychrome decoration of tall curved trees & stylized flowers, banded in yellow & green, marked**437.00**

Plates, 9" d., "Bizarre" ware, each decorated w/a crayon-like landscape scene in shades of green, yellow & blue w/brown, black & maroon, A.J. Wilkinson, England marks, pr..**287.50**

Platter, 14" l., Tonquin patt., polychrome stylized design**95.00**

Sugar shaker, "Bizarre" ware, No. 660, 5½" h.**135.00**

Teapot, cov., "Tee Pee" patt., modeled as a conical American Indian teepee w/a figural Indian spout & Indian head handle, decorated around the sides w/lightly molded elk & maple leaves & painted geometric bands in brown, red & green, stamped mark, 6 ⅝" h.**690.00**

Vase, 6¼" h., 3¼" d., "Fantasque" line, Shape No. 196, Trees and House patt., a cylindrical body w/a widely flaring & rolled rim, decorated w/a wide central landscape band in black, orange & green against an ivory ground, marked**880.00**

Vase, 6½" h., 4¼" d., "Bizarre" ware, Patina Tree patt., tapering ovoid body w/a wide, flat mouth & set on a flat disc foot, decorated w/a large blue flowering tree & a yellow landscape w/overall blue splatters, inkstamped "PATINA HAND PAINTED Bizarre by Clarice Cliff - Newport Pottery England"**660.00**

Vase, 9 ⅝" h.,"Fantasque" line, Isis shape, Umbrella and Rain patt., wide ovoid body tapering to a flat flaring rim, decorated around the middle w/a wide band divided into panels each w/three large stylized 'blossoms' or 'umbrellas' in black, red & blue & divided by

white bars, yellow bands at top & base, marked (small glaze nicks at rim, small ground off glaze bubble on base)........**2,530.00**

Vegetable bowl, cov., square, Tonquin patt., 8" w.**150.00**

Wall plaque, round, "Bizarre" ware, Red Roses patt., a design of flowerheads & foliage in tomato red & black on a cream ground, company mark & painted "Latona," 13" d.**690.00**

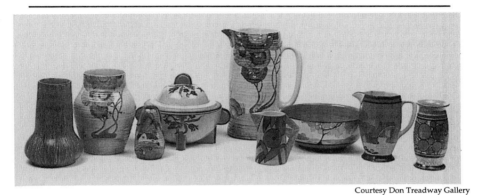

1　　2　　3　　4　　5　　6　　7　　8　　9

Courtesy Don Treadway Gallery

A Grouping of Clarice Cliff Pieces

Bowl, 8½" d., 3½" h., "Bizarre" ware, Secrets patt., wide low rounded sides, decorated w/a landscape w/two brown-roofed cottages atop green & yellow ground w/purple highlights surrounding vivid blue water, on the opposite shore a prominent tree w/black trunk & stylized leaves of yellow & blue circles, back & interior decorated in rings of orange & black, pattern No. 6070, marked, repaired rim chip**605.00** (Illustration: No. 7)

Pitcher, 4½" h., "Bizarre" ware, Café-Au-Lait patt., slightly tapering cylindrical body w/a wide angled handle, stippled vivid green background shows through bold stylized leaf & berry design in blue, green, orange, red & brown, marked**440.00** (Illustration: No. 6)

Pitcher, 6½" h., "Bizarre" ware, Applique Avignon patt., footed ovoid form w/paneled sides

decorated w/a stylized landscape w/purple, green, blue & brown trees on a yellow, black & rose ground backed by a vivid blue bridge & an orange sky, top banded in black & orange, marked, base chip ...**605.00** (Illustration: No. 8)

Pitcher, tankard, 11" h., "Bizarre" ware, Rhodanthe patt., Lynton shape, tall cylindrical body decorated w/large blossoms in blue, grey, green, aqua, yellow & rose on twisting brown stems, among tall blades of lavender grass, rising from a stylized yellow, tan & green ground on a rich cream background, marked, flakes....................................**495.00** (Illustration: No. 5)

Salt shaker, "Bizarre" ware, slender tapering ovoid form, decorated w/a landscape design w/orange-roofed cottage surrounded by trees & ground in green, aqua, brown, yellow & orange backed by a

sky of mustard yellow, dark brown & brick red, marked, 5" h.**412.50**
(Illustration: No. 3)

Tureen, cov., deep rounded base w/four wide buttress feet & half-circle side handles, the domed cover w/a half-circle handle, decorated w/stylized red, yellow & orange blossoms on brown stems w/green & yellow leaves highlighted by blue stars w/white centers on a cream background, handles in vivid yellow & orange, lid edge trimmed in concentric yellow, orange & dark green circles, marked "Clarice Cliff, Made For Woman's Journal," tiny chip on one foot, 9" d., 7" h..........**440.00**
(Illustration: No. 4)

Vase, 6" h., "Bizarre" ware, Café-Au-Lait patt., footed ovoid slender body w/a widely flaring mouth, the stippled brown & white background shows through a design of stylized leaves & round fruit in rose, orange, blue, yellow, brown & green, bordered by rings of black, green, orange & blue, marked**467.50**
(Illustration: No. 9)

Vase, 7½" h., "Bizarre" ware, Delicia patt. squatty bulbous base tapering to a tall cylindrical neck, covered w/a vivid green over orange matte glaze w/linear white highlights, marked**330.00**
(Illustration: No. 1)

Vase, 8" h., "Bizarre" ware, Rhodanthe patt., ovoid body tapering to a wide flat mouth decorated w/large blossoms in blue, yellow, aqua, green, lavender & rose on twisting cocoa brown stems & rising from a stylized yellow & green ground on a rich cream back ground, marked**467.50**
(Illustration: No. 2)

CLEWELL WARES

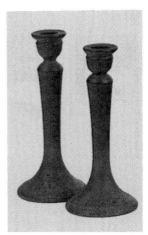

Clewell Candlesticks

Charles W. Clewell of Canton, Ohio did not operate his own pottery but developed a type of fine art pottery featuring his unique metal coating placed on pottery blanks obtained from various potteries including Owens and Weller. He encased these objects in a thin metal shell which produced a copper-and bronze-finished ware. Sometime later, Clewell's experiments led him to chemically treat his metal coatings thus obtaining a blue-green patination typical of copper and bronze wares. He produced his metal-coated pottery from 1902 through the mid-1950s but offered a limited production since he felt no one else could adequately recreate his artwork.

Bowl, 3⅛ h., wide flat bottom below the low rounded & incurved sides, mottled natural copper & coppery green patina, base marked "Clewell 422-2-6," early 20th c.**$247.50**

Bowl-vase, bulbous body on a small flaring foot, tapering to a widely flaring rim, original bright orange & green patina, incised "Clewell - 418-2-9," 6½" d., 5½" h.**770.00**

Candlesticks, slender tapering standard w/widely flaring base, bell-form socket w/flat rim, rich original copper & green patina, both incised "Clewell 414-2-6," 9½" h., pr............................**1,320.00** (Illustration)

Miniature Clewell Vase

Vase, miniature, 3" h., squatty bulbous form w/four lobes, two lobes issuing a low loop handle rising to the narrow mouth, on four small feet, rich original greenish brown patina, incised "B22 Clewell"........................**935.00** (Illustration)

Vase, 4½" h., 3½" d., footed ovoid body w/a very wide, flaring mouth, copper-clad w/a fine verdigris & brown patina, hand-incised "Clewell 11 - 330-2-9 - UYX"**440.00**

Vase, 5½" h., 4½" d., copper-clad, wide tapering ovoid body, the wide shoulder tapering to a small rolled rim, bright verdigris & orange patina, etched in base "Clewell - 320 - 6 - 2"....**660.00**

Vase, 5½" h., 6" d., bulbous ovoid body tapering to a short wide cylindrical neck, original copper & green patina, incised "Clewell - 440-419"................**935.00**

Vase, 6" h., goblet-form, a wide slightly tapering cylindrical bowl w/rolled rim raised on a short double-knob stem on a flaring disc foot, original bright green patina, incised "CW - Clewell - 503 - 210"**660.00**

Vase, 6½" h., footed slightly swelled cylindrical body w/a flat molded mouth, original vivid orange & green patina, incised "Clewell - 329-2-9"**715.00**

Vase, 6½" h., 2½" d., tall slender corseted form w/a wide flared base, fine orange to green patina, incised "Clewell - 342-2-6"**302.50**

Vase, 6½" h., 6" d., bulbous base tapering to a wide mouth, decorated w/incised Art Nouveau-style flowers over a heavily embossed band of stylized flowers, under a darkly patinated metal jacket, etched into base "Clewell - CANTON O." ..**522.50**

Vase, 7" h., footed shouldered ovoid body tapering to a short wide cylindrical neck, original rich dark brown & green patina, incised "Clewell 456 - 26" (minor flakes)**522.50**

Vase, 7" h., 3¼" d., bottle-shaped w/collared rim, covered in a metal jacket patinated in a rich orange to mint green, etched into base "Clewell - 308-2-6"**605.00**

Vase, 7" h., 4 ¾" d., tapering base, rounded shoulder & tiny mouth, copper jacket w/fine brown & verdigris patina, hand-incised "Clewell 388-2-9"**880.00**

Vase, 7¼" h., 4¼" d., gently swelled cylindrical body w/a narrow angled shoulder to a wide flat mouth, orange to bright green patina, incised "Clewell 445-211"................**440.00**

Vase, 8¼" h., 3¼" d., copper-clad, a slender trumpet-form body on a short, flaring foot, rust to verdigris finish, incised, "Clewell - 413-2-6"**440.00**

Vase, 8½" h., copper-clad, simple ovoid body tapering to a flat rim, overall green incrustations over the rich orangish red copper patina, base inscribed "Clewell - 60-2-9"**990.00**

Vase, 8½" h., 3 ¾" d., swelled cylindrical body w/a flaring foot & rim, brown to green patina, incised "Clewell - 322-2-6"**467.50**

Vase, 11" h., 6" d., wide ovoid body tapering to a short cylindrical neck, orange to green patina, incised "Clewell - 286-2-6"**770.00**

Vase, 16" h., tall baluster-form copper-clad body w/flared rim on the short neck, mottled coppery blue patina, base inscribed "Clewell 277-6," on a Weller blank (minor scratches & abrasions on patina)**1,540.00**

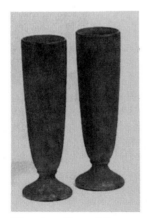

Slender Clewel Vases

Vase, 9" h., tall slender slightly tapering cylindrical body on a flaring foot, original green & blue patina, incised "Clewell 412-6".....................................**550.00**
(Illustration: left)

Vase, 9" h., tall slender slightly tapering cylindrical body on a flaring foot, original green & blue patina, incised "Clewell 412-6"......................................**522.50**
(Illustration: right)

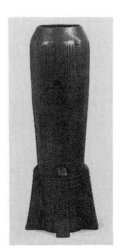

Rocket-form Clewell Vase

Vase, 20" h., tall futuristic rocket-form body w/four fin-like buttresses at the base supporting the tapering cylindrical body w/four indented ribs at the top under an angled lip, numerous incised vertical lines at the top above prominent hammered marks, incised "Clewell 4098-12".....................................**3,575.00**
(Illustration)

CLIFTON POTTERY

William A. Long, founder of the Lonhuda Pottery, joined Fred Tschirner, a chemist, to found the Clifton Art Pottery in Newark, New Jersey, in 1905. Crystal Patina was their first art pottery line and featured a subdued pale green crystalline glaze later also made in shades of yellow and tan. In 1906 they introduced their Indian Ware line based on the pottery made by

American Indians. Other lines which they produced include Tirrube and Robin's-egg Blue. Floor and wall tiles became the focus of the production after 1911 and by 1914 the firm's name had changed to Clifton Porcelain Tile Company, which better reflected their production.

Bank, figural, model of a seated monkey, a coin slot in its stomach, dark brown bisque-fired clay, impressed "Clifton - 278," 4" w., 6" h. ...**$495.00**

Humidor, cov., Indian Ware, squatty w/mushroom-form cover, incised & painted abstract "bird" design in black & flesh on a brick red ground, impressed "Homolobi - Ariz - 221," incised "CAP" mark, 6" d., 4" h.................................**247.50**

Humidor, cov., Indian Ware, unglazed brick red exterior w/geometric Indian relief-molding at rim & on lid, black matte incised & h.p. decoration-around center, glazed interior**95.00**

Lamp base, Crystal Patina line, a broad squatty bulbous base tapering to a short cylindrical neck w/flat mouth, flowing celadon green crystalline glaze over a clear amber base, factory hole in base, incised "Clifton - 1906 - CAP - 160," 7 ¾" d. 5¼" h.**357.50**

Teapot, cov., Crystal Patina line, compressed globular form w/short spout & elongated handle, rich flowing creamy yellow to golden brown flambé glaze, die-stamped "CLIFTON - 271," 9½" w., 3¼" h.**110.00**

Teapot, cov., a tall wide funnel base tapering up & continuing to form the squatty bulbous body w/a short flaring cylindrical spout & a heavy loop handle, a low domed cover w/button finial, pale mottled green Crystal Patina glaze, ca. 1910, company mark & "272-42," 5 ⅜" h.**302.50**

Teapot, cov., a tall slightly tapering cylindrical base below the squatty bulbous body w/a short cylindrical spout & long C-scroll handle, low domed cover w/button finial, pale green over olive green matte glaze, ink mark & impressed "272 - 27236," 6" h.**165.00**

Teapot, cov., Indian Ware, tall cylindrical body w/outcurving spout & handle rising from base to rim, incised & painted black geometric decoration on a brick red ground, die-stamped "27400," 7½" w., 6½" h.**247.50**

Vase, 3" h., 4" d., Indian Ware, squatty bulbous body w/a short, cylindrical neck, black & tan geometric designs on a terra cotta ground, impressed "CLIFTON - FOUR MILE RUN - ARIZONA - 208"....................**192.50**

Vase, 3¼" h., 2 ¾" d., barrel-shaped body w/a low, molded rim on the closed mouth, buff-to-celadon semi-matte glaze, 1905, incised "Clifton - 1905 - 127".............................**137.50**

Vase, 3½" h., 3½" d., spherical body w/a small cylindrical neck, boldly molded w/raised carp in swirling water, dark patina, hand-incised on base "Clifton - 1906" & stamped "108"**1,760.00**

Vase, 3½" h., 4½" d.,Indian Ware, squat body w/narrow rim, incised geometric band in black on a brick red ground, unmarked**165.00**

Vase, 4" h., 3 ¾" d., Crystal Patina line, deeply waisted double gourd-form body w/small horizontal ring handles at the center band, olive green & brown crystalline glaze, incised "Clifton - 1906 - CAP - 110," 1906**220.00**

Vase, 4½" h., footed ovoid body tapering to a small flat mouth, small rounded tab handles, tan & grey drip glaze over a pale green glaze, incised "Clifton" & impressed "135"**275.00**

Vase, 4½" h., 3½" d., footed ovoid body tapering to a flat mouth, small rounded ear handles at sides, buff-to-celadon crystalline glaze, incised "Clifton"**192.50**

Vase, 5" h., 6" w., Crystal Patina line, a tapering cylindrical body below a wide squatty bulbous shoulder w/wide integral angled handles down to the base, a rolled neck at the top center, celadon green crystalline glaze, incised "Clifton - 1905 - 116," 1905..................**192.50**

Vase, 6" h., 7¼" d., squatty spherical body on a narrow footring, tapering to a short, narrow mouth, fine Crystal Patina pale green & gold satin glaze, incised "Clifton - CAP - 161 - 1905," dated 1905........**330.00**

Vase, 6 ¾" h., 4 ¾" d., Crystal Patina line, expanding cylinder w/closed-in mouth, embossed decoration of large poppy blossoms & stems cascading down the sides, light green glaze w/white showing through, impressed "#173"**522.50**

Vase, 7¼" h., 4½" d., Crystal Patina line, footed squatty bulbous base below a tall, widely flaring squared trumpet-form neck, even olive green & creamy light gold matte crystalline glaze, incised "Clifton - CAP - 1907 - #137"**220.00**

Vase, 7¼" h., 4½" d., Crystal Patina line, a footed squatty bulbous base below a tall squared & widely flaring neck, mottled yellow & buff crystalline glaze, incised "Clifton 1907 - 137"......................................**302.50**

Vase, 8" h., 4¼" d., Tirrube line, tall slightly flaring cylindrical body w/a wide angled shoulder to a flat mouth, decorated w/painted white & yellow jonquils & green leaves against a matte brick red ground, die-stamped "Clifton - 261 - 192"......................................**330.00**

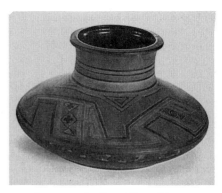

Squatty Indian Ware Vase

Vase, 9" h., 14½" d., Indian Ware, a wide low squatty base centered by a wide cylindrical short neck w/a flattened rim, overall geometric design in black & beige on a terra cotta ground, some abrasion to broadest part, interior hairline, impressed "PUEBLO VIEJO - UPPER GILA VALLEY - ARIZ" & "190" & incised "Clifton - CAP"**1,650.00**
(Illustration)

Vase, 9½" h., slender baluster-form body w/a short neck & flared rim, yellowish green drip matte glaze w/tan & pale blue highlights, incised "Clifton 1906" & artist's initials & impressed "156"**385.00**

Vase, 10½" h., 4½" d., Crystal Patina line, bottle-form, squatty bulbous base tapering to a tall 'stick' neck, matte green shaded to olive green matte crystalline glaze, incised "Clifton 1905" & impressed "165," 1905**385.00**

Vase, 10½" h., 7" d., Crystal Patina line, a shouldered baluster-form body w/a tall, wide cylindrical neck flanked by long angled strap handles, rich celadon green & creamy crystalline glaze, incised "Clifton - 1906 - CAP - 163," 1906**330.00**

Vase, 12¼" h., 5 ¾" d., wide ovoid body tapering to a heavy molded rim, decorated w/a large crane standing amid exotic flowers on a burgundy dead-matte ground, by Albert Haubrich, impressed "Clifton - 257"& painted "AH"**1,980.00**

COWAN

In 1913 R. Guy Cowan opened a studio pottery in Cleveland, Ohio and production continued almost continuously in and around Cleveland until forced to close in 1931 because of financial troubles. Although fine art pottery was produced, the lines were gradually expanded to include more commercial wares. All Cowan wares are collectible but the earlier artwares bring some of the highest prices today.

A new reference on Cowan is The Collector's Encyclopedia of Cowan Pottery *by Tim and Jamie Saloff (Collector Books, 1994). References to company marks are taken from this book.*

Book ends, figural, a nude kneeling boy & nude kneeling girl, each on oblong bases, creamy white glaze, designed by Frank N. Wilcox, Shape No. 519, marks 8 & 9, ca. 1925, 6½" h., pr.**$300.00 to 375.00**

Box, cov., round w/deeply incurved low cylindrical sides, the flat cover centered by a large flame-form finial & embossed w/stylized flowers & leaves, ivory crackled satin glaze, die-stamped "COWAN," 6" d., 4½" h**247.50**

Candlesticks, short w/oblong flaring base, molded w/small blossoms & scrolls, blue glaze, mark 6, 3¼" h., pr...................**50.00**

Candlesticks, cylindrical ringed stem w/flaring rim & foot, blue glaze, Shape No. 501-A, 7" h., pr. ...**50.00**

Candlesticks, modeled as a thick stock of a bamboo-like plant w/curled tips flanking the socket, flowing powder blue glossy glaze w/golden brown highlights, die-stamped "COWAN" & flower mark, 3½" d., 8" h., pr.**192.50**

Charger, round, the flat front incised w/the Tennis patt. featuring stylized abstract tennis rackets & a net, all-white glaze, designed by Viktor Schreckengost, marked on the back, artist-initialed in the design, ca. 1930, 11¼" d.**1,210.00**

Charger, large circular piece w/an embossed dancing woman & jumping dog in a crackled ochre on a crackled greenish blue ground, a border of stars, impressed mark, 15½" d. (two repaired rim cracks)**605.00**

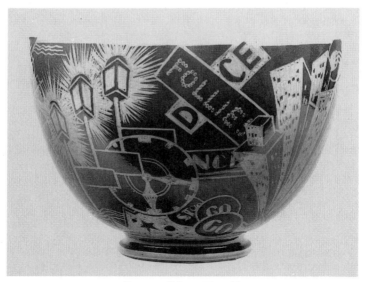

Cowan "Jazz Bowl"

Charger, round, the center lightly molded w/large stylized exotic spread-winged bird, border band of smaller stylized birds, designed by R.G. Cowan, Shape No. 750, blue glaze, ca. 1828, mark 8, 15½" d............**850.00**

Flower frog, figural nude w/scarf, white glaze, 6½" h. ..**135.00**

Flower frog, figural, modeled as a slender, leaping female dancer curved backwards & raised on her flowing dress above open scrolls on a molded plinth base, ivory semi-matte glaze, impressed "COWAN," 6½" d., 10" h.**990.00**

Lamp base, footed bulbous ovoid body tapering to a small flat mouth, a shaded yellow to light blue ground decorated down the sides w/thin rings of dark blue & h.p. w/large arched stylized tulips & stems in dark blue, clear glossy glaze, cast base hole, stamped Cowan logo & notation "Cowan," 8⅛" h....................................**660.00**

Punch bowl, "Jazz Bowl," deep rounded sides w/a wide flat rim, on a thick footring, overall sgraffito decoration in bright "Egyptian Blue" crackle & black glossy glaze, depicts stylized scenes of New York City on New Year's Eve, including glowing street lamps, stylized faces, champagne bottle & glasses, dice, skyscrapers, clock, street signs & traffic lights, designed by Viktor Schreckengost, ca. 1931, restored crack, 16" d., 11½" h.**29,700.00** (Illustration)

Vase, 6¼" h., 5½" d., bulbous ovoid body w/a wide rolled rim, a mottled brick brown ground decorated w/a series of pale green 'stairstep' stripes swirled up the sides, die-stamped "Cowan"**247.50**

Vase, 7½" h., tall slender paneled ovoid body w/a flaring foot & short flaring neck, yellowish orange glaze, Shape No. 691-A, mark 6................................**80.00**

Vase, 8" h., fan-shaped w/figural sea horse base, yellow matte glaze**85.00**

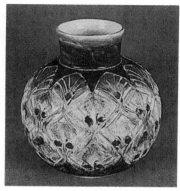

Bulbous Cowan Vase

Vase, 9½" h., 9" d., spherical body w/a short cylindrical neck, embossed & painted geometric design of women & leaves in blue, pink & green, designed by T. Frazier Winter, ca. 1930, die-stamped "Cowan" & "T. Frazier - 1930"**2,640.00** (Illustration)

Vase & stand, 8" h., 5½" d., simple ovoid body tapering to a narrow mouth, glossy green crackle glaze, on a matte gun-metal-glazed stand w/low-relief decoration, impressed marks, ca. 1935, 2 pcs.**172.50**

Vase, 11¼" h., 8" w., a molded platform base supporting large stylized figures of Oriental phoenix birds below a flattened & widely flaring ribbed neck, emerald green glossy glaze, impressed "COWAN"**385.00**

DEDHAM & CHELSEA KERAMIC ART WORKS

In 1866 a pottery was established by Alexander W. Robertson in Chelsea, Massachusetts and became A.W. & H. Robertson in 1868. The name was changed to Chelsea Keramic Art Works in 1872 and then to Chelsea Pottery, U.S.A. in 1881. The pottery was moved to Dedham, Massachusetts around 1895 and was renamed Dedham Pottery. Wares with crackled glazes in blue and white and high-fired colored pieces were specialties until the factory closed in 1943.

The Potting Shed, Concord, Massachusetts, has been making quality reproductions of Dedham crackle wares since 1977, but these copies are carefully marked to avoid any confusion with the original examples.

CHELSEA KERAMIC ART WORKS ROBERTSON & SONS.

Bacon rasher, narrow oval dished form, Rabbit patt., 6 x 9¼"**$357.50**

Bell, curved conical form w/knob top, Rabbit patt., unsigned, 4" d., 4" h.............................**770.00**

Bowl, 5" d., 2" h., Swan patt., ink stamp "Registered" mark**330.00**

Bulb bowl, deep rounded & slightly flaring sides on a footring, Lotus patt., 5¼" d., 2½" h...................................**345.00**

Coffeepot, cov., conical body, domed cover, angled handle, Rabbit patt., inscribed "first one made," dated "4/1/14," blue stamp mark & exhibition label, 8½" h.**1,430.00**

Cup & saucer, Elephant patt., stamp registered mark, saucer 6" d.....................................**770.00**

Cups & saucers, demitasse, Rabbit patt., blue stamp mark, saucer 4½" d., set of 6**747.50**

Flask, footed, wide flat rectangular form w/rounded corners & a small molded neck, sculpted on one side w/a scene of an old bearded man dressed in rags in dark blue, the sides & back in green, by Hugh Robertson, incised "HCR" on front, die-stamped "CKAW" on base, 4" w., 6½" h. (short line at rim, stilt pull on back)**715.00**

Flower frog, figural, a model of a standing rabbit atop a domed base pierced w/holes, stamped mark & dated "1931," 6¼" h......................................**880.00**

Paperweight, figural, model of a recumbent rabbit, unsigned, 2 ⅞" l.....................**230.00**

Paperweight, figural, model of an elephant standing on a flat oval foot, stamped mark & exhibition label, 6" l., 4" h. ...**7,700.00**

Pitcher, 5" h., jug-type, Night & Day patt., blue stamp mark ...**402.50**

Plate, 6 ⅜" d., Lobster patt., registered blue stamp & double impressed rabbit marks.........**230.00**

Plate, 7½" d., Tapestry Lion patt., registered blue stamp mark**374.00**

Plate, 8¼" d., Tapestry Lion patt., marked**1,320.00**

Plate, 8½" d., Horse Chestnut patt., blue stamp & impressed rabbit marks & paper exhibition label**862.50**

Plate, 8½" d., Rabbit patt., edge panel w/initials "KF," registered blue stamp & double impressed rabbit mark**374.00**

Plate, 8½" d., Snowtree patt., ink-stamped mark**275.00**

Plate, 8 ⅝" d., Mushroom patt., blue stamp & impressed rabbit marks (glaze pitting).............**690.00**

Plate, 8 ⅝" d., Owl patt. w/wom-an's face, blue stamp & star marks (hairlines, staining)**2,415.00**

Plate, 8 ⅝" d., Upside-Down Dolphin patt., design artist-initialed "FC," impressed "CPUS (clover) X"**920.00**

Plate, 8 ¾" d., Grouse patt., blue stamp & impressed rabbit marks (peppering)**1,725.00**

Plate, 8 ¾" d., Pineapple patt., impressed rabbit mark**275.00**

Plate, 8 ¾" d., Raised Pineapple patt., decorated by Hugh C. Robertson, artist's mark & impressed "CPUS (clover)" & "C"**489.00**

Plate, 8 ⅞" d., scalloped rim, molded Putti & Goat patt., marked**605.00**

Plate, 9¹³/₁₆" d., Reverse Rabbit patt., raised rabbits in cobalt blue, impressed "CPUS" clover mark**1,840.00**

Plate, 10" d., Turtle patt., impressed rabbit mark**805.00**

Plate, 10⅛" d., Grape patt., experimental pink glaze, blue stamped & impressed rabbit marks**402.50**

Plate, 12" d., Rabbit patt., stamped mark**412.50**

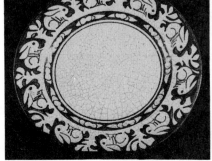

Dedham Rabbit Plate

Plates, 7 ¾" d., Rabbit patt., set
of 6**800.00**
(Illustration: one of six)

Platter, 12" d., Lobster patt.,
stamped & impressed marks
& exhibition label...................**715.00**

Platter, steak, 8¼ x 14" oblong,
Rabbit patt., blue stamp &
impressed rabbit marks**920.00**

Rice bowl, deep rounded sides
on thin footring, Chick patt.,
blue stamp mark, 3⅛" d.,
2" h.....................................**1,265.00**

Tea tile, Iris patt., artist-signed,
5½" sq.**185.00**

Tea tile, square, decorated w/a
circular band of elephants in
blue on a white ground, square
blue "REGISTERED" mark,
5 ¾" sq.**522.50**

Vase, 3½" h., 3 ¾" d., squatty
bulbous compressed base cen-
tered by a short cylindrical
neck, buff glossy glaze, incised
"DEDHAM POTTERY
- HCR"..................................**192.50**

Vase, 4½" h., 3¼" d., ovoid body
w/a round shoulder to a wide
short cylindrical neck, *sang-de-
boeuf* glaze in a thick orange
peel dark mottled blood red,
glaze-filled mark**715.00**

Vase, 6½" h., 4 ¾" d., slightly
globular base w/short thick
neck, 'Volcanic' glaze, red,
orange & green lustered glaze,
designed by Hugh Robertson,
hand-incised "Dedham Pottery
- HCR".................................**3,080.00**

Vase, 6 ¾" h., 4 ¾" d., bottle-
form, footed squatty bulbous
body tapering to a central cylin-
drical neck flanked by four
slightly smaller cylindrical
necks, fine mustard yellow
satin matte glaze, in the style
of Christopher Dresser, die-
stamped "CKAW"**1,430.00**

Vase, 7¼" h., 4" d., ovoid body
tapering gently to a wide cylin-
drical neck, thick green &
bluish grey flambé glaze, by
Hugh Robertson, incised
"Dedham Pottery - HCR".......**770.00**

Vase, 8¼" h., 5" d., Crackle
Ware, slightly swollen cylin-
der, decorated w/large blue
poppy blossoms & pods
against a white ground, paint-
ed "Dedham III - 15"**2,860.00**

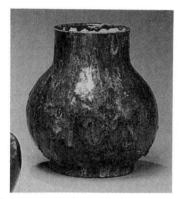

Dedham 'Volcanic' Glaze Vase

Vase, 9 ⅞" h., 'Volcanic' glaze,
bulbous ovoid body tapering to
a short cylindrical neck, w/a
thick dripping apple green, pale
blue, red, oxblood red & mossy
green glaze blended to resem-
ble *sang-de-boeuf*, wrinkling &
bubbling around the base, exe-
cuted by Hugh Robertson,
base inscribed "Dedham
Pottery -- HR," ca. 1895 ..**18,400.00**
(Illustration)

Vase, 10" h., 4 ¾" d., 'Volcanic'
glaze, tall ovoid body tapering
to a wide cylindrical neck,
Volcanic glaze in thick dark
brown over khaki w/white drips,
by Hugh Robertson, incised
"Dedham Pottery HCR -
B.W."**1,650.00**
(Illustration: top next page)

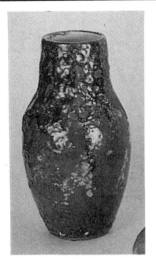

Volcanic Glaze Dedham Vase

DOULTON & ROYAL DOULTON

The well known Royal Doulton Company of England, was founded around 1858 in Lambeth, near London, and operated at that location until 1956. The marks of their wares often incorporated the words "Doulton" and "Lambeth." In 1878 the firm of Pinder, Bourne & Co., Burslem, was purchased and in 1882 became known as Doulton & Co., Ltd. This branch added porcelain to its line and, since 1902, has used the "Royal Doulton" mark.

Although the Royal Doulton character jugs and figurines are most familiar to modern collectors, the Lambeth factory did produce some fine stoneware pieces in the

late 19th century, including their "Silicon" line, which can be considered Art Pottery quality. In the early 20th century the Royal Doulton firm also produced some artistic lines such as Chang Ware, Sung Ware, and Rouge Flambé, which featured a streaky red & black glaze. It is the unique Lambeth and later Doulton wares which we include here.

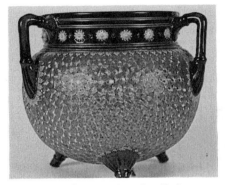

Doulton Stoneware Jardiniere

Jardiniere, stoneware, a large nearly spherical body raised on three short legs, w/a wide short cylindrical neck flanked by three molded angled handles, the body decorated overall w/hand-tooled spirals w/a rich goldleaf finish, the neck w/a band of cut-back white flower-heads, impressed mark & "1904," 9" d., 8¼" h.**$880.00** (Illustration)

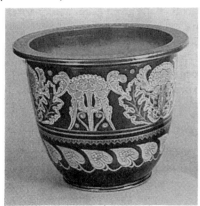

Large Doulton Jardiniere

Jardiniere, wide gently flaring cylindrical body on a narrow footring, w/a wide flat rim, decorated w/a wide upper band of stylized leafy flowers in pink & white on an olive green ground, a lower band of leaves in green & pink on a cobalt blue ground, ink-stamped "Royal Doulton - England - D1059," small tight hairline in footring, 17½" d., 14 ¾" h.............................**1,100.00** (Illustration)

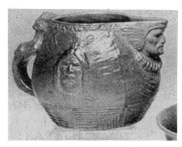

Doulton Indian Head Pitcher

Pitcher, 5 ¾" h., 7" d., stoneware, "American Indian" patt., the bulbous body molded in high-relief w/American Indian heads around the sides & bold relief Indian head spout, figural Indian head handle, glazed in shades of pale brown, modeled by Edward Kemeys, for Burley and Co., Chicago, possibly for the 1893 Columbian Exhibition, impressed mark & incised artist's signature........**316.00** (Illustration)

Vase, 4½" h., cabinet-type, Silicon Ware, brown, tan & light blue medallions, No. 2424 Doulton - Lambeth, late 19th c.**65.00**

Vase, 6¼" h., flambé glaze w/silver overlay, Art Nouveau designs, stamped ink & impressed marks, ca. 1920s**1,200.00**

Vase, 6½" h., Sung Ware, flambé glaze, signed "Noke" & "F. Moore," early 20th c.**295.00**

Doulton Rouge Flambé Vase

Vase, 8" h., 5" d., Rouge Flambé glaze, bulbous ovoid body tapering to a short small cylindrical neck w/flared rim, decorated w/a large black sailing ship w/other ships in the distance, deep red ground, 20th c.**195.00** (Illustration)

Early Doulton Silicon Ware Vase

Vase, 9¼" h., 4 ⅞" d., Silicon Ware, footed baluster-shaped, a dark brown ground w/a wide center band of white relief & tan leafy blossoms w/touches of bluish green, neck & base

bands of white relief stylized pointed leaves,19th c., marked**325.00** (Illustration)

Vase, 19⅛" h., Rouge Flambé glaze, red squatty bulbous base w/a wide shoulder to a swelled cylindrical tall neck, fitted w/a sterling silver raised footring & w/a sterling silver flaring & incurved rim chased w/strapwork & flowerheads, silver marked by the Gorham Mfg. Co., Providence, Rhode Island, ca. 1905**1,725.00**

FULPER

Founded in Flemington, New Jersey in 1805, The Fulper Pottery operated until 1935 except in 1929 when the main plant was destroyed by fire. In 1929 the company name was changed to Stangl Pottery and continued to operate until the summer of 1978 when Pfaltzgraff, a division of Susquehanna Broadcasting Company of York, Pennsylvania, purchased the assets of the Stangl Pottery, including the name.

The art pottery wares produced by Fulper in the early 20th century are today much sought by collectors.

Book ends, block-style, molded w/large stylized lion heads covered in a crystalline blue to moss flambé glossy glaze, Model 49A, die-stamped vertical rectangular mark, 5 ¾" w., 5½" h., pr.**$302.50**

Book ends, figural, a peacock w/a large, fanned tail perched between tapering uprights, khaki & blue flambé glaze, vertical ink mark, 4" w., 5 ¾" h., pr. (restoration to one beak)**412.50**

Book ends, figural, a large seated animal w/its lower legs straight out & its upper paws in its lap, its head raised & leaning back, shear white matte glaze w/some crystals, ink 'racetrack' mark & original paper label, 8" w., 7½" h., pr. (professional repair to one broken leg)**2,310.00**

Bottle, triangular w/concave sides, narrow neck w/rolled rim, dark blue w/metallic highlights, early rare circular ink mark, 4¼" w., 8" h.**137.50**

Bowl, 8" d., 5½" h., globular, the sides w/alternating rows of stacked, sharply defined artichoke-type leaves under a cream to metallic green flambé glaze, incised vertical oval mark**1,320.00**

Bowl-vase, bell pepper-shaped ribbed spherical body w/closed rim, covered in a metallic green flambé glaze ending unevenly over a dark green mottled matte glaze, early ink mark, 5" d., 4¼" h..................**467.50**

Bowl-vase, footed spherical form w/closed rim, covered in a yellow & grey satin glaze dripping over a speckled matte mustard base, early rectangular stamp & "P," 6½" d., 5 ¾" h........................**770.00**

Bulb vase, sharply tapering funnel-form base supporting a wide, shallow cupped rim, overall moss-to-Chinese blue flambé matte glaze, Model 28, die-stamped vertical rectangular mark, 4" d., 4½" h.............**192.50**

Candlesticks, round cushion foot tapering to a slender swelled shaft below the flared socket, leopard skin glaze, vertical box ink mark, 6" d. foot, 8½" h., pr........................**357.50**

Center bowl, three-footed, wide shallow form w/a wide flat rim, the interior w/an ivory & black flambé glaze, the exterior w/a blue & olive crystalline flambé glaze, incised oval mark, 11" d., 5" h...................**330.00**

Center bowl, a widely flaring shallow bowl raised on a low flaring & geometrically-pierced foot, moss-to-rose flambé glaze, ink-stamped "FULPER" & paper label, 16 ¾" d., 4 ¾" h.**495.00**

Centerpiece, a round shallow bowl w/inverted rim supported by three effigy figures kneeling on a stepped disc base, the bowl w/a glossy dark blue, khaki & lavender flambé glaze, the base w/a matte green & blue glaze, vertical ink mark, 10¼" d.,7¼" h........................**550.00**

Chamberstick, miniature, a round shallow dish w/one tall shaped side above a short cylindrical socket, a small loop handle on the tall side, mottled brown & black matte glaze, vertical ink mark, 2½" d., 2" h. (minute rim chip & flake)**176.00**

Chamberstick, the cylindrical shaft w/swelled socket on a thick flaring foot w/a square handle at the side, olive, medium & pale green leopard skin glaze, original paper label, 4" h.**231.00**

Doorstop, figural, cat in reclining position w/tail curled around body, matte pink to Mirrored Black flambé glaze, vertical rectangular ink stamp mark, 9" l., 5½" h. (minor restoration to ear)..................**770.00**

Flower frog, modeled in the form of an Indian squaw kneeling in a canoe resting on rocks, turquoise & brownish green flambé glaze, vertical ink mark, 7½" l., 3 ¾" h.**220.00**

Jug w/bulbous stopper, musical type, wide cylindrical body w/a wide, slightly domed shoulder tapering to a narrow cylindrical neck, a high arched handle on the shoulder, overall ivory glossy glaze over a mustard yellow matte glaze, works marked "Ritz - garet - New York," 5" d., 9½" h.**302.50**

Perfume lamp, porcelain, figural, modeled as a crimson-chested robin w/brown feathers standing on a rockwork base, probably designed by J.M. Stangl, vertical ink mark, 5" d., 8" h............................**550.00**

Perfume lamp, porcelain, figural, modeled in the form of a blue & yellow feathered cockatoo perched on a creamy white ball-shaped footed base, probably designed by J.M. Stangl, 5½" w., 13" h.**385.00**

Pitcher, 7¼" h., footed wide swelled cylindrical body w/a narrow angled shoulder to a wide, short neck w/a very wide flaring spout, angled handle, mirror black crystalline glaze over mustard yellow, ink-stamped oval logo mark (typical grinding flakes on base)**495.00**

Urn-vase, footed, rounded lower section, sloping shoulder w/rectangular upright handles, corseted neck, flared rim, glossy green glaze over a matte cobalt crystalline glaze, early ink mark, 7½" w., 9½" h.**605.00**

Vase, 4½" h., 5 ¾" d., squatty body w/wide mouth & two buttressed handles, overall

Copperdust Crystalline
glaze**467.50**

Vase, 4 ¾" h., 3½" d., cylindrical
w/angled shoulder & collared
rim, Chinese Blue flambé
glaze, incised 'racetrack'
mark**110.00**

Vase, 4 ¾" h., urn-form, squatty
bulbous lower half w/an angled
shoulder & sharply tapering
neck to a flat rim flanked by
square C-scroll handles, two
shades of mottled green crys-
talline glaze, ink-stamped
rectangular logo mark**220.00**

Vase, 5" h., 4" d ., footed barrel-
shaped body w/a wide, flat
mouth, streaky black to
Copperdust glaze, incised
vertical mark..........................**357.50**

Vase, 5" h., 6" d ., bulbous
w/collared rim, silvery dark
green flambé glaze dripping
unevenly over a sandy brown
matte ground, incised vertical
mark**275.00**

Vase, 5" h., 6" d ., globular
w/collared neck & short but-
tresses, dripping lustered sage
green glaze over a sandy
ground, incised vertical
mark**247.50**

Vase, bud, 5¼" h., 3 ¾" d., bul-
bous base & tall cylindrical
neck, rich Cat's Eye flambé
glaze**275.00**

Vase, 5½" h., 7" d., spherical
w/closed-in rim, feathered
metallic brown-to-mahogany
flambé glaze, vertical rectangu-
lar stamp**495.00**

Vase, 5 ¾" h., 8" d., slightly
rounded sides tapering toward
the top, angular handles from
midsection to rim, wisteria
matte mottled purple glaze
over a grey ground, vertical
incised mark..........................**715.00**

Vase, 6" h., 3½" d ., ovoid
w/rolled rim, Flemington Green
lustered glaze, mark obscured
by glaze.................................**137.50**

Vase, 6½" h., 7½" d ., wide
squatty bulbous body w/a short
rounded neck flanked by
angled loop handles, vibrant
grey to butterscotch to
mahogany flambé glaze, ink
'racetrack' mark.....................**385.00**

Vase, 6 ¾" h., 4 ¾" d ., bullet-
shaped w/short, flaring neck
flanked by three small buttress
handles, overall smooth matte
purple glaze, die-stamped ver-
tical oval mark**247.50**

Vase, 7¼" h., 4¼" d ., corseted-
form, Cat's Eye flambé glaze
over mahogany flambé glaze,
incised mark...........................**165.00**

Vase, 7½" h., 5" d ., sharply
waisted cylindrical body, over-
all buff glossy glaze, Model 26,
die-stamped vertical rectangu-
lar mark**165.00**

Vase, 7½" h., 9" d ., wide squat-
ty bulbous body tapering to a
wide closed rim flanked by
square loop handles, even
cafe-au-lait matte glaze,
incised 'racetrack' mark, origi-
nal price tag & Panama Pacific
Exhibition label...................**1,100.00**

Vase, 7½" h., 10¼" d ., wide
squatty base below a sharply
conical & stepped shoulder to a
small flat mouth, heavy loop
handles from the rim to the
base of the shoulder, overall
moss green to rose red flambé
matte glaze, die-stamped verti-
cal 'racetrack' mark, Model
T25**302.50**

Vase, 7½" h., 10½" d ., bulbous
w/collared neck, sky blue flam-
bé glaze ending unevenly
over a mirrored mustard-to-
mahogany flambé glaze, early
ink stamp & trial mark**935.00**

Vase, 7 ¾" h., 5½" d., bulbous ovoid body tapering to a slightly tapering cylindrical neck flanked by arched handles from rim to shoulder, overall pea green to robin's egg blue glossy glaze, Model 643, die-stamped vertical 'racetrack' mark**220.00**

Vase, 8" h., 5" d., bulbous bottom & long cylindrical neck, Rouge Flambé glaze, black ink 'racetrack' mark.....................**247.50**

Vase, 8 ¾" h., 3 ¾" d., upright square & slightly tapering body, decorated w/a Mirrored Black to Moss Flambé glaze, ink-stamped "PRANG"**385.00**

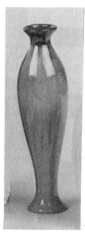

Slender Fulper Vase

Vase, 9" h., very slender baluster-form body w/short flaring neck, blue, caramel & tan flambé glaze, vertical ink mark**308.00**
(Illustration)

Vase, 9" h., 8½" d., bulbous ovoid body below a wide cylindrical neck flanked by small angular loop handles, smooth Mirrored Black glaze, raised oval mark**990.00**

Vase, 9¼" h., 10¼" d., spherical body w/three wide buttressed handles bridging circular depressions, flowing matte crystalline brown glaze, early rectangular vertical stamp**2,200.00**

Vase, 9½" h., 4½" d., the slightly flaring base molded w/a band of stylized small mushrooms below a tall plain cylindrical body, dripping black to periwinkle blue flambé glaze, early rectangular ink mark.....**770.00**

Vase, 9½" h., 4½" d., tall cylindrical body w/two square cut-out windows in the sides above a relief-molded base band of stylized mushrooms, finely shaded ivory to elephant's breath flambé glaze, vertical inkmark & paper label**825.00**

Vase, 9 ¾" h., 7¼" d., rounded lower section, two flat handles rising from shoulder to rim of tapering neck, flowing Copperdust Crystalline to Flemington Green flambé glaze, incised 'racetrack' mark**440.00**

Vase, 9 ¾" h., 8" d., footed wide squatty bulbous body tapering to a ringed cylindrical neck w/a flaring rim, matte crystalline dark blue glaze, vertical oval ink mark & incised mark........**440.00**

Vase, 10" h., 5½" d., seven-sided body w/slightly rounded sides tapering up to a wide mouth, Chinese Blue to mahogany to ivory flambé glaze, early rectangular ink mark**522.50**

Vase, 10" h., 9" d., large curving handles, beehive-form body w/horizontally ridged sides, feathered medium brown to mahogany brown flambé glaze, die-stamped "FULPER - 818L"....................................**357.50**

Vase, 10¼" h., 7½" d., pilgrim flask-style, wide flattened round sides on a short flaring

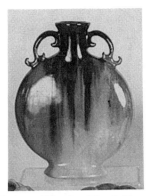

Fulper Pilgrim Flask Vase

foot & tapering to a short
flaring neck flanked by scrolled
handles, Flemington Green
flambé glaze, incised vertical
mark**632.50**
(Illustration)

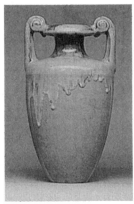

Fulper Baluster-form Vase

Vase, 10½" h., shouldered
baluster-form body tapering to
a short cylindrical neck w/a
rolled rim flanked by scroll
handles from rim to shoulder,
royal blue ground w/pale
green glazes, impressed
"FULPER"**483.00**
(Illustration)

Vase, 10½" h., 5½" d., urn-form
w/two tall scrolled handles
rising from the flat shoulder to
the rolled rim, rich vibrant
Chinese Blue flambé glaze
over a textured blue matte,

incised mark & remnant of a
paper label**605.00**

Vase, 10½" h., 8" d., wide
barrel-shaped body w/a wide
closed rim, flowing turquoise
blue flambé glaze,
incised 'racetrack' mark**385.00**

Vase, 10 ¾" h., wide bulbous
ovoid body tapering to a
cylindrical neck w/flaring rim,
small S-scroll handles at the
shoulder, streaky slightly
crystalline Mirrored Black
glaze over a deep rose
ground, raised oval logo
mark**880.00**

Vase, 11" h., 3" d ., simple
cylindrical form, decorated w/a
rich & heavily mottled green
semi-matte glaze,
stamped "PRANG"**412.50**

Vase, 11" h., 5½" d., tall waisted
cylindrical body w/a flat mouth
flanked by angular loop but-
tress handles, overall leopard
skin crystalline glaze, vertical
rectangular mark**467.50**

Vase, 11 ¾" h., 8¼" d., wide
baluster-form body w/a short,
wide cylindrical neck, Chinese
Blue, mahogany & Mirrored
Black glossy flambé
glaze**935.00**

Vase, 12" h., bulbous baluster-
form body w/a short cylindrical
neck w/flattened rim, small
loop handles at the shoulder, a
hammered mottled green
ground under a streaky
medium blue crystalline glaze,
base marked "490" &
horizontal name mark**880.00**

Vase, 12" h., 11½" d., footed
bulbous ovoid shouldered
body w/a short, wide
cylindrical neck w/thick
flattened rim, small loop
handles at the shoulder,
hammered surface w/a bluish
green flambé glaze ending
unevenly over a Rouge
Flambé glaze, incised
mark**935.00**

Vase, 12¼" h., 11" d., wide
ovoid body tapering to a round-
ed, stepping neck w/a flat rim,
mirrored black to sky blue
flambé glaze, raised vertical
oval mark**2,200.00**

Vase, 12½" h., 7¼" d., tall
ovoid body on a small footring,
tapering to a closed rim, two
ring handles near the top,
even *cafe-au-lait* matte glaze,
raised 'racetrack' mark**522.50**

Vase, 12 ¾" h., 4½" d ., tall
cylindrical body, the sides
molded in relief w/intertwining
cattails, Antique Verde matte
glaze, stamped vertical
rectangular mark**2,530.00**

Vase, 13" h., 7½" d., squatty
bulbous base on footring below
a tall trumpet-form neck, mot-
tled glossy brown, purple &
mint green flambé glaze, oval
incised mark & two paper
labels**935.00**

Vase, floor-type, 17" h., 8½" d.,
tall baluster-form body w/a
short wide neck w/flared rim,
fine Mirrored Black to
Flemington Green flambé
glaze, raised vertical oval
mark**1,760.00**

Vase, floor-type, 17" h., 9" d.,
wide baluster-form body w/low,
flaring neck, brown, grey,
green & cream flambé glaze,
drilled base & factory wire hole
on side, raised vertical mark
& paper label**660.00**

Vase, 18" h., tall slender ovoid
body tapering to a flat mouth,

heavy angled strap handles at
the shoulder, overall thin con-
centric rings up the sides,
green & black matte glaze,
Shape No.TC 51, horizontal
ink mark**522.50**

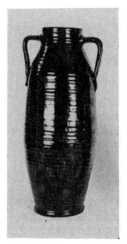

Tall Fulper Vase

Vase, 22½" h., 8½" d., Colonial
Revival line, tall slender ovoid
body tapering to a short
cylindrical neck flanked by
short loop angled handles, thin
rings up the sides, mottled
warm red, Cat's Eye & dark
blue flambé glaze,
unmarked**825.00**
(Illustration)

Vases, 5½" h., 4 ¾" d ., wide
bulbous ovoid body tapering to
a thick, molded flat mouth,
Copperdust glaze, raised
'racetrack' mark, pr.**467.50**

Bulb vases, hourglass-form
w/wide thin squatty base,
waisted body & wide cupped
rim, frothy bluish green flambe
glossy glaze over a cobalt blue
matte body, rectangular ink
mark, 4½" d., 4½" h.,pr.**330.00**
(Illustration: No. 3)

Candlesticks, miniature,
Vasekraft period, two matching
w/flaring hexagonal base taper-
ing to a slender shaft, both
decorated w/a matte green
glaze, a third w/a round disc
foot & tapering cylindrical shaft
decorated in speckled matte

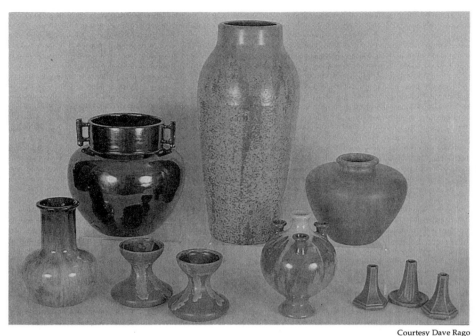

Courtesy Dave Rago

Fulper Vases & Candlesticks

blue, blue stick marked, each
3½" h., 3 pcs.**220.00**
(Illustration: No. 7)

Vase, 6 ¾" h., 7" d., very wide
bulbous ovoid body w/a wide
flattened shoulder to a small
short cylindrical neck w/rolled
rim, rich Wisteria Matte glaze,
vertical oval ink mark**412.50**
(Illustration: No. 6)

Vase, 8" h., 5" d., bulbous squat-
ty base tapering to a wide
cylindrical neck w/flared rim,
Cat's Eye & Blue Flambé
glaze, vertical oval incised
mark**275.00**
(Illustration: No. 1)

Vase, 8" h., 5¼" d., 'flag vase,' a
small pedestal base supporting
a wide spherical body w/three
short small flaring necks

around the shoulder centering
a larger flaring central neck,
textured ivory to mahogany to
Flemington Green flambé
glaze, oval incised mark**880.00**
(Illustration: No. 5)

Vase, 9½" h., 8" d., Chinese
translation-style, a wide bul-
bous ovoid body w/a wide
shoulder tapering to a wide
short cylindrical neck flanked
by square loop handles, rich
even silvery Mirrored Black
glaze, raised oval mark**715.00**
(Illustration: No. 2)

Vase, floor-type, 17" h., 7" d., tall
ovoid body tapering to a short
cylindrical neck, textured
Leopard Skin crystalline glaze,
incised vertical mark**1,650.00**
(Illustration: No. 4)

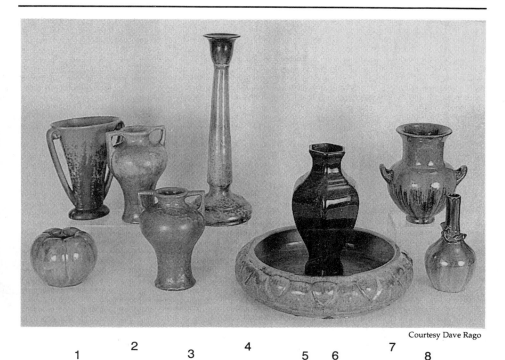

Courtesy Dave Rago

1 2 3 4 5 6 7 8

Fulper Center Bowl, Candlestick and Vases

Bowl-vase, spherical lobed 'bell pepper' form body, mottled Flemington Green & gun-metal flambé glaze, early rectangular ink mark, 4 ¾" d., 4" h.**385.00** (Illustration: No. 1)

Candlestick, stepped & domed foot below the tapering columnar standard w/a trumpet-form socket, rich Cat's-Eye to Elephant's Breath to Leopard Skin crystalline glaze, early rectangular ink mark, 5¼" d., 15½" h.**467.50** (Illustration: No. 4)

Center bowl, wide flat bottom w/low incurved sides, embossed spade-like devices around the sides, textured Flemington Green glossy glaze over matte blue ground, early rectangular ink mark, 13" d., 3 ¾" h.**522.50** (Illustration: No. 5)

Vase, 7½" h., 6 ¾" d., urn-form w/small foot supporting a wide bulbous body tapering to a wide cylindrical neck w/flaring rim, loop shoulder handles, Chinese Blue flambé over Mahogany flambé glaze, early rectangular ink mark**825.00** (Illustration: No. 7)

Vases, 7 ¾" h., 5" d., bulbous baluster-form body w/short flaring neck flanked by angled handles, one w/a feathered Wisteria Matte glaze, other w/a textured Matte Green glaze, both w/incised oval mark, pr. ..**522.50** (Illustration: No. 3)

Vase, 8" h., 3 ¾" d., bottle-form, bulbous ovoid body tapering to a tall 'stick' neck wrapped w/a salamander, Cat's-Eye flambé glaze, vertical ink stamp........**770.00** (Illustration: No. 8)

Vase, 8" h., 7" w., fan-shaped body tapering to an oval foot, long scroll handles, fine Leopard Skin crystalline glaze, oval ink mark**330.00** (Illustration: No. 2)

Vase, 11" h., 5¼" w., Oriental translation-type, hexagonal baluster-form body w/flaring neck, fine crystalline Mirrored Black glaze, incised vertical oval mark**385.00** (Illustration: No. 6)

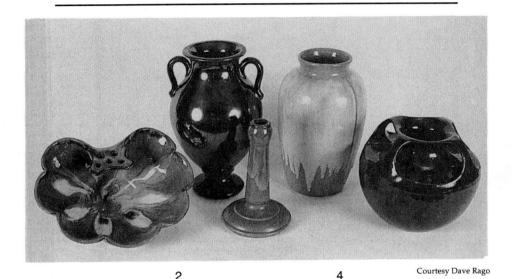

1 2 3 4 5

Courtesy Dave Rago

Fulper Flower Bowl, Candlestick & Vases

Candlestick, low domed disc foot centered by a slightly tapering cylindrical shaft w/a bulbous socket, flowing Chinese Blue flambé over mustard yellow matte glaze, original "Vasekraft" label & rectangular ink-stamped mark, 5½" d., 9" h..................**192.50** (Illustration: No. 3)

Flower bowl, wide shallow scalloped shell-shape w/one scallop pulled inward & pierced w/flower holes, Chinese Blue flambé over an oyster matte glaze, rectangular ink-stamped mark, 11½" w., 3½" h.**220.00** (Illustration: No. 1)

Vase, 8½" h., 9" d., squatty bulbous body w/a wide shoulder attached to the short

flaring neck for four arched short handles, flowing Mirrored Black glaze, embossed 'racetrack' mark, small flat chip to side, minor bruise to rim ..**550.00** (Illustration: No. 5)

Vase, 12" h., 5 ¾" d., simple ovoid body tapering to a short flaring neck, ivory drip glossy glaze over a mustard yellow matte glaze, die-stamped 'racetrack' mark....................**935.00** (Illustration: No. 4)

Vase, 12 ¾" h., 6½" d., classical baluster form w/flared neck & tapering to a small flaring foot, the shoulders fitted w/small loop handles, Mirrored Black glaze, rectangular ink-stamped mark**550.00** (Illustration: No. 2)

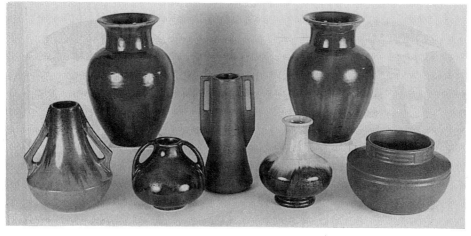

2
1
3
4
5
6
Courtesy Dave Rago
7

Fulper Bowl-Vase & Vases

Bowl-vase, Chinese translation-style, a broad squatty bulbous body w/a nearly flat wide shoulder tapering to a wide short cylindrical neck molded w/panels of stylized Chinese symbols, *cafe-au-lait* matte glaze, early rectangular ink mark, 8½" d., 6" h.**357.50** (Illustration: No. 7)

Vase, 6½" h., 6" d., footed wide squatty bulbous ovoid body tapering to a short neck flanked by long arched loop handles, satiny cobalt blue & purple mottled glaze, incised 'racetrack' mark....................**330.00** (Illustration: No. 3)

Vase, 8" h., 6" d., footed wide squatty bulbous body tapering to a cylindrical neck w/a rolled rim, ivory crystalline to metallic Mirrored Black flambé glaze, ink-stamped 'racetrack' mark**467.50** (Illustration: No. 5)

Vase, 9½" h., 7¼" d., wide squatty base w/an angled shoulder to the tall conical sides flanked by low pierced angular buttress handles, Copperdust Crystalline to Flemington Green glaze, incised 'racetrack' mark**522.50** (Illustration: No. 1)

Vase, 10½" h., 4½" d., tall slender conical body w/the flat rim flanked by long pierced square buttress handles, *cafe-au-lait* matte glaze, original "Vasekraft" label on bottom...**660.00** (Illustration: No. 4)

Vase, 11 ¾" h., 7" d., wide baluster-form body w/a short cylindrical neck w/flaring rim, flowing moss green to rose flambé glaze, ink 'racetrack' mark**522.50** (Illustration: No. 6)

Vase, 11 ¾" h., 7" d., wide baluster-form body w/a short cylindrical neck w/flaring rim, flowing, textured wisteria matte glaze, ink-stamped 'racetrack' mark**440.00** (Illustration: No. 2)

GOUDA

The city of Gouda, Holland has been a center of tin-enameled earthenware production since the early 17th century but it is the pieces from more modern factories which are attracting collectors today. The brightly colored art pottery wares from Gouda are very recognizable with the peasant-style and stylized floral and geometric designs, some featuring a "cloisonné" effect. Several pottery workshops were located in and around Gouda including those of Regina, Zenith, Plazuid, Schoonhoven, Arnhem and others. Utilitarian wares and large outdoor garden ornaments were produced as well as decorative vases and miniatures.

Candlestick, tall slender standard w/a widely flaring domed base, a wide flat dished drip pan at the top centered by the double-gourd form socket, decorated around the foot w/a wide band of stylized leafage, spaced geometric bands around the shaft & socket, green ground w/cobalt blue, yellow & rust on cream, inscribed "873 - Candia - (house) - Gouda - Holland," five-branch date tree & artist's initials, incised "0124/2," 17¾" h. (drilled)**$374.00**

Candlesticks, tall inverted trumpet-form shaft supporting a wide flat dished drip pan centered by the double-knob tall socket, a high arched D-form handle from top of socket to middle of the shaft, decorated w/large stylized swirling leaves in black & shades of brown w/yellow & cobalt blue on cream, inscribed "1561 - Gluck (house) - Plazuid - Holland - Gouda - 42.39 - 1929," 14⅜" h., pr...........................**632.50**

Candlesticks, tall slender tapering shaft w/a widely flaring foot, the wide flat drip pan w/a shallow scalloped rim & centered by the double-gourd form socket, decorated w/cobalt blue scrolls on the cream ground & floral designs in semi-gloss white, green & rust outlined in yellow, inscribed "872 - Blanca. Holland. Gouda - Hm. H., 1923 (house)," incised "S-12H," 14⅞" h., pr.**575.00**

Decanter w/stopper, bulbous ovoid body tapering to a short slightly tapering cylindrical neck, the stopper composed of four knobs, the sides decorated w/large oval panels w/applied knobs alternating w/bands of stylized flowers in shades of green w/black, yellow, lavender, cobalt blue & rust, inscribed "920A - Madeleine (house) - Gouda - Made in Holland - 1928," 9½" h.**230.00**

Humidor, cov., colorful designs in cobalt blue, beige, yellow & orange, artist-signed, 5" h.**265.00**

Inkwell, triangular w/insert, black ground, marked "Regina WB, House, Gouda, Holland"................................**150.00**

Inkwell - pen tray combination w/matching cover, artist-signed, marked "Gouda Holland IVORA," 10½" l.**275.00**

Jar, cov., Art Deco style, bulbous barrel-shape w/wide, low-domed cover, decorated overall w/various triangles & other geometric designs in black, orange, yellow, blue, green, cream, brown & rust, inscribed "452 - Krias - Koninklyk -

Goedewaagen, Gouda,
Holland, GB," 5¼" d.,
6 ⅜" h.**431.00**

Model of a Dutch shoe, green,
orange & black, marked
"Maas," 5½" l.**110.00**

Plaque, rectangular, polychrome
enamel decoration of a village
harbor scene, mounted in a
wide oak frame, artist-signed,
house symbol for Zuid, plaque
12¼ x 16¼"**770.00**

Vase, 6" h., wide bulbous balus-
ter-form body w/a short cylindri-
cal neck, geometric decoration
of bands of diamonds enclos-
ing C-scrolls w/stripes of her-
ringbone around the shoulder
& base, in black, gold, yellow,
olive green, mustard yellow &
aqua on a dark brown ground,
painted signature "B.F.K. - 994
- CA".....................................**143.00**

Banded Gouda Vase

leaves & ovals in dark blue,
cream, light green, yellow,
caramel & black against a
black ground, narrow bands at
the rim & base, artist-initialed &
brushed marks**495.00**
(Illustration)

Vase, 15½" h., 7½" d., in the
Rozenberg style, baluster-form
body tapering to a swelled stick
neck w/large loop handles
extending from the neck center
to the shoulder, decorated
w/butterflies above tall swirling
flowers on stems, marked
"Made in Holland - P- a - R" ..**577.50**

Colorful Gouda Vase

Vase, 10¼" h., 7" d., footed
ovoid body tapering to a short
flaring neck, decorated w/wavy
bands of stylized florals in
shades of green w/cobalt blue,
mustard yellow & rust on a
cream ground, matte glaze,
inscribed "0104/4 - MAJJA,"
w/house mark & artist's
initials**374.00**
(Illustration)

Vase, 10½" h., slender ovoid
body tapering to a short trum-
pet neck, the shoulder decorat-
ed w/a wide band of stylized

Floral Decorated Gouda Vase

Vase, 16 ⅜" h., 10" d., baluster-shaped body, decorated w/a band of very large stylized flowers & leaves in semi-gloss white, cobalt blue & dark red, rim & base in black w/pale bluish grey, neck & shoulder in brick-red w/black over light green, inscribed "0123 - Herat - Gouda - Holland - AR," & house mark, rim hairline.....**1,035.00** (Illustration)

Vase, 16½" h., baluster-form w/two handles, decorated w/stylized floral designs in colors of burgundy, aubergine, violet, moss green & caramel, signed "B.O IVORA GOUDA HOLLAND" & incised "213"....................................**460.00**

Vase, 17" h., tall ovoid body tapering to a slender trumpet-form neck flanked by slender round loop handles, deep umber ground decorated w/stylized blossoms, stems & foliage in violet, yellow, blue & green, painted mark "213 B.O. GOUDA HOLLAND," & incised "213".................................**1,100.00**

Vase, 19" h., decorated w/stylized roosters in blue & mustard yellow on an emerald green ground**550.00**

Vases, 10⅛" h., wide baluster-form body w/a wide cylindrical neck w/flaring rim, thick handles from rim to shoulder, the body decorated w/a wide band of large stylized blossoms & scrolling leaves in green w/rust, yellow, lavender, cobalt blue & mustard yellow on cream, inscribed "Percy - 602 - 4 - Holland (house) 1923," pr.**374.00**

Vases, 13 ⅞" h., bulbous base tapering to tall cylindrical sides w/a widely flaring rim, decorated w/tall panels of stylized flowers between geometric border bands, cream ground w/grey, cobalt blue, brick red,

Tall Gouda Vase

greyish green & yellow, inscribed "Oud - Holland - H 100," pr.**402.50** (Illustration: one of two)

Vases, 14 ⅜" h., tall slender baluster-form w/a wide foot, loop handles from the foot to the lower body, decorated w/large stylized flowers & long scrolling leaves, green ground decorated w/cream, yellow, shades of green & outlined in cobalt blue, inscribed "661. Corona. Gouda. Holland - AR - (six branch tree - 2) & a house," incised "661," pr.**690.00**

GRAND FEU

BRAUCKMAN ART POTTERY

GRAND FEU POTTERY L. A., CAL.

T

Grand Feu, French literally translated to "great fire," was the name chosen for a pottery established in Los Angeles, California in 1912. The founder was Cornelius

Brauckman, however, little histori-
cal background about Brauckman
and his pottery has surfaced. It is
known that the firm concentrated on
"gres" type earthenwares fired at a
high temperature. Examples of
Grand Feu ware did not feature any
applied or painted decoration but
relied on the natural effects of the
firing to create interesting glazes. A
number of named glazes are known
including various shades of
Crystals, Green and Blue Ramose,
Venetian Green, Moss Agate
(sponged appearance in green over
light tan), Multoradii and Sun Ray.

The pottery was awarded a Gold
Medal at the San Diego exposition
of 1915 and production apparently
continued through about 1918.

Two Grand Feu Vases

L.A. CAL. - T," incised
"7/4/GA"**3,850.00**
(Illustration: right)

Small Grand Feu Vase

Vase, 4½" h., 4¼" d., squatty
bulbous base tapering to a
wide flaring cylindrical neck,
pigeon-feathered silvery green
& brown layered glaze w/a mir-
rored finish, die-stamped
"Grand Feu Pottery - L.A.
CAL.," incised "154"**$3,300.00**
(Illustration)

Vase, 5½" h., 3" d., bottle-form,
wide squatty bulbous base w/a
wide shoulder to the tall stick
neck w/flared rim, mottled
Mission Matte brown glaze,
impressed "Brauckman Art
Pottery"**1,045.00**

Vase, 6 ¾" h., 3 ¾" d., footed
slightly flaring cylindrical body
covered in blue, green, grey &
black crystalline glaze, die-
stamped "Grand Feu Pottery -

Rare Grand Feu Vase

Vase, 8½" h., 4½" d., bottle-
form, footed wide nearly spher-
ical base tapering to a tall,
slightly flaring cylindrical neck,
hare's-fur matte mustard yel-
low, light green & mahogany
flambé glaze on a brown &
blue glossy ground, die-
stamped "Grand Feu Pottery -
L.A. Cal. - TT 1730"**7,425.00**
(Illustration)

Vase, 10½" h., 4" d., squatty bulbous base w/cylindrical sides tapering to squatty bulbous rim, decorated w/vibrant green, dark brown & mahogany brown hare's-fur flambé glaze, typed yellowed paper description taped on side, die-stamped "Grand Feu Pottery - L.A. Cal," incised "BR17" ...**8,525.00** (Illustration: left)

GRUEBY

The Grueby Faience and Tile Company was founded in Boston, Massachusetts in 1891 and became well known for its unique art pottery. Molded naturalisitic designs featuring broad leaves and small blossoms often covered in thick organic-colored glazes became a hallmark of Grueby production, often imitated by other potteries but seldom equaled in uniqueness and quality. The pottery closed in 1907 and today the best examples of Grueby's output sell for very high prices.

Most Grueby pieces were marked and often bear the initials of the decorator.

GRUEBY

Bowl, 5¼" d., 2¼" h., squatty bulbous sides w/a wide shoulder to a rolled rim, molded w/wide, rounded leaves, matte green glaze, artist-initialed & dated "1906".......................**$467.50**

Bowl-vase, squatty bulbous low sides tapering to a wide flat mouth, rich caramel & brown matte glaze, impressed mark, 3" d., 2" h..............................**412.50**

Bowl-vase, bulbous nearly spherical body w/a wide rolled rim, molded w/five wide rounded leaves alternating w/thin stems topped by small buds, rich matte green glaze w/yellow buds, impressed mark, 5½" d., 3½" h.....................**1,870.00**

Candleholder, shallow dished base w/a low, flaring candle socket in the center joined to the rim by two arched handles, dark matte blue glaze, circular impressed mark & original paper label, 6" d., 2" h...........**357.50**

Candlestick, tall slender tapering conical standard w/a bulbous swelled neck below the flaring socket rim, decorated around the neck w/overlapping applied leaves, thick yellow matte glaze, original paper label, 9" h.**990.00**

Jardiniere, wide bulbous spherical body w/a wide mouth & short everted rim, the sides applied w/long stylized vertical leaves, decorated by Kiichi Yamada, marked, 19½" d., 15" h...............................**20,700.00**

Lamp, table model, bulbous ovoid base w/waisted tapering shoulder, the body molded w/four layers of overlapping leaves covered in a rich green matte glaze, fitted w/a hand-hammered copper-framed conical shade w/wide mica panels produced by Dirk van Erp, the Grueby base marked w/the initials of artist Marie Seaman, shade unmarked, shade 18" d. overall 20" h.**8,800.00**

Paperweight, figural, model of a large, oval scarab, light green matte glaze, impressed "Grueby Faience Co. - Boston, USA," 4" l., 1½" h. (minute flakes to side)**412.50**

Tile, square, squeezebag decoration of two tan swans w/black eyes on blue water under two arching trees w/green leaves & trunks on cocoa brown earth backed by a blue sky, set in a

Tiffany bronze frame w/four square ribbed feet w/original dark brown patina, 4½" sq., 1½" h...................................**935.00**

Tile, square, a carved design of a leaping reindeer w/long antlers, unglazed brick red clay, in a wide flat oak frame, tile 4" sq.**286.00**

Tile, square, decorated w/a detailed stylized design of a brown lion w/open mouth & extended tongue against a bone white ground & flanked by two tall green trees w/broad leaves against a blue sky & pale blue lake, enclosed within a Tiffany bronze frame w/square tab feet w/a rich original golden brown patina, 6" sq.**1,650.00**

Tile, square, molded in relief w/a stylized mermaid looking into a hand mirror, oatmeal curdled matte on a green ground, stamped mark, wide oak frame, 6" sq..........................**1,100.00**

Tile, nearly square, landscape scene w/a large 'puffy' green oak tree on a green ground against a cream sky w/white clouds, unframed, painted "28" on the back, 6 x 6½............**2,640.00**

Tile, square, carved design w/a central cross framed by small quatrefoil squares & angled bands, dark brown design on a rich medium matte green ground, in a wide flat oak frame, 8" sq..........................**715.00**

Tiles, square, four matching, each w/a geometric pattern of circles & squares in a vivid tan & royal blue matte glaze, in a wide flat oak frame, 8" sq., set of 4**286.00**

Tiles, square, four matching, each w/a quatrefoil design in tan & cream crackled matte glaze on a dark red clay

Framed Grueby Tiles

ground, in a wide flat oak frame, tiles 8" sq., set of 4.....**297.00** (Illustration)

Vase, 3" h., 3 ¾" d., squatty bulbous melon-lobed body w/a wide flat molded mouth, flowing matte green glaze, impressed 'pottery' mark**660.00**

Vase, 3¼" h., 3 ¾" d., squatty bulbous body, rich mustard glaze over a ribbed body, circular mark "GRUEBY POTTERY BOSTON USA," & original price tag & paper label**935.00**

Vase, 3½" h., bulbous tapering ovoid body w/a narrow shoulder to the small flat mouth, ivory matte glaze, impressed mark**330.00**

Vase, 4" h., 5½" d., squatty bulbous base w/a wide shoulder to a short, cylindrical neck molded w/thin rings, deep cucumber green glaze, impressed "Grueby Faience - 92B"**522.50**

Vase, 4¼" h., 3¼" d., bulbous ovoid body w/a rounded shoulder to the short flaring neck, thick textured matte green glaze, impressed 'pottery' mark (two small nicks at rim)..........**467.50**

Vase, 5" h., 3¼" d., ovoid body tapering to a short cylindrical

neck, molded & applied around the lower half w/broad pointed leaves, rich organic matte green glaze, circular paper label & original price tag over the mark**1,045.00**

Vase, 5" h., 3 ¾" d., bulbous ovoid body w/a wide shoulder tapering to a small short rolled neck, decorated w/a band of wide pointed leaves, green mottled matte glaze, w/a paper label (grinding chip at base in making)**1,980.00**

Vase, 5½" h., ovoid body tapering to a gently flaring three-lobed rim, the sides molded w/three broad leaves alternating w/slender stems & buds, matte green glaze, impressed mark**805.00**

Vase, 5½" h., wide ovoid body w/a small thick molded rim, molded w/broad rounded leaves under a thick curdled green matte glaze, artist-signed, impressed.............**2,090.00**

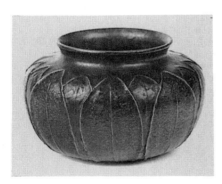

Squatty Grueby Vase

Vase, 6" h., 9½" d., squatty bulbous shouldered body w/a short flaring neck, the sides applied w/wide pointed over-lapping leaves, dark matte green glaze**5,225.00** (Illustration)

Vase, 6½" h., 4½" d., squatty bulbous base tapering to a tall cylindrical neck, tooled panels

from the top creating stylized round-tipped leaves, vegetal matte green glaze, impressed mark**1,100.00**

Vase, 6 ¾" h., 3" d., cylindrical body rounded at the bottom & shoulder w/a wide molded rim, full-length tooled & applied broad leaves alternating w/slender stems w/yellow buds around the shoulder, green matte glaze, die-stamped mark (minor chip repairs under rim)**2,970.00**

Vase, 7" h., wide ovoid body tapering sharply to a short flaring neck, thick dark green matte glaze, impressed mark & partial paper label**1,320.00**

Vase, 7" h., wide ovoid shouldered body w/a short rolled neck, molded up the sides w/long leaves w/rounded tips at the shoulder, green matte glaze, impressed mark.......**2,200.00**

Vase, 7" h., 3" d., footed cylindrical body w/a rounded shoulder to the short rolled neck, curdled mustard yellow glaze, die-stamped mark**605.00**

Vase, 7 ⅜" h., ovoid body tapering to a wide, flat mouth, the sides molded w/wide leaves w/curled tips separated by slender stems topped by small molded buds around the rim, light matte green glaze, by Ruth Erickson, ca. 1908, signed**1,045.00**

Vase, 7½" h., slightly swelled cylindrical body w/the flaring rim pulled into five points above tall broad pointed leaves alternating w/stems & flower buds at the rim, opaque green glossy glaze, impressed mark (hairline)**1,540.00**

Vase, 7½" h., swelling cylindrical body w/a rounded shoulder to the short flaring neck, narrow reeded bands down the sides,

matte green glaze, paper label
& impressed mark w/incised
artist's initials "J.E.," ca.
1905**1,380.00**

Vase, 7½" h., 4½" d., slightly
swelled cylindrical body applied
w/six full-length broad pointed
leaves w/the tips at the rim
slightly flared, rich cucumber
matte green glaze, impressed
circle mark (minor nicks
at leaf tips)**1,650.00**

Vase, 7½" h., 4½" d., tapering
ovoid body molded w/tall nar-
row overlapping leaves
w/rounded tips, organic matte
green glaze, impressed
mark**2,420.00**

Vase, 8¼" h., footed wide ovoid
body w/a wide shoulder to the
short rolled neck, molded in
low-relief w/long & wide over-
lapping leaves up the sides,
matte green glaze, modeled by
Wilhelmina Post, Model No.
164, impressed mark & artist's
initials, ca. 1904**1,840.00**

Vase, 8½" h., wide ovoid body
tapering slightly to a molded
rolled rim, delicately applied
decoration of a single blossom
atop a narrow stem among four
narrow vertical leaves, the
design repeated three times
around the body, two blossoms
in vivid yellow & one in oat-
meal, thick green matte
ground, by Ruth Erickson,
impressed mark, in-the-
making rim line**4,400.00**

Vase, 8½" h., 5" d., slightly
expanding cylinder w/flat nar-
row shoulder, covered w/
superimposed full-length tooled
& applied leaves, under a rich
tactile & uneven matte green
glaze, by Florence Liley,
impressed circular mark
"GRUEBY FAIENCE CO.
BOSTON U.S.A."**2,320.00**

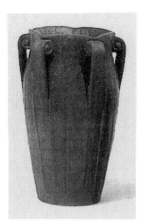

Grueby Vase with Curled Handles

Vase, 9" h., ovoid body tapering
to a five-sided rim, the sides
w/five broad long pointed
leaves alternating w/five tall
leaves curled under at the rim
to form handles, by Wilhelmina
Post, impressed mark, a cou-
ple of minor chip repairs.....**4,400.00**
(Illustration)

Vase, 10½" h., 4" d., tall slender
body w/tapering neck & flaring
rim, decorated w/spade-
shaped green leaves & yellow
buds under a rich cucumber
matte glaze, marks obscured
by glaze, original paper
label**4,125.00**

Vase, 11½" h., 5" d., tall ovoid
body tapering to a slightly flar-
ing rim, wide, tall pointed
leaves alternating w/slender
stems w/flower buds around
the top, thick green matte
glaze, by Marie A. Seaman,
impressed circular mark &
"MS"**5,500.00**

Vase, 11½" h., 7½" d., wide
ovoid body w/a collared neck &
incurved wide rim, deeply
incised w/full-length ribbed
leaves w/folded tips, a second
row of leaftips at the rim, thick
vegetal mustard yellow matte
glaze, impressed "Grueby

Pottery - Boston USA," & two
paper labels**15,400.00**

Vase, 12" h., tall ovoid shoul-
dered form w/a short flaring
neck, molded up the sides
w/alternating broad pointed
leaves & slender stems w/small
buds, matte green glaze,
impressed mark, base
drilled**2,070.00**

Vase, 12" h., 6¼" d., tall ovoid
body, molded w/wide, tall point-
ed leaves up the sides to the
narrow shoulder & the short,
flaring neck, leaves alternate
w/slender stems topped by
small yellow buds around the
shoulder, veined matte green
glaze, incised medallion
mark & "255"**3,850.00**

Vase, 12½" h., wide baluster
body w/widely flaring squatty
neck, decorated w/high-relief
modeled leaf blades alternating
between eight organic handles,
matte green glaze, by George

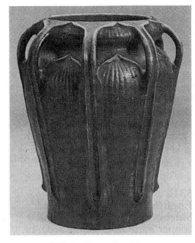

Wide Grueby Vase

P. Kendrick, modeled by
Wilhelmina Post, impressed in
a circle "Grueby Pottery Boston
USA," paper label & lamp,
lamp shade information paper
label, incised artist's initials,
includes Tiffany Studios bronze
electric three-light lamp canis-
ter insert, ca. 1900**34,500.00**
(Illustration: above)

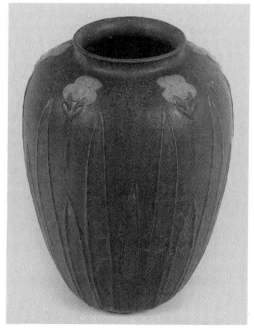

Rare Large Grueby Vase

Vase, 13" h., squatty bulbous base molded w/two tiers of broad rounded leaves w/curled tips, the base tapering to a tall, wide cylindrical neck w/a molded rim, mottled green glaze w/heavy dripping around the upper neck, by Wilhelmina Post, signed**3,450.00**

Vase, 13" h., 8½" d., gourd-shaped, clear glaze over a curdled cobalt to light blue dripping over a light grey flambé glaze, showing a buff body, impressed circular mark "GRUEBY POTTERY BOSTON U.S.A."**6,050.00**

Gourd-Shaped Grueby Vase

Vase, 14½" h., large ovoid body tapering to a short rolled neck, molded w/alternating tall slender & short slender pointed leaves & broad iris blossoms on stems, yellow blossoms & a fine matte green ground, executed by Lillian Newman, large circular impressed mark, No.140**36,300.00** (Illustration: bottom of previous page)

Vase, 15¼" h., 10½" d., wide ovoid shouldered body w/a low rolled neck & small tab handles at the shoulder, decorated w/one full-length iris on each side, one burgundy & one French blue atop light green stems & foliage, against a fine, veined leathery organic matte green glaze, impressed circular mark & "A.L." (small drill hole in base)**22,000.00**

Vase, 16½" h., 9" d., gourd-shaped body, low-relief foliate decoration, matte cucumber green glaze, designed by George Kendrick, modeled by Wilhelmina Post, impressed mark & incised artist's initials, drilled, minor traces of blue paint, ca. 1902**20,700.00** (Illustration)

Tall Grueby Vase

Vase, 22" h., 8½" d., ovoid base tapering to a cylindrical neck, decorated w/tooled & applied leaves alternating w/full-length stems w/bright yellow buds, matte green glaze, circular stamp "Grueby Faience - Boston U.S.A.," manufacturing chips at base**16,500.00** (Illustration)

Waterspout tile, figural, square w/the figure of an open-mouthed fish diagonally across the body, rich blue matte glaze on red clay, 7½" sq.**770.00**

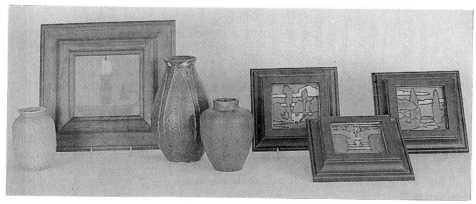

Courtesy Dave Rago

1 2 3 4 5 6 7

Grueby Tiles & Vases

Tile, square, a garden scene w/a tall fountain framed by hedge in matte green, blue, brown & ivory, outlined in black, framed, 4" sq.**330.00** (Illustration: No. 6)

Tile, square, stylized landscape w/tall green poplar trees against a blue sky w/white clouds, outlined in black, impressed mark, framed, 4" sq.**715.00** (Illustration: No. 7)

Tile, square, stylized landscape w/tall trees near a brown house, blue sky & white clouds in distance, outlined in black, impressed mark, framed, 4" sq.**715.00** (Illustration: No. 5)

Tile, square, decorated w/a green chamberstick & white candle on a French blue ground, artist-signed "D.C.," framed, 6" sq.**1,860.00** (Illustration: No. 2)

Vase, 5" h., 3¼" d., tall barrel-shaped body w/the rounded shoulder tapering to a short flaring neck, incised w/stylized arch-shaped leaves & ribbing, unusual thick curdled light blue matte glaze, impressed mark & incised "RE," by Ruth Erickson, tiny glaze chip rim repair**825.00** (Illustration: No. 1)

Vase, 5½" h., 3 ¾" d., tapering ovoid body w/a wide rounded shoulder to a small, short cylindrical neck the body divided into wide lobe panels, cucumber green matte glaze, die-stamped mark**825.00** (Illustration: No. 4)

Vase, 8½" h., 4 ¾" d., ovoid body tapering to a short flaring neck, full-length tooled wide pointed leaves, leathery cobalt blue matte glaze, impressed mark & incised artist initials "MCJ," some small glaze slips near top.............................**1,860.00** (Illustration: No.3)

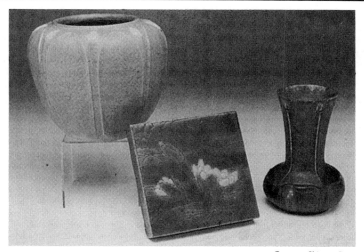

Courtesy Skinner, Inc.

1 2 3
Grueby Tile & Two Vases

Tile, square, yellow lotus blossoms & green leaves w/a matte glaze, green-glazed sides, paper label, inscribed artist's initials, 6" sq.**1,092.50**
(Illustration: No. 2)

Vase, 6 ¾" h., 7½" d., very wide ovoid body w/a closed rim, molded in low-relief w/tall wide leaves alternating w/slender stems w/tiny cream blossoms around the rim, matte yellow glaze, modeled by Marie Seaman, ca. 1904, impressed mark & artist's initials**6,325.00**
(Illustration: No. 1)

Vase, 7" h., squatty bulbous base below a tall & wide trumpet neck, molded around the base w/wide rounded leaves & up the neck w/buds on long stems, matte green glaze, impressed mark & artist's initials "J.E.," ca. 1905**1,610.00**
(Illustration: No. 3)

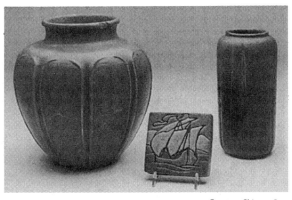

Courtesy Skinner, Inc.

1 2 3
Tall Grueby Vases & Ship Tile

Tile, square, decorated w/a two-masted sailing galleon, in pale blue, ivory, yellow & green, matte glaze, impressed mark, ca. 1909, 4" sq.**345.00** (Illustration: No. 2)

Vase, 9" h., cylindrical body on a thin footring, the rounded shoulder to a short molded neck, molded w/six wide vertical panels separated by incised lines, matte blue glaze, modeled by Ruth Erickson, impressed mark & artist's initials, ca. 1904**1,610.00** (Illustration: No. 3)

Vase, 10½" h., 9" d., bulbous ovoid shouldered body w/a short flaring neck, molded w/a band of tall broad leaves up the sides, matte ochre glaze, modeled by Marie Seaman, impressed mark & incised artist's initials, ca. 1904, rim chip, nicks**1,725.00** (Illustration: No. 1)

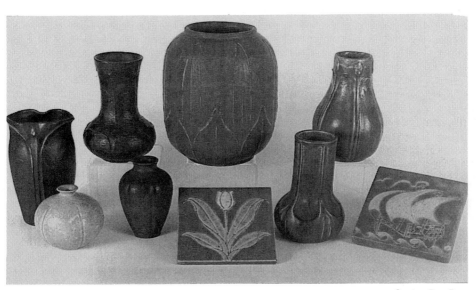

Courtesy Dave Rago

3 5 8
1 7 9
 2 4 6

Grueby Vases & Tiles

Tile, square, decorated w/a single yellow tulip blossom on a green stem above four flaring green leaves against a light blue ground, raised mark "Grueby Faience CO. - Boston, MASS.," 6" sq.**495.00** (Illustration: No. 6)

Tile, square, decorated w/a sailing galleon w/three sails & a pennant & sea gulls above in ivory, brown & green matte glaze, unmarked, 6¼" sq.**440.00** (Illustration: No. 9)

Vase, 4" h., 4" d., spherical gourd body tapering to a thin short flaring rim, incised lines covered in a thick mottled light blue matte glaze, incised circular mark, restoration to rim**275.00** (Illustration: No. 2)

Vase, 5½" h., 3¼" d., ovoid body tapering to a short, flaring neck, incised wide vertical ribbing, thick dark green elephant skin matte glaze, by Norma Pierce, impressed circular mark**467.50**
(Illustration: No. 4)

Vase, 7" h., 4½" d., squatty bulbous base tapering to a wide, gently flaring cylindrical neck, decorated w/buds on long stems & applied wide leaves in a rich & leathery green matte glaze, by Wilhelmina Post, incised artist's signature.....**1,540.00**
(Illustration: No. 3)

Vase, 7¼" h., 4¼" d., squatty bulbous base tapering to a wide & tall cylindrical neck, molded w/full-length leaves in a feathery green matte glaze, impressed mark**990.00**
(Illustration: No. 7)

Vase, 7½" h., 4 ¾" d., ovoid body w/two applied leaves & flower buds in a rich elephant skin green glaze, impressed "Grueby Faience - Boston USA," incised "ER," minute nick in base**1,760.00**
(Illustration: No. 1)

Vase, 7 ¾" h., 4½" d., ovoid gourd-form body w/a flat rim, decorated w/alternating applied wide leaves & buds in a light green mottled matte glaze, impressed "Grueby - Boston, Mass"**990.00**
(Illustration: No. 8)

Vase, 9½" h., 5 ¾" d., wide ovoid body tapering to a wide, flat molded mouth, decorated w/alternating long & short applied leaves, mottled green matte glaze, impressed "Grueby Faience Co. - Boston U.S.A.," minor repair to rim**1,540.00**
(Illustration: No. 5)

HAMPSHIRE POTTERY

As far back as the 18th century potteries were operating in Keene, New Hampshire but the company known as Hampshire Pottery was established by J.S. Taft shortly after 1870. Art pottery, as well as other wares, were produced at this plant over the years. Cadmon Robertson, Taft's brother-in-law, joined the firm in 1902 and was responsible for developing over 900 glaze formulas while he was in charge of all production. When Robertson died in 1914 the firm was without an effective leader and Taft sold out to George Morton in 1916. Although closed during part of World War I, the pottery later reopened for a short time and manufactured white hotel china. Mosaic floor tiles were the main production between 1919 and 1921 and all operations ceased in 1923.

HAMPSHIRE Hampshire J.S.T.&CO.
 Pottery KEENE. N H.

Bowl, 5" d., 3" h., squatty bulbous form molded overall w/artichoke leaves, veined green matte glaze, unmarked**$192.50**

Bowl, 5½" d., 2½" h., squat form, decorated w/flowers, smooth matte green glaze, impressed "Hampshire Pottery - MO"**247.50**

Bowl, 6½" d., 4" h., low squatty bulbous base molded w/short

oval leaves below the wide tapering sides w/a wide flat molded mouth, fine mottled light green & *cafe-au-lait* matte glaze, impressed "Hampshire Pottery - OM - 154"**357.50**

Bowl, 9 ¾" d., 4" h., low w/incurved rim, decorated w/heavily embossed leaves & buds, rich matte green glaze, incised "Hampshire Pottery - ST"**330.00**

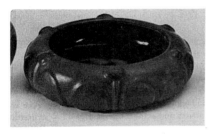

Hampshire Bowl

Bowl, 10" d., 3" h., squatty bowl w/closed rim, decorated w/alternating leaves & buds, matte green glaze, impressed "Hampshire Pottery - OM/57"**357.50** (Illustration)

Bowl-vase, footed very wide squatty bulbous body w/the wide shoulder tapering to a wide molded flat mouth, mottled matte green glaze, die-stamped mark, 11½" d., 6¼" h.**550.00**

Chamberstick, a wide rolled socket rim ring above a flaring cylindrical shaft w/a thick disc base, a round applied loop handle near the base, thick pinkish brown matte glaze, impressed "Hampshire Pottery - OM - 182," 4 ¾" d., 5 ¾" h.**192.50**

Inkwell, low cylindrical form, the flat top pierced w/pen holes centering the small domed cap w/button finial, ceramic liner, smooth matte green glaze,

marked & numbered "26," 4¼" d., 3½" h.........................**165.00**

Lamp base, kerosene-type, table model, squat bulbous bottom & a long cylindrical neck, covered in a finely veined green matte finish, factory electrified w/period brass font, die-stamped "Hampshire - MO." & original paper label, base, 8" d., 15" h.........................**1,100.00**

Lamp base, table model, slightly tapering cylinder w/narrow shoulder, relief-molded long leaves, smooth matte green glaze, factory-drilled hole in base, marked "Hampshire Pottery M," 9½" d. 15" h.**990.00**

Pitcher, 7 ¾" h., 6½" d., bulbous melon-form body tapering to a wide top half molded w/large leaves, long strap handle, smooth matte green glaze, unmarked**495.00**

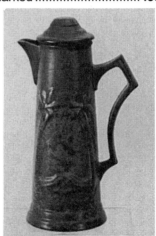

Hampshire Pitcher

Pitcher, cov., 11¼" h., 6" d., tankard-type, tall slightly tapering cylindrical body, angular handle, domed cover, embossed palm tree, rich bluish grey textured & veined matte glaze, impressed "Hampshire Pottery - MO - 81," minor chip to raw clay of retainer rim......**357.50** (Illustration)

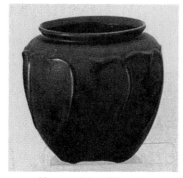

Hampshire Planter

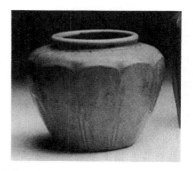

Wide Bulbous Hampshire Vase

Planter, bulbous body w/wide rolled rim, decorated w/embossed stylized leaves, matte green glaze, impressed "Hampshire Pottery - OM - 93," 7½" d., 7 ¾" h.......................**605.00** (Illustration)

Vase, 3 ¾" h., 3½" d., bulbous ovoid body tapering to a small flat mouth, embossed w/large spade-shaped serrated leaves, even matte green glaze, mark partially obscured by glaze**385.00**

Vase, 4¼" h., 5" d., bulbous w/closed rim & tapering base, smooth-grained matte green glaze, impressed "Hampshire Pottery - 40"**192.50**

Vase, 5" h., 5 ¾" d., bulbous w/narrow sloping shoulder & wide mouth, impressed Greek key design around the shoulder, mottled brown, blue, green & grey flowing glaze, incised "Hampshire Pottery - 59".......**302.50**

Vase, 5½" h., 6¼"., bulbous melon-ribbed body w/a rolled rim, speckled grey matte glaze, impressed "Hampshire Pottery - 119"**412.50**

Vase, 5 ¾" h., wide bulbous shouldered tapering body w/a wide molded mouth, molded around the body w/an upright band of long rounded leaves, matte mauve drip glaze,

designed by Cadmon Robertson, impressed marks**460.00** (Illustration)

Vase, 6" h., 3 ¾" d., hand-thrown, tapering cylinder w/sloping shoulder, dripping dark to medium green matte flambé glaze, marked "Hampshire" in red ink...........**275.00**

Vase, 6½" h., 3 ¾" d., tapering cylindrical body w/a swelled shoulder & a wide molded flat mouth, embossed w/wide long pointed leaves alternating w/small buds around the shoulder, flowing matte blue glaze, impressed "Hampshire Pottery - 33 - MO"**495.00**

Vase, 6½" h., 5½" d., bulbous ovoid body tapering to a wide short tapering cylindrical neck molded w/stylized iris blossoms, fine dark blue matte glaze, impressed "Hampshire Pottery - OM - 142 -1"**385.00**

Vase, 6 ¾" h., 4" d., expanding cylinder w/rounded shoulder, relief-molded leaf decoration, rich curdled & marbleized bluish green matte glaze, marked "33, Hampshire Pottery"**412.50**

Vase, 6 ¾" h., 4" d., tapering cylindrical body w/a wide swelled shoulder tapering to a flat molded mouth, the sides

molded w/long wide pointed leaves alternating w/stems & buds, green matte glaze, incised "Hampshire Pottery - M0"**605.00**

Vase, 6 ⅞" h., slender ovoid body w/a narrow shoulder to the thick molded rim, four-color matte glaze, blue & pale red shoulder in a resist-effect, the body in teal blue w/pale blue & red drip glaze on three low-relief reeded panels, designed by Cadmon Robertson, Model No. 157, incised marks & inscribed "461 - 98928 - 0908...29," ca. 1907**862.50**

Vase, 7" h., 3 ¾" d., tapering cylindrical body w/the round shoulder tapering slightly to a flat molded mouth, embossed around the sides w/tall wide pointed leaves alternating w/small buds on stems, mottled green leaves on a taupe ground, impressed "Hampshire Pottery - OM - 33"**385.00**

Vase, 7" h., 4" d., tapering cylindrical body w/a swelled shoulder & a wide molded flat mouth, embossed w/wide long pointed leaves alternating w/small buds around the shoulder, leathery mottled blue glaze, incised "Hampshire Pottery"**357.50**

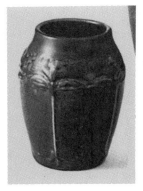

Hampshire Vase with Flowers

Vase, 7" h., 5" d., wide ovoid body tapering slightly to a wide flat mouth, embossed around the shoulder w/a band of stylized blossoms w/pairs of long leaves raised on slender stems forming broad panels down the sides, leathery dark blue & green mottled glaze, impressed "Hampshire Pottery - OM - 123"**550.00** (Illustration)

Vase, 7¼" h., 4" d., wide plain cylindrical form, smooth blue matte glaze, impressed "Hampshire Pottery M0 - 17-4".....................................**302.50**

Vase, 7¼" h., 4½" d., wide ovoid body w/a wide molded mouth, heavily embossed up the sides w/broad pointed leaves, even matte green glaze, impressed "Hampshire Pottery - OM - 98".......................................**605.00**

Vase, 7¼" h., 4 ¾" d., wide ovoid body w/the round shoulder tapering to a wide rolled rim, embossed w/wide pointed leaves up the sides, even pinkish brown matte glaze, impressed "Hampshire Pottery - OM - 98".............................**330.00**

Vase, 7½" h., 4" d., swelled cylindrical body w/flattened closed rim, lightly embossed w/long stylized leaves down the sides w/a dripping matte blue glaze, impressed "Hampshire Pottery - MO - 131"**412.50**

Vase, 7 ¾" h., 4" d., slightly swelled cylindrical body w/a short flaring waisted neck, a narrow incised band of curvilinear designs near the top, smooth veined green matte glaze, impressed "Hampshire Pottery - 105 - MO"**550.00**

Vase, 8½" h., 6¼" d., bulbous ovoid body tapering to a wide flat mouth, embossed around

the sides w/a band of large tulips flanked by pairs of C-form leaves, even ochre matte glaze, impressed "Hampshire Pottery - OM - 67"**467.50**

Vase, 9 ¾" h., 6½" d., squatty bulbous base w/a wide shoulder tapering to a tall cylindrical neck w/a flared rim, molded around the base w/short broad pointed leaves, oatmeal textured satin matte glaze, impressed "Hampshire Pottery - MO - 124"**412.50**

Vase, 11¼" h., , 4 ¾" d., tall slender ovoid body w/a round shoulder & wide molded mouth, fine leathery matte green glaze, impressed "Hampshire Pottery - OM - 101"**605.00**

Vase, 7" h., 4½" d., cylindrical w/rounded shoulder, embossed w/full-length leaves alternating w/buds on tall stems, matte green glaze, marked "Hampshire Pottery - MO - 33"**467.50**

Vase, 8 ⅜ h., wide ovoid body tapering to a flat mouth, molded up the sides w/overlapping bands of upright rounded leaves, matte green glaze, designed by Cadmon Robertson, shape No.127, impressed marks..................**489.00**

Vase, 9" h., squatty bulbous base w/the wide shoulder tapering to a tall cylindrical neck w/flared rim, matte green glaze, incised & impressed "107" (rust stain on side)**231.00**

Vases, 9½" h., 7" d., compressed globular base & long neck w/flaring rim, base decorated w/relief-molded leaves, matte dark blue glaze, marked "124, Hampshire Pottery, M," pr....................................**770.00**

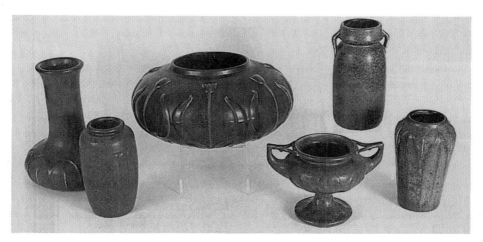

Courtesy Dave Rago

1 2 3 4 5 6

Variety of Hampshire Pieces

Lamp base, kerosene-type, table model, squatty, heavily embossed tulips & leaves under a rich flowing dark matte green glaze, incised "Hampshire Pottery - 156," 11¼" d., 6¼" h. **935.00** (Illustration: No. 3)

Vase, 5½" h., 7 ¾" w., two-handled kylex-shaped, the squatty bulbous bowl w/rolled rim flanked by angled & forked handles, the sides embossed w/stylized leaves, raised on a flaring pedestal foot, tight in-body hairline in bowl, flowing matte blue glaze, impressed "HAMPSHIRE POTTERY - 35"..**82.50** (Illustration: No. 4)

Vase, 7" h., 3 ¾"d., straight-sided, impressed panels of leaves, feathered bluish green matte glaze, incised

"Hampshire Pottery - 157".....**385.00** (Illustration: No. 2)

Vase, 7" h., 4" d., expanding cylinder w/rounded shoulders, wide mouth, lightly embossed long flat leaves alternating w/buds, rich flowing matte blue glaze, impressed "Hampshire Pottery"**385.00** (Illustration: No. 6)

Vase, 8" h., 3½" d., two small buttressed handles, feathered matte blue glaze, incised "Hampshire Pottery - 156"**440.00** (Illustration: No. 5)

Vase, 9½" h., 6½" d., squat-bottomed body w/a tall neck & flared rim, impressed light blue leaves around the base, flowing dark blue ground, impressed "hampshire pottery - 124"**495.00** (Illustration: No. 1)

JUGTOWN

Pottery production has a long history in North Carolina but it was a dying art when Juliana and Jacques Busbee visited the state 1915. They decided to encourage local potters to continue production of their native utilitarian wares and set up a training and sales organization which they named "Jugtown Pottery." The Busbees opened a tearoom in New York City where they sold the pottery produced in North Carolina and the wares soon had a strong following.

Jacques Busbee returned to North Carolina in 1921 to establish a central pottery shop in Jugtown, North Carolina and hired Ben Owen to turn the pieces which Busbee designed and glazed. Eventually several men were hired to help mix clay, cut wood and tend the kilns.

The simple forms and adaptations of early wares continued to be popular with the buying public for

many years and various glazes added visual appeal. Jacques Busbee died in 1947. Juliana Busbee and Ben Owen continued production until 1958 when Owen left to form his own pottery. A newly formed corporation reopened the pottery in 1960. Mrs. Busbee died in 1962, but the pottery continues in production today.

Bowl, 8" d., Chinese Blue glaze**$159.00**

Candlestick, flaring base & cupped top, rich white glaze, circular mark, 4½" d., 11¼ h.**125.00**

Pitcher, 8½" h., bulbous body, speckled brown glaze, incised decoration, circle mark............**57.00**

Vase, 3 ¾" h., 3½" d., waisted ovoid body w/a wide, flat rim, glossy black glaze, impressed "JUGTOWN WARE".............**137.50**

Vase, 4½" h., bulbous ovoid body w/a small flat mouth, fine Chinese red glaze, impressed mark.....................................**880.00**

Vase, 5" h., wide bulbous ovoid body tapering to a small flat mouth, a thick Chinese Blue glaze w/a band of rich brown clay exposed at the base, impressed mark.....................**522.50**

Vase, 5" h., 3½" d., ovoid body, thick mottled dark blue matte glaze, circular mark "JUG-TOWN WARE".....................**522.50**

Vase, 5" h., 5 ¾" d., slightly rounded sides, flat shoulder & short neck, Chinese Blue glossy red & turquoise glaze, impressed circular mark "JUGTOWN WARE"..............**467.50**

Vase, 5¼" h., 5" d., bulbous body, rich flowing Chinese Blue flambé dripping unevenly over a dark brown bisque-fired body, impressed circle mark.....................................**330.00**

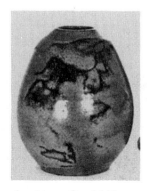

Jugtown Ovoid Vase

Vase, 6" h., 4½" d., ovoid body tapering unevenly to a small

flat mouth, covered in a Chinese Blue glaze**687.50** (Illustration)

Vase, 6¼" h., 4 ¾" d., pear-shaped body tapering to a short, cylindrical neck, overall speckled robin's-egg blue glaze on a red ground, impressed "JUGTOWN WARE"................................**357.50**

Vase, 6 ¾" h., 4" d., ovoid w/closed-in rim, horizontal banding, Chinese Blue glossy glaze, impressed "JUGTOWN WARE"..............**467.50**

Vase, 7" h., ovoid, flowing Chinese Blue semi-gloss glaze dripping over a red clay body, impressed circle mark...........**495.00**

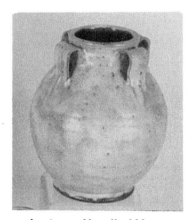

Jugtown Handled Vase

Vase, 8½" h., 6" d., footed wide ovoid body tapering to a flat rim flanked by four short, wide strap handles, opaque white glaze, impressed "JUGTOWN WARE"................................**440.00** (Illustration)

LONGWY

In 1798 a faience factory was established in the town of Longwy, France and became noted for its

brightly enameled pottery wares which sometimes resemble cloisonné. Although utilitarian wares were the first pieces produced, by the 1870s an art pottery in the Oriental style was developed using heavy enamels in relief. In the early 20th century modern Art Deco style designs were featured and these wares, along with the early Oriental-inspired pieces, are appealing to collectors today.

Bowl, 10" d., 7" h., footed octagonal body w/two handles & scalloped rim, ivory crackled ground decorated w/a stylized berry design, glazed in aqua & cobalt blue trimmed in gold**$299.00**

Bowl, 14 ¾" d., round flaring sides, white crackled glaze decorated w/Cubist stylized vine in blue, green, yellow & grey, the exterior glazed in blue, stamped "PRIMAVERA LONGWY FRANCE" & artist's signature, ca. 1920s..............**528.00**

Charger, octagonal, crackled aqua ground decorated w/a geometric border & centered w/a bouquet of flowers, glazed in ivory & cobalt blue, company mark & "D5447," 12" d.**437.00**

Charger, round, decorated w/a central medallion showing two stylized female nudes & a fawn, glazed in cream, black, caramel & pale yellow, stamped company mark & "PRIMAVERA LONGWY FRANCE," 14 ¾" d.**1,035.00**
(Illustration: top next column)

Longwy Charger with Nudes & Deer

Charger, round, decorated w/a stylized desert scene depicting two seated female nudes amid blossoming flowers & cacti within a geometric border, glazed in camel, tan, chocolate brown, gold & salmon, stamped w/company mark "LONGWY FRANCE" & "POMONE BON MARCHE," incised "1252 D805," 15" d.**460.00**

Charger, round, the deep blue ground decorated in black w/a disc design border centered by a stylized deer in woods, glazed on the back "Atelier primavera longwy," w/partial paper label, 15" d.**368.00**

Longwy Charger with Jungle Scene

Charger, circular, decorated w/stylized jungle scene w/two elephants, a maiden & lush greenery, thick glaze in turquoise, royal blue, violet, amber, bright green & aubergine, marked "LONGWY SOCIETE DES FAIENCERIES FRANCE" & "POMONE ATELIER D'ART BON MARCHE," 15" d.**2,070.00** (Illustration)

Plaque w/hanger, cloisonné-style enamel decoration of a spread-winged parrot on colorful blossoming branches against a blue ground, 9" d.**275.00**

Vase, 10 ⅞" h., footed cylinder w/everted rim, decorated w/a Cubist landscape in rust, grey & moss green over a crackled glaze, enhanced w/black, stamped "Atelier primavera LONGWY FRANCE" & w/artist's signature, ca. 1920s (some restoration at rim)**605.00**

Vase, 13 ⅜" h., bell-shaped, a band of stylized flowers & fruits in mustard & cherry around the lower portion, the octagonal upper portion w/defined ribbing ascending to rim, over a crackled glaze, stamped "SOCIETE DES FAIENCERIES LONGWY FRANCE" w/company logo ...**935.00**

MARBLEHEAD

Dr. Herbert J. Hall founded the Marblehead Pottery in 1904 as a therapeutic aid to patients in a sanitorium he operated in Marblehead, Masschusetts. Later the pottery and sanitorium were separated and Arthur E. Baggs directed the pottery. Baggs was a fine artist and designer and he bought out the factory in 1916 and continued to operate it until the final closing in 1936.

The wares were mostly hand-thrown and decorated and will carry the company mark of a stylized sailing ship flanked by the letters "M" and "P."

Basket, hanging-type, three loop handles at thick ringed rim, rounded body w/pointed bottom, dark blue matte glaze, oval paper label, 4½" d., 4" h.**$220.00**

Bowl, 7" d., 2" h., compressed bulbous incurved sides, decorated around the rim w/a band of stylized blue berries & grey foliage on a matte grey ground, impressed ship mark**880.00**

Bowl, 12" d., 4" h., cylindrical base w/widely flaring rim, light blue matte interior, glossy green exterior w/some bubbles, by Arthur E. Baggs, impressed mark & artist initialed.............**412.50**

Bowl-vase, footed widely flaring trumpet-form, pale bluish green matte glaze w/violet flecks, impressed mark & paper label, 3½" h.**209.00**

Bowl-vase, wide rounded bottom w/deep cylindrical sides, dark matte blue decorated around the upper half w/faintly tinted complex repeating designs, decorated by Hannah Tutt, stamped logo & artist's initials, 3 ¾" h.**440.00**

Bowl-vase, bulbous w/narrow flaring rim, incised floral decoration in blue, red & green against a dark matte blue ground, marked, 4½" d., 3 ¾" h.**825.00**

Bowl-vase, wide bulbous ovoid body tapering slightly to a wide flat mouth, lavender & pale blue matte glaze, impressed mark, 4½" h.**253.00**

Bowl-vase, footed deep & widely flaring trumpet-form, delicate pale pink matte glaze, impressed mark, 7" d., 5½" h.**209.00**

Candlesticks, cylindrical standard w/broad flaring base & flaring rim, smooth matte speckled green glaze, impressed ship mark & paper label, 6" d.,14¼" h., pr........**1,870.00**

Chamberstick, a thick round dished base centered by a slender tapering cylindrical shaft w/a cupped rim, a heavy strap handle from shaft to rim of base, dark blue matte glaze, incised script "M" w/"bird," 4 ¾" d., 6" h.**495.00**

Inkwell, cov., dished round tray base centered by a short cylindrical well w/a flat cover & button finial, black geometric decoration on a dark green ground, impressed ship mark, 5" d., 3½" h. (glass insert missing)**1,100.00**

Perfume bottle, Egyptian Revival style in the form of a sarcophagus, decorated w/brown "hieroglyphics" on a mottled violet ground, oval paper label & "R" in brown, 5" h., 1½" w. (two cracks to applicator stem)**412.50**

Pitcher, tankard, 8½" h., 5 ¾" d., slender trumpet-form w/a pinched spout & long loop handle, green rim & base band w/sandy matte body, incised 'winged M' mark**385.00**

Tile, square, decorated w/a seascape of a blue three-masted sailing ship w/pale blue sails & blue reflection on a pea green matte glazed ground, in period flat wide oak frame, impressed mark & paper label w/"47," 6" sq.**1,650.00**

Vase, 2 ¾" h., 5" d., wide squatty bulbous body the top half tapering to a wide flat mouth, low long loop handles from the rim to the shoulder, decorated w/stylized spade-form designs flanked by arched 'branches,' black on a smooth teal green matte ground, decorated by Arthur Baggs, early ship mark & "AEB" (small repaired rim chip)**2,310.00**

Vase, 3" h., wide squatty bulbous ovoid body w/a wide flat mouth, pale blue & rose matte glaze, impressed mark**242.00**

Vase, 3¼" h., 4 ¾" d., spherical body w/flat rim, decorated w/stylized swirling grey flower sprigs against a smooth matte speckled grey ground, by Hannah Tutt & Arthur Baggs, impressed ship mark & artists' initials.....................**1,045.00**

Vase, 3½" h., simple ovoid body tapering slightly to a wide flat mouth, pale bluish grey matte glaze w/violet flecks, impressed mark & paper label**209.00**

Vase, 3½" h., 2¼" d., slightly expanding cylinder, smooth matte speckled grey glaze, impressed mark**137.50**

Vase, 3½" h., 3" d., short ovoid body tapering to a wide flat mouth, decorated w/a band of blue heart-shaped leaves & stems near the rim, smooth grey speckled matte ground, impressed ship mark.............**935.00**

Vase, 3½" h., 3" d., swelled cylindrical body tapering slightly to a flat mouth, incised band of stylized blossoms & leaves in yellow & green on a yellow ground, impressed ship mark & "19B17" (two cracks)**467.50**

Vase, 3 ¾" h., 4" d., wide squatty bulbous ovoid body tapering to a wide flared rim, incised & surface painted looped dark grey whale bones against a smooth matte speckled light grey ground, ship mark & incised "MT"**990.00**

Vase, 4¼" h., 4" d., squatty tapering ovoid body w/a flat mouth, tooled stylized flower beds around the top in mustard yellow, blue & brown on a grey speckled matte glaze ground, decorated by Hannah Tutt, impressed ship mark & artist's initials**2,310.00**

Vase, 4 ⅜" h., wide ovoid body w/wide flat mouth, matte grey ground decorated w/a repeated design of tall stems supporting branched stylized blossoms around the top in blue, tan & grey-green, decorated by Hannah Tutt, marked, ca. 1918**1,320.00**

Vase, 5" h., 3" d., slender tapering ovoid body w/a wide flat mouth, even matte blue glaze, impressed ship mark**330.00**

Vase, 5" h., 6½" d., wide bulbous body tapering to a wide flat mouth, even matte blue glaze, impressed ship mark**412.50**

Vase, 5¼" h., 3" d., ovoid body tapering to a wide, flat mouth, decorated w/incised pine cones on long stems in rust on a smooth dark blue matte ground...............................**1,100.00**

Vase, 5¼" h., 3¼" d., ovoid body matte yellow glaze, impressed mark**220.00**

Vase, 5 ¾" h., 3¼" d., footed ovoid body w/a wide gently flaring neck, smooth matte dark blue exterior & a sky blue glossy interior, ship mark**220.00**

Vase, 6¼" h., 3 ¾" d., ovoid body tapering to a wide closed rim, deeply incised w/a band of trees w/ green leaves & red berries around the top w/the dark blue trunks down the sides on a blue ground, impressed ship mark..........**2,200.00**

Vase, 6½" h., 5" d., pear-shaped w/flaring rim, rich dark blue matte glaze, die-stamped ship mark**495.00**

Ovoid Marblehead Vase

Vase, 7" h., simple ovoid body tapering slightly to a wide flat mouth, grey matte glaze w/rose highlights, impressed mark**605.00**
(Illustration)

Marblehead Cylindrical Vase

Vase, 7" h., swelled cylindrical form w/wide flat mouth, blue ground decorated w/a band of

tall, slender stylized trees in green outlined in black, impressed mark**1,725.00** (Illustration)

Vase, 7" h., 4" d., slightly ovoid, decorated w/a repeated pattern of stylized grapevines w/green leaves, blue berries & brown narrow tree trunks against a smooth speckled matte ochre ground, artist-initialed "HT," Hannah Tutt, & impressed ship mark w/"M/P"**4,950.00**

Vase, 9" h., 4½" d., ovoid, even grey matte glaze exterior, blue interior, impressed ship mark**715.00**

Vase, 9½" h., 5¼" d., cylindrical body rounded at the bottom & at the closed rim, smooth matte dark blue speckled glaze, ship mark**605.00**

Marblehead Vase with Flowers

pea green ground, decorated by Hannah Tutt, impressed ship mark & incised "HT," ca. 1908**7,700.00** (Illustration)

MARTIN BROTHERS POTTERY

RW Martin + Brothers London & Southall

The Martin brothers, Robert, Wallace, Edwin, Walter and Charles, founded what is often considered the first British studio pottery, in 1873. Martinware, as it is called, is completely hand-thrown and worked. The earliest wares were simple forms with conventional decoration but the Martin brothers then developed a reputation for producing ornately engraved, incised and carved decorations as well as very bizarre figural wares, often in the forms of grotesque birds and beasts. These unique pieces as well as their amusing face-jugs, are highly collectible and have become very expensive. From 1910 on the products of the pottery declined and it is consid-

Marblehead Vase with Leaves

Vase, 9½" h., 5½" d., cylindrical, decorated w/incised Arts & Crafts style leaves in dark brown against a speckled matte dark green ground, impressed ship mark & "M.T."**1,980.00** (Illustration)

Vase, 10½" h., 8½" d., semi-ovoid w/narrow shoulder & wide neck, decorated w/incised geometric stylized flowers in dark green against a speckled

ered finished by 1915, although some pieces were fired as late as the 1920s.

Figure of a pan, seated pudgy grotesque figure playing pan pipes, glazed in ivory, on a circular ebonized wooden base, incised "Martin Bros.," 4½" h.**$1,380.00**

Jardiniere, wide bulbous body tapering to a wide low rolled rim, decorated on either side w/a medallion depicting a monster's head, surrounded by fantastic dragons within swags & festoons, glazed in beige, brown & ivory, incised "R.W. Martin Brothers London & Southall 2-1889," 11" d., 8½" h.**1,725.00**

Jar, cov., modeled as a strange bird, the cover formed by the head, naturalistic coloring, the base & cover incised "Martin Bros. London Southall RW," & base "71890," & cover "7V890," 15" h. (beak restored)**7,475.00**

Jug, slightly swelled squared cylindrical body w/a short rim spout & top loop handle, decorated overall w/an underwater scene w/fish, glazed in brown & ivory, incised "R.W. Martin Bros London & Southall 4.1887," 9½" h.**805.00**

Jug, flattened ovoid body tapering to a short cylindrical neck & angled loop handle, decorated w/an underwater scene w/four fantastic sea creatures, two octopus & a sea snail, glazed in beige, brown & moss green, incised "Martin Bros London & Southall 6.1897," 10½" h.**1,610.00**

Jug, slender cylindrical slightly shouldered body w/one handle, modeled as an eskimo w/the face under the spout, a sterling silver rim band, the rough surface glazed in pale white, grey & moss green, incised "Martin London 23.8.82" & "2.8.82," English hallmarks on the silver, 12 ⅔" h.**920.00**

Mug, slightly tapering cylindrical body w/loop handle modeled w/a face on each side, one doubtful, the other smiling, glazed in grey, brown & ivory, incised "R.W. Martin Southall 1916," 4½" h.**2,300.00**

Pitcher, jug-type, 6" h., bulbous body modeled on each side as a smiling bald-headed man w/dark brown hair at the sides, the face glazed in lighter shades of brown, incised "R.W. Martin Bros. London & Southall 11.3.1911"**4,140.00**

Pitcher, 8 ⅝" h., jug-type, the bulbous ovoid body w/short cylindrical neck, pulled spout & applied handle, molded in low-relief w/a smiling grotesque face amid incised clusters of raspberries & leafage, decorated in black slip under textured salt glaze, inscribed "Martin Bros. - London & Southall - 2-1892," dated 1892**3,850.00**

Vase, 5¼" h., 3½" d., ovoid lobed body w/a short, molded neck, over-all semi-gloss speckled brown glaze, marked "Martin Bro. - London & Southall - 1x2 - 1-1901"**412.50**

Vase, 6" h., bulbous body w/a small closed mouth, four full-length handles up right side modeled as snakes biting the rim, glazed in warm brown, moss green & ivory, incised "Martin Bros London & Southall 2.1903"**3,220.00**

Vase, 8" h., 6" d., bulbous base below a tall, wide & slightly tapering neck flanked by loop handles down the sides, the base w/staggered blue vertical ribbing on a tan ground, the neck w/bluish green fanned &

spiky leaves in a zigzag pattern on a tan ground, brown rim & handles, marked "Martin London & Southall 29-6-82"**770.00**

Vase, 9¼" h., 4 ¾" d., bulbous ovoid body tapering to a flaring neck, incised overall w/star-like jellyfish w/protruding centers, copper luster glaze, incised "Martin Brothers - London & Southall" 1894**990.00**

Vase with Flying Lizards

Vase, 9½" h., baluster-form w/the flattened shoulder tapering to a short trumpet neck, carved decoration of winged lizards w/long twisting tails, open mouths w/long forked tongues & clawed feet, in bone white, tan & dark brown on a gun-metal brown & black ground w/blue highlights, incised "Martin Bros., London & Southall 8-18-98"**2,530.00** (Illustration)

Vase, 9½" h., ovoid squared body w/a slightly tapering square neck w/everted rim, each side decorated w/an incised fantastic sea creature,

glazed in green, pale blue & ivory, incised "Martin Bros. London & Southall 11. 1903"**1,380.00**

Vase, 9½" h., wide bulbous baluster-form body w/a short cylindrical neck w/a wide cupped rim, carved design of iris blossoms & buds on twisting stems & leaves among dragonflies, all in brown & white against a tan & brown ground, incised "Martin Bros., London & Southall, 3-1903" (repaired chip at top)**330.00**

Vase, 9 ¾" h., footed baluster-form, decorated around the body w/four fantastic dragons, glazed in brown, ivory & beige, incised "Martin Bros London & Southall 8.1898"**1,150.00**

Martin Bros. Dragon Vase

Vase, 10" h., wide bulbous ovoid body tapering to a flaring neck, incised decoration of five grotesque stylized dragons**5,225.00** (Illustration)

Vase, 18½" h., footed baluster-form, decorated around the sides w/fantastic dragons & snakes, glazed in beige, brown & ivory, incised "R.W. Martin & Bros London & Southall, 1893"**2,300.00**

Courtesy Christie's

1 2 3 4
 5 6 7

A Whole Flock of Martin Bros. Birds

Jar, cov., modeled as three grotesque birds, the center bird embracing the other birds w/its wings, glazed in shades of blue, moss green, grey & brown, w/an oval base & mounted on an oval ebonized wooden base, each head incised "R.W. Martin & Bros London & Southall," two heads incised "10.6.1908," the base incised "R.W. Martin & Bros London Southall 10.6.1908," 3 x 6 ¾", 7½" h.**13,800.00**
(Illustration: No. 6)

Jar, cov., modeled as a grotesque bird, glazed in shades of blue, moss green, ivory & grey, mounted on a circular ebonized wooden base, head & base of bird incised "Martin Bros. London & Southall 1900," 9" h.**4,025.00**
(Illustration: No. 2)

Jar, cov., modeled as a grotesque bird, glazed in shades of pale blue, grey, moss green & ivory, mounted on a circular ebonized wooden base, the bird's head & base incised "R.W. Martin & Bros. London & Southall 3.1902," 9½" h.**4,370.00**
(Illustration: No. 3)

Jar, cov., modeled as a grotesque bird, glazed in shades of brown, pale blue, ivory & moss green, mounted on a circular ebonized wooden base, the head & base of bird incised "Martin & Bros London & Southall 4.1889," 10½" h.**6,325.00**
(Illustration: No. 1)

Jar, cov., modeled as a grotesque bird, glazed in shades of brown, moss green, tan & ivory, mounted on a circular ebonized wooden base, the bird's head & base incised "Martin Bros. London & Southall 3.1899," 11½" h.**6,900.00**
(Illustration: No. 4)

Jar, cov., modeled as a grotesque bird w/oversized head & wide beak, glazed in shades of brown, pale moss green, tan & grey, mounted on a circular ebonized wooden base, the bird's head & base incised "R.W. Martin Bros. London & Southall," head dated "6.1888," base dated "10.1889," 12½" h.**11,270.00**
(Illustration: No. 5)

Jar, cov., modeled as a grotesque bird w/a bulbous oversized head w/a long narrow beak molded as part of the body, glazed in shades of warm moss green, pale blue, ivory & green, the head incised "R.W. Martin & Brothers London Southall 6.1884," the base incised twice "R.W. Martin & Bros. London 1884," 14" h.**8,625.00**
(Illustration: No. 7)

Jar, cov., figural, bulbous model of a smiling, winking face on each side, the hat forming the cover, glazed in brown, ivory & tan, incised "R.W. Martin & Bros London & Southall 11.1903," 8" h.**5,520.00**
(Illustration: No. 6)

Mug, slightly tapering cylindrical body w/thick loop handle, modeled on each side w/a face, one doubtful, the other smiling, glazed in dark brown & tan, incised "R.W. Martin & Bros London & Southall 28.11.1912," 5 ¾"h.**1,840.00**
(Illustration: No. 3)

1 2 3 4
 5 6 7

Various Martin Brothers Wares

Pitcher, jug-type, 7" h., bulbous spherical body modeled on each side w/a smiling face w/side-glancing eyes, glazed in tan & warm brown, incised "R.W.Martin & Bros London & Southall 9.5.1910"..............**3,680.00**
(Illustration: No. 7)

Pitcher, jug-type, 7½" h., bulbous spherical body modeled w/a smiling face on each side, matte light brown glaze, incised "Martin Bros. London & Southall 9.1.98," 1898, 7½" h.**2,875.00**
(Illustration: No. 5)

Spoon warmer, figural, modeled as the head of a fish w/a wide gaping mouth, glazed in black, brown & ivory, incised "Martin London & Southall," 3½" h.**1,265.00**
(Illustration: No. 2)

Spoon warmer, figural, modeled as a bulbous fantastic creature's head w/a wipe gaping mouth, glazed in dark brown & slate grey, incised "R.W. Martin London & Southall," stamped "R.W.MARTIN," 5½ x 6", 5" h.**2,530.00**
(Illustration: No. 1)

Wall ornament, figural, round head of a fantastic creature w/a wide open mouth, small slit eyes & incised hair, glazed in shades of brown & yellow, incised "Martin Bros. London," 6" h.**1,725.00**
(Illustration: No. 4)

MASSIER (Clement)

Although not widely known in this country, French artist potter Clement Massier was an early producer of fine wares with the most notable examples featuring lovely lustrous iridescent glazes. His production dates from the late l9th and early 20th centuries.

Clement-MASSIER
Gdf Juan AM

Charger, round, w/a multi-colored iridescent glaze decorated w/two sailboats against the horizon, signed "CLEMENT MASSIER GOLFE JUAN AM" & stamped "CLEMENT MASSIER GOLFE JUAN AM," 13"d.**$690.00**

Jardiniere, oblong boat-form boldly molded overall as swirling waves w/a nude mermaid emerging from the waves at one end & a second riding the crest at the opposite rim, iridescent glaze in gold, red & green w/a blue interior, inscribed "MCM - Golfe Juan - A.M. - 1901," 9 x 14", 7 ¾" h. (restoration, nicks)**2,415.00**

Plaque, rectangular, molded in high-relief w/a scene of a nude woman holding aloft a torch & riding atop a sea creature in rough water, flanked by two muscular men, one blowing a large conch shell, all covered in a rich bluish grey matte glaze w/iridescent highlights in yellow, blue & violet, paper label w/"Clement Massier, Vallauris, Alpes Maritimes E," minor base chips, 11 x 13½" **1,100.00** (Illustration: right)

Plaque, rectangular, large embossed bust profile of St. Cecilia, vibrant nacreous chartreuse, pink, blue & gold iridescent glaze, die-stamped "CLEMENT MASSIER - GOLFE JUAN (A-M)," signed

Massier Vase & Plaque

by hand on the side,
15½ x 21"**5,500.00**

Plate, 10¼" d., footed, decorat-
ed overall w/a landscape by
the water & a setting sun in
green, gold & burgundy iri-
descent glaze, signed
"Massier"..............................**935.00**

Vase, miniature, 2¼" h., squatty
bulbous ovoid body tapering to
a tiny short neck, decorated
w/three-leaf clovers in a gold &
green iridescent glaze, partial
paper label**287.50**

Vase, 4 ¾" h., gentle tapering
cylindrical body w/a wide
square mouth, scattered styl-
ized flowers & leaves all in iri-
descent shades of green, base
marked "MCM Golfe. Juan
(AM)" & stamped circular logo-
mark (minor rim rough-
ness)**495.00**

Vase, 5½" h., footed squatty bul-
bous base tapering to tall
slightly tapering sides w/point-
ed tab handles at the rim, an
overall painted design of
mistletoe leaves & berries in
pale lavender & rich cream
w/gold highlights, signed
"Clement Massier Golfe-Juan -
AM," minute flake at rim &
base**275.00**
(Illustration: left bottom previous
column)

Vase, 10" h., 3½ d., ovoid dou-
ble gourd-form body, decorated
w/flowers in an iridescent pur-
ple & gold glaze, signed
"Clement Massier Golfe-Juan
AM"**770.00**

Vase, 18 ¾" h., baluster-form
w/two handles, mustard yellow
ground w/a golden iridescent
glaze, decorated in mauve, yel-
low & green daisy stems &
foliage, signed in gilt enamel
"C.M. Golfe Juan A.M."**345.00**

Vase, 22" h., 10" d., tall baluster-
form w/a cylindrical neck, mold-

ed around the shoulder w/a
row of lion medallions among
overall scrolling gilded florals,
the lower half w/large stylized
flowers & angled bars,
impressed "CLEMENT
MASSIER -GOLFE
JUAN"**1,100.00**

MERRIMAC POTTERY

Thomas S. Nickerson first orga-
nized The Merrimac Ceramic
Company in Newburyport,
Massachusetts in 1897. Early pro-
duction included inexpensive gar-
den pottery and decorated tiles. In
less than a year, however, produc-
tion expanded to include decorative
art pottery and was renamed
Merrimac Pottery Company in 1902.
The first glazes used on the art
wares were generally matte green
and yellow but by 1903 a greater
variety were used including irides-
cent and metallic lustre finishes.
The first pieces only carried a paper
label but after 1901 an impressed
mark featuring a long fish and the
word "Merrimac" was used. The
pottery was destroyed by fire in
1908 so the short production period
means pieces are scarce and much
sought after today.

Bowl-vase, wide squatty bul-
bous form w/a wide flat rim,
delicately applied & carved
swirling stems & wide leaves
w/prominent veins, rich dark
green mottled glaze,
8½" d., 5" h......................**$2,530.00**
(Illustration: top next page)

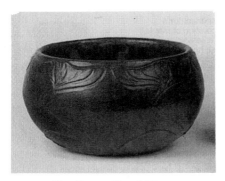

Merrimac Bowl-Vase

Vase, 4" h., 3 ¾" d., squatty bulbous body tapering to a short cylindrical neck, heavy strap handles applied at the sides of the base, dark green mottled glaze, unmarked.......**275.00**

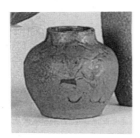

Merrimac Vase

Vase, 4½" h., 4½" d., bulbous ovoid body tapering to a short wide neck, textured & feathered burnt orange & yellowish green dead matte glaze, unmarked**715.00** (Illustration)

Vase, 6¼" h., 5" d., cylindrical w/gently rounded shoulder & wide mouth, decorated w/tooled & applied full-length leaves alternating w/flowers, under a feathered two-tone matte green glaze, unmarked**1,870.00**

Vase, 6½" h., 3½" d., iridescent mauve snakeskin fragmented glaze, marked**660.00**

Vase, 6½" h., 6 ¾" d., a wide flat closed mouth above the wide bulbous ovoid body tapering to a small molded foot, matte green glaze, impressed "MERRIMAC" w/sturgeon**495.00**

Vase, 7" h., 3¼" d., swelled cylindrical body w/a wide rounded flat shoulder to a closed mouth, carved around the top w/four-petal blossoms on sinewy stems & leaves down the sides, feathered matte green glaze, paper label**4,125.00**

Vase, 7½" h., 3 ¾" d., simple ovoid body tapering to a short cylindrical neck, rich gloppy volcanic orange & green matte glaze, original label**990.00**

Vase, 7½" h., 4¼" d., slightly swelled cylindrical body w/rounded shoulder to the closed mouth, applied w/long, curled broad leaves, matte dark green glaze, unmarked (restoration to rim, hairline)**1,980.00**

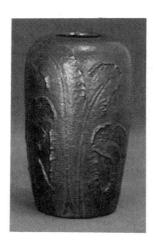

Merrimac Vase with Leaves

Vase, 7 ¾" h., 4¼" d., slightly swelled cylindrical body w/rounded shoulders to a closed mouth, decorated w/tooled & applied curly leaves, matte mottled dark green glaze, paper label

w/"MERRIMAC CERAMIC
COMPANY"**4,400.00**
(Illustration)

Vase, 8" h., 5½" d., bulbous
ovoid body tapering sharply to
a short, cylindrical neck, cur-
dled green matte glaze, partial
paper label**990.00**

Vase, 9" h., slender ovoid body
tapering to a widely flaring flat-
tened rim, thick pale blue matte
glaze w/yellowish green high-
lights at neck, paper label**660.00**

Vase, 10 ¾" h., 5¼" d., tall ovoid
body tapering to a flat rim, thick
matte green glaze, die-
stamped mark (small glaze
nicks at base**550.00**

MOORCROFT

*In 1897 William Moorcroft
became a designer for James
Macintyre & Company and he was
soon put in charge of their art pot-
tery production. During his years
with the firm Moorcroft developed
several popular hand-painted
designs including Florian Ware.*

*Art pottery production ceased at
the Macintyre factory in 1913 and
Moorcroft then left to set up his own
pottery in Burslem. He continued to
produce his earlier art lines and
also introduced new ones. After
William's death in 1945, his son
Walter continued to operate the pot-
tery.*

MOORCROFT

W Moorcroft

Bowl, 7" d., 2½" h., Claremont
patt., decorated w/large mush-
rooms**$450.00**

Bowl, 7½" d., 3½" h., Moonlit
Blue patt., wide rounded sides,

decorated w/a landscape
w/whimsical trees & foliage in
pale blue & green w/mustard
yellow highlights against a rich
dark blue ground, large script
signature & impressed mark
& "M71Y - B"**990.00**

Bowl, 8 ⅜" d., 4 ⅝" h., wide
deep sides w/flaring rim, raised
on a small domed foot, glossy
green ground decorated w/pan-
sies in shades of white &
green, inscribed signature &
impressed "993," ca. 1913**632.50**

Bowl, 9½" d., 3" h., Claremont
patt., wide flat bottom w/low
straight sides & horizontal loop
handles, decorated w/toad-
stools in brick red, yellow, rose
& dark blue against a blue
ground, impressed mark &
painted signature**357.50**

Bowl, 9 ¾" d., Hibiscus patt., red
blossom on brown ground.....**310.00**

Bowl, 10" d., shallow circular
body on a short pedestal foot,
decorated w/a band of fruit &
glazed in shades of red, purple,
green & turquoise, signed "W.
Moorcroft" in underglaze green
& dated 1921, impressed
"854"..................................**1,265.00**

Bowl, 10" d., 2½" h., shallow,
Hibiscus patt., red & yellow
w/blue highlights on white
ground..................................**310.00**

Bowl, 12" d., wide shallow
rounded sides, the interior dec-
orated w/the African Lily patt.
w/pink & yellow flowers &
green foliage against a shaded
green to blue ground,
marked**220.00**

Condiment jar, cov., bulbous
ovoid body tapering to a short,
wide cylindrical neck fitted w/a
nearly flat silver plate cover
w/urn-form finial, the body
decorated w/stylized poppies &
forget-me-nots in green & yel-
low on a white ground, die-

stamped "Macintyre - Burslem - England" & painted signature "W.M.," 3½" d., 4½" h..........**605.00**

Jar, cov., cylindrical w/a flat fitted cover, African Lily patt. w/yellow to light red blossoms in cloisonné against a clear bluish green ground, marked, 3½" d., 3 ¾" h..........**192.50**

Jar, cov., Cobridge Ware, Hazeldene patt., ovoid body w/flattened domical lid, decorated w/leafy trees in the foreground, w/gentle hillocks in the distance, glazed in shades of ochre, rose red, cobalt blue, green & tan, base impressed "MOORCROFT - MADE IN ENGLAND - 769," signed in cobalt blue "Moorcroft," lid impressed "MOORCROFT," ca. 1930, 9½" h.**3,788.00**

Lamp, table model, cloisonné-style, decorated in the Fuchsia patt. w/large blossoms in red, yellow, pink & blue, in silver plated mount, marked "MOOR-CROFT" w/green smear, vase 11" h.**1,100.00**

Lamp, table model, Orchid patt., footed spherical base on a round pierced metal base, flambé glaze w/a design of blossoms & leaves in red, salmon, blue, white, deep violet, olive green, pink & yellowish green against a reddish brown to dark blue ground, no visible markings, w/conical cloth shade, base 8" d., 10" h., overall 23" h.**715.00**

Lamp, table model, Grape & Leaf patt., tall slender waisted cylindrical body, decorated w/a flambé glaze w/dark violet & red grapes among broad red & yellow leaves w/green highlights against a rich wine red ground, no visible markings, on a narrow round metal foot, w/a conical cloth shade, base 12" h., overall 24" h.**1,210.00**

Lamp, table model, wide squatty bulbous base tapering to a very tall slender ringed neck flaring slightly at the top, decorated w/overall large green blossoms, buds & stems w/a green glossy glaze w/dark blue highlights at the base, on a pierced metal round base w/knob feet, painted & impressed marks, paper label, w/cylindrical cloth shade, base 11" h., overall 30" h.**715.00**

Plate, 8½" d., Anemone patt., pink-and-white & pink-and-blue flowers w/green foliage against a green & cobalt blue ground, impressed signature "W. Moorcroft," die-stamped "POTTER TO H.M. THE QUEEN - MADE IN ENLAND," 1945-49**110.00**

Moorcroft Urn

Urn, bulbous urn shaped body w/incurved loop handles at shoulder, decorated w/medallions of chrysanthemum flowers & stylized acanthus leaves, in shades of ochre, purple & burgundy, on mottled blue & amber ground, painted green signature "W. Moorcroft," painted factory mark, 7¼" h...........**748.00** (Illustration)

Vase, 3¼" h., 18th Century patt., Macintyre period, brown W. Moorcroft mark, ca. 1908**650.00**

Vase, 3½" h., spherical body raised on a low flaring pedestal

foot, w/a short rolled neck, floral decoration in translucent shades of red, yellow, blue & green on a pale greenish blue ground, impressed marks**345.00**

Vase, 4⅛" h., compressed globular form w/short slightly flaring neck, decorated w/large magnolia blossoms in pink, green & brown on a cobalt blue ground, signature & impressed marks**220.00**

Vase, 5¼" h., 5½" w., Florian Ware, gently flaring cylindrical body flanked by three long, angled handles, decorated w/stylized cornflowers & floral sprays in blue, yellow & green, die-stamped "Florian Ware - Jas. Macintyre & Co. - Burslem - England," w/painted Moorcroft signature, ca. 1902-04**880.00**

Vase, 5½" h., 4" d., bulbous body, Hibiscus patt., orange blossoms on a green ground**185.00**

Vase, 6" h., decorated w/red poppies & blue forget-me-nots, ruffled rim, Macintyre period, ca.1897-1913**1,320.00**

Vase, 7" h., 4¾" d., bulbous body Pomegranate patt., vermillion & purple fruit against a sheer mottled blue ground, die-stamped "MOORCROFT - MADE IN ENGLAND - 60," 1918-29**357.50**

Vase, 8½" h., 4½" d., tapering cylindrical shouldered body w/a short, wide rolled neck, decorated w/large orchids in red, yellow & blue on a blue ground, die-stamped "MOORCROFT" w/script signature**467.50**

Vase, 8½" h., 10" d., Pomegranate patt., footed wide squatty bulbous base tapering sharply to a slightly flaring cylindrical neck, large rose & tan fruit w/deep violet & dark blue centers on tan & green

leaves surrounded by dark blue & roseberries, all on a dark blue ground, large painted signature & impressed mark & paper label, No. M32.........**1,210.00**

Vase, 8¾" h., bottle-shaped, Florian Ware, green & gold design of tulips, Macintyre period, ca. 1903**1,199.00**

Vase, 9" h., Fruit & Leaf patt., baluster-form body w/a short flaring neck, large violet & red berries among green, rose & yellow leaves against a pale green to dark blue ground, painted "W.M." & impressed mark, w/paper label...............**550.00**

Moorcroft "Moonlit Blue" Vase

Vase, 9½" h., baluster-form w/short flaring neck, Moonlit Blue patt., decorated in shades of blue, turquoise & green w/large trees on a royal blue ground, impressed factory marks & painted green signature**1,150.00** (Illustration)

Vase, 10"h., Anemone patt., baluster-form body w/a short flaring neck, decorated w/large blossoms in rose, white & pale blue w/dark blue centers & narrow leaves of olive & bluish green against a bright dark blue ground, large painted signature & impressed mark**495.00**

Tall Ovoid Moorcroft Vase

Vase, 10½" h., slender ovoid
body tapering to a short flaring
rim, decorated w/a band of
flambé slipper orchids &
foliage, in shades of red, yellow
& green, deep burgundy

ground, impressed factory
mark, paper label, painted blue
label**690.00**
(Illustration)

Vase, 10 ¾" h., 6" d., corseted-
form, Pomegranate patt., ver-
million & purple fruit against a
mottled green to cobalt blue
ground, marked "Moorcroft -
BURSLEM - ENGLAND
- 60," 1918-29**715.00**

Vase, 12 ⅝" h., footed baluster-
form body, decorated w/a band
of stylized fruit in shades of
rose, ochre, purple & blue on a
cobalt blue ground, impressed
mark & script signature**1,725.00**

Vase, 16¼" h., baluster-form,
incised w/undulating iris blos-
soms & leafage & glazed in
shades of green & blue, signed
"W. Moorcroft" in green,
early 20th c.**1,955.00**

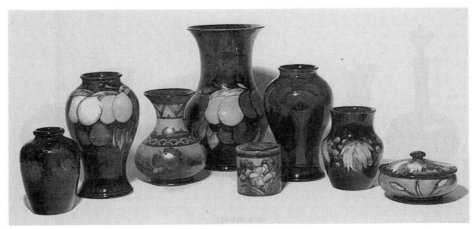

Courtesy Don Treadway

1　　2　　3　　4　　5　　6　　7　　8

Various Moorcroft Pieces

Bowl, cov., 5½" d., 3½" h.,
Blackberry & Leaf patt., wide
squatty bulbous bowl on a low
pedestal foot, slightly domed
cover w/button finial, yellow &
pink buds on long slender pale
green leaves against a pale

green to dark blue ground, the
cover w/deep violet & rose
berries among broad green,
yellow & rose leaves,
impressed marks...................**330.00**
(Illustration: No. 8)

Jar, cov., Hibiscus patt., cylindrical body w/flat fitted cover, rose & yellow blossoms w/prominent blue stamens & green leaves on a pale green to blue ground, impressed marks, two minute chips on cover rim, 4" h**275.00**
(Illustration: No. 5)

Vase, 6" h., Grape & Leaf patt., ovoid shouldered body tapering to a short neck w/thick molded rim, flambé glaze w/deep purple, blue & red berries among red, green & yellow leaves on a rich reddish brown ground, printed "W. Moorcroft" signature & painted "W.M." initials ..**770.00**
(Illustration: No. 1)

Vase, 6¼" h., Blackberry & Leaf patt., baluster-form body w/wide slightly flaring cylindrical neck, deep violet & rose berries among broad leaves of green, yellow & rose against a dark blue ground, impressed mark & script signature**302.50**
(Illustration: No. 7)

Vase, 7½" h., Dawn patt., footed squatty bulbous base tapering to a widely flaring trumpet neck, decorated w/a bright blue landscape scene around the base & neck separated by a band of interlocking half circles & topped by a band of V-shapes in blue & gold, top & bottom edges in royal blue, impressed mark, tight hairline**1,100.00**
(Illustration: No. 3)

Vase, 9" h., Moonlit Blue patt., baluster-form body w/a short rolled neck, a landscape design of tall trees & ground in rich royal blue w/mustard yellow highlights & outlines against a dark blue ground, impressed mark & painted signature**1,760.00**
(Illustration: No. 6)

Vase, 9½" h., Wisteria patt., baluster-form body w/a short rolled neck, large purple, blue, pale pink & yellow blossoms w/pale green leaves circling the shoulder on a dark blue ground, impressed mark**605.00**
(Illustration: No. 2)

Vase, 12½" h., Wisteria patt., bulbous baluster-form w/a wide trumpet neck, large purple, rose & yellow blossoms w/pale green leaves circling the body on a dark blue ground, impressed mark & painted signature**880.00**
(Illustration: No. 4)

NEWCOMB COLLEGE POTTERY

The art department of Newcomb College, New Orleans, Louisiana, established this pottery in 1897. All the pieces were hand-thrown and carried the potter's mark and decorator's monogram on the base. Pieces are fairly scarce because it always operated as a studio business and not a formal factory. Their earlier wares decorated by their best known artists are bringing very strong prices on today's market. Most pieces feature soft matte glazes and pieces with glossy glazes are quite rare. The pottery closed in 1940.

Bowl, 5¾" d., 2" h., wide shallow sides tapering to a footring, the exterior crisply incised w/flowers in light blue & yellow buds against a dark blue glossy ground, by Leona Nicholson, signed "NC - LN - CP50," 1908**$3,575.00**

Bowl, 7 ¾" d., 1 ¾" h., low sides tapering inward at mouth, decorated w/a band of pink blossoms & green leaves on a light blue to violet ground, decorated by Sadie Irvine, impressed "NC - 277 - KG38 - JM - SI," 1919**770.00**

Bowl, 8¼" d., 3" h., wide squatty bulbous form w/a flat bottom, decorated around the upper half w/a continuous garland of large white stylized gardenias against a deep bluish green body, by Henrietta Bailey, probably sold at the 1904 Louisiana Purchase Exposition, incised mark "NC - HB - JM - W- CX21"**4,675.00**

Bowl-vase, squatty bulbous base tapering to a wide flat mouth, carved around the shoulder w/a band of stylized pale pink hollyhock blossoms w/pale green leaves against a violet-blue ground, by A.F. Simpson, initialed & impressed "NC M86 - 70," 5" d., 2½" h..........................**990.00**

Bowl-vase, footed squatty bulbous wide body w/a wide short cylindrical neck, crisply molded around the upper half w/rose blossoms in purple & yellow w/green leaves against a purple ground, by Henrietta Bailey, ca. 1910, marked "HB - JM - 253," 7" d., 4½" h.**1,760.00**

Bowl-vase, bulbous, decorated w/a scene of oak trees, Spanish moss & a yellow moon in tones of dark blue & green, by Henrietta Bailey, impressed "NC - KS - UL16 - HB," 6" d., 5" h. (lines at rim)......**1,210.00**

Center bowl, squatty bulbous wide body w/a flat rim, deeply carved w/a band of pink, yellow & blue flowers on a vine against a mottled blue ground, by Sadie Irvine, marked "NC - KZ54 - 246," 1920, 7 ⅝" d...**770.00**

Center bowl, footed, very wide shallow rounded sides w/a closed rim, sharply carved w/pink & lavender poppies & green foliage on a lavender ground, by Sadie Irvine, impressed "NC - JM - SI - JM32 - 256," 11" d., 4" h. ...**1,760.00**

Chamberstick, widely flaring conical base supporting a cupped small bowl centered by a candle socket, a C-scroll side handle on the base, decorated in the Espanol patt. of narrow blue & white bands against a dark blue ground, carved & decorated by Sadie Irvine, 1927, 3 ¾" h.**715.00**

Mug, cylindrical body flaring at the base, angled handle, decorated w/a wide upper band of stylized ivory flowers w/green stems above a cobalt blue band over the green base, cobalt blue handle, by Leona Nicholson, 1906, 3" d., 3" h.............................**1,870.00**

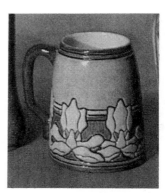

Newcomb College Mug

Mug, slightly rounded conical body w/D-form handle, deeply carved & painted about the bottom half w/a band of large stylized white magnolia-like blossoms against a dark blue band, greyish blue upper body & dark blue handle, marked "NC - BK 57 - Q - JM," artist-initialed, 1906, 5 ⅜" h.**2,530.00** (Illustration)

Plaque, pierced to hang, round, incised & painted w/tall stylized cypress trees in the foreground & a distant forest in the background, in blue & green on a light blue ground, by Amelie Roman, 1906, ink marked "NC - AR - BG45 - JM - W," 7 ¾" d.**3,850.00**

Plaque, rectangular, decorated w/a landscape of large cypress trees reflected in water in light yellow & periwinkle blue, w/original wide & flat pickled wood frame, by Sadie Irvine, 1913, paper labels, tile 6 x 10"**3,080.00**

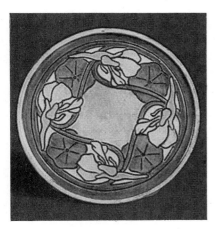

Newcomb College Tea Tile

Tile, round, incised w/a band of yellow nasturtium & green vines on a light blue ground, by Desiree Roman, signed "NC - DR - QQ96" w/a paper label, 5 ¾" d.**2,420.00** (Illustration)

Tile, hand-built, round souvenir-type, modeled w/a scene of Jackson Square in New Orleans in satin tones of blue, green & pink, by Leona Nicholson, incised "LN - HB - NC - M," 4" d.**990.00**

Vase, miniature, 2" h., 3" d., wide tapering cylindrical body molded in relief around the sides w/a band of stylized foliate design in mauve, green & grey matte glaze on a blue ground, incised "NC Sa 14 12" & artist's initials**715.00**

Vase, miniature, 2¼" h., 2 ¾" d., squatty bulbous ovoid body w/a short molded neck, carved w/a stylized landscape of blue oak trees & Spanish moss on a cream ground, matte glaze, decorated by Sadie Irvine, 1931, die-stamped "NC - SI-JH - ST97"**1,045.00**

Vase, 4" h., wide ovoid body tapering slightly to a short cylindrical neck, decorated w/a continuous landscape of moss-laden trees in deep blue against a pink ground, by Sadie Irvine, impressed "NC - 5 - RV20"**1,760.00**

Vase, 4½" h., hand-thrown, simple ovoid body tapering to a short rounded cylindrical neck, green matte glaze, by Joseph Meyer, impressed mark**412.50**

Vase, 4½" h., 2" h., slightly swelled cylindrical body, modeled w/white narcissus & green leaves against a light blue ground, decorated by A.F. Simpson, 1922, impressed "NC - MO28 - 15 - AFS"**770.00**

Vase, 4½" h., 2" d., tapering cylindrical body w/concave shoulder & wide mouth, decorated w/stylized pink blossoms & green stems against a matte blue ground, decorated by Sadie Irvine, impressed "NC - 15 - OV93," incised "SI," 1925**880.00**

Vase, 4½" h., 5" d., squatty bulbous ovoid body tapering to a wide, flat mouth, decorated w/a night landscape w/a full moon shining through oak trees hung w/Spanish moss, in shades of light & dark blue w/a white moon, by Sadie Irvine, 1931**1,320.00**

Vase, 4½" h., 6" d., squat bulbous body, decorated w/stylized surface painted leaves & flowers in medium & light blue on a cream ground, decorated by Carrie Sliger, impressed "NC - JM - U" & ink mark "CBS," ca. 1901**3,300.00**

Vase, 4 ¾" h., 2 ¾" d., cylindrical body w/flaring rim, decorated w/incised white flowers & tall green stems against a dark blue matte ground, by A.F. Simpson, marked "NC - AFS - DV9," 1910...............**1,540.00**

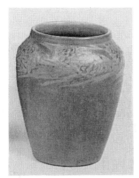

Newcomb Vase with Pine Cones

Vase, 5½" h., wide ovoid body tapering to a wide flat mouth, carved & painted around the shoulder w/a band of pine cones & needles in red & brown & light green against a medium blue matte ground, by Henrietta Bailey, No. RZ38, impressed marks................**1,100.00** (Illustration)

Vase, 5½" h., 5½" d., squatty bulbous base w/a narrow angled shoulder to the wide tapering cylindrical neck, carved around the neck w/a band of pale blue blossoms w/yellow centers & pale green stems & leaves against a light blue ground, a wide band of pale green around the rim, by Sadie Irvine, impressed "NC - 272 - LT6 - 12"..........**1,210.00**

Vase, 6" h., swelled cylindrical body w/a shallow shoulder tapering to a short cylindrical neck, carved & decorated w/a moonlit scene of live oak trees w/Spanish moss, in shades of pale blues & green, by Sadie Irvine, base marked "NC - NE 51 - JM - 79," 1923 (small grinding flake off base).......**1,870.00**

Vase, 6" h., 3" d., bottle-form, bulbous base tapering to a cylindrical neck, incised w/a wide band of stylized leaves in cream on a light green glossy ground, by Sabrina Wells, 1903, impressed "NC - SEWELLS - LL46 - M"**2,530.00**

Vase, 6" h., 5½" d., bulbous body, decorated w/carved bunches of white flowers w/tall greyish green foliage against a deep blue ground, incised or ink marks "NC - AFS - EH73 - JM - K," by A. F. Simpson, 1911.........**1,980.00**

Vase, 6½" h., 6½" d., wide bulbous ovoid body tapering to a wide flat mouth, carved & painted w/a large landscape featuring a full moon amid live oak trees hung w/Spanish moss, in green & blue matte glaze w/a light blue sky & yellow moon, by Sadie Irvine, No. SV18, impressed marks**3,575.00**

Vase, 6 ¾" h., bulbous ovoid body w/a wide, molded flat mouth, deeply carved w/large grape clusters & leaves against a ribbed trellis ground in shades of light & dark blue, by Maria De Hoa LeBlanc, base marked "NC - AG 50 - Q - JM," 1905**7,150.00**

Vase, 6 ¾" h., 4"d., squatty bulbous body w/a sharp angled shoulder tapering to a cylindrical neck, incised geometric designs in dark blue & green on the lower half w/light blue on the neck, by Ada Lonnegan, marked "NC - ZZ6 - Lonnegan,"

1904 (spider cracks to
body)**1,210.00**

Henrietta D. Bailey Vase

Vase, 6⅞" h., 6"d., inverted
pear-shaped body tapering to a
wide flat mouth, matte glazed
pale pink, blue & green on low-
relief pine cones & needles,
blue ground, cream interior,
decorated by Henrietta D.
Bailey, impressed "NC -
Kl10 - 292 - J.M."**1,495.00**
(Illustration)

Vase, 7" h., 3¼" d., cylindrical
w/flaring rim, landscape scene
of a moon shining through the
branches of a tree draped
w/Spanish moss, matte glaze,
decorated by Anna Simpson,
incised "NC - JM - MK96
AFS," 1922**1,980.00**

Vase, 7" h., 4" d., dimpled ovoid
base below a wide tapering cylin-
drical neck, green & turquoise
glossy glaze dripping over red
clay, marked "NC -
JM - F.H.C.".............................**385.00**

Vase, 7¼" h., 3 ¾" d., gently
swelling cylindrical body w/a
swelled shoulder tapering to a
short, wide neck, blue flowers
on tall green stems against a
blue ground, matte glaze, by
Henrietta Bailey, marked "NC -
HQ34" & artist's cipher,
1915**3,080.00**

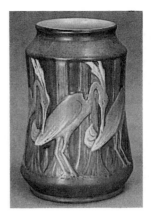

Newcomb College Egrets Vase

Vase, 7¼" h., 4 ¾" d., waisted
cylindrical body w/an angled
shoulder to the short, wide
neck, decorated w/large carved
egrets in blue & white against
tall tree trunks in bluish green
interspersed w/bands of cobalt
blue ground, by A.F. Simpson,
1930, impressed "NC - SG 1 -
JH - 80 - AFS"**6,050.00**
(Illustration)

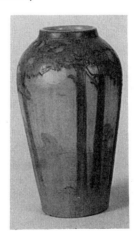

Ovoid Newcomb College Vase

Vase, 7½" h., 3½" d., slender
ovoid body tapering to a short
cylindrical flat mouth, moonlit
landscape w/ tall trees in a blue
& green matte glaze, marked
"NC - JK76 - 208 - JM"**3,190.00**
(Illustration)

Vase, 8" h., 5¼" d., footed teardrop-form, the squatty bulbous base tapering to a cylindrical neck, decorated around the lower body w/a narrow band of white starflowers & green leaves on a dark blue band against a light blue body, decorated by A.F. Simpson, 1925, impressed "NC - 247 - JM - AFS - OX56"**1,430.00**

Vase, 8½" h., 3" d., slightly flaring cylindrical body w/a gently tapering neck, incised around the shoulder & neck w/stylized green leaves on a light blue ground, by M.C. Chalaron, marked "NC - KD95 - CMC," 1919**1,760.00**

Vase, 8½" h., 3 ¾" d., cylindrical w/shallow shoulder & short neck, decorated w/live oak trees hung w/Spanish moss w/a full moon shining through, in blue & green on a light blue ground, matte glaze decorated by Sadie Irvine, impressed "NC - 250 - QM53 - SI" & w/original paper label, 1927**2,860.00**

Vase, 8½" h ., 5" d., footed wide cylindrical body tapering slightly at the top to a flat mouth, decorated w/cut-back & incised thistles & leaves around the sides in green & blue on a dark & light blue ground, decorated by MI, signed "NC - MI - M11 - JM - U,"**11,550.00**

Vase, 8 ⅝" h., tapering ovoid body tapering to a wide, flat mouth, decorated w/a landscape scene of live oak trees draped in Spanish moss w/a full moon peeking through, shades of blue & green, potted by Joseph Meyer, decorated by Anna F. Simpson, 1924**3,520.00**

Vase, 8 ¾" h., 3½" d., ovoid body tapering to a short neck w/a flat rim, decorated w/a landscape of oak trees

w/Spanish moss in light & dark blue & ivory matte glaze, marked "NC - MZ86 - 250," 1923**2,750.00**

Vase, 8 ¾" h., 3½" d., tall slender corseted shape, incised bulbous white blossoms around the top on long green stems down the sides on a blue ground, by M. Robinson, 1908, impressed "NC - MROBINSON - JM - CH47 - M"**3,300.00**

Vase, 9" h., 3½" d., corseted-form, decorated w/stems of tall yellow & white flowers alternating w/three pointed leaves, light & dark blue on a pale blue ground, decorated by Desiree Roman, die-stamped "NC - JM - M - U" & painted in blue "D.R. - C87" & triangle mark**4,675.00**

Vase, 9½" h., tall slender waisted cylindrical body decorated around the top half w/a carved & painted band of stylized mushrooms in shades of dark & light blue above a light blue lower body, marked "NC - ZZ 20 - ZZ 20 - W - JM," artist-initialed, 1904**2,310.00**

Vase, 10½" h., 4¼" d., tapering cylindrical body flaring slightly at the rim, decorated w/sharply incised full-length narcissus in white w/orange centers & green leaves on a blue waxy matte ground, decorated by Anna Mason, impressed "NC - JM - B in circle - 83 - A.M.," painted "F.W.22," 1913**3,850.00**

Vase, 10½" h., tall slender ovoid body tapering to a flat mouth, deeply carved & painted w/a moonlit scene of tall leafy trees in dark blue against a pale blue & green ground, decorated by Sadie Irvine, marked "NC - JK 40 - 133 - JM," 1918...........**7,700.00**

Vase, 10½" h., 6" d., wide ovoid body tapering slightly to a wide,

flat mouth, decorated around the shoulder w/large pink pine cones & green needles against a matte blueground, by H. Bailey, 1919**3,960.00**

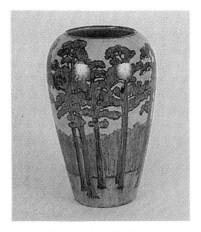

Large Newcomb College Vase

Vase, 11" h., 7 d., ovoid gourd-form body, flat rim, decorated w/deeply incised long green leaves below a broad band of 'curly' blue blossoms, by Hattie Joor, 1903, rim restoration, marked "NC - LL78 - JH" ..**6,050.00** (Illustration)

Vase, 11½" h., cylindrical, painted w/stylized daffodils & foliage in yellow & lime against a cream ground, inscribed "C" & painted "B'60" & w/firm's mark**4,600.00**

Vase, 12½" h., tall slender waisted cylindrical form, decorated w/elongated stylized blue & white iris blossoms & green buds & spiked leaves, impressed marks "NC LN Cp-63 JM" & "W"**3,850.00**

Vase, 12½" h., 7½" d., ovoid body tapering to a wide flat mouth, decorated w/a landscape of tall dark green pine trees outlined in dark blue against a light blue forest & light green fields, marked in ink "NC - HJ - U87 - JM - Q," (restoration to hairlines at rim)**13,200.00**

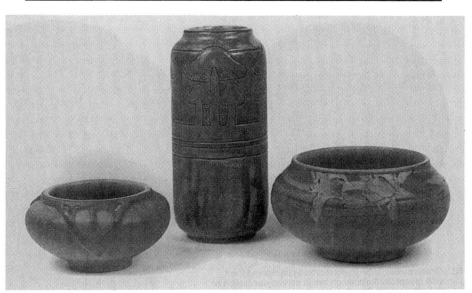

Courtesy Dave Rago

1 2 3
Newcomb College Bowls & Vase

Bowl, 6½" d., 3½" h., squatty bulbous body w/a wide flat mouth, tapering to a small cylindrical base, carved around the shoulder w/three blue stylized spades & three-pointed broad band rising from the base, all against a pale rose & green ground w/yellow highlights, thrown by Joseph F. Meyer, decorated by Corinne Chalaron, impressed "NC 256 - 32," repaired hairline**770.00**
(Illustration: No. 1)

Bowl, 8"d., 4½"h., squatty bulbous form w/a wide flat mouth, the base tapering to a short foot, decorated around the shoulder w/pale pink & blue iris blossoms on pale green & blue horizontal stems against a rich medium blue matte ground, decorated by Henrietta Bailey, impressed logo & "K185 - 243 - J1"**1,870.00**
(Illustration: No. 3)

Vase, 10" h., cylindrical body w/a rounded base on a thin footring & the rounded shoulder sloping to a flat mouth, the top half carved w/twelve overlapping toadstools above a medial band, unusual rose red over pale blue glossy glaze, decorated by Leona Nicholson, impressed "NC - LL83"......**9,350.00**
(Illustration: No. 2)

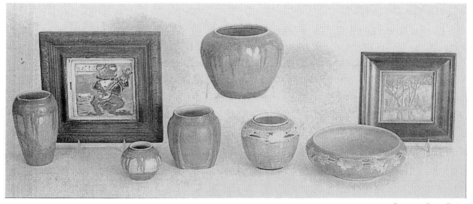

Courtesy Dave Rago

1 2 3 4 5 6 7 8

Variety of Newcomb College Pieces

Bowl, 6 ¾" d., 2½" h., wide squatty rounded sides, molded pink bellflowers & mint green leaves on a blue ground, by A.F. Simpson, dated 1924, impressed "NC - AFS - 55 - OI68 - JM"**1,210.00**
(Illustration: No. 7)

Tile, square, decorated w/a landscape of a bayou w/blue trees & green leaves w/a pink sky & yellow setting sun, framed, by Sadie Irvine, dated 1919, stamped "NC - SI - KJ - 17," 4" sq...........................**2,530.00**
(Illustration: No. 8)

Tile, square, hand-built, relief-molded decoration of a tuxedo-clad frog playing the banjo in front of an audience of frogs, glossy polychrome colors by Leona Nicholson, framed, incised "LN - HB - NC - M," 4½" sq.**1,320.00**
(Illustration: No. 2)

Vase, miniature, 2½" h. 2¾" d., spherical w/short molded neck, decorated w/a landscape of green & blue live oak trees w/Spanish moss, by Sadie Irvine, dated 1931, impressed "NC - JM - SI - 2 - ST97".......**935.00** (Illustration: No. 3)

Vase, 3½" h., 3¾" d., bulbous spherical body w/closed molded rim, a modeled band of white blossoms & green leaves around the shoulder on a blue ground, by M.W. Summey, dated 1909, impressed "NC - JM - CV-25 - M. Summey - W."**1,760.00** (Illustration: No. 6)

Vase, 4" h., 3½" d., bulbous ovoid body tapering to a wide flat mouth, molded w/four buttress handles up the sides, blue & violet matte glaze, by

Sadie Irvine, dated 1930, impressed "NC - SI - JH - 5 - ST13"**1,320.00** (Illustration: No. 4)

Vase, 5" h., 3" d., simple ovoid body w/a wide flat mouth, carved landscape of blue & green live oak trees hung w/Spanish moss w/a yellow moon through the trees, by Sadie Irvine, dated 1931, marked "NC SI - JM - 7 - SU94"**1,650.00** (Illustration: No.1)

Vase, 5" h., 5½" d., wide bulbous ovoid body w/a wide closed rim, decorated w/a continuous scene of live oak trees hung w/Spanish moss & a large white moon all on a blue ground, by Sadie Irvine, dated 1932, impressed "NC - SI - JM - UC34"**2,310.00** (Illustration: No. 5)

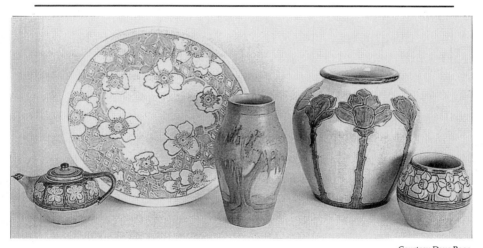

Courtesy Dave Rago

1 2 3 4 5

Newcomb Teapot, Charger & Vases

Charger, decorated w/a wide border band of wild roses in ivory outlined in brown against a bluish green trellis on an ivory ground, glossy glaze, die-stamped "NEWCOMB COL-LEGE - NC - JM - U - B13 -

H.J.," by H. Joor, 1901, small rim chip repair, some burst bubbles, 12 ¾" d.**2,530.00** (Illustration: No. 2)

Teapot, cov., spherical body w/a short angled spout, molded

rim w/inset cover & C-form handle, wide incised band of quatrefoils in white & dark green around the shoulder on a light blue & dark blue ground, by Leona Nicholson, 1906, signed "NC - LN - BG82 - Q.4," restoration to cover & spout, 6 ¾" w., 4" h.**1,320.00** (Illustration: No. 1)

Vase, 4½" h., 4 ¾" d., squatty bulbous ovoid body w/a wide flat mouth, sharply incised w/a wide band of yellow & white daffodil blossoms in green blocks on a blue ground, yellow thin rim band, by M.H.LeBlanc, stamped "NC - JM - MHLB - Q - SS77," 1904....................**5,500.00** (Illustration: No. 5)

Vase, 8½" h., 4½" d., ovoid body

tapering to a flat mouth, modeled landscape scene w/large live oak trees w/Spanish moss in feathered green over blue matte, a yellow full moon in the sky, by A.F. Simpson, impressed "NC - RY25 - JH - AFS," original paper label, 1929**4,675.00** (Illustration: No. 3)

Vase, 9½" h., 8" d., wide bulbous ovoid body tapering to a short rolled neck, decorated w/a band of large upright cactus blossoms on long stems in dark blue on a white & light blue ground, by Maude Robinson, impressed "NC - JM - Y42 - MR W.," 1903, invisible repair to small base drill, tight rim hairline..................**7,150.00** (Illustration: No. 4)

NILOAK

Benton, Arkansas was the home of this pottery which is best known for its hand-thrown line featuring vari-colored swirled clays in simple classic designs. This Mission Ware line is the most desirable of Niloak's production from early in this century. A later more commercial ware called the Hywood Line featured glossy and semi-matte glazes on many animal and plant-form planters and vases. Produced during the 1930s Hywood pieces only bring a fraction of the prices received for the best Mission Ware examples. The pottery was closed in 1946.

ΝΙᴄΟΑᏥ

Basket, hanging-type, Mission Ware, swirled clays, 6" h.....**$195.00**

Bowl, 8" d., 5 ¾" h., Mission

Ware, wide bottom w/deep gently tapering sides to a flat rim, dark swirled clays, die-stamped "NILOAK"................**440.00**

Candlestick, Mission Ware, slender tapering shaft w/a widely flaring base & wide cupped socket, 10¼" h..........**285.00**

Candlesticks, Mission Ware, widely flaring base tapering to a slender shaft ending in a wide, rounded candlecup, swirled clays, 9" h., pr.**275.00**

Chamberstick, Mission Ware, widely flaring conical base w/a cupped socket, loop handle at the side of the bottom rim, 5" h..............................**245.00**

Cornucopia-vase, Hywood Line, pink glaze**12.00**

Flower frog, Mission Ware, short cylindrical form, 3" d., 1½" h.......................................**85.00**

Niloak Jar & Vase

Jar, cov., Mission Ware, cylindrical, inset cover w/turned finial, swirling blue, brown, grey & ivory clays, impressed "NILOAK," minute rim flake, 2 ¾" d.,4¼" h....................... **330.00** (Illustration: right)

Jardiniere, Mission Ware, marbleized swirls, 8½ x 9½"........**400.00**

Pitcher, 9½" h., Mission Ware, baluster-form w/a flaring rim w/a pinched spout, small strap handle, swirled blue, brown & cream clays, marked.............**495.00**

Planter, Hywood line, model of a camel, green glaze..................**40.00**

Planter, Hywood Line, model of a deer, blue glaze, 7" h.**22.00**

Planter, Hywood Line, model of a elephant**35.00**

Planter, Hywood Line, model of a rabbit, green glaze**25.00**

Planter, Hywood Line, model of a squirrel, brown matte glaze**30.00**

Smoking set: cylindrical humidor w/inset cover, cylindrical match holder, cigarette holder & ashtray, on a large round tray w/low flaring edges; Mission Ware, each piece marked, humidor 5" d., 7" h., set of 6 (tight hairline in cigarette holder)**715.00**

Vase, 3¼" h., Mission Ware, slightly swelling waisted cylindrical body, marbleized swirls**60.00**

Vase, 4½" h., baluster-form w/a widely flaring & flattened trumpet neck, swirls of brown, cocoa, reddish brown, cream & blue, signed**77.00**

Vase, 4½" h., 3½" d., Mission Ware, marbleized swirled clays, artist-signed**85.00**

Vase, 4 ⅝" h., Mission Ware, marbleized swirls, artist-signed**65.00**

Vase, 5" h., Mission Ware, ovoid body tapering to a short flared neck, marbleized swirls...........**65.00**

Vase, 5½" h., Mission Ware, slightly tapering cylindrical body, marbleized swirls...........**90.00**

Vase, bud, 6" h., 2½" d., cylindrical w/rounded foot, swirled blue, pink, grey & cream clays, speckled blue high gloss interior**88.00**

Vase, 6" h., 4" d., Mission Ware, marbleized shades of tan........**85.00**

Vase, 6¼" h., 5 ¾" w., fan-shaped, footed, swirling grey, ivory, blue & terra cotta clays, die-stamped "Niloak".............**192.50** (Illustration: left)

Vase, 6½" h., Mission Ware, baluster-form body w/a narrow neck flaring at the rim, swirled blue, brown & cream glazes under a pale green glossy glaze, unmarked**247.50**

Vase, 6½" h., Mission Ware, gently flaring cylindrical body w/a narrow angled shoulder to a short flaring rolled neck, swirls of tan, blue, brown & rust, marked**143.00**

Vase, 6½" h., Mission Ware, slender ovoid body tapering to

a closed rim, swirls of brown, cream, cocoa & blue, signed**121.00**

Vase, 6½" h., Mission Ware, slightly swelled cylindrical body, swirls of cream, blue, brown & reddish brown, marked**121.00**

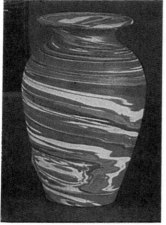

Niloak Marbleized Vase

Vase, 7½" h., 4½" d., Mission Ware, baluster-form w/flaring flat rim & tapering base, swirling bluish grey & brown matte clays**192.50** (Illustration)

Vase, 8" h., 4¼" d., Mission Ware, trumpet-form body tapering down to a widely flaring foot, swirled brown, beige & dark blue clays, die-stamped "NILOAK"................**220.00**

Vase, 8¼" h., 3 ¾" d., Mission Ware, footed ovoid body tapering to a small flat mouth, swirled brown & dark blue clays, die-stamped "NILOAK"**220.00**

Vase, 8¼" h., Mission Ware, cylindrical, marbleized swirls**125.00**

Vase, 8½" h., Mission Ware, baluster-form w/a short widely flaring trumpet neck, swirls of

cream, blue, brown & rust, signed**165.00**

Vase, 9" d., 3½" d., cylindrical, swirling dark blue, dark brown & beige clays, impressed "Niloak"..................................**220.00**

Vase, 10" h., Mission Ware, slender ovoid body w/molded rim, swirls of reddish brown, cocoa & chocolate brown, signed**357.50**

Vase, 10" h., 5" d., expanding cylinder w/closed-in rim, swirling brown, light brown & rust clays, die-stamped mark**385.00**

Vase, 10¼" h., 5" d., Mission Ware, tall baluster-form body w/cupped rim, swirled multicolored clays, marked**220.00**

Vase, 15 ¾" h., 7¼" d., Mission Ware, tall ovoid body tapering to a thick molded mouth, swirled blue, grey, putty & brown clays, die-stamped "NILOAK"**825.00**

NORTH DAKOTA SCHOOL OF MINES

It was in 1910 that the University of North Dakota School of Mines hired Margaret Kelly Cable to teach pottery making. All the pottery was produced using North Dakota clay and a variety of pieces were produced under Mrs. Cable's direction until her retirement. Two other noted pottery instructors between 1923 and 1970 were Julia Mattson and Margaret Pachl. Various designs and glazes were featured ranging from Art Nouveau through Art Moderne and the best examples are prized today. A circular mark with wording was used on most pieces and the students also signed pieces until 1963. Since that

time pieces only carry the students'
signatures. Pieces signed "Huck"
were done by artist Flora Huckfield
between 1923 and 1949.

Bowl, 6" d., 2½" h., incised
flower decoration, lime green to
sand color, artist-signed**$225.00**

Bowl, 9 ⅜" d., wide shallow form
in mustard yellow decorated
w/a wide inner band of colorful
stylized fruits within black &
charcoal grey rim bands, deco-
rated by M. Jacobson, marked
& dated "2 - 15 - 49"**247.50**

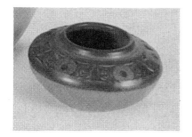

North Dakota Bowl-Vase

Bowl-vase, Prairie Rose line,
squatty bulbous body w/a wide
shoulder tapering to a flat
mouth, decorated around the
shoulder w/a band of carved
roses & leaves in pink & green
on a light brown matte ground,
die-stamped circular mark,
incised "M. Cable - Prairie
Rose," 4 ¾" d., 2½" h.**605.00**
(Illustration)

Bowl-vase, Prairie Rose line,
squatty bulbous form w/a wide
slightly rounded shoulder to the
flat molded mouth, rust red
ground w/black designs on the

shoulder, designed by Flora
Huckfield, Shape No. 51,
marked, 2 ⅝" h.**302.50**

Bowl-vase, squatty bulbous
body w/a closed rim, painted
w/a band of buffalo in black
against a rust matte ground, by
Mattson, die-stamped circular
mark & "JM - 992," 4½" d.,
3¼" h.**660.00**

Bowl-vase, squatty globular
body, a band of carved yellow
flowers & green foliage at the
shoulder on a matte pink
ground, by Flora Huckfield,
1933, round ink mark, incised
"Huck - 2540," 4 ¾" d.,
3" h.**357.50**

Bowl-vase, Prairie Rose line,
squatty ribbed body &
embossed flowers in green &
brown on a brown ground, cir-
cular ink mark, incised "Prairie
Rose," 5" d., 2 ¾" h.**275.00**

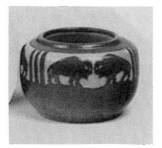

Fine North Dakota Bowl-Vase

Bowl-vase, squatty bulbous
body w/a narrow shoulder to a
molded rim, carved band deco-
ration of buffalo standing head
to head & separated by three
wide vertical bands, glossy
medium blue carved to rich
creamy white, incised "JM
1194" & blue ink mark, 5" d.,
4" h.**935.00**
(Illustration)

Bowl-vase, wide base w/high
rounded sides tapering slightly
to a wide flat mouth, an
American Indian design of tan

stylized birds, branches & leaves among black linear geometric designs on a barn red ground, rim & base banded in tan & black, incised "E. Dorpat," blue ink mark, 4" h.**467.50**

Charger, the wide center decorated w/a large basket of stylized flowers in dark blue & green on a white ground, the wide flat border band in a dark blue, green & rust starburst design, decorated by Hazel Rohde, logo mark & "Hazel Rohde 1934," 8⅞" d. (few minor burst glaze bubbles)**385.00**

Decanter w/original stopper, spherical base below a tall cylindrical neck fitted w/a bulbous ribbed stopper, the base incised w/American Indian designs, pale blue speckled glaze on creamy white ground, die-stamped circular mark & incised "Sioux Cal. - Mattson," 5" d., 9" h.**467.50**

North Dakota Humidor

Humidor, cov., wide conical body w/a flat rim supporting a flat cover w/large knob finial, the sides molded w/six sailboats in blue on a band of dark blue wavy water, decorated by Van Camp, marked "Van Camp - 7 - 2 - 41," 1941, 5 ⅝" h.**880.00** (Illustration)

Jardiniere, straight sides, incised w/an Arts & Crafts design of blue & green stylized flowers against a matte green ground, by E.W. Wilker, ca. 1920, round ink mark, incised "EWW"**1,870.00**

Lamp base, table model, round-bottomed tapering cylindrical body w/short cylindrical neck w/a flat cap rim, carved overall w/stylized palm trees in green matte glaze, by Peterson, die-stamped circular mark & "PETERSON," 1951, 5" d., 9" h.**330.00**

Trivet, round, cut-back bluebell blossoms on a white & caramel ground, by Flora Huckfield, round ink mark & incised "H" in circle & "15," 5¼" d.**247.50**

Vase, 3" h., 4" d., squatty bulbous body w/a wide shoulder to a small closed mouth, rose & pale greyish green matte glaze, initialed UND mark**187.00**

Vase, 3¼" h., 3¼" d., bulbous ovoid body w/a wide shoulder tapering to a flat mouth, the shoulder incised w/a band of stylized flowers in pink & green on a matte pink ground, die-stamped circular mark...........**385.00**

Vase, 3½" h., 4½" d., bulbous, black curvilinear Indian designs on a brick, black & ochre ground by Julia Mattson, marked w/incised "J. Mattson - Test 3" (minute glaze nicks)**300.00**

Vase, 3½" h., 5¼" d., wide base tapering to a flat mouth, the sides decorated w/an excised design of standing cowboys in medium brown on a dark brown ground, by B.J. Anderson, circular ink mark, incised "B.J. Anderson - 52 - 1947"**660.00**

Vase, 3 ¾" h., 5½" d., bulbous body decorated w/incised geo-

metric designs outlined in black against a dark blue glossy ground, circular ink stamp, incised "MT"**330.00**

Vase, 3 ¾" h., 5 ¾" d., trumpet-form, a widely flaring rolled rim tapering sharply to a cushion foot, the interior decorated w/lavender & yellow flowers, the exterior in a glossy lavender glaze, die-stamped circular mark "Pasque Flowers F.C.H.," 1929**302.50**

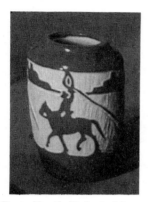

Rare North Dakota Vase

Vase, 4½" h., swelled cylindrical shouldered body tapering to a flat mouth, carved w/a wide scenic band w/cowboys riding horses & using a lasso w/distant mesas in the background, dark blue carved to white, by Julia Mattson, logo mark & "132 J Mattson Cowboy," 1930s**1,430.00**
(Illustration)

North Dakota Wheat Vase

Vase, 4½" h., 5" d., wide squatty bulbous body w/the wide shoul-der tapering to a low molded rim, carved decoration of banded shocks of wheat around the shoulder, rich rosy brown, tan & green-flecked matte glaze, blue circular ink mark, incised "Huck 28, No.Dakota Wheat"**825.00**
(Illustration)

Vase, 5" h., squatty bulbous ovoid body tapering to a banded cylindrical neck w/a rolled rim, the neck band incised w/a row of circles, designed by Margaret Cable, dark green matte glaze, marked w/logo mark & "M. Cable 41" ..**302.50**

Vase, 5" h., 4½" d., bulbous ovoid body tapering to a short cylindrical neck, the shoulder incised w/a wide band of stylized Dutch girls (?) holding hands, brown matte glaze, artist-signed**412.50**

Vase, 5" h., 7½" d., high closed-in body decorated w/a geometric Indian design of black lines against a warm reddish orange ground, under a clear over glaze, ink stamp, incised "GLN - 1931"**357.50**

Vase, 5½" h., 3 ¾" d., ovoid body w/a wide, flat mouth, decorated w/large, stylized daisies, overall white speckled glaze, die-stamped circular mark & "M. Youngs 1938"**302.50**

Vase, 6" h., simple slender ovoid body tapering to a small flat mouth, deeply carved w/three stylized iris w/broad blossoms on tall stems & swirled leaves, tobacco brown to medium green matte glaze, circular ink mark, incised "JTT 2.4.49"**770.00**

Vase, bud, 6" h., 2 ¾" d., squatty bulbous base tapering to a cylindrical neck, incised w/a geometric palm leaf design around the base, glossy ivory glaze, die-stamped circular

mark & incised "YUCCA - M. CABLE 98"**275.00**

Vase, 6½" h., 7½" d., squatty bulbous ovoid body w/the broad shoulder tapering to a short cylindrical neck, decorated w/a looped linear design in dark greyish green on a peach clay ground covered w/a clear glossy glaze, circular inkmark, incised "Pincombe 1958" (minute glaze flake at rim).....**357.50**

Vase, 6 ¾" h., 4½" d., tapering cylindrical body w/a rounded rim to a closed mouth, carved around the lower half w/figures of cowboys on bucking broncos in light brown on a dark brown ground, by Julia Mattson, incised "JM - 133A," circular ink mark**1,650.00**

Vase, 7½" h., gourd-form body, deeply incised w/a band of large brown oak leaves on a light yellowish green matte ground, incised "R. Sheppard," blue ink mark.........................**935.00**

Vase, 7 ¾" h., 4" d., tall ovoid body w/a short neck & flat mouth, black & blue bands around the neck & shoulder above a light blue glossy glaze, die-stamped circular mark, incised artist's cipher & "278"......................................**412.50**

Vase, 7 ¾" h., 4 ¾" d., bulbous ovoid body tapering to a small flat mouth, incised w/large, tall stalks of wheat against a celadon ground, by M. Cable, die-stamped circular mark & incised "N.D. WHEAT - M. Cable - 61"**770.00**

Vase, 9" h., ovoid body w/flat molded mouth, incised tulip blossoms on stems w/broad leaves, thin pale aqua glossy glaze, incised "Elizabeth Breacy," circular ink mark, dated 1933**605.00**

Vase, 9" h., 5½" d., tapering cylinder w/short neck, decorated w/sgraffito iris blossoms & leaves in brown on a medium green ground, circular ink mark & incised "L.M. Barlow 1-11-50"**467.50**

Vase, 9½" h., 5" d., ovoid w/short wide neck, stamp-decorated w/crosses, stars, moons & tulips under a matte greenish brown glaze, by Julia Mattson, ink stamp, incised "Mattson"**385.00**

OHR (George) POTTERY

Sometimes referred to as "the mad potter of Biloxi," George Ohr was an eccentric original who worked in Biloxi, Mississippi between 1883 and 1906. Today many authorities believe Ohr was one of the most expert pottery throwers who ever worked in this country. Most of his wares are hand-thrown and feature very thin walls, often crushed, twisted and folded into unique shapes. Ohr sold very little of his production originally and instead stockpiled it for his children. It was in 1972 that this family collection was purchased by an antiques dealer and entered the resale market where it continues to draw strong interest and high prices today.

GEO. E. OHR

BILOXI, MISS.

Bowl, 4" d., 2¼" h., squatty bulbous rounded pinched sides

below a squared & pointed incurved rim, glossy royal blue exterior, die-stamped "G.E. OHR - Biloxi, Miss."............**$935.00**

Bowl, 4¼" d., 2¼" h., squatty bulbous body w/a nearly flat lipped shoulder, sponged green on yellow glaze, die-stamped "GEO. E. OHR - Biloxi, Miss."........................**495.00**

Bowl, 4½" d., 2 ¾" h., low foot, tapering sides & a severely folded & pinched rim, sheer lustered khaki-green glaze w/orange clay body showing through, die-stamped "G.E. OHR - Biloxi, Miss."**990.00**

Ohr Pottery Bowl

Bowl, 5" d., 2 ¾" h., low foot, straight sides w/an in-folded rim, light brown clay, script signature**770.00** (Illustration)

Bowl, 6" d., 4" h., canted sides beneath angled shoulder, frothy mottled green, pink, blue & red glaze, die-stamped "G.E. OHR Biloxi, Miss."**1,045.00**

Bowl, 6¼" d., 3" h., squatty bulbous footed body tapering to a widely flaring folded & crimped rim, gun-metal black bisque clay, die-stamped "G.E. OHR - Biloxi, Miss."........................**605.00**

Bowl-vase, simple squatty bulbous wide body below a short & wide cylindrical neck, brown & ochre mottled glossy glaze, die-stamped GEO. E. OHR - Biloxi, Miss.," 3" d., 2½" h., ..**385.00**

Bowl-vase, a squatty bulbous footed body w/a heavy in-body twist on the upper shoulder tapering to a wide, short cylindrical neck, brown on a yellow speckled glaze, die-stamped G.E. OHR - Biloxi, Miss.," 3 ¾" d., 3½" h.,**1,715.00**

Bowl-vase, squatty bulbous body w/a lower half pinched & pulled into four small points, the swelled upper half w/a wide lobed & slightly flaring rim, fine 'metal shaving' silvery textured glaze, script signature, 5½" d., 3 ¾" h.....................**4,950.00**

Bowl-vase, squatty bulbous body tapering to a thick footring, the closed mouth w/a crimped & twisted band, light bisque clay, incised script signature, 6" d., 4½" h...........**742.50**

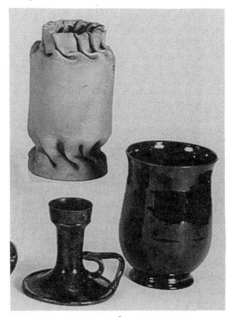

1

2 3

Ohr Candlholder & Vases

Candleholder, double handle & flared base, speckled dark green glaze, die-stamped "G.E. OHR - Biloxi, Miss.," 4½" d.,

4¼" h.**330.00**
(Illustration: No. 2)

Chalice, a wide funnel foot supports a wide upright crimped & cupped top, burnt grey glaze at top & green blistered glaze on the base, die-stamped "GEO. E. OHR - BILOXI"**990.00**

Inkwell, figural, model of a house set upon a wide rectangular base in the form of the American flag, the house in green on an ochre & green speckled base, die-stamped "GEO. E. OHR - BILOXI, MISS.," 3½" x 9" (minor chip to corner of base, two small chips under base)**1,870.00**

Jug, wide spherical body raised on a short wide pedestal, an upright ring handle at the top center, a knob handle on one shoulder opposite a short, flaring spout, orange bisque clay, die-stamped "G.E. OHR - Biloxi, Miss.," 8¾" d., 10½" h. (hairline in foot & handle)**495.00**

Model of a broad-brimmed hat, the free-form piece w/a wide ripped & folded brim & rounded crown, khaki brown & gunmetal black glaze, incised "Biloxi," 6" d., 2¼" h.**1,870.00**

Mug, waisted cylindrical body w/an in-body twist near the base, leathery blue glaze above a band of yellow & green glaze at the base, mottled interior glaze, incised script signature, 3¾" h. (firing line at rim)**1,210.00**

Mug, footed cylindrical body w/a loop handle near the base, fine raspberry, green, white & purple mottled glaze, die-stamped mark "G.E. OHR - Biloxi, Miss. - 3/18/96," 4½" d., 4½" h.**797.50**

Mug, cylindrical w/three strap handles & an in-body twist around the middle, buff-colored

bisque clay, incised script signature, 7" w., 4¾" h.**935.00**

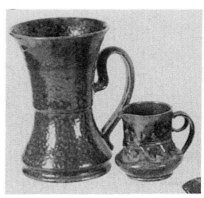

Ohr Tall Mug & Small Pitcher

Mug, footed tall deeply waisted cylindrical body w/an ear-form loop handle, purple & blue spotted glaze, inscribed "Thomas, In the words of J. Jefferson, Here's to your good health and all your family's and may they all live long and prosper," base w/incised script signature "G.E. OHR - Biloxi Jan. 1901 - Compliments from the creator of shapes in clay," 6" d., 6¾" h.**3,025.00**
(Illustration: left)

Pitcher, 3¼" h., 3½" d., footed squatty bulbous body w/center twist below the wide cylindrical neck w/pinched spout, folded loop handle, green & black glossy glaze, die-stamped, G.E.OHR - Biloxi, Miss."**2,090.00**
(Illustration: right)

Pitcher, 3½" h., 5"d., bulbous body w/a low rim & pinched spout & loop handle, the body pinched & dimpled & decorated w/a purple, pink & white glossy glaze, die-stamped "GEO. E. OHR - BILOXI, MISS."**2,310.00**

Pitcher, 4" h., 4¼" w., cylindrical sides w/overall random dim-

pling & a flared rim w/pinched spout, long twisted loop handle, brown glossy speckled glaze, die-stamped mark "G.E. OHR- Biloxi, Miss." ...**1,540.00**

Pitcher, 4" h., 6" w., a swelled & pulled body below a pinched & scalloped rim, a pinched-flat angled handle, glossy khaki glaze, die-stamped "G.E. OHR - BILOXI,MISS."**1,320.00**

Pitcher, 4¼" h., 7" l., bulbous footed body w/indented sides & a wide rim folded down at the center of the sides, a pinched spout at one end, applied crossed ribbon handle, gun-metal black drip glaze, incised script signature...................**2,200.00**

Pitcher, 4¼" h., 7" l., oblong pinched & folded-in rim & an angled cut-out handle, buff-colored bisque clay, incised script signature...................**1,100.00**

Pitcher, 5" h., 4¼" d., footed squatty & bulbous body below a wide folded & pinched neck w/a pinched in-body handle, sponged blue & rust glaze on a yellow glossy base, incised "OHR Biloxi" & die-stamped "G.E. OHR - Biloxi, Miss." (minute rim flake)**3,575.00**

Pitcher, 6¼" h., 5½" d., footed & slightly swelled cylindrical body tapering slightly to a wide & deep crimped & ruffled mouth, applied strap handle, midnight blue & green glaze, incised script signature...................**2,090.00**

Plaque, flat round form in glossy green mounted w/a model of a large woman's hand in pale matte green holding a small brown bird, die-stamped "G.E. OHR - Biloxi, Miss.," 5½" d.**1,100.00**

Plaque, nearly square, mounted w/a boldly molded model of a crab in a dark green glossy glaze, die-stamped "G.E. OHR

- Biloxi, Miss - 1899," 8 x 8½"**4,950.00**

Puzzle mug w/rope-twist handle, upper portion pierced w/round holes, gun-metal & olive green glaze, script signature, 5" d., 3½" h..........**440.00**

Teapot, cov., a wide squatty bulbous body w/a short, domed neck supporting an inset flat cover, orange & brown glossy glaze, die-stamped "G.E. OHR - Biloxi, Miss.," 7¼ l., 3 ¾" h.**2,090.00**

Teapot, cov., wide cylindrical body w/a wide rounded shoulder w/an in-body twist tapering to a short cylindrical wide neck w/inset flat cover, swan's-neck spout & C-form handle, mottled & speckled dark reddish brown glaze, die-stamped "G.E. OHR - Biloxi, Miss.," 6"d., 4" h.**3,025.00**

Teapot, cov., spherical body w/a deep in-body twist band around the lower body, a deep galleried rim w/inset cover, swan's-neck spout & C-loop handle, clear dark blue glaze over an orange clay body, die-stamped mark "G.E. OHR - BILOXI," 7" l., 4¼" h.**3,300.00**

Teapot, cov., wide squatty cylindrical body raised on a wide, low pedestal base, the wide shoulder to a flaring cupped rim w/inset cover, C-scroll handle & swan's-neck spout, incised banding & a brilliant green sponged glaze on a red glossy base, die-stamped "G.E. OHR - Biloxi, Miss.," 8" d., 5" h...........................**8,800.00**

Vase, 2 ¾" h., 3¼" d., squatty bulbous body w/a pinched & undulating waist below a wide, flaring neck, yellow & green neck & leathery blue-glazed lower section, die-stamped "G.E. OHR - Biloxi"...............**660.00**

Vase, 3 ¾" h., the ovoid body w/a mid-ring below the wide, slightly tapering neck w/a flat rim, two loop handles, one looped upward & the other pinched & looped downward, khaki green glaze, incised script signature.....................**770.00**

Vase, 4" h., 2¼" d., a ringed cylindrical body raised on a short pedestal foot, the wide shoulder tapering to a short, cylindrical neck w/a flat rim, glossy blue glaze, die-stamped "G.E. OHR - Biloxi, Miss."**605.00**

Vase, 4" h., 3½" d., spherical w/stove pipe neck & in-body twist, beige & orange bisque finish, incised script signature "G.E. OHR"............**715.00**

Vase, 4½" h., 4 d., footed bulbous ovoid body tapering to a flaring ruffled rim, blue & blood red glossy glaze, die-stamped "G.E. OHR - Biloxi, Miss."......................**5,775.00**

Vase, 4¼" h., 4½" d., wide bulbous ovoid ridged body tapering to a flaring folded & twisted rim, half brown & half yellow speckled glaze, die-stamped "G.E. OHR - Biloxi, Miss." ..**1,540.00**

Vase, 4½" h., 2 ¾" d., ovoid body tapering to a double bulb-pinched neck, blue glossy overall glaze, die-stamped "G.E. OHR - Biloxi, Miss." ..**1,155.00**

Vase, 4½" h., 2 ¾" d., a squatty bulbous compressed body raised on a flaring foot, the sides tapering sharply to a wide flaring trumpet neck, blood red & green glossy glaze, die-stamped "G.E. OHR - Biloxi, Miss."............**1,100.00**

Vase, 4½" h., 3" d., footed squatty compressed base w/a wide angled shoulder to the ringed, trumpet-form neck,

pinched & looped handles at the sides of the neck & shoulder, die-stamped "G.E. OHR - Biloxi, Miss." (rim nick)**1,980.00**

Vase, 4½" h., 3 ¾" d., cylindrical form w/an upright lobed mouth & an in-body twist in the lower body, orange & buff-colored bisque clay, incised script signature...................**1,100.00**

Vase, 4 ¾" h., cylindrical body w/a bulbous swelled shoulder below the wide symmetrically folded & crimped flaring neck, glossy mottled black & brown glaze, base incised "GE Ohr"**990.00**

Vase, 4 ¾" h., wide flattened, pinched & twisted body in a scroddle cream & terra cotta bisque clay, the exterior inscribed "mary had a little Lam & George had a little pot ohr E/Dec 18, 1906 - $ amen - Edna Dadler - Dec 18, 06," base incised w/script signature "G.E. Ohr"...........**3,410.00**

Vase, 4 ¾" h., 2½" d., footed bulbous body tapering gently to a squatty bulbous rim band, pink & blue blistered glaze, die-stamped "G.E. OHR - Biloxi, Miss."**715.00**

Vase, 4 ¾" h., 2 ¾" d., footed barrel-shaped body, blistered pink & blue matte exterior glaze, yellow & green speckled interior glaze, unmarked**880.00**

Vase, 4 ¾" h., 4½" d., corseted folded body w/folded rim, bisque-fired terra cotta clay, incised script signature "G.E. OHR"**1,100.00**

Vase, 5" h., 3¼" d., baluster-form w/flaring neck & a dimpled band around the body, overall unusual white bisque glaze, incised script signature**550.00**

Small Ohr Vase

Vase, 5" h., 5" d., bulbous ovoid body w/crimped & folded rim, banded shoulder & dimpled lower body, lavender speckled glossy glaze, die-stamped "G. E. OHR - Biloxi, Miss."**3,575.00** (Illustration)

Vase, 5 ¾" h., 4½" d., footed spherical body w/an in-body twist below the wide trumpet-form neck, long looping handles down each side, green & yellow mottled glaze (rim repair)...............................**3,300.00**

Vase, 6" h., 5" w., jack-in-the-pulpit form, the footed baluster-form body tapering to a very large, over-sized pinched & folded four-sided rim w/three of the folds pointed & pulled out, lustered brown glaze, impressed in one line mark "GEO.E. OHR, BILOXI, MISS."**1,430.00**

Vase, 6" h., 4" d., low foot, slightly bulging cylindrical body w/a flared rim, crisp mirrored greenish brown high glaze, die-stamped "G.E. OHR - Biloxi, Miss".**715.00** (Illustration: No. 3, with candleholder)

Vase, 6" h., 5" d., footed bulbous ovoid body w/an in-body twist at the base of the three-tiered neck w/a flaring rim, dark green & gun-metal black glaze, die-stamped "G.E. OHR - Biloxi, Miss."**3,025.00**

Vase, 6¼" h., 5" d., wide baluster-form body w/a deep in-body twist at the shoulder & forming the low neck w/a flaring rim, gun-metal black glaze, stamped "G.E. OHR - Biloxi, Miss."**3,025.00**

Ohr Footed Vase

Vase, 7" h., 5" d., low pedestal foot supports a wide bulbous body w/a cylindrical lower half & swelled bulbous upper half topped by a short cylindrical neck w/a folded & crimped rim, brilliant cobalt blue glossy glaze, script mark**1,760.00** (Illustration)

Vase, 7" h., 5½" d., bulbous nearly spherical body tapering to a wide crimped & folded cylindrical neck, overall green & gun-metal black mottled glossy glaze (minor touch-up to rim nicks)..................**2,200.00**

Vase, 7¼" h., 3½" d., footed cylindrical body w/corseted neck, metallic mottled gun-metal black & green high glaze, die-stamped "G.E. OHR, Biloxi, Miss."**880.00**

Vase, 7¼" h., 4" d., cylindrical w/deep in-body twist at base & top, folded rim, bisque-fired buff clay, incised script mark**880.00** (Illustration: No. 1, with candleholder)

Vase, 7 ¾" h., 3½" d., 'hour-glass' form, a low pedestal foot supporting a body w/a squatty bulbous base tapering to a slender cylindrical middle supporting a wide bulbous cupped rim, fine mottled green, red & gun-metal flambé glaze, orange & red interior, marked "G.E. OHR - Biloxi, Miss."**1,430.00**

Vase, 8½" h., 5½" d., slightly globular w/large dimples in the sides & collapsed rim, covered in a pigeon-feathered olive, green, dark blue, rose & mustard glaze, clear glossy interior, marked "GEO. E. OHR - BILOXI, MISS."**14,300.00**

Bottle-Shaped Ohr Vase

Vase, 9¼" h., 3" d., bottle-shaped, a cylindrical body w/a baluster-form neck w/a deep cupped rim, mottled deep blue & green glossy glaze, die-stamped "G.E. OHR - Biloxi, Miss."**1,870.00** (Illustration)

Vase, 9¼" h., 3¼" d., corseted two-segment body w/the ovoid body segment on a disc foot & the cylindrical upper segment w/an in-body twist below the widely flaring rim, khaki green to brown glossy glaze, die-stamped "G.E. OHR - Biloxi, Miss."**3,740.00**

Tall Conical Ohr Vase

Vase, 13 ¾" h., 4 ¾" d., tall slender conical base tapering to a double gourd throat & flared rim, even metallic black satin gloss glaze, die-stamped "GEOHR - Biloxi, Miss.," line emanating from rim flake**7,700.00** (Illustration)

Pitcher, 3¼" h., 4" l., ovoid pinch-sided body w/cut-out angular handle & long vertical dimples, fine gun-metal lustered glaze, die-stamped "G.E. OHR - Biloxi - Miss.".............**1,650.00** (Illustration: No. 3)

Teapot, cov., left-handed, footed spherical body w/wide cupped rim w/inset cover, C-scroll handle, swan's-neck spout, mottled matte purple, blue & green glaze, die-stamped "G.E. OHR - Biloxi - Miss.," 7" d., 4½" h.**3,575.00** (Illustration: No. 1)

Vase, 4½" h., 5" d., bulbous ovoid footed body pulled into an almond-shaped top opening, fine Mirrored Black glaze, obscured mark**715.00** (Illustration: No. 2)

1 2 3

Ohr Teapot, Vase & Pitcher

OWENS

The J.B. Owens Pottery Company operated in Ohio from 1890 to 1929. Zanesville was the home of the pottery from 1891 on and beginning in 1896 art pottery wares were made. The "Utopian" line was the first true art pottery Owens made but others followed. After 1907 the factory switched to the production of tiles. The factory burned in 1928 and attempts to rebuild failed so the company closed in 1929.

Bowl, 7" d., 3 ¾" h., Venetian line, a swelled band around the base below the upright sides molded w/an undulating design, iridescent gold nacreous mirrored glaze, unmarked**$165.00**

Ewer, Utopian line, tall slender baluster-form body w/a widely

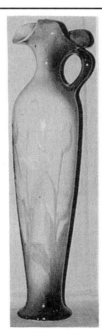

Tall Owens Utopian Ewer

flaring & folded rim, small loop rim handle, decorated w/tall yellowish orange tulips w/pale green stems & leaves on a shaded brown to pale orangey tan ground, glossy glaze, No.1082**2,000.00** (Illustration)

Jardiniere, Cyrano line,
8" h.**300.00**

Jug, Art line, decorated w/poppy
florals, glossy glaze, shape
No. 820, 6" h.**175.00**

Jug, Art line, floral & corn deco-
ration, numbered "820"**115.00**

Mug, Utopian line, leaves &
berries decoration, dated
1908**95.00**

Pitcher, 12½" h., Utopian line,
decorated w/cherries, num-
bered "1015"**250.00**

Plaque, wall-type, rectangular,
quenca-decorated w/a land-
scape of a path leading into
mountains in yellow, pink &
green, matte glaze, marked
"OWENS," framed,
13" sq.**1,210.00**

Vase, 4½" h., 3" d., Utopian
line, yellow slip floral decora-
tion on a dark brown to
reddish brown ground**95.00**

Vase, 5¼" h., 4½" l., flattened
wide swelled body w/a four-
lobed scalloped rim, raised on
four small tab feet, decorated
w/a large white daisy against a
dead matte shaded brown to
green ground, decorated by
Hattie Eberline, impressed
mark & artist's initials**110.00**

Vase, 6¾" h., 6½" d., Verde
Matte line, squatty bulbous
base w/tall conical sides,
embossed around the bottom
w/stylized flowers, rich matte
green glaze, unmarked**220.00**

Vase, 8¾" h., 5½" d., squatty
bulbous base w/a wide shoul-
der to tall tapering cylindrical
sides w/a flat rim, overall
squeezebag decoration of out-
lined large daisies on a shaded
pink to olive green ground,
impressed torch mark, minor
roughness on some
squeezebag decoration......**1,045.00**
(Illustration: top next column)

Rare Owens Vase

Vase, 9¾" h., 4¼" d., slightly
tapering cylindrical body,
angled buttress handles near
w/the top, embossed stylized
roses, matte green glaze, die-
stamped "OWENS - 34"**385.00**

Vase, 10" h., Utopian line, bul-
bous body, floral decoration,
artist-signed (factory glaze
bubbles on bottom)**295.00**

Vase, 11" h., 4" d., baluster-form
w/a tiny flaring neck, Coralene
Opalesce glaze, glossy glazed
slip-decorated orange flowers
covered by a green gold cora-
lene surface, impressed
mark**715.00**

Vase, 13" h., Utopian line, bul-
bous w/trumpet-shaped top,
Opalesce glaze**595.00**

Vase, 13½" h., 8½" d., Mission
line, ovoid w/tiny mouth, slip-
decorated scene of the Santa
Barbara Mission in grey &
brown against the evening sky,
artist-signed & "Mission
Pottery"**900.00**

Vase, Opalesce line, tall slender
ovoid body w/a flat mouth, dec-
orated w/random patches of
brown, reddish brown, orange,
creamy yellow & olive green on
a green iridized ground w/white
outlined small patches**1,100.00**
(Illustration: top next page)

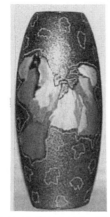

Owens Opalesce Vase

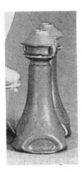

Pair of Owens Vases

Vases, 9½" h., 4" d., flaring base w/footed effect, tapering body w/buttressed top, No. 1158, glaze nick to edge of one, pr. ...**522.50**
(Illustration)

PAUL REVERE POTTERY

A group of philanthropists founded this pottery in Boston, Massachusetts in 1906 in order to better conditions for underprivileged young girls and women in the area. The small "Saturday Evening Girls Club" pottery was supervised by Edith Brown and the operation moved, in 1912, to a house near the Old North Church famous for Paul Revere's lanterns. Most of the wares were hand-decorated with mineral colors and both sgraffito and molded designs were used. The wares became popular but the operation was never profitable and depended on financial contributions. Edith Brown died in 1932 and the pottery foundered and finally closed in 1942.

S.E.G.

Bowl, cov., 5" d., 3¼" d., decorated w/a medallion on the lid depicting tall poplar trees by a river, in green, brown & white against a yellow ground, lid painted "E.M. - 11 - 7".........**$495.00**

Bowl, 7 ⅜" d., deep rounded sides, the interior decorated w/a gun-metal black exterior glaze & a black over dark blue interior, original paper label on base reading "Paul Revere Pottery Price $2.50"**175.00**

Bowl, 8½" d., 2¼" d., squat low body decorated w/a sharply defined band of yellow nasturtium blossoms & green leaves outlined in black against a blue sky on a green ground, decorated by Albina Mangini, painted in black "AM - 10 - 17 - SEG," 1917**1,870.00**

Box, cov., wide squatty bulbous body w/closed rim, low-domed cover w/button finial, overall bluish green glaze, dated "7/9/26," 5½" d.,4¼" h.**137.50**

Center bowl, low rounded sides w/a closed rim, decorated w/a repeating band of reflecting clouds, trees & small houses in green, white, blue & brown, base marked "S.E.G." & obscured date & artist signature, 8⅝" d.**715.00**

Creamer, gently tapering cylindrical body w/pinched spout, applied handle, cream ground decorated w/a rim band of ducks against a blue band, inscribed "S.E.G. 5-18," 3⅛" h.**287.50**

Cups & saucers, demitasse, decorated w/white & black lilies on a yellow & white ground, painted in black "SEG - E.G. - 1-20" or "4-21," cup 3½" d., 2" h., 8 sets (some minor nicks & one small chip & hairline)**660.00**

Jar, cov., squatty bulbous ovoid body w/a nearly flat fitted cover w/button finial, decorated w/a band of winged insects in lavender on pink & yellow bands on an ivory matte ground, signed "E.G. - S.E.G. - 72-2-12," 4½" h. ...**1,870.00**

Jar, cov., gently rounded sides, decorated w/a scenic band of stylized green & black trees against white mountains & a blue sky, on a sheer white ground, button finial on flat lid, painted in black "SEG - T.M. - 11-13," 1913, 5¼" d., 5¼" h.**770.00**

Mug, incised tree-filled landscape & solitary nightingale over the inscription "In the forest must always be a nightingale and in the soul a faith so faithful that it comes back even after it has been slain," glazed in greens, brown, blue, cream & yellow, decorated by Sara Galner, inscribed artist's initials & marks, ca. 1915, 4" h.**1,430.00**

Plate, 8½" d., incised around the edge w/a border band of running pigs in green, cream, mustard yellow & brown outlined in black, a monogram in the center "H.O.S." in a circle, matte glaze, inscribed "S.E.G. 423.12.10 - R.B.".................**1,495.00**

Plate, dinner, 8½" d., decorated w/a wide border band of smiling walking pigs in cream on a green, yellow & brown background, a small circle in the center w/the monogram "HOS," painted mark SEG - R.B. - 438.12.10" (minor rim bruise)**1,540.00**

Table setting: berry bowl, underplate & 9½" d. dinner plate; border design of white flowers on a white ground against an overall blue ground, painted in black "348-9-10 - SEG - FL," 1910, 3 pcs.**550.00**

Tea set: six cups, saucers & 6" d. plates; satiny yellow matte finish, die-stamped circle mark, 18 pcs.**247.50**

Tile, octagonal, decorated w/a windmill in tan & cocoa on a tan ground, outlined in black against a mustard yellow ground, marked "S.E.G. A-17 JMD," 2½" w.........................**319.00**

Tile, square, decorated w/a rim band in a Greek key type design in medium blue & light blue outlined in black & surrounding a rich blue center square, narrow white outer border band, framed, 5" sq.**467.50**

Vase, 4¼" h., 3 ¾" d., wide ovoid body w/closed rim, overall green volcanic glaze, impressed mark & "5/25".......**220.00**

Vase, 4½" h., simple wide ovoid body w/a wide closed rim, a stylized Arts & Crafts design in black w/royal blue highlights against an opaque white ground in a wide band around the top above a lower portion w/a rose pink matte glaze, mark covered by large original paper label**990.00**
(Illustration: top next page)

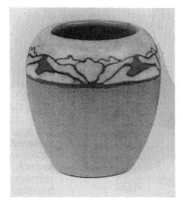

Decorated Paul Revere Vase

Vase, 4½" h., hexagonal, nine-color, decorated overall w/cottages, trees, flowers, village on river, fence, etc., No. 145, 2 -12, artist-signed "A.M."(?)**3,850.00**

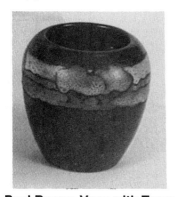

Paul Revere Vase with Trees

Vase, 4½" h., 3 ¾" d., wide ovoid body tapering to a closed mouth, decorated w/a band of trees in green & light blue against a dark blue matte ground, unmarked**990.00** (Illustration)

Vase, 7¼" h., cylindrical body w/slightly flared rim, decorated w/a continuous design of stylized trees in greyish green & brown w/black outlining, marked**440.00**

Vase, 8½" h., 7" d., wide ovoid body w/a wide closed mouth, decorated w/a broad band of grey geese in flight over a deep blue body of water & an ochre landscape in a band around the top above a black lower body, painted mark "S.E.G. 8/26"**3,190.00**

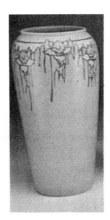

Paul Revere Vase with Daffodils

Vase, 10¼" h., slightly swelled tapering cylindrical body w/a wide mouth, decorated around the shoulder w/stylized daffodils in two shades of matte yellow, outlined in black, white upper background & pale mustard yellow rim & shoulder, by Fanny Levine, inscribed marks, hairlines at rim**1,380.00** (Illustration)

Bowl, cereal, 5½" d., 2½" h., deep tapering rounded sides, decorated w/an upper band featuring groups of three little pigs walking towards a house in green outlined in black, on a brown path, marked in black

"SEG - EG - 40-7-12 - AM," 1912, short hairline at rim**935.00** (Illustration: No. 4)

Tea set: tall cov. teapot, open sugar, creamer, five cups & six saucers; each piece w/a frothy

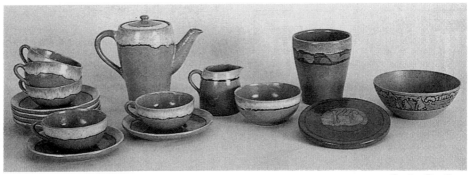

Courtesy Dave Rago

1 2 4

3

Paul Revere Tea Set & Other Pieces

white upper band lined in black over a bluish grey lower body, some pieces marked, small under spout chip on creamer, teapot 7½" w., 6¾" h., the set**577.50**
(Illustration: No. 1)

Trivet, round, decorated w/a center medallion of a swimming white swan against a yellow & light blue sky, dark blue outer bands, painted "FL - 11-

24" & die-stamped pottery mark, 1924, 5½" d.................**495.00**
(Illustration: No. 3)

Tumbler, gently flaring cylindrical form, an upper band painted w/stylized tulips in white & blue outlined in black under a frothy rim band & over a green lower ground, large paper label, 4" d., 5" h.**302.50**
(Illustration: No. 2)

PETERS & REED

John D. Peters and Adam Reed formed a partnership in 1897 to produce flowerpots. Established in Zanesville, Ohio the firm was formally incorporated as Peters and Reed in 1901. Utilitarian ware was the main production until after 1907 when they expanded into the art pottery field. A former designer from the Weller Pottery, Frank Ferrell, developed the "Moss Aztec" line at Peters and Reed and other art lines followed. Pieces are not marked but attribution is fairly easy once one becomes familiar with their lines. The company became the Zane

Pottery in 1921 and continued production until 1941.

ZANEWARE
MADE IN U.S.A.

Basket, hanging-type, Moss Aztec line, 9¼" d., 4" h.**$59.00**

Bowl, 2" h., Persian Ware, decorated w/geometric designs....................................**25.00**

Bowl, low, Landsun line**75.00**

Bowl, low, green matte glaze,
stamped "Zane Ware"**75.00**

Cuspidor, Ferrell line, pine
cone decoration, 5" h.**90.00**

Jardiniere, decorated w/green
lion heads on beige ground,
bunting between lions, fluted
around bases, 7½" d.,
6½" h.**62.00**

Mug, grape decoration**50.00**

Pitcher, jug-type, 4½" h., Brown
Ware, embossed lion's head &
grape swags decoration**50.00**

Vase, 5" h., 6" d., three-footed,
three shoulder handles, deco-
rated w/three pink & beige
applied cavaliers, glossy
streaked brown glaze**40.00**

Vase, bud, 5½" h., Landsun
line, brown glaze**60.00**

Vase, 8" h., blackberry
decoration**90.00**

Vase, 8" h., Landsun line**65.00**

Vase, 8" h., laurel decoration**90.00**

Vase, bud, 11½" h., brown
glaze**125.00**

Vase, bud, 14½" h., Moss Aztec
line**165.00**

Wall pocket, Egyptian Ware,
green glaze, 9" h.**75.00**

Wall pocket, decorated
w/ferns, green ground, matte
finish...................................**190.00**

PEWABIC

*The Pewabic Pottery was estab-
lished in Detroit, Michigan in 1903
as a partnership between Mary
Chase Perry (Stratton) and Horace
J. Caulkins. Pewabic Pottery
evolved from their Revelation
Pottery and they chose the
Chippewa Indian word "Pewabic"
as the name since it meant "clay
with copper color." It was Caulkins
who developed the clay formulas
while Mary Perry Stratton was the
artistic creator of the forms and
glazes. The pottery eventually
offered a wide range of colored and
finely textured glazes and they
developed a reputation for fine
wares and architectural tiles.
Although Caulkins died in 1923,
Mrs. Stratton continued to success-
fully operate the pottery through the
Depression years, until her death at
age ninety-four in 1961.*

Book ends, the upright sides
w/beveled top corners, incised
w/a frontal view of a rabbit in
light green against a blue
ground, clear lustred glaze,
stamped "PEWABIC -
DETROIT," 3 ¾" w., 5¼" h.,
pr.**$605.00**

Bowl, 5" d., 2½" h., deep round-
ed tapering sides w/a wide flat
rim, iridescent lustre glaze in
pale blue, gold, violet & tan,
bright aqua interior**275.00**

Bowl-vase, squatty bulbous
form w/a wide flattened shoul-
der forming a closed mouth, iri-
descent lustre glaze in aqua,
yellowish green & gold
w/caramel highlights,
impressed mark, 6½" d.,
4" h......................................**770.00**

Flower frog-vase, ball-shaped
body w/horizontal ridging &
pierced w/two staggered rows
of round holes, purple & red iri-

descent glaze, die-stamped "Pewabic - Detroit," 3" d., 2" h.......................................**110.00**

Vase, 2¼" h., 2½" d., compressed globular form, incised w/swirling lines, lustered celadon, gold & burgundy glaze, incised "PEWABIC"**412.50**

Vase, 2 ¾" h., 3½" d., nearly spherical body tapering to a wide flat mouth, blue & purple iridescent glaze, impressed circle mark............................**495.00**

Vase, 3 ¾" h., wide ovoid body w/a very wide flat rim, a wide band of pale blue iridescent drip glaze around the rim above a silvery grey iridescent glazed body, marked on base**275.00**

Vase, 3 ¾" h., 3 ¾"d., footed squatty bulbous body w/a wide shoulder tapering to a short rolled neck, iridescent gold & blue flambé glaze, impressed early circular mark................**495.00**

Vase, 5" h., bulbous ovoid body w/the narrow shoulder tapering to a short cylindrical neck w/rolled rim, royal blue glossy glaze w/large patches of golden green lustre, impressed mark**605.00**

Vase, 5" h., 4" d., bulbous w/pinched & flared neck, rich flowing iridescent purplish blue & turquoise flambé glaze, die-stamped circular mark..........**660.00**

Vase, 5" h., 5½" d., footed bulbous body w/short flaring rim, mottled bluish grey & gold iridescent glaze, impressed circular mark "PEWABIC - DETROIT"..........................**715.00**

Vase, 6¼" h., 6" d., bulbous ovoid body tapering to a short flaring neck, sky blue flambé exposing the clay body, die-stamped "Pewabic - Detroit"**660.00**
(Illustration: top next column)

Bulbous Ovoid Pewabic Vase

Squatty Bulbous Pewabic Vase

Vase, 6½" h., footed squatty bulbous body w/the wide shoulder tapering to a short cylindrical neck w/flared rim, iridescent blue glaze w/violet, green, gun-metal & gold highlights, partially obscured impressed mark**715.00**
(Illustration)

Vase, 8½" h., cylindrical body w/a narrow angled shoulder to the short widely flaring neck, aqua glossy drip glaze over a tan, green & rose glossy glaze w/violet & blue iridescent highlights, impressed mark**1,045.00**

Vase, 9" h., 7½" d., bulbous ovoid body tapering to a short wide & slightly flaring neck w/molded rim, iridescent copper glaze dripping over a cobalt blue body, w/paper label (restoration to rim)..............**1,210.00**

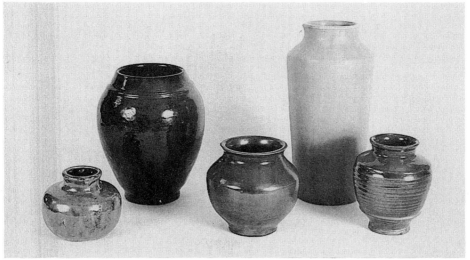

Courtesy Dave Rago

1 3 5
 2 4

Group of Pewabic Vases

Vase, 3 ¾" h., 3 ¾" d., squatty body w/flat shoulder & short neck, overall rich thick dripping iridescent cobalt, silver & green glaze, paper label "Pewabic - Detroit,"**770.00** (Illustration: No. 1)

Vase, 5" h., 4 ¾" d., bulbous w/tapering shoulder & short flaring rim, lustered blue & purple semi-matte glaze, die-stamped circular mark...........**440.00** (Illustration: No. 3)

Vase, 5¼" h., 4" d., bulbous footed body w/a tapering shoulder & flared rim, lustered violet, copper & gold iridescent flambé over a ridged body, circular mark, "PEWABIC - DETROIT,"**715.00** (Illustration: No. 5)

Vase, 8" h., 5½" d., ovoid w/a ridged rim & hammered surface, black, turquoise, blue lustered glaze, impressed circular mark "Pewabic - Detroit"**1,540.00** (Illustration: No. 2)

Vase, 10 ¾" h., 5" d., tapering cylinder w/concave shoulder, dripping shaded light mint green matte glaze, die-stamped maple leaf mark......**495.00** (Illustration: No. 4)

PISGAH FOREST

Shortly after 1900 Walter Stephen began experimenting with making pottery with his parents in Tennessee. After 1910, when his parents died, Stephen eventually moved to the foot of Mt. Pisgah in North Carolina and joined in a pottery making partnership with C.P. Ryman. The two built a kiln and a shop before the partnership dissolved in 1916. During the early 1920s Stephen carried on experiments with his pottery and by 1926

he owned his own pottery and equipment where he produced a variety of wares, most notably his "Cameo Ware" featuring white relief figural scenes reminiscent of the famous Wedgwood Jasper Ware. Most pieces were marked and may also carry the "W. Stephen" signature along with the date. Although Walter Stephen died in 1961 the pottery continues to operate on a part-time basis.

Bowl, 6 ¾" d., 2 ¾" h., Cameo ware, low rounded sides, a white relief-molded wagon train scene around the sides on a matte green ground, raised mark & "Stephen"...............**$220.00**

Pisgah Forest Cameo Bowl

Bowl, 7 ¾" d., Cameo ware, wide flat bottom w/low upright slightly rounded sides w/a flat rim, matte green decorated w/a white relief continuous scene of a log cabin & a hunter seated on a stump w/his dog nearby, base marked "Cameo Stephen Long Pine Ardenne," & dated 1953**275.00** (Illustration)

Creamer, Cameo ware, bulbous ovoid body tapering to a flat rim

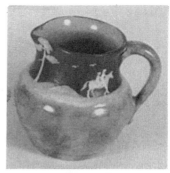

Pisgah Forest Creamer

w/a pinched spout, applied strap handle, upper half w/a matte green ground decorated w/a white relief wagon train scene, the lower half in glossy blue, raised mark, 5½" d.**220.00** (Illustration)

Creamer, Cameo ware, scene of a mountain man, his dog, a cabin & mountains**350.00**

Creamer & cov. sugar bowl, Cameo ware, bulbous ovoid body, each w/a white relief band of covered wagons & oxen on a green matte ground, loop handles, raised mark, 4½" & 5" h., pr.**385.00**

Mug, Cameo ware, waxy blue ground decorated in white w/an elderly lady sitting at a spinning wheel, embossed potter mark & "STEPHEN," 4" d., 3¼" h.**165.00**

Mug, Cameo ware, white relief covered wagon scene, ca. 1949, signed "Stephen"..............**150.00 to 175.00**

Pitcher, 5" h., 5½" d., Cameo ware, bulbous ovoid body tapering to slightly tapering rim, loop handle, decorated w/wagon trains in white relief on a matte green ground over a glossy blue body, raised Pisgah Forest mark...............**220.00**

Pitcher, 5¾" h., Cameo ware, wide ovoid body tapering to a

flat rim w/pinched spout, applied D-form handle, dark green matte glaze w/a white relief covered wagon scene around the neck, interior w/glossy pink glaze, base marked w/company logo, "W.B. Stephen" & "1946"...............**357.50**

Teapot, cov., Cameo ware, squatty bulbous body w/an inset low domed cover w/button finial, thick D-form handle & a short shoulder spout, dark blue green matte glaze decorated w/a white relief covered wagon scene, base marked "Cameo Stephen Long Pine Ardenne," & dated 1953, 4½" h...................................**495.00**

Vase, 4" h., bulbous, blue crystalline glaze w/pink interior, dated "1938"...........................**50.00**

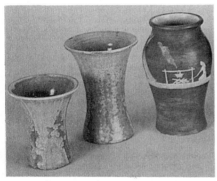

Three Pisgah Forest Vases

Vase, 5" h., 4" d., trumpet-shaped body, covered w/white snowflake glaze on a greyish blue ground, raspberry interior, embossed mark, date obscured by glaze.................**275.00** (Illustration: left)

Vase, 5½" h., 4" d., corseted-form, white crystals sparsely set against a cream to green high gloss ground, pink interior, embossed "Stephen - 1948"**110.00**

Vase, 5½" h., 5½" d., bulbous body tapering to a short neck

w/flat rim, yellow & white cyrstalline glaze, raised mark**440.00**

Vase, 6" h., 3 ¾" d., Cameo ware, baluster-form, olive green ground decorated w/a white relief covered wagon scene & mountains, pink interior, embossed "194 - - Cameo - Stephen - Long Pine - Ardenne"**330.00**

Vase, 6" h., 4 ¾" d., Cameo ware, wide baluster-form body swelled around the middle & tapering to a wide cylindrical neck, the neck molded w/a white-relief scene of a dog chasing two deer on an olive green ground, celadon green glossy glaze on lower body, embossed 'potter' mark & "1938"....................................**550.00**

Vase, 6" h., 5" d., two-handled, ovoid w/rounded shoulder & short wide neck, soft pink satin glaze, by W. Stephen, 1934**110.00**

Vase, 6½" h., Cameo ware, simple ovoid body tapering to a wide cylindrical neck, the neck in dark matte green decorated w/a white relief band of covered wagons, the lower body in a glossy mottled blue, the interior in glossy pink, marked & dated 1932**522.50**

Vase, 6½" h., 4½" d., trumpet-shaped body, covered w/a silver & ivory crystalline glaze, clear raspberry interior, embossed pottery mark, date obscured**165.00** (Illustration: center)

Vase, 7" h., 4 ¾" d., Cameo ware, ovoid body below the wide slightly waisted neck, the neck decorated in white relief w/an Indian buffalo hunt scene on a dark green ground, a white crystalline lower body, rose pink interior, raised mark**1,210.00**

Vase, 7½" h., 4" d., Cameo ware,baluster-form body, decorated w/white relief scenes of Indian life, matte blue mottled ground, decorated by Walter Stephen, embossed pottery mark & dated 1937....**325.00** (Illustration: right)

Vase, 7½" h., 6" d., squatty bulbous body tapering to a wide, slightly flaring neck, three long handles from rim to shoulder, overall celadon green glossy glaze, raised mark "Pisgah Forest - Aunt Nancy".............**165.00**

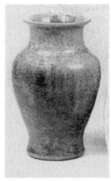

Fine Pisgah Forest Vase

Vase, 8" h., baluster-form w/short cylindrical neck & flaring rim, blue, green & white crystalline glaze w/gold highlights, raised mark..............**1,210.00** (Illustration)

Vase, 8½" h., 5¼" d., ovoid body w/a rounded shoulder to the short cylindrical neck w/flat wide mouth, lustre glaze in blue & bluish green crystals over a gold body, rose pink interior, raised mark, 1943**550.00**

Vase, 10" h., 6" d., flaring cylindrical form w/horizontal ribbing, Persian blue & wine crackled flambé w/pink interior, embossed potter mark & dated 1942**220.00**

Vase, 15" h., 8½" d., wide ovoid body tapering to a slightly flar-

ing molded rim, turquoise glossy glaze, raised mark ..**1,100.00**

RED WING

Various potteries operated in Red Wing, Minnesota from 1868, the most successful being the Red Wing Stoneware Co., organized in 1878. Merged with other local potteries through the years, it became known as Red Wing Union Stoneware Co. in 1894, and was one of the largest producers of utilitarian stoneware items in the United States. After a decline in the popularity of stoneware products, an art pottery line was introduced to compensate for the loss and this was reflected in a new name for the company, Red Wing Potteries, Inc., in 1930. Stoneware production ceased entirely in 1947, but vases, planters, cookie jars and dinnerwares of art pottery quality continued in production until 1967 when the pottery ceased operation altogether.

Vase, 10½" h., 6" d., ovoid body tapering to a short cylindrical neck, overall green & ochre mottled matte glaze, diestamped "RED WING ART POTTERY"..................**$275.00**

Vase, 10½" h., 6" d., footed squatty bulbous base below a tall, wide & gently tapering neck w/a rolled rim, mottled green & ochre matte glaze, diestamped "RED WING ART POTTERY"...........................**302.50**

ROOKWOOD

The most famous and highly respected American producer of art pottery, the Rookwood Pottery Company was founded in Cincinnati, Ohio in 1880 by Mrs. Maria Nichols Longworth Storer. A unique mark and dating system were introduced in the mid-1880s and today this back-to-back "RP" insignia is known to most collectors. Over the

*years a wide range of glazes and
decorative techniques were utilized
at Rookwood and the best wares
were one-of-a-kind hand-decorated
pieces which are rare and expensive
today. Less expensive, more commer-
cial cast wares were eventually
introduced in the early 20th century
and these generally sell for lower
prices.*

*The pottery operated in Cincin-
nati until 1959 when it was sold to
the Herschede Hall Clock Company
and moved to Starkville, Missis-
sippi where it continued to operate
until 1967.*

*A few years ago a private compa-
ny obtained some of the original
molds and produced a limited line
of pieces.*

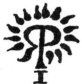

BLACK OPAL GLAZE WARES

Bowl, 10 ⅜" d., shallow widely
flaring sides, decorated on the
interior w/a band of overlapping
leaves in dark blues & browns
against a deep maroon ground,
Black Opal glaze, No. 2295 E,
1929, Sara Sax**$880.00**

Bowl-vase, wide bulbous lower
body below a short angled
shoulder to the wide flat mouth,
decorated around the shoulder
w/a band of stylized streaky flo-
rals in dark maroon & blue
above the dark smeary blue
body, Black Opal glaze,
No. 1927, 1924, Sara Sax,
4" h.**825.00**

Vase, 6" h., spherical body
tapering to a trumpet-form
short neck, decorated w/faint
blue & red florals against a
mottled dark blue ground, deep
orange interior, Black Opal
glaze, No. 402, 1925, Harriet
Wilcox**990.00**

Vase, 7¼" h., simple ovoid body
tapering to a short cylindrical
neck, decorated w/large white
chrysanthemums & dark green
leaves against a shaded dark
maroon to blue-black ground,
orange interior, Black Opal
glaze, No. 927 E, 1924,
Harriet Wilcox....................**2,310.00**

Vase, 8 ¾" h., tall slender waist-
ed body w/flat rim, decorated
w/large exotic pale blue blos-
soms w/red & gold centers, on
dark blue leafy stems against a
shaded pale lavender & blue
ground, Black Opal glaze,
No. 1358 D, 1923, Sara
Sax.....................................**2,970.00**

Rare Black Opal Vase

Vase, 17⅛" h., tall ovoid body
tapering to a short, wide cylin-
drical neck w/a rolled rim, the
sides decorated w/large white
& brown lotus blossoms
against a mottled deep rose
red & blue ground, the neck
w/triangular leaf designs, Black
Opal glaze, No. 384, 1927,
Sara Sax**17,600.00**
(Illustration)

BUTTERFAT GLAZE WARES

Vase, 5 ¾" h., 3 ¾" d., porcelain, baluster-shaped w/a widely flaring neck, decorated w/pale blue daisies on a lavender Butterfat ground, 1944, Jens Jensen**522.50**

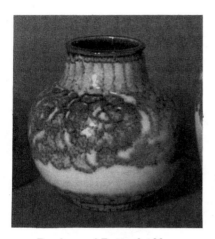

Rookwood Butterfat Vase

Vase, 7" h., wide bulbous body on a narrow footring, the shoulder tapering to a wide, short & slightly tapering neck, decorated around the upper half w/large stylized blue blossoms & leaves against a creamy white ground, bluish white banded neck, Butterfat glaze, No. 2969, 1926, Lorinda Epply**1,045.00** (Illustration)

Vase, 8½" h., elongated bell-form bowl w/widely flaring rim, raised on a short pedestal foot w/a pair of thick loop handles from edge of foot to base of body, decorated on the lower half w/a band of stylized flowers in pink, dark blue & pale green below a creamy white upper half, dark blue interior, Butterfat glaze, No. 6110, 1929, Lorinda Epply**1,430.00**

Vases, 6⅛" h., flaring rectangular sides w/chamfered corners, raised on small knob feet, the sides decorated w/a large brown-speckled white blossom on a dark blue leafy stem against a pale blue ground dotted in dark blue, Butterfat glaze, No. 6036, 1946, Elizabeth Barrett, pr.**660.00**

CAMEO GLAZE WARES

Luncheon set: cup fitted into a two-part segmented plate; each piece w/a swirl-molded rim band & stylized white florals on a creamy white Cameo glaze ground, No. 258, 1888, Anna Valentien, plate 8" d., 2 pcs.**220.00**

Plate, 6 ¾" w., squared shape w/rounded notches at each corner, decorated w/delicate white blossoms on a slender leafy stem against a shaded dark to light to brown ground, Cameo glaze, No. 288, 1886, Anna Bookprinter (glaze scratches)**165.00**

Plate, 8½" d., shallow lightly scalloped lily pad-form, decorated w/white poppies & green leaves against a light tan ground, Cameo glaze, No. 205 C, 1889, Amelia Sprague......**275.00**

COMMERCIAL & MISCELLANEOUS WARES

Book ends, figural, modeled in full-relief w/a flower basket, full of pink, yellow & dark blue flowers & green leaves, No. 2837, 1927, 6⅛" h., pr. (small grinding chips on base).........**385.00**

Book ends, figural, model of a horse head, glossy Wine Madder glaze, No. 6014, 1956, designed by William P. McDonald, 6" h., pr. (firing crack in base of one).............**275.00**

Book ends, figural, model of a large owl perched atop a thick book, bluish grey Matte glaze, No. 2655, 1933, W. McDonald, pr. (restoration to minor chip on one book corner)**330.00**

Book ends, figural, model of a polar bear walking, on a rectangular base, ivory semi-matte glaze, No. 2678, 1934, 6 ¾" l., 4 ¾" h., pr.**495.00**

Book ends, figural, Art Deco style, large eagle perched on a rectangular base, its head extended forward, white Matte glaze, No. 6491, 1945, 5 ⅜" h., pr. (professionally repaired base corner chip on one)**660.00**

Book ends, figural, model of a large kingfisher on a grass-molded rectangular base, crystalline blue Matte glaze, No. 2657, 1929, designed by William McDonald, 5½" h., pr.**522.50**

Book ends, figural, modeled as a wide, rounded leafy tree, overall mottled brown Coromandel glaze, No. 6023, 1929, designed by William McDonald, 5½" h., pr.**550.00**

Book ends, figural, model of a rook standing in front of a flower-molded block, mauve glaze, over-sized weighted design, No. 2274, 1926, 6½" h., pr.**412.50**

Bowl-vase, a small foot supporting a widely flaring bell-form bowl, rich purple porcelain exterior glaze & medium blue interior glaze, No. 2260 C, 1921, 6¼" h.**522.50**

Bust of the Virgin Mary, life-size model w/an ivory glossy glaze & a light blue mantle, No. 6949, 1946, 5½" d., 9 ¾" h.**247.50**

Candlesticks, a long rectangular thick foot w/chamfered cor-

ners centered by a tall upright rectangular shaft w/a round molded mouth, long slender C-scroll handles from the top to the sides of the base, smooth dark bluish grey Matte glaze, factory-drilled hole in base, No. 2680, 1923, 3 ¾" w., 5½" h., pr.**247.50**

Rookwood Center Bowl

Center bowl, long oval bowl on a flaring foot, cast at each end w/a standing nude female lightly draped & leaning backwards into the bowl, white glaze, No. 2923, 1946, designed by Kataro Shirayamadani & Louise Abel, 6 ⅞" h.**440.00** (Illustration)

Compote, open, 10½" h., a wide shallow bowl supported on a figural pedestal base w/three standing putti holding hands w/their backs to a central tree trunk, bowl interior in bright yellow, lower body in deep purple, No. 2440, 1921**467.50**

Figure of a fisherman, stylized lean man wearing blue pants & blue suspenders w/a brown shirt & carrying a large glossy brown fish, on a thin rectangular base, No. 6808, 1942, J. Reich, 8 ⅞" h.**660.00**

Fountain, wall-type, figural, porcelain, modeled as a large young satyr figure framed by two long, curved slender fish above a large scallop shell at the base, mottled greenish yellow & brown glaze, No. 2339,

1916, designed by Ernest Bruce Haswell, 6½" w., 8 ⅝" h.**660.00**

Commercial Humidor

Humidor, cov., cylindrical body in dark glossy green molded around the base w/a scroll-embossed band in mirror brown glaze imitating a metal base & molded around the rim w/a matching band & fitted w/an inset, slightly domed open fretwork cover w/bulbous knob, No. 2622, 1926, 9 ⅜" h.**495.00** (Illustration)

Jardiniere, wide bulbous body w/a wide molded mouth, a purplish blue shaded to cream ground decorated w/scattered Japanesque designs in fired-on gold & h.p. large white chrysanthemums, shiny gold undulating band around the rim, dull satin finish, No. 180 C, 1888, Martin Rettig, 7 ⅝" h....**660.00**

Paperweight, figural, model of a standing elephant w/its trunk resting on the thick rectangular base, crystalline green Matte glaze, No. 2797, 1926, 3¼" h....................................**440.00**

Paperweight, flat square plaque embossed in the center w/a walking elephant w/trunk down, within a molded edge band,

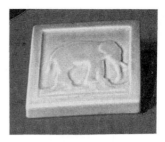

Flat Square Paperweight

shaded pale green to pink Matte glaze, No. 2054, 1921, 3½" sq.**247.50** (Illustration)

Paperweight, figural, model of a blue & red bird perched on a flowering branch in red, blue & white, No. 6837, 1946, 5" h...**467.50**

Paperweight - lamp base, figural, model of the horse 'Man-O-War' standing on a rectangular base w/tree stump, mottled dark & light brown glaze, fitted w/a metal base w/small knob feet & a metal electric light standard behind, No. 6140, 1930, ceramic portion 6¼" h. (small base chip covered by metal trim)**385.00**

Plaque, rectangular, a long arrangement of flowering apple blossom branches in white, pale green & pale brown against a background shading from deep violet at the sides & creamy white in the center, unglazed biscuit form, No. 678, 1920, E.T. Hurley, original wide frame, 9⅛ x 14½" (several firing cracks at edges)**3,410.00**

Sign, counter-type, flattened front w/round top w/embossed Rookwood trade-mark about wording "Rookwood Pottery - Starkville, Miss.," grey glaze, 1965, 4½" h.**357.50**

Smoking set: pair of shallow round ashtrays, a rectangular cov. box w/rounded ends & a beehive-form lighter; each in

pale yellow w/a large blue jay perched on a leafy branch, glossy glaze, box No. 6922 B, lighter No. 6922 & ashtrays No. 6922 A, 1948, Ora King, the set (lighter mechanism broken)**467.50**

Special Cigarette Box

Smoking set: table model lighter, cov. cigarette box & four round ashtrays; the rectangular box w/flat cover & rounded ends decorated w/a large colorful flying pheasant against a creamy white ground, matching decoration on other pieces, special commission pieces, Numbers 6922, 6922A & 6922B, 1945, 1946 & 1950, Lois Furukawa & Loretta Holtkamp, lighter 3 ¾" h., 3 pcs.**467.50**
(Illustration: cigarette box)

Teapot, cov., wide domed & paneled body w/flat inset cover w/paneled knob finial, squared spout & rectangular handle, white ground decorated around the base w/a band of small blue sailing ships, No. M-15, 1925, 4" h.**357.50**

Teapot, cov., spherical body w/narrow vertical ribbing below a plain neck band, swan's-neck spout & C-form handle, low domed cover w/gold button finial, incised & painted w/flowers around the shoulder & highlighted w/fired-on gold against a pale yellow ground

dusted w/pale blue on the cover & upper half, dull satin glaze, No. 193, 1886, Grace Young, 6⅛" h. (small spout chip, two nicks on inner lid rim)**220.00**

Framed Rookwood Tile

Tile, square, a landscape w/leafy trees in the foreground framing a lakeside scene w/distant mountains, wide flat oak frame**2,970.00**
(Illustration: close-up)

Tile, square architectural-type, incised w/a sailing galleon on wide seas beneath billowy white clouds, in shades of dark & light blue, yellow & creamy white, marked "Rookwood Faience - 1251 Y," wide black frame, 12" sq......................**1,540.00**

Commercial Trivet with Bird

Trivet, square, incised w/a large long-legged & long-billed bird in gold & cobalt blue against a white ground w/incised pink iris & green leaves, No. 6778, 1940, 5 ⅜" sq.**302.50** (Illustration: close-up)

Trivet, square, a Dutch landscape w/the large figure of a lady carrying a bucket in the foreground walking toward a canal & village in the background, in blues, greens, white & brown, Vellum glaze, No. 1819, 1921, recently framed, 5½" sq.**330.00**

Trivet, square, a large pale lavender cockatoo spreading his wings against a swirled creamy white & green ground, Vellum glaze, No. 2043, 1930, recently framed, 5½" sq.**220.00**

Rookwood Trivet with Grapes

Trivet, square, molded blue grapes, green leaves & pale purple ground, Vellum glaze, No. 1683, 1919, recent frame, minor glaze pitting, 5 ⅝" sq. ...**220.00** (Illustration)

Trivet, square, molded in relief w/clusters of deep pink grapes & pale green leafy vines against a dark blue ground, Vellum glaze, No. 1683, 1929, recently framed, 5 ⅝" sq.**330.00**

Trivet, square, incised stylized rose pink apples against stylized dark blue, light blue & green leafage, Vellum glaze,

No. 1263, 1921, recently framed, 5½" sq.**192.50**

Trivet, square, a large black rook standing in front of an incised white trelliswork ground w/blue trim, Vellum glaze, No. 1794, 1927, recently framed, 5 ⅝" sq. (minor glaze flaw)....**522.50**

Vase, 4 ⅞" h., footed egg-shaped body tapering to a small rolled mouth, decorated around the base w/embossed stylized leafy flowers in pale lavender against a mottled robin's-egg blue ground, No. 6544, 1935**330.00**

Vase, 5" h., ovoid body tapering to a short flaring neck, overall molded small oblong leaves, copperdust crystalline glaze, No. 6510, 1937**330.00**

Vase, 5 ¾" h., 5" d., hand-thrown, bulbous spherical body tapering to a short cylindrical neck below a deeply ruffed rim, incised flowers against a glossy ochre & burnt orange ground, No. 272C, A.M. Bookprinter.............................**385.00**

Vase, 6 ⅜" h., simple swelled cylindrical body w/a flat rim, decorated around the upper half w/green repeating abstract designs against a dark gold ground, overall speckled & drippy brown Ombroso glaze, No. 155, 1915, William Hentschel**1,045.00**

Vase, 6 ¾" h., 3½" d., tall ovoid body w/flat mouth, carved grape & leaf design on the upper half, streaked turquoise blue semi-matte glaze, No. 2604, 1930**220.00**

Vase, 8" h., footed trumpet-form body w/slightly flaring sides below a wide rolled rim, vertical heavy loop handles below the rim, dark purple blue porcelain-like glaze, No. 2197, 1921**275.00**

Vase, 13⅛" h., a thick flaring foot supporting a tall slender trumpet-form body, molded around the base & foot w/stylized calla lilies, overall pale pink glaze, No. 2010, 1915 ...**357.50**

Vase, 15" h., 7" d., simple tall ovoid body tapering to a short rolled neck, light green semigloss glaze, 1919, No. 614B**467.50**

HIGH (GLOSSY) GLAZE WARES

Book ends, figural, a model of St. Francis kneeling & wearing a dark brown hooded robe, a grey wolf at one side & a grey dove at the other, on a trapezoidal base, glossy glaze, No. 6883, 1945, 7⅜" h., pr. ..**825.00**

Ewer, a wide squatty bulbous base on a footring, the sides tapering to a flaring neck w/wide, pinched spout, applied strap handle, decorated w/large bright pink flowers, buds & leaves against an overall creamy white ground w/a glossy glaze, 1882, Albert Humphreys, 9" h.**467.50**

Figure of an elf, standing on a thick rectangular base, wearing a brown shirt, green tights & brown pointed-toe shoes, a pink feather on his shirt, glossy glaze, 1948, 6⅜" h.**660.00**

Jar, cov., porcelain, ovoid shouldered body w/a short cylindrical neck w/a fitted domed cover, decorated on the cover & around the upper half of the body w/a wide band of cream spade-like devices w/pink & green blossoms above dark green leaf clusters all against a creamy green ground, glossy glaze, No. 47 C, 1918, Sara Sax**1,760.00**

Model of a pheasant, the walking bird w/long tail on a taper-

ing oblong base, decorated in naturalistic browns, blacks & yellows, glossy glaze, No. 2832, 1926, Sara Sax, 8¾" h.**550.00**

Mug, conical sides & D-form handle, decorated w/a bust portrait of American Indian Big Looking Glass, glossy glaze, No. 587C, notation on base "Big Looking Glass," 1946, Flora King, 4⅞" h. (small glaze flaw at rim)**302.50**

Paperweight, figural, model of a small stylized rooster standing on a thick rectangular base, mottled polychrome glossy glaze, No. 6030, 1946, 5" h...**330.00**

Pitcher, 6⅞" h., bulbous nearly spherical body w/a short & wide cylindrical neck w/rim spout, C-form handle, decorated w/large stylized rose & pale pink blossoms against a mottled pinkish cream & blue ground, streaky charcoal rim band, glossy glaze, No. 13, 1924, William Hentschel**550.00**

Vase, 3⅝" h., footed squatty bulbous body tapering to a flat mouth, decorated w/an overall streaked & drippy blue, dark brown & cream glossy glaze, No. 6514, 1952, w/original cardboard sales box..............**192.50**

Vase, 3¾" h., squatty bulbous shouldered body w/a short wide cylindrical neck, decorated w/overall large white & pale blue Art Deco style blossoms on a mottled blue ground, variegated grey, black & brown interior, glossy glaze, No. 1110, 1925, William Hentschel**467.50**

Vase, 4½" h., footed squatty bulbous body tapering to a short, rolled neck, overall streaky & mottled green & tan glossy glaze on blue, 1953, Earl Menzel**247.50**

Vase, 4 ¾" h., bulbous ovoid shouldered body w/a short rolled neck, decorated w/large stylized white irises touched with blue against a mottled pale green ground, dark pink interior, glossy glaze, No. 6194 F, 1948, Jens Jensen............**522.50**

Vase, 5 ⅜" h., simple ovoid body tapering gently to a molded flat rim, decorated w/white & pale yellow crocus blossoms & green stems against a shaded dark rose to dark blue ground, glossy glaze, No. 913 F, 1924, Kataro Shirayamandani**1,430.00**

Vase, 5½" h., bulbous ovoid footed body tapering to a short rolled neck, decorated around the shoulder w/small yellow fruit blossoms & green leaves against a golden rust ground, narrow band of streaky brown around the neck & mottled brown interior, glossy glaze, No. 2831, 1925, Sara Sax.....**935.00**

Vase, 5 ⅝" h., footed bulbous body tapering to a short cylindrical neck w/a widely flaring rim, decorated w/two large stylized tan & blue fish against a mottled greyish blue ground, glossy glaze, No. 6148, 1943, Jens Jensen................**770.00**

Vase, 6⅛" h., footed slender baluster-form body w/a widely flaring neck, decorated around the bottom w/a wide band of large deep rose & tiny yellow blossoms on green leafy vines against a dark blue ground, upper bands of small blue & white arches w/small pink blossoms against a white ground, glossy glaze, No. 357 F, 1919, Arthur Conant........................**880.00**

Vase, 6¼" h., upright rectangular form w/each side folded down the center, the base w/four beveled legs, decorated w/a colored spearpoint design at the base of each side below

mottled blue & cream slightly iridescent upper sides, mottled blue slightly iridescent interior, glossy glaze, No. 6047, 1928, Lorinda Epply**385.00**

Vase, 6½" h., baluster-form body w/wide flaring cylindrical short neck, decorated up the sides w/large stylized pink cherry blossoms on greyish green leafy stems against a mottled blue ground, glossy glaze, 1934, Kataro Shirayamadani**1,650.00**

Vase, 6 ¾" h., swelled cylindrical body w/a narrow shoulder to a molded flat mouth, decorated w/a large willow tree in brown & green & red-flowered bushes beside a lake in which two white birds swim, pale purple mountains & dark blue sky in the background, glossy glaze, No. 938 D, 1920, Arthur Conant**3,410.00**

Vase, 7⅛" h., footed flattened fan-shaped body w/a scalloped & rolled rim, decorated w/clusters of deep pink cherries on pale green & blue leafy stems against a creamy white ground, glossy glaze, No. 6314, 1946, Clotilda Zanetta...........**330.00**

Vase, 7⅛" h., footed tapering ovoid body w/a flaring rim, decorated w/large stylized pale blue & yellow blossoms & dark blue leaves against a creamy yellow round, glossy glaze, No. 6359, 1946, Jens Jensen......**660.00**

Vase, 7 ⅜" h., porcelain, slender slightly swelled cylindrical body w/a short rolled neck, decorated around the shoulder w/a wide band of stylized flying birds amid Oriental blossoms in dark blue on a lighter blue ground, the lower body & neck in dark blue, glossy glaze, No. 2069, Lorinda Epply**1,210.00**

Vase, 7½" h., bottle-form, footed bulbous ovoid base tapering to

a tall, slightly flaring cylindrical neck, decorated around the base w/stylized hyacinths in dark blue, grey & pink against a pale yellow ground, a brown foot & a black mottled band at the rim, glossy glaze, No. 2963, 1927, Lorinda Epply**660.00**

Vase with Penn. Dutch Decor

Vase, 8" h., simple ovoid body w/short flaring neck, decorated around the lower half w/Pennsylvania Dutch-style blossoms on vines against a blue ground, glossy glaze, No. 356 D, 1922, William Hentschel**935.00** (Illustration)

Vase, 8¼" h., ovoid body tapering to a small, short rolled neck, decorated w/a wide band of smeared swirls & flourishes in deep red against a streaked brown & tan ground, crystalline inclusions at the base & rim, glossy glaze, No. 8959, 1946, Jens Jensen**825.00**

Vase, 8½" h., wide ovoid shouldered form tapering to a short rolled neck, decorated w/large abstract flowers & bizarre fish in tan, blue & maroon between rim & base bands of pink & maroon, glossy glaze, No. 6707, 1945, Jens Jensen**1,320.00**

Vase, 8 ¾" h., ovoid body tapering to a thin molded mouth decorated w/large stylized pale & dark pink jonquils w/dark green leaves on a dark blue shaded to gold ground, glossy glaze, No. 6869, 1944, Kataro Shirayamadani**2,310.00**

Vase, 8 ¾" h., a swelled cylindrical body w/a wide flat mouth, decorated w/a wide band of folk art-style exotic geese, sunflowers & leaves in pale yellow outlined in brown against a black ground, upper & lower narrow bands in blue & brown, glossy glaze, No. 2187, 1944, Elizabeth Barrett**990.00**

Vase, 9⅛" h., swelled cylindrical body w/a wide flat mouth, decorated around the upper half w/blue violets & green leaves against a pale blue rim band & a dark blue lower body, glossy glaze, No. 1369D, 1925, Fred Rothenbusch**770.00**

Vase, 10½" h., gently swelled cylindrical body w/a wide, flat mouth, overall embossed design of large parrots in jungle foliage, glossy translucent blue glaze, No. 6088, 1929, designed by Kataro Shirayamadani**385.00**

Vase, 10 ⅝" h., tall & wide waisted cylindrical body, decorated w/large deep pink lotus blossoms & dark lavender leaves against a streaky & mottled dark blue ground, glossy glaze, No. 1358 C, 1924, Kataro Shirayamadani (minor glaze runs)**2,420.00**

Vase, 11½" h., tall slender ovoid body tapering to a short flaring neck, decorated w/pairs of pale gold & dark blue birds perched amid exotic vines w/large burgundy floral clusters & green leaves against a shaded dark maroon to rosy orange ground, glossy glaze, No. 170, 1922, E.T. Hurley**3,520.00**

Vase, 12 ⅞" h., tall slender baluster-form body w/a short trumpet neck, decorated w/smeary design of magnolia blossoms & a large mocking bird in white, blue & black against a streaky, mottled tan ground, glossy glaze, No. 8689, 1946, Jens Jensen (drill hole in base)**770.00**

Vase, 13 ⅜" h., baluster-form body w/a slender neck widely flaring at the rim, decorated w/large stylized deep red flowers on black-green leafy stems against a mottled pinkish tan ground, glossy glaze, No. 216, 1944, Loretta Holtkamp..........**522.50**

Large and Rare Glossy Glazed Vase

Vase, 16 ⅜" h., tall slender baluster-form body tapering to a small, short cylindrical neck, decorated w/a flower garden of large red zinnias on dark green leafy stems & tall blue phlox on light green leafy stems against a dark blackish green shaded to pale cream ground, glossy glaze, No. 2368, 1925, Kataro Shirayamadani**19,800.00** (Illustration)

IRIS & BLACK IRIS GLAZE WARES

Vase, 4 ⅞" h., ovoid body tapering to a short flaring neck, decorated w/pale wild roses on green leafy stems against a dark blue shaded to white ground, Iris glaze, No. 605, 1901, Ed Diers**770.00**

Vase, 5½" h., 3¼" d., bulbous w/short slender neck, decorated w/white & yellow flowers & greyish green foliage against a dark to light grey ground, Iris glaze, No. 905, 1908, Irene Bishop.........................**605.00**

Vase, 5 ⅝" h., slender ovoid body tapering to a short cylindrical neck, decorated w/white flowers on long pale green stems against a pale violet ground, Iris glaze, No. 918, 1901, Sara Sax**550.00**

Vase, 5 ⅞" h., ovoid body tapering to a short cylindrical neck flanked by small angled strap handles, decorated w/a small cluster of blue blossoms w/long green stems & leaves down the sides, all against a dark green to cream ground, Iris glaze, No. 604 E, 1906, Irene Bishop**1,045.00**

Vase, 6¼" h., slender conical body below a squatty bulbous cupped rim, decorated around the base w/a narrow band of stylized fruit blossoms in creamy white w/the remainder of the body in a dusty mauve Iris glaze, No. 1656 F, 1911, Katherine Van Horne**495.00**

Vase, 6¼" h., wide ovoid body tapering slightly to a wide flat mouth, decorated w/large dark blue grape clusters on dark green leafy vines against a white shaded to black ground, Iris glaze, No. 942 C, 1903, Irene Bishop, original store paper label**2,310.00**

Vase, 6 ⅜" h., ovoid body tapering to a short cylindrical neck, decorated around the shoulder w/purplish blue berries & dark & light green leaves against a grey-blue shaded to cream ground, Iris glaze, No. 905 E, 1904, Clara Lindeman...........**935.00**

Vase, 6½" h., ovoid body tapering to a short cylindrical neck, decorated around the upper half w/red cherry blossoms & green leaves against a pale green shaded to dark brown ground, Iris glaze, No. 905 E, 1900, Harriet Wilcox...........**1,210.00**

Vase, 6½" h., slightly swelled slender cylindrical body w/a narrow shoulder to the short rolled neck, decorated w/large pale lavender-white crocus blossoms & long pale green ground, Iris glaze, No. 904 D, 1902, Constance Baker**935.00**

Vase, 6 ⅝" h., slightly swelled cylindrical body w/a flat mouth, decorated w/a stylized Art Nouveau landscape w/bending trees & a bay w/sailboats in pale blues, greens & yellows, Iris glaze, No. 951 E, 1905, Fred Rothenbusch**2,530.00**

Vase, 6 ⅞" h., gently swelled cylindrical body tapering to a short cylindrical neck, decorated w/clusters of light blue wild violets & green stems against a light green to creamy white shaded ground, Iris glaze, No. 907 F, 1907, Irene Bishop**825.00**

Vase, 6 ⅞" h., simple ovoid body

tapering to a flat mouth, decorated w/long vines of yellow trumpet creeper blossoms against a shaded grey to a pale cream ground, Iris glaze, No. 939 D, 1903, Josephine Zettel**825.00**

Vase, 6 ⅞" h., wide ovoid body tapering to a short flaring neck, decorated w/large bursting milkweed pods in white & brown w/pale green leafy stems, on a black shaded to white shaded to pale green ground, Iris glaze, No. 902 D, 1906, Irene Bishop.............**2,090.00**

Vase, 7" h., slightly swelled cylindrical body w/a wide closed rim, decorated w/drooping green vines of slender trumpet-form pale yellow blossoms against a dark green shaded to cream ground, Iris glaze, No. 951 E, 1907, Katherine Van Horne**1,100.00**

Vase, 7" h., slightly swelled cylindrical body w/a narrow shoulder to the short cylindrical neck, decorated w/large yellow jonquils on tall dark green leafy stems against a dark green shaded to white ground, Iris glaze, No. 907 E, 1904, Josephine Zettel...................**825.00**

Vase, 7⅛" h., ovoid body tapering to a flat mouth, decorated around the upper half w/trailing stylized white apple blossoms on dark green branches against a banded ground shading from dark blue to light blue to pale green to cream to pink, Iris glaze, No. 939 D, 1910, C.S. Todd.................**1,045.00**

Vase, 7⅛" h., tapering cylindrical body below a compressed bulbous top w/a flat mouth, decorated around the top half w/trailing pink & green cherry blossoms & leaves against a banded dark green to pale green to pink ground, Iris

glaze, No. 1659 E, 1911, Lenore Asbury............**880.00**

Vase, 7 ⅞" h., slender ovoid body tapering gently to a wide flat mouth, decorated w/pale yellow jonquils on tall pale green leaves stems against a dark grey shaded to cream ground, Iris glaze, No. 925 D, 1907, Irene Bishop............**1,210.00**

Vase, 8" h., ovoid body tapering to a short, narrow flaring neck, decorated w/yellow dandelions & pale green leaves suspended from the top against a dark blue shaded to pale green shaded to pale yellow ground, Iris glaze, No. 745 B, 1901, Rose Fechheimer..............**1,980.00**

Vase, 8 ⅜" h., footed slender ovoid body tapering to a short cylindrical neck, decorated w/tall stalks of goldenrod against a white shaded to dark blue shaded to yellow ground, Iris glaze, No. 786 D, 1902, Rose Fechheimer..............**1,870.00**

Vase, 8 ⅝" h., baluster-form body w/a swelled shoulder tapering to a short cylindrical neck, decorated around the upper half w/large pale blue hydrangea blossoms & dark green leafy stems against a black shaded to white ground, Iris glaze, No. 900 C, 1902, Fred Rothenbusch (two small glaze runs on back)............**1,430.00**

Vase, 9¼" h., tall slender swelled cylindrical body tapering to a short cylindrical neck, decorated w/clusters of large pale pink wild roses & green leafy stems against a dark slate blue shaded to creamy pink ground, Iris glaze, No. 907 E, 1911, Lenore Asbury.....**2,750.00**

Vase, 9½" h., swelled cylindrical shouldered body tapering to a short tapering cylindrical neck, decorated w/four black geese

flying against a cream band w/bands of bluish grey at the top & base, No. 943 C, 1904, E.T. Hurley........................**4,400.00**

Vase, 9 ⅝" h., swelled cylindrical body w/a rounded shoulder to the short rolled neck, decorated w/large white lotus blossoms & pale green leaves against a dark green shaded to creamy white ground, Iris glaze, No. 904 C, 1906, Sara Sax....................................**3,520.00**

Orchid Blossom Vase

Vase, 10¼" h., tall slender cylindrical body w/a closed rim, decorated w/very large stylized orchid blossoms in mottled dark blues, white & pale yellow, Iris glaze, No. 952 C, 1907, minor glaze scratches, John Dee Wareham**17,600.00** (Illustration)

Vase, 10 ⅜" h., baluster-form body tapering to a short cylindrical neck, decorated w/large lily-of-the-valley up the sides in dark green & white against a pink shaded to cream shaded to dark green ground, Iris glaze, No. 1667, 1909, Carl Schmidt (professionally repaired)............................**3,630.00**

Vase, 10 ⅜" h., tall slightly tapering cylindrical body w/flat mouth, decorated around the

lower half w/large white lotus blossoms on dark green leafy stems against a dark green shaded to cream ground, Iris glaze, No. 950 C, 1904, Mary Nourse**2,750.00**

Rookwood Black Iris Vase

Vase, 10½" h., 4¼" d., thin ovoid body tapering to a short cylindrical flat mouth, decorated w/purple, grey & green iris blossom & bud, black & cobalt blue ground, Black Iris glaze, No. 907D, 1904, Carl Schmidt**5,610.00** (Illustration)

Vase, 11" h., tall ovoid body tapering to a short rolled rim, decorated w/very large white lotus blossoms & pale green leaves floating above a very dark blue mottled lower body, Black Iris glaze, No. 531 D, 1900, William McDonald ..**39,600.00**

Vase, 11 ⅜" h., baluster-form body tapering to a flat mouth, decorated w/large, colorful & finely detailed peacock feathers against a shaded dark blue to grey ground, Iris glaze, No. 909 B, 1902, Carl Schmidt**17,600.00** (Illustration: top next column)

Vase, 12 ⅝" h., tall slender ovoid body tapering to a short cylin-

Iris Glaze Vase with Peacock Feather

drical neck, decorated w/large white calla lilies & green leafy stems against a greyish blue shaded to pale gold ground, Iris glaze, No. 940 B, 1903, Sara Sax**3,300.00**

Iris Glaze Vase with Hydrangeas

Vase, 14⅛" h., tall swelled cylindrical shouldered body tapering to a short flaring neck, decorated around the top half w/a band of large white hydrangea flowers on pale green leafy stems against a mottled dark blue to cream to white ground, Iris glaze, No. 614 b, 1905, Albert Valentien**20,900.00** (Illustration: bottom previous page)

Iris Glaze Vase with Poppies

Vase, 14 ⅜" h., tall ovoid body tapering to a short cylindrical neck, decorated w/huge white poppy blossoms on long green stems against a shaded grey ground, Iris glaze, No. 905 B, 1902, Albert Valentien**24,200.00** (Illustration)

Vase, 14 ⅝" h., tall ovoid body tapering to a small, short flaring neck, decorated w/a continuous band of white daisies on tall pale green stems against a black shaded to cream shaded to light & dark ground, Black Iris glaze, No. 787 B, 1909, Kataro Shirayamandani ...**51,700.00** (Illustration: top next column)

Black Iris Vase with Daisies

JEWEL PORCELAIN WARES

Vase, 5½" h., 2 ¾" d., Jewel Porcelain, ovoid body tapering to a short rolled neck, decorated w/stylized cascading flowers in raspberry red against a deep purple ground, No. 356 F, 1922, Sara Sax**825.00**

Vase, 6½" h., 4½" d., Jewel Porcelain, ovoid body tapering to a short cylindrical neck, decorated w/large stylized anemone blossoms in salmon w/orange centers on a shaded light blue to white ground, No. 6107, 1945, Kataro Shirayamandani**1,320.00**

Vase, 6¼" h., 5½" d., Jewel Porcelain, bulbous ovoid body w/a wide narrow molded rim, decorated w/large blue & ivory stylized blossoms on a brown ground, No. 8097, 1945, Jens Jensen**715.00**

EARLY LIMOGES-STYLE WARES

Basket, Limoges-style, nearly spherical body tapering to an integral overhead handle above the curved rim pierced w/a band of small holes, dark reddish brown decorated w/black & creamy white dragonfly & Oriental grasses, No. 33, 1883, William McDonald, 4 ¾" h...................**385.00**

Bowl, 5¼" d., 1¼" h. Limoges-style, smooth notched rim, decorated w/a blue butterfly over a smear-glazed cloud & rush decoration in black & white on a creamy brown ground, No. 120, 1884, Mary Taylor.........**220.00**

Dish, Limoges-style, a shallow wide round bowl on three feet w/a long stick handle to one side, decorated in the interior w/a single butterfly & Oriental grasses in black & white on a deep gold ground, 1883, M.A. Daly, 6 ¾" l....................**220.00**

Ewer, Limoges-style, footed bulbous ovoid body tapering to a bulbous neck w/wide, high arched spout, D-form handle on shoulder, decorated w/black grasses against yellow & white clouds on a dark brown ground, No. 1 R, 1883, William McDonald, 5 ¾" h.................**302.50**

Ewer, Limoges-style, footed spherical body below a tall slender cylindrical neck w/a tri-corner rim, long S-scroll handle, decorated w/a slip-relief butterfly & bullrushes in blue & black on a gold & brown bisque ground, the neck tooled in gold, No. 101D, 1885, William McDonald, 5" d., 6½" h.**550.00**

Jar. cov., Limoges-style, globular body w/dimpled sides & low collared neck, decorated w/snails & insects on a rust, sand & deep blue ground w/green foliage & gilded

accents, 1882, Maria Longworth Nichols, 5" d., 6" h. (tight hairline in side)**1,650.00**

Perfume jug, Limoges-style, ovoid body tapering to a small molded neck, small loop handle on one shoulder, decorated w/a swallow flying above Oriental grasses in black & white against a mottled brown ground, glossy glaze, No. 60, 1883, Hattie Horton, 4 ¾" h. (flat base chip)**275.00**

Small Limoges-Style Pitcher

Pitcher, 4 ¾" h., Limoges-style, ovoid body tapering to a short ringed neck w/angled strap handle, decorated w/a small dark blue swallow flying amid swirling clouds & grasses in white, dark blue & black against a creamy yellow ground, tight line at rim near handle, No. 54, 1882, Martin Rettig**385.00** (Illustration)

Punch bowl, Limoges-style, deep rounded bowl raised on a low flaring foot, decorated around the exterior w/a large fire-breathing dragon in black & dark brown being ridden by several black devils & preced-

ed by a large group of black bats, mottled dark brown ground & fired-on gold trim & accents on the creamy yellow interior, No. 163, 1882, probably by Maria Longworth Nichols, 16 ⅜" d., 8¼" h.....**6,325.00**

Vase, 5⅛" h., Limoges-style, footed spherical body tapering to a short trumpet-form neck, pale yellow ground decorated w/a wide white band decorated in black & yellow w/Oriental grasses, two quail & two flying swallows, No. 1 G, 1882, Martin Rettig..........................**605.00**

Limoges-Style Vase

Vase, 10¼" h., Limoges-style, flattened cylindrical body w/a flat incurved rim w/the edge pulled into four small points, slender angled loop handles flank the shoulder, decorated in black, white & brown against a creamy yellow ground, one side w/a web w/several spiders, the other side w/a small Japanese seaside village w/small flying sea gulls, small flat base chip, professionally repaired handle, 1882, Maria Longworth Nichols**1,100.00** (Illustration)

MATTE GLAZE WARES

Bowl, 10½" d., Arts & Crafts style, wide low rounded sides, decorated around the edge w/five repeating narrow rectangular panels of stylized flowers & long leaves in red, yellow & green, dark green Matte glaze ground, No. 1196, 1914, C.S. Todd..........................**1,210.00**

Bowl-vase, large nearly spherical form tapering slightly to a flat mouth, overall stylized streaky designs in yellow, green & blues on a dark purple ground, Matte glaze, No. 703, 1922, Elizabeth Barrett, 5½" h.**550.00**

Bowl-vase, Arts & Crafts style, a wide squatty compressed body w/a short, wide molded flat rim, deeply carved around the sides w/large dragonflies, dark Matte green glaze, No. 1109, early 20th c., 6" d.**825.00**

Candleholder, hand-formed, a wide disc foot centered by a twisted & pinched standard w/a wide flat socket rim, a looped thick handle at the base, alligatored silvery green Matte glaze, No. 208Z, 1901, Mary Perkins, 4½" d., 5 ¾" h..........**220.00**

Art Deco Matte Candlesticks

Candlesticks, Art Deco style, figural, a figure of a nude woman standing w/her hands to her face, wearing a small black mask & long black hair down her back, a columnar capital atop her head, standing on a wide banded rectangular platform base, overall creamy white Matte glaze, No. 2524, 1924, designed by Louise Abel, 12 ⅜" h., pr...............**1,210.00** (Illustration)

Card tray, round w/a reticulated design of mistletoe leaves on a branch along one side & further molded leaves glazed in bluish green in the center, the rim & one side trimmed w/electroplated copper, Matte glaze, No. 267 Z, 1901, Kataro Shirayamadani, 5 ⅜" d.**1,430.00**

Center bowl, wide shallow squatty deeply incurved round sides, decorated w/a band of stylized yellow flowers & blue & green leaves against a pale yellow ground, Matte glaze, No. 2106 C, 1925, Charles Klinger, 10" d. (minor glaze discoloration).........................**330.00**

Charger, the slightly dished surface carved & painted as a large lotus pad w/a blossom at one side, overall sea green Matte glaze, No. 353 Z, 1901, Anna Valentien, 9¼" d.**715.00**

Charger, Arts & Crafts style, decorated w/three dark-green stylized seahorses radiating from the center, their tails entwined in swirling pale green seaweed at the center, on a mottled green ground w/pale yellow border band, Matte glaze, No. 678 Z, 1903, Sallie Toohey, 11" d.**715.00**

Charger, the slightly dished surface decorated w/a large brown & yellow swimming fish in sea currents against a pale greenish blue ground, Painted Matte glaze, No. 188A, 1901, Albert Valentien, 15⅛" d. (some glaze flakes at rim)**1,760.00**

Loving cup, Z line, three-handled, wide slightly tapering cylindrical form w/long strap handles from near rim to the base, molded w/three paired triangles near the top, smooth Matte dark green glaze, No. 258, 1903, 7" d., 6½" h. ...**385.00**

Loving cup, three-handled, wide cylindrical body w/a band of impressed curvilinear design near the rim, rich green Matte glaze, No. 830B, 1905, 8 ¾" w., 7" h.**467.50**

Loving cup, wide cylindrical body w/three large D-form loop handles below the slightly uneven rim, deeply carved w/large red & pale green apples on brown branches w/dark green leaves against a pale green shaded to brown ground, Matte glaze, No. 790 BZ, 1904, Kataro Shirayamadani, 7 ¾" h. (several glaze blisters)**2,420.00**

Matte Glaze Mug

Mug, slightly tapering cylindrical body, Arts & Crafts style, incised base band of zigzag lines & triangles, overall Matte green glaze, No. 345 CZ, 1901, Albert Munson, 4 ¾" h...........**220.00** (Illustration)

Pitcher, 4¼" h., 5" d., rounded tapering triangular body w/three pinched spouts, decorated around the lower half w/stylized red blossoms on a green ground, Matte glaze, No. 341E, 1902, A. R. Valentien**385.00**

Pitcher, 4¼" h., 5" d., rounded tapering triangular body w/three pinched spouts, decorated around the lower half w/stylized red blossoms on a green ground, Matte glaze, No. 341E, 1902, A. R. Valentien**385.00**

Trivet, round, molded w/white & yellow flying sea gulls over swirled light & dark blue waves, Matte glaze, No. 2350, 1929, 6" d.**247.50**

Trivet, square, molded w/a design of a large parrot perched on a flowering branch in shades of red, pink, pale blue, yellow & green against a white ground, Matte glaze, No. 3077, recently framed, 5 ¾" sq. (minor glaze pitting)**357.50**

Umbrella stand, wide slightly tapering cylindrical body w/a gently flared mouth, boldly molded w/a gaggle of large geese, Matte green glaze, No. 1235 AY, 1905, 26⅛" h.**2,970.00**

Vase, 3 ¾" h., ovoid body w/a wide, flat mouth, carved w/a blue-trimmed rooster against a greenish yellow ground, Matte glaze, No. 942F, 1905, Sallie Toohey**495.00**

Vase, 4 ⅝" h., Arts & Crafts style, bulbous ovoid body molded w/six wide, rounded smooth leaves below the short cylindrical neck, rich green Matte glaze, No. 2095, 1917**247.50**

Vase, 4 ¾" h., Arts & Crafts style, bulbous ovoid body w/closed mouth, incised w/slender upright spearpoint blossoms alternating around the body w/wide pointed long leaves, shaded light to dark blue Matte glaze, No. 1120, 1910, William Hentschel**825.00**

Fine Matte Glaze Vase

Vase, 5" h., bulbous ovoid footed body tapering to a wide, rolled rim, decorated w/pale lavender & white blossoms on slender stems w/leaves all against a pale blue shaded to pink shaded to pale green ground, Matte glaze, 1939, Kataro Shirayamadani**1,320.00** (Illustration)

Vase, 5⅛" h., footed ovoid body tapering to a flat wide molded mouth, decorated w/a wide band of stylized purple berries on mottled brown & green leafy vines against a shaded green to yellow mottled ground, Matte glaze, No. 2191, 1929, Janet Harris**385.00**

Vase, 5 ¾" h., ovoid body tapering to a flat mouth, decorated around the top half w/a band of stylized orange, yellow & green flowers against a bright yellow

ground, Matte glaze,
No. 604 F, 1924, Katherine
Jones**467.50**

Vase, 6¼" h., urn-form, squatty
bulbous body raised on a short
flaring pedestal base, the wide
& short cylindrical neck flanked
by small angled loop handles,
decorated w/a repeating design
of stylized blossoms in yellow
& green against a blue ground,
Matte glaze, No. 2355,
1922, Louise Abel**1,100.00**

Vase, 6¼" h., wide ovoid body
tapering to a short wide cylin-
drical neck, incised around the
shoulder w/three stylized pea-
cock feathers in dark greens &
blues against a dark brown
ground, Matte glaze, No. 1123,
1910, Sara Sax**1,540.00**

Vase, 6½" h., bulbous ovoid
melon-lobed body below a
short cylindrical neck molded
w/wide bands of stylized round-
ed leaves & berries wrapping
around the sides, mottled
turquoise blue & pale green
Matte glaze, No. 6147,
1937**192.50**

Vase, 6½" h., footed bulbous
body below a tall wide trumpet
neck, decorated around the
body w/large stylized red &
green nasturtium blossoms &
leaves against a bright yellow
upper body & dark blue lower
body, Matte glaze, 1933, Sallie
Coyne....................................**467.50**

Vase, 6 ⅝" h., footed ovoid body
tapering to a short, flaring
neck, decorated w/an Art Deco
floral design of broad pointed
leaves below arching blossom
branches in dark green &
brown against a reddish tan
ground, Matte glaze, No. 2918,
1929, Elizabeth Barrett**412.50**

Vase, 6 ¾" h., slightly waisted
cylindrical body w/flat rim, dec-
orated w/stylized pink fruit blos-

soms on a mottled cream &
blue ground, Matte glaze, No.
1930, 1921, Elizabeth
Lincoln.................................**330.00**

Matte Pastel Vase

Vase, 7" h., simple ovoid body
w/slightly flaring rim, decorated
around the top w/a band of
stylized blossoms & leaves in
pastel shades of purple, blue &
green above a shaded peach
ground, Matte glaze, No. 925
E, 1929, Katherine Jones......**522.50**
(Illustration)

Vase, 7" h., slender ovoid shoul-
dered body w/a short rolled
neck, decorated around the
shoulder w/a band of pink, yel-
low, green & blue leaves &
berries against a dark blue
ground, Matte glaze, No. 614
F, 1926, Katherine Jones......**550.00**

Vase, 7⅛" h., stick-type, tall
slender sides above a wide
disc base & tapering to a flar-
ing rim, dark purplish blue
ground decorated w/black styl-
ized florals around the base &
a streaked black band around
the rim, Matte glaze, No. 2307,
1924, Elizabeth Lincoln........**357.50**

Vase, 7⅛" h., wide ovoid body
tapering to a short, wide cylin-
drical neck, streaky & smeary
decoration in dark blue & green
on a yellowish green ground,
Matte glaze, No. 927
E, 1931, Jens Jensen**302.50**

Matte Vase with Day Lilies

Vase, 7 ⅜" h., footed pear-shaped body tapering to a wide flaring mouth, decorated w/pale yellow day lilies & green leaves against a pale creamy green Matte glaze ground, blue interior, No. 6359, 1943, Kataro Shirayamadani**1,100.00** (Illustration)

Vase, 7½" h., tapering cylindrical body w/a flat rim, decorated w/a dripping mottled blue, purple & green glaze over a shaded dark bluish green to creamy pink Matte ground, No. 2066, 1928, Sallie Coyne (unobtrusive glaze skip at base).........**357.50**

Vase, 7½" h., 3½" d., slender tapering cylindrical body w/a flat mouth, a small band of embossed stylized flowers near the top above long radiating ribs down the sides, rich burgundy Matte glaze, No. 1769, 1911**275.00**

Vase, 7 ⅝" h., simple ovoid body tapering to a flat mouth, decorated around the shoulder w/a band of trailing flowers w/fan-shaped blossoms in dark red, mottled dark blue neck & light shaded bluish green lower body, Matte glaze, No. 604 D, 1920, Elizabeth Lincoln.........**467.50** (Illustration: top next column)

Matte Glaze Vase with Flower Band

Vase, 7 ⅝" h., tapering ovoid body w/a small flaring foot & a wide, closed mouth, embossed stylized wide band of oak leaves & acorns, crystalline blue over Matte brown glaze, No. 2590, 1924..........**220.00**

Vase, 7 ¾" h., ovoid shouldered body w/a rolled trumpet-form neck, decorated around the shoulder w/large pink-trimmed yellow dogwood blossoms & green leaves below the blue neck & pale yellow body, Matte glaze, No. 6198 D, 1931, Lenore Asbury..........**2,090.00**

Vase, 8⅛" h., Arts & Crafts style, bulbous ovoid body tapering to a tapering cylindrical neck w/flat rim, carved & painted around the neck w/stylized dark green & maroon florals against the dark blackish purple Matte ground, No. 989 D, 1911, William Hentschel**522.50**

Vase, 8⅛" h., ovoid body tapering to a flaring neck, stylized pale yellow & pink nasturtium blossoms & green leaves against a blue ground, Matte glaze, No. 117D, 1924, Herman Moos**440.00**

Vase, 8⅛" h., slender ovoid body tapering slightly to a flared rim, decorated in the Art Deco style w/large almond-shaped veined leaves on slender berried stems w/slip-trail outlining in black on a blue crystalline Matte glaze ground, No. 233, 1928, Elizabeth Barrett**412.50**

Vase, 8⅛" h., slightly tapering cylindrical body w/a band of carved stylized floral clusters in yellow around the top, the flower stems down the sides dividing it into three panels in green Matte glaze, No. 950D, 1904, Kataro Shirayamadani**2,750.00**

Vase, 8¼" h., ovoid shouldered body w/a short, rolled neck, decorated w/stylized red & green flowers dripping down from the shoulder against a bright yellow ground, Matte glaze, No. 614E, 1928, Sallie Coyne......................**1,320.00**

Vase, 8¼" h., slightly swelled cylindrical body w/a rolled wide mouth, embossed around the top w/several iris clusters on long leafy stems, dark purple over blue Matte glaze, No. 2476 (small grinding chip on base)**715.00**

Vase, 8½" h., 3 ¾" d., slender baluster-form w/short flaring neck, decorated around the top w/a band of large stylized red flowers & green leaves against a brownish yellow ground, Wax Matte glaze, No. 117 D, 1926, Katharine Jones**605.00**

Vase, 8⅝" h., wide slightly swelled cylindrical body w/a flaring foot & wide flat mouth, carved & painted in shades of bluish green & pale green w/fish swimming through seaweed, Matte glaze, No. 1661, 1912, William Hentschel**825.00**

Vase, 8 ¾" h., Arts & Crafts style, waisted cylindrical form w/flat mouth, decorated w/three vertical bands of subtly carved leaf-like designs in mottled green against a dark green Matte glazed ground, No. 1358 D, 1911, William Hentschel**440.00**

Vase, 8 ¾" h., 4½" d., waisted cylindrical body, decorated w/an incised band of mushrooms in dark blue on a burgundy ground, Matte glaze, No. 1358, 1911, William E. Hentschel (small base repair)....................................**357.50**

Vase, 9⅛" h., tall slender waisted square form w/beveled corners, decorated w/tall dark red & yellow blossoms on dark green leafy stems against a mottled dark blue & brown ground, Matte glaze, No. 697, 1923, Louise Abel**550.00**

Vase, 9¼" h., ovoid body tapering to a short, wide rolled rim, slip-trailed banding around the bottom half below a wide band of smeared spearpoints, all in shades of tan, blue, brown & creamy yellow Matte glaze, 1930, Elizabeth Barrett**522.50**

Arts & Crafts Matte Vase

Vase, 10" h., Arts & Crafts style, gently waisted cylindrical body w/a wide flat mouth, deeply incised w/stylized peacock feathers, overall leathery Matte green glaze, No. 578 CZ, 1904, Sallie Toohey**825.00** (Illustration)

Vase, 10" h., 3 ¾" d., tall slender ovoid body below a widely flaring trumpet neck, embossed below the neck w/a band of simple rings & diamonds above long ridges down the sides, shaded green to raspberry feathered Matte glaze, No. 482, 1909**357.50**

Vase, bottle-form, 10" h., 5½" d., bulbous ovoid base tapering to a cylindrical neck, incised around the neck w/a diamond & long V band in green on a reddish brown ground, Matte glaze, No. 229CZ, 1904, Sara Sax**605.00**

Vase, 10½" h., ovoid body w/a flat mouth, decorated w/large Art Deco style fanned leafy branches in brownish green against a pale blue ground, Matte glaze, No. 977, 1931 (minor glaze discoloration, small glaze bubbles)**440.00**

Tall Matte Vase with Cherries

Vase, 11¼" h., tall slender trumpet form body w/a flaring molded base, decorated around the top w/a wide band of red cherries & green leaves against a blue shaded to rose shaded to pale green ground, Matte glaze, No. 1357 C, 1926, Sallie Coyne................................**1,210.00** (Illustration)

Vase, 11 ⅜" h., tall slender ovoid body tapering to a short, small flaring neck, incised & decorated w/curved bands of yellow bellflowers down the sides against a banded & swirled pale yellow & blue-green ground, Matte glaze, 1921, C.S. Todd (drilled, unobtrusive glaze skip near base)**605.00**

Vase, 11 ⅝" h., four-paneled swelled cylindrical body raised on a short pedestal foot, a wide flaring cylindrical neck, decorated w/a different flower in each panel, deep rose poppies & green leaves, daisies, irises & dogwood, each against a dark blue to pink to cream to pale green shaded ground, Matte glaze, No. 2933, 1939, Kataro Shirayamadani**3,190.00**

Vase, 11 ¾" h., 5" d., expanding cylinder w/narrow flared rim, decorated w/golden daffodils & green foliage against a shaded pink ground, Wax Matte glaze, No. 2790, 1928, Sallie Coyne................................**1,540.00**

Vase, 13½" h., tall slender conical body w/a slightly flaring rim, carved & painted around the base w/dark blue stylized florals against a ground shaded from dark blue to dark rose at the mouth, Matte glaze, No. 807, 1920, C.S. Todd (base drilled)**467.50**

Vase, 16¼" h., bottle-form, footed spherical base tapering to a tall slender 'stick' neck, decorated around the base w/large

red & green lotus blossoms & green pads against a reddish tan shaded to green ground, Matte glaze, No. 2825 A, 1925, Sallie Coyne**660.00**

Vase, 16 ¾" h., tall ovoid body tapering to a short wide cylindrical neck w/a flattened flaring rim, incised around the neck w/stylized red apples, green leaves & dark blue grape clusters on green vines against a brown ground above the yellow shaded to deep rose body, Matte glaze, No. 324, 1917, C.S. Todd (minor glaze skips on rim top)**2,640.00**

Art Deco Matte Glaze Vase

Vase, 17½" h., Art Deco style, tall slender ovoid body tapering to a short flaring neck, decorated w/tall thin triangles up from the blue-banded base & alternating w/long double bands of graduated berry-like designs in grey-blue against a pale blue

ground, Matte glaze, tiny grinding nick on base, No. 2523, 1927, William Hentschel**7,700.00** (Illustration)

Wall pocket, figural, model of a large winged insect, feathered green & blue Matte glaze, No. 1636, 1922, 4" w., 9" h.**770.00**

"1932" GLAZE WARES

Small "1932" Glaze Vase

Vase, 3" h., bulbous ovoid body w/a wide shoulder to a molded mouth, "1932" glaze of bluish green & orange dripping over a glittering Coromandel base, No. 6307, 1932**467.50** (Illustration)

Vase, 3" h., bulbous ovoid body w/a wide flat molded mouth, a pale yellow band at the mouth above a crystalline medium blue body, "1932" glaze, No. 6319 F, 1932**137.50**

Vase, 3" h., wide ovoid shouldered body tapering to a molded mouth, purple over brown over blue "1932" glaze, No. 6307 F, 1932**357.50**

Vase, 4" h., simple baluster-form body, dripping glazes in turquoise blue to sky blue to light brown, "1932" glaze, 1932**110.00**

Vase, 4⅛" h., bottle-form, bulbous spherical body tapering to a short 'stick' neck, the neck in

pale yellow & the body in mottled blue slightly crystalline "1932" glaze, No. 2587 F, 1930**110.00**

Vase, 6⅛" h., trumpet-form body w/a flaring foot & widely flaring rim, streaky crystalline brown over mustard yellow "1932" glaze,1932**137.50**

SEA GREEN GLAZE WARES

Bowl, 9¼" d., the wide flattened dish w/upturned shallow rim w/several pinched 'spouts' decorated w/a pair of large black stylized fish against a mottled green, tan & brown ground, Sea Green glaze, No. 205 B, 1900, Fred Rothenbusch (repaired glaze flaws)............**522.50**

Ewer, bulbous ovoid body tapering to a very slender tall neck flaring to a trefoil rim, applied S-form strap handle, decorated w/a school of fish in various shades of green, Sea Green glaze, 1894, A. R. Valentien, 13⅛" h. (restored)**978.00**

Humidor, cov., a wide squatty bulbous body tapering to a wide flat rim fitted w/a silver plate band & an inset silver plate cover w/stamped looped bands & a large domed finial, the sides of the body decorated w/a large black flying bat against a pale greenish yellow moon on a shaded dark green ground, Sea Green glaze, No. T 1230, 1900, Rose Fechheimer (tight lines in body & cover)**2,310.00**

Vase, 3 ¾" h., bulbous nearly spherical ovoid body tapering to a short wide mouth, small loop handles on the shoulder, decorated w/yellow daisy-like flowers on dark blue-green leafy stems against a greenish yellow to dark blue ground,

Bulbous Sea Green Vase

Sea Green glaze, No. 919, 1901, Sallie Coyne (minor glaze scratches)**770.00** (Illustration)

Vase, 6" h., slender ovoid body tapering to a wide flat mouth, decorated w/large dark blue-green blossoms & green leaves against a shaded dark blue-green & brown ground, Sea Green glaze, No. 30, 1899, Fred Rothenbusch ...**2,530.00**

Sea Green Vase with Yellow Flowers

Vase, 6 ⅝" h., slightly swelled cylindrical body w/a short, flat shoulder to a short molded neck, large heavy slip yellow flowers against a black ground, Sea Green glaze, No. 734DD, 1900, Fred Rothenbusch ...**4,400.00** (Illustration)

Vase, 6 ¾" h., simple ovoid body tapering to a short rolled neck, decorated w/yellow & green wild roses against a shaded black to dark green ground, Sea Green glaze, No. 80 B, 1903, Sallie Coyne (minor underglaze flaws)**1,540.00**

Vase, 7⅛" h., slender ovoid body tapering to a short cylindrical neck, decorated w/yellow & white daffodils on dark green leafy stems against a very dark teal blue ground, Sea Green glaze, No. 901 D, 1902, Sallie Coyne**2,530.00**

Sea Green Vase with Thistles

Vase, 7 ⅝" h., gently swelled cylindrical body w/a narrow flat shoulder to the short molded wide neck, decorated w/large stylized red thistles on dark green leafy stems against a pale green ground, Sea Green glaze, No. 589 F, 1901, Rose Fechheimer...............**1,650.00** (Illustration)

Vase, 11 ⅝" h., tall baluster-form body w/the wide shoulder tapering to a slender neck w/widely flaring flattened rim, decorated around the shoulder w/large pale green blossoms on a night blooming cactus against a shaded pale to dark

green ground, Sea Green glaze, No. 216, 1895, Albert Valentien (very little crazing)**7,975.00**

STANDARD GLAZE WARES

Small Standard Glaze Bowl

Bowl, 2½" h., shallow wide squatty bulbous body tapering to a wide, flaring mouth, decorated on one side w/grasses & on the opposite w/a yellow & black butterfly, Standard glaze, No. 82, 1885, Martin Rettig ...**330.00** (Illustration)

Bowl, 2½" h., wide low rounded sides w/closed mouth, decorated w/bright reddish orange blossoms & dark green leaves against a shaded dark brown to dark green ground, Standard glaze, No. 214 C, 1900, Laura Lindeman**247.50**

Bowl, 2½" h., wide squatty bulbous form w/closed rim, decorated w/pine boughs & pine cones in brown & dark green against a dark brown shaded ground, Standard glaze, No. 214 C, 1908, Katherine Van Horne**275.00**

Bowl, 7" d., 3½" h., squatty bulbous body w/a wide shoulder tapering to a wide flat mouth w/molded rim, decorated w/large maple leaves in shades of brown, Standard glaze, No. T 1258 B, 1901, Elizabeth N. Lincoln..................................**316.00**

Bowl-vase, squatty bulbous form w/a wide shoulder tapering to a flat rim, decorated w/yellow dogwood blossoms & green leaves on a shaded dark brown to yellow ground, Standard glaze, No. 536E, 1894, Elizabeth Lincoln, 3⅛" h.**440.00**

Bowl-vase, squatty bulbous body raised on a footring, the top tapering to a flat mouth, decorated w/brown buds & blossoms on a shaded gold to rust ground, Standard glaze, No. 536E, 1892, Olga Reed ..**302.50**

Box, cov., squatty bulbous round body w/a flanged domed cover, the cover decorated w/yellow iris & green leaves against a shaded green ground, the base in brown, Standard glaze, No. 591 C, 1890, Grace Young, 2" h.......**467.50**

Creamer, spherical body w/pinched rim spout & loop handle, decorated w/a branch of yellow wild roses & green leaves against a brown & moss green ground, Standard glaze, No. 832, 1901, Edith Felten, 2⅛" h.**192.50**

Creamer, squatty bulbous body tapering to a wide, arched spout, decorated w/orange clover & green leaves against a shaded brown to gold ground, Standard glaze, No. 630, 1897, Adeliza Sehon, 3" h..............**220.00**

Creamer, squatty bulbous body w/butterfly-form handle, decorated w/yellow & blue violets against a shaded dark brown to orange ground, Standard glaze, No. 829, 1894, Sadie Markland**165.00**

Creamer & open sugar bowl, each w/a squatty bulbous body w/a wide pinched rim, each decorated w/large pale gold dogwood blossoms on a black

ground, Standard glaze, No. 330, 1900, Jeannette Swing, creamer 2½" h., sugar 2⅞" h., pr.**302.50**

Standard Glaze Creamer & Sugar Bowl

Creamer & cov. sugar bowl, each w/a squatty bulbous body tapering to a flat rim, the sugar w/a slightly domed fitted cover, each w/loop handles, each decorated w/small yellow & orange blossoms & green leaves against a dark brown ground, Standard glaze, No. 770, 1899, Elizabeth Brain, creamer 2½" h., sugar 3" h., pr.**385.00** (Illustration)

Dishes, modeled as half an almond shell, creamy exterior, the interior incised & painted w/small scattered flowers on a shaded dark brown to gold ground, Standard glaze, No. 279, 1888, 5 ¾" l., pr.**192.50**

Ewer, a wide disc-form base centered by a slender tall neck w/a wide tricorner rim, a slender handle from the rim to the shoulder, decorated w/holly leaves & berries on a shaded dark brown ground, Standard glaze, No. 715DD, 1900, William Klemm, 5 ⅝" h.**385.00**

Ewer, baluster-form tapering to a tall slender neck w/a high arched spout, D-form handle from neck to shoulder, decorated w/white clover & green

leaves against a black & brown ground, Standard glaze, No. 639 D, 1898, Katharine Hickman, 6 ⅜" h.**275.00**

**Standard Ewer with
Leaf & Berries**

Ewer, ovoid body tapering to a cylindrical neck w/flaring rim & rolled-up spout, strap handle from rim to shoulder, decorated w/gold leaf clusters & orange berries against a gold shaded to dark brown ground, Standard glaze, No. 685, 1893, Sallie Coyne, minor glaze scratches, 6½" h.**550.00** (Illustration)

Ewer, wide squatty bulbous cushion-form base centered by a tall slender cylindrical neck w/tricorner rim, slender S-form handle from rim to shoulder, decorated w/orange & yellow grape leaves & clusters against a dark maroon ground w/hints of Tiger Eye effects, Standard glaze, No. 433, 1888, Harriet Wilcox, 6 ⅞" h............**495.00**

Ewer, bulbous base on a small footring, the sides tapering to a slender tall neck w/a tricorner rim & long strap handle, decorated w/a yellow wild rose & green stems against a golden ground, Standard glaze, No. 381C, 1888, Grace Young, 7" h. (small glaze scratch on top of spout)**495.00**

Ewer, flattened spherical body tapering to a slender tall neck w/a tricorner rim, a long D-form handle from rim to shoulder, decorated w/large clusters of yellow apple blossoms & dark green leaves against a shaded rust to dark brown ground, Standard glaze, No. 716 CC, 1894, Kate Matchette, 8⅛" h.**385.00**

Ewer, wide squared cushion base tapering sharply to a slender neck w/a widely flaring tricorner rim, strap handle from rim to shoulder, decorated w/stylized red blossoms & green stems on a black shaded to dark brown ground, Standard glaze, No. 740, 1895, Lenore Asbury, 8⅛" h. (some burst glaze bubbles, some minor glaze scratches)**357.50**

Ewer, squatty bulbous base below a tall slender neck w/a trilobed rim & S-shaped handle, the base w/silver overlay Art Nouveau flowers & scrolling foliage, silver overlay on the rim & handle, the background h.p. w/sprigs of orange flowers & green foliage on a shaded brown ground, Standard glaze, No. 468CC, 1893, Josephine Zettel, silver marked "Gorham," 5½" d., 8½" h.....................**3,475.00**

Ewer, bulbous body tapering to a tall slender cylindrical neck w/a tricorner rim, a long S-scroll handle from the rim to the shoulder, decorated w/dark golden orange wild roses & green leaves against a shaded dark brown ground, Standard glaze, No. 557, 1901, Fred Rothenbusch, one small glaze bubbled, 9¼" h.**495.00** (Illustration: top next page)

Standard Ewer with Wild Roses

Tall Silver Overlay Ewer

Ewer, squatty spherical body tapering to a tall 'stick' neck w/a wide arched spout & S-form long handle, decorated w/large gold chrysanthemums & dark green leafy stems against a shaded dark brown ground, Standard glaze, No. 462, 1889, Anna Valentien, 9 ⅜" h. (very minor glaze imperfections)**550.00**

Ewer, footed wide squatty cushion-form body tapering to a tall slender cylindrical neck w/a widely flaring tricorner rim & a long S-scroll handle, decorated w/large clusters of autumn leaves in dark gold, brown & green against a shaded dark to light brown ground, Standard glaze, No. 611 C, 1899, Katharine Hickman, 10" h. ...**440.00**

Ewer, compressed cushion-form body tapering to a tall slender neck w/a tricorner rim, long handle from rim to shoulder, decorated w/green wheat stalks against a shaded brown to gold ground, ornate silver overlay design of leafy scrolls, flowers & small birds, Standard glaze, silver marked "Gorham

Mfg. Co. R 786," No. 438 A, 1892, Albert Valentien, two small spots of missing silver, 12¼" h.**6,875.00** (Illustration)

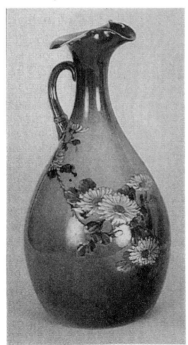

Tall Rookwood Ewer

Ewer, tall wide ovoid body tapering to a small flaring neck w/tricorner rim, small C-form handle at the neck, decorated w/finely painted daisies in yellow w/brown centers & green leaves on a shaded brick red to dark green ground, No. 391W, 1888, Kataro Shirayamadani, unevenness at rim, 6" d., 13" h.**1,375.00**
(Illustration: bottom previous page)

Humidor, cov., wide waisted cylindrical body w/an inset cover w/squatty bulbous knob, decorated w/two cigars, a pipe & vining plant in dark browns & greens against a shaded dark brown to gold ground, Standard glaze, No. 858, 1900, Fred Rothenbusch (small, tight line on interior rim)**440.00**

Jug, wide bulbous ovoid body w/flattened sides, the wide shoulder tapering to a short molded neck w/strap handle from rim to shoulder, decorated w/dark rust & gold hops & dusty green leaves against a shaded dark brown to gold ground, Standard glaze, No. 706, 1896, Elizabeth Lincoln, 4½" h.**275.00**

Jug w/original stopper, silver overlay, double gourd form, decorated w/a painted ear of corn surrounded by an overlay design of grapes & leaves, the silver stopper attached w/the original chain, Standard glaze, No. 674, 1893, H.R. Strafer, silver marked "GORHAM MFG. CO. - R-0801 - STERLING," 4 ¾" d., 8" h.......................**1,540.00**

Jug w/original stopper, silver overlay, ovoid body w/the rounded shoulder tapering to a silver-wrapped cylindrical neck fitted w/a small silver-wrapped knopped stopper, silver-wrapped loop handle, decorated w/an ear of corn in shades of green & brown w/stylized

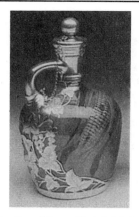

Sterling Silver Overlaid Jug

grapevine silver overlay in sterling silver attributed to the Gorham Mfg. Co. & impressed "R315," Standard glaze, No. 673, 1892, William McDonald, crazing, 4 ¾" d., 8 ¾" h.**2,990.00**
(Illustration)

Lamp, banquet-style kerosene-type, an ornate scroll-footed domed brass foot & short disc pedestal support a tall slender baluster-form standard supporting a bulbous bowl w/metal insert for font, decorated up the sides w/a continuous large blossoming fruit branch in shades of yellow & dark green against a brown shaded to gold ground, Standard glaze, No. 702, 1894, ceramic portion 18" h. (font & burner missing, tight line in top professionally repaired)............................**1,210.00**

Lamp, kerosene table-type, a squatty wide bulbous body tapering toward the top, decorated w/yellow wild roses & dark green leaves against a dark brown to gold ground, Standard glaze, fitted at the top w/a metal collar & at the bottom w/a metal ring foot w/beaded edge, w/a ring shade holder & newer umbrella-form clear frosted shade, No. S 1209, 1899, Lenore Asbury, ceramic body 4 ⅝" h. (electrified)**770.00**

Mug, tapering cylindrical body w/thick D-form handle, decorated w/a scene of the Five of Spades Child from "Alice in Wonderland," shaded dark brown to gold ground, Standard glaze, No. 587, 1892, Harriet Wilcox, 4½ h. (small repaired rim chip)**935.00**

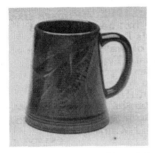

Rookwood Mug with Ear of Corn

Mug, tapering cylindrical body w/fine rings around the base, C-form handle, decorated w/an ear of corn & husk in yellowish brown, No. 587, 1899, Elizabeth Lincoln, crazing, 3" d., 4 ⅝" h..........................**172.50** (Illustration)

Mug, baluster-form w/gently flaring rim, D-form handle, decorated w/a bust portrait of a smiling black man wearing a cylindrical cap, shaded black to gold ground, Standard glaze, No. 671, 1895, Harriette Strafer, 5" h. (pinhead-sized glaze nicks on rim, some minor glaze scratches)................**3,850.00**

Mug, bullet-form, decorated w/a large head portrait of a tiger against a shaded dark brown ground, Standard glaze, No. 793, 1895, Bruce Horsfall, 5 ⅝" h. (minor glaze scratches)**4,620.00**

Mug, two-handled, very tall slender trumpet-form body above a flaring, ringed foot, decorated w/yellow roses & green leaves against a blackish brown shaded to gold ground, Standard

glaze, No. 292 B, 1889, Albert Valentien, 14" h. (old foot repair)............................**825.00**

Pitcher, 4" h., 5" w., flattened ovoid body w/wide mouth, decorated w/golden clover blossoms on a shaded gold to dark brown ground, Standard glaze, No. 692, 1894, Sadie Markland**220.00**

Pitcher, tankard, 5 ⅜" h., cylindrical body tapering at the top to a flat rim w/a pinched spout, decorated w/yellow daisy-like flowers & green stems on a shaded dark brown to olive green ground, Standard glaze, No. 819, 1902, Burley & Co., Chicago paper label, Carrie Steinle**440.00**

Pitcher, tankard, 5½" h., 3 ¾" d., silver overlay, slender cylindrical body w/a rounded shoulder to a short cylindrical neck w/a long, pointed spout, long C-scroll handle, decorated w/yellow flowers & green foliage on a dark brown ground, Standard glaze, overall ornate silver overlay on leafy scrolls & arabesques by Gorham Mfg. Co., No. 626, 1892, Sally Toohey**1,870.00**

Pitcher, 6 ⅜" h., simple ovoid body tapering to a short cylindrical neck w/long pinched spout, angled handle, decorated w/a long holly sprig in green & brown w/red berries highlighted in white against a shaded bluish grey ground w/ivory rim & interior, Standard glaze, No. 18, 1890, Edward Abel......................................**605.00**

Pitcher, tankard, 8 ⅝" h., ringed base below a tall slender conical body w/a pinched rim spout, decorated around the bottom w/a row of green turtles walking through grass against a dark gold ground, Standard glaze, No. 564 D, 1894, Kataro

Shirayamadani (tiny spout
flake, line at the rim)...........**1,210.00**

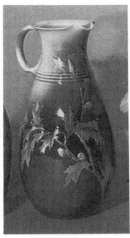

Tall Standard Glaze Pitcher

Pitcher, tankard, 12⅛" h., tall
ovoid body tapering to a short
flaring neck w/pinched spout &
a short C-form neck handle,
decorated w/a large cluster of
oak leaves & acorns in browns
& greens against a shaded
golden-green to dark brown
ground, Standard glaze, No.
567, 1891, Albert Valentien,
few small bubbles & scratches
in the glaze, 14" h.**880.00**
(Illustration)

Punch bowl, wide deep round-
ed sides w/three large incurved
crimps around the rim, the
exterior decorated w/a jungle
scene in dark green w/seven
large golden apes in the trees,
against a shaded green to rust
to gold ground, Standard glaze,
No. 163 B, 1893, Bruce Hors-
fall, tight small rim bruise,
minor glaze scratches,
16 ¾" w., 7⅛" h.**4,180.00**
(Illustration: below)

Salt cellar, boat-shaped w/a
pointed prow at one end & an
upswept & incurved stern, dec-
orated w/golden orange hops &
green leaves against a shaded
dark brown ground, Standard
glaze, No. 527, 1891,
Harriette Strafer, 2 ¾" h.**385.00**

Sugar bowl, cov., bulbous han-
dled body w/low domed cover
w/knob finial, decorated w/yel-
low flowers & long green
leaves on a shaded dark brown
ground, Standard glaze, No.
554, 1894, Sallie Coyne,
3 ¾" h.**275.00**

Tea set: cov. teapot, cov. sugar
bowl & creamer; each piece
w/a squatty bulbous body,
each w/molded 'butterfly' han-
dles & cover finials, decorated

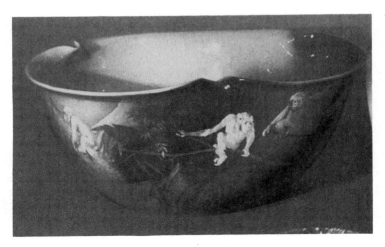

Unique Standard Glaze Punch Bowl

w/clusters of yellow wild roses & green leaves against a blackish green & brown to yellow ground, Standard glaze, sugar bowl & creamer No. 329, teapot No. 404, 1890, Kataro Shirayamadani, teapot 4½" h., 3 pcs. (wicker teapot handle needs rewinding)**1,650.00**

Vase, 2 ⅜" h., low & wide cushion-form body centered by a narrow, short flaring neck, decorated w/small yellow blossoms & leafy vines against a shaded dark brown ground, Standard glaze, No. 687, 1894, Sadie Markland**330.00**

Vase, 3" h., squatty bulbous form w/conical sides to a flat mouth, decorated w/yellow wild roses blossoms on dark green leafy stems against a greenish black shaded to yellow ground, Standard glaze, No. 536E, 1889, Harriet Wilcox (small burst bubble near base)**412.50**

Vase, 3½" h., small ovoid body tapering to a flat mouth, decorated w/yellowish orange clover & green leaves on a dark brown shaded ground, Standard glaze, No. 654 E, 1902, Carrie Steinle**275.00**

Small Spherical Standard Glaze Vase

Vase, 3 ⅝" h., spherical body on three knob feet, the top centered by a small molded mouth, small loop handles on the

shoulders, incised & painted yellow & green shamrocks against a brown shaded to yellow ground, Standard glaze, No. 71 C, 1886, Alfred Brennan**247.50** (Illustration)

Small Moon-Flask Vase

Vase, 3 ⅞" h., moon flask-form, flattened round body on four small knob feet, the low rim pinched together at the top center, decorated w/a large yellow clover blossom & green leaves against a reddish tan ground, yellow interior, Standard glaze, No. 90 C, 1889 ...**302.50** (Illustration)

Vase, 4 ⅝" h., simple balusterform body w/incurved loop handles at the shoulder, decorated around the shoulder w/Virginia creeper leaves & berries in golden green & green against a shaded black-green to pea green ground, Standard glaze, No. 583F, 1898, Fred Rothenbusch (tiny stilt pull on base)**247.50**

Vase, 5¼" h., ovoid body tapering to a wide, flat mouth, decorated around the shoulder w/a band of reddish orange maple leaves on a shaded dark brown to olive green ground, Standard glaze, No. 654C, 1901, Amelia Sprague**357.50**

Vase, 5 ⅜" h., silver overlay, ovoid body tapering to a short rolled neck, small yellow poppy-like blossoms on a shaded gold ground, decorated on the flaring foot & around the base w/ornate silver overlay loops & scrolls & on the pointed small loop handles & around the neck rim, silver marked "R 137 - Gorham Mfg. Co.," Standard glaze, No. 6 W, 1892, Mary Nourse**2,420.00**

Vase, 5½" h., ovoid body tapering to a short cylindrical neck, decorated w/large yellowish orange clover blossoms & green leaves against a dark brown ground, Standard glaze, No. 927 F, 1902, Constance Baker**357.50**

Vase, 5½" h., spherical body below a wide trumpet neck, decorated w/delicate stylized daisies on scrolling vines in gold & dark brown against a dark mustard to gold ground, Standard glaze, No. 402, 1888, Albert Valentien...........**330.00**

Vase, 5 ⅝" h., bulbous ovoid shouldered body on a small footring, tapering to a short neck w/flaring mouth, decorated around the top half w/long yellow blossoms & dark green leaves against a shaded dark brown to dark gold ground, Standard glaze, No. 625, 1900, Toby Vreeland (minor glaze discoloration near base)........**247.50**

Vase, 5 ⅝" h., rose bowl-form, footed spherical body w/lightly molded swirled ribbing & a five-crimp everted rim, decorated w/a cluster of yellow wild roses & green leaves against a shaded dark brown & olive green ground, Standard glaze, No. 612 C, 1897, Ed Diers**522.50**

Vase, 5 ⅝" h., slender ovoid body tapering to a short cylin-drical neck, decorated w/large pale yellow blossoms & dark green leaves on a dark green shaded to gold ground, Standard glaze, No. 918E, 1905, Alice Willitts.................**412.50**

Squatty Standard Glaze Vase

Vase, 5 ⅝" h., very wide squatty bulbous body w/a wide shoulder to the short rolled neck, decorated around the upper half w/large overlapping horse chestnut leaves in dark greens against a black shaded to gold ground, Standard glaze, No. 762 C, 1898, Mary Nourse**1,100.00** (Illustration)

Vase, 5 ⅝" h., wide ovoid shouldered body w/a short cylindrical neck, decorated w/clusters of reddish orange cherries & green leaves against a shaded dark green-black to gold ground, Standard glaze, No. 531 E, 1896, John Dee Wareham (minor glaze scratches, one small glaze bubble)**522.50**

Vase, 6" h., 2 ¾" d., slender gently swelled cylindrical body tapering to a short cylindrical neck w/a flat rim, decorated w/dark leaves & berries against a gold shaded to brown ground, Standard glaze, No. 932 F, 1903, Janette Swing**385.00**

Vase, 6 ⅜" h., shouldered ovoid body tapering to a short tapering cylindrical neck, decorated w/large yellow hydrangea flowers on dark green leafy stems against a shaded dark brown to deep gold ground, Standard glaze, No. 905E, 1902, Irene Bishop..........................**990.00**

Vase, 6 ⅞" h., shouldered ovoid body w/a short rolled neck, decorated w/red clover & green leaves on a shaded dark brown to gold ground, Standard glaze, No. 922 D, 1901, Marianne Mitchell.................................**275.00**

Standard Glaze Vase with Berries

Vase, 8" h., baluster-form body w/a tall trumpet neck, decorated w/clusters of purple-blue berries on leafy stems against a black-green shaded to gold ground, Standard glaze, No. 908, 1903, Lena Hanscom, minor glaze scratches...........**275.00** (Illustration)

Vase, 8" h., slender ovoid body w/flat mouth, decorated w/a bust portrait of a 17th century cavalier in cream, black-brown & flesh tones against a shaded dark brown ground, Standard glaze, No. 939 C, 1903, Grace Young (small flat chip on base)**825.00**

Vase, 8" h., 3½" d., simple baluster-form body w/a gently flaring neck, decorated w/large orange poppies w/green centers & green stems against an orange shaded to brown ground, Standard glaze, No. 117 C, 1899, A.D. Sehon...................................**550.00**

Vase, 8¼" h., 4¼" d., bottle-shaped, decorated w/golden pine cones & green needles against a dark brown shaded ground, Standard glaze, 1903, Cecil Duell...................**412.50**

Vase, 8½" h., ovoid body tapering slightly to a wide, flat mouth, decorated w/large bright red tulips w/curling green leaves against a dark brown to gold ground, Standard glaze, No. 913 C, 1902, Mary Nourse**522.50**

Vase, 9⅛" h., ovoid body tapering to a flat mouth flanked by small flat angled loop handles, decorated w/orange trumpet vine flowers & green leaves against a dark brown ground, Standard glaze, No. 604C, 1900, Sallie Toohey (minor glaze scratch, two small bubbles)**412.50**

Vase, 9¼" h., pillow-type, wide flattened round sides tapering to a pinched-in rim, decorated w/a large head of a St. Bernard, Standard glaze, No. 707 AA, 1901, E.T. Hurley (moderate glaze burn, underglaze runs)**770.00**

Vase, 9 ⅜" h., baluster-form body w/a short trumpet neck, decorated around the upper half w/stalks of goldenrod against a dark brown shaded to gold ground, Standard glaze, No. 562, 1897, Olga Geneva Reed**330.00** (Illustration: top next page)

Standard Glaze Vase with Goldenrod

Vase, 9 ⅜" h., slender baluster-
form body, decorated w/a large
yellow tulip on a dark green
leafy stem, against a dark
brown shaded to golden tan
ground, Standard glaze,
No. 562, 1899, Carl
Schmidt**660.00**

Vase, 9 ⅞" h., ovoid body taper-
ing to a small, short cylindrical
neck, decorated w/five sea
gulls flying through stormy
skies, shaded dark brown to
olive green & brown ground,
Standard glaze, No. 786 C,
1897, Albert Valentien (some
minor underglaze runs, minor
glaze scratches)**1,430.00**

Vase, 10" h., large ovoid body
tapering to a short, narrow
neck w/flaring, flattened rim,
decorated w/large orange
autumn leaves on a shaded
dark brown & dark olive green
ground, Standard glaze,
No. 903 B, 1901, Sallie
Toohey**687.50**

Vase, 10" h., silver overlay, thin
ovoid body tapering to short
flaring rim, painted w/portrait of
Jumping Thunder & silver over-
lay, Standard glaze, No. 614D,
1899, Mathew A. Daly, im-

Rookwood Jumping Thunder Vase

pressed factory marks, in-
scribed "Jumping Thunder -
by M.A.DALY"**13,800.00**
(Illustration)

Vase, 10 ⅝" h., squatty bulbous
base tapering slightly to a tall
slender & slightly tapering
cylindrical body w/a widely flar-
ing rim, decorated w/large
orange poppies & green stems
against a rust shaded to black
ground, Standard glaze,
No. 535C, 1890, Albert
Valentien**1,100.00**

Vase, 10 ⅞" h., ovoid body w/a
wide shoulder tapering to a
narrow neck w/a widely flaring
trumpet-form rim, decorated
w/a crane gliding over pine
bows in brown & gold against a
mottled gold ground, Standard
glaze, 1885, Albert
Valentien**1,100.00**

Vase, 11⅛" h., tall slender
baluster-form body, decorated
w/large yellow & orange nas-
turtium blossoms & dark green
leafy stems against a dark
brown ground, Standard glaze,
No. 792 C, 1902, E.T.
Hurley...................................**522.50**

Vase, 11 ¾" h., tall, slender slightly swelled cylindrical body w/a narrow shoulder to the short neck w/widely flaring & flattened rim, decorated w/large yellow jonquils & green stems against a shaded dark brown to olive green ground, Standard glaze, No. 904C, 1902, Virginia Demarest (very minor glaze scratches)**1,320.00**

Vase, 12 ¾" h., footed bulbous ovoid body tapering to a tall cylindrical neck w/flaring rim, decorated w/very large deep red parrot tulips & dark green leaves against a dark brown ground, Standard glaze, No. 846 B, 1900, Fred Rothen-busch (small glaze blister, minor glaze flaw)**605.00**

Vase, 13 ¾" h., bottle-form, wide bulbous nearly spherical body tapering to a very slender tall trumpet neck, decorated w/a yellow & brown sparrow perched on a brown branch w/pale green leaves & dark purple berries against a dark brown shaded to tan ground, Standard glaze, No. T 1105, 1897, Kataro Shirayamadani (minor underglaze spots, small patch of loose glaze)**1,210.00**

Vase, 14 ¾" h., 6¼" d., bulbous ovoid body tapering to a tall, slender neck w/a widely flaring rim, decorated w/large gold iris-es & green leaves against a shaded brown ground, Standard glaze, No. 303A, 1898, A.M. Valentien..........**1,320.00**

Vase, 15" h., gently swelled cylindrical body tapering to a flat rim, decorated w/long leafy stems w/small yellow roses on a shaded gold to dark brown ground, Standard glaze, No. 269 A, 1889, Albert Valentien, several small blisters & inclusions**1,210.00**
(Illustration: top next column)

Tall Standard Glaze Vase

Vase, 17½" h., large ovoid body tapering to a short cylindrical neck, decorated w/large gold & black iris & dark gold leafy stems against a black ground, Standard glaze, No. 905 A, 1900, Kataro Shiraya-madani**5,500.00**

Vase, 18" h., 9½" d., tapering ovoid body w/a wide flat mouth, decorated w/large orange & brick-red lotus blossoms & tall green stems against a shaded black to olive green ground, Standard glaze, No. S1737, 1903, Mary Nourse**5,500.00**

Whiskey jug, ovoid body taper-ing to a short neck w/molded rim, short D-form handle from rim to shoulder, decorated w/golden hops & green leafy vines against a shaded dark to light brown ground, Standard glaze, No. 767, 1896, Josephine Zettel, 5 ⅝" h........**275.00**

Whiskey jug w/original bulbous stopper, silver overlay, waisted bulbous cylindrical body tapering to a short molded neck w/small loop handle to shoulder, decorated w/dark blue-green grapes & leafy vines against a shaded dark to light brown ground, Standard glaze, scrolling silver overlay band around the base & up the back continuing over the handle & neck & over the squatty bulbous stopper, silver marked by Gorham Mfg. Co., No. 674, 1896, Louella Perkins, 8" h.**3,300.00**

Whiskey jug w/stopper, bulbous 'beehive' form tapering to a short molded neck w/bulbous pointed stopper, decorated w/large ears of leafy corn in browns, yellow & dark green against a shaded dark brown to rust ground, Standard glaze, No. 747 C, 1902, Howard Altman, 7¾" h.**605.00**

Standard Glaze Whiskey Jug

Whiskey jug w/pointed stopper, ovoid shouldered body tapering to a small molded neck w/loop handle from rim to shoulder, decorated w/a profile bust portrait of American Indian Chief Lean Wolf in browns & golds against a shaded black to gold ground, Standard glaze, No. 512 B, marked on base "Lean Wolf Chief of Hidatsa - Sioux," 1901, Adeliza Sehon, very minor glaze scratches, 9⅜" h.**2,530.00**
(Illustration)

UNUSUAL GLAZES

Vase, 7⅜" h., footed ovoid body w/a narrow shoulder to the short neck w/flaring rim, decorated w/an overall deep red Coromandel glaze, 1933**660.00**

Vase, 8" h., wide flattened cushion-form body tapering to a flaring trumpet neck, Cameo-style decoration w/a large cluster of white wild roses & leafy branches against a dull-glaze dark blue ground, No. 684, 1893, Albert Valentien........**2,640.00**

Vase, 8⅛" h., tall slender ovoid body tapering slightly at the top to a flat mouth, decorated around the shoulder w/a band of abstract swirled flowers in dark green on dark yellow above a dark green ground, Aventurine glaze, 1920, Lorinda Epply (minor grinding flakes on base).....................**880.00**

Vase, 8⅝" h., Aerial Blue line, slightly swelled cylindrical body on a molded footrim, a narrow shoulder to the short, wide neck w/molded mouth, decorated w/a tall full-length portrait of a young woman in long white gown walking w/a tiger at her side, trees in the background, all in shades of dark & light blue & grey, dull satin finish, No. 589 C, 1895, Sallie Toohey**22,000.00**
(Illustration: top next page)

Rare Aerial Blue Vase

Vase, 13⅛" h., tall slender swelled cylindrical body tapering to a short slightly flaring cylindrical neck, the body decorated w/large dark maroon flowers on black leafy stems against a streaky tan ground, black neck, Wine Madder glaze, No. 2785, 1946, Kay Ley (minor glaze bubbles)**825.00**

Rare French Red Vase

Vase, 14⅛" h., large ovoid body tapering to a short rolled neck, incised & decorated overall w/a Mideastern-style design of large scrolled leaves, arabesques & stylized tulips & lilies in dark rose & pink, teal blue, bright blue & black against a dark charcoal ground, French Red glaze, deep rose interior, No. 2246 C, 1923, Sara Sax**31,900.00** (Illustration: bottom previous column)

VELLUM GLAZE WARES

Bowl, 1 ⅞" h., squatty bulbous tapering sides w/wide closed rim, decorated around the rim w/a repeating band of small stylized red flowers & mauve swirls above a pale greenish blue ground, Vellum glaze, No. 957 E, 1915, Mary Grace Denzler..................................**302.50**

Candlestick, widely flaring base tapering to a cylindrical shaft topped by a ring below the flaring, flat-topped socket, decorated around the base w/a band of pink wild roses & green leaves against a pale blue shaded to pale pink ground, Vellum glaze, No. 822, 1909, Edith Noonan, 7½" h.**247.50**

Jardiniere, wide bulbous ovoid body tapering to a flared base & tapering slightly to a wide flat mouth, decorated around the top w/a wide white band painted w/Oriental-style pink cherry blossom branches, deep rose pink ground, Vellum glaze, No. 2466, 1920, Lorinda Epply, 8 ⅝" h.**1,870.00**

Plaque, long narrow rectangular form, decorated w/a misty landscape of slender trees beside a stream in soft shades of brown & cream, Vellum glaze, 1913, Lorinda Epply, back w/Rookwood paper logo &

label w/title "Summer Idyl Lorinda Epply," shadowbox frame, 3 ¾ x 7 ⅝"**1,430.00**

Plaque, narrow upright rectangular form decorated w/tall birch trees near a lake w/a pink sky in the background, in shades of dark blue, green, cream & pink, Vellum glaze, original wide black frame, 1927, E.T. Hurley, 4 x 7 ⅞"**3,410.00**

Plaque, rectangular, decorated w/a landscape of tall trees in the foreground & a river & low trees in the distance, in shades of dark blue, dark green, pale yellow & cream, Vellum glaze, 1926, Fred Rothenbusch, original wide dark blue & gold frame w/an original Rookwood paper logo & label titled "Path to the River, F. Rothenbusch," 5 x 7 ⅞"**3,630.00**

Plaque, rectangular, decorated w/a winter riverside snow scene in pastel blues & pinks, Vellum glaze, 1919, original wide wood frame, Sallie Coyne, 5 x 9⅛"...................**1,650.00**

Vellum Plaque with Mountains

Plaque, rectangular, a lakeside landscape w/tall fir trees & high mountains in the distance, in shades of blue, green & grey, Vellum glaze, penciled title "Among the Rockies," 1913,

Carl Schmidt, original wide black frame, 5 x 7½"**1,540.00** (Illustration: close-up)

Plaque, rectangular, decorated w/a landscape of tall green trees reflected in a small pond, in shades of greys & greens, Vellum glaze, 1920, Ed Diers, new wide flat frame, penciled inscription on back "Tall Sycamore by Ed Diers," 5 ⅞ x 7 ⅞" (glaze losses on edges)**2,090.00**

Plaque, rectangular, decorated w/a misty landscape w/a group of leafy trees in dark blues, yellow & pale green, Vellum glaze, 1913, original wide black wood frame, Lenore Asbury, 8½ x 10 ⅞"**3,190.00**

Plaque, rectangular, a meadow landscape w/a stream to one side w/tall trees in foreground & tall distant trees, in dark shades of blue, rose, black & green, Vellum glaze, 1919, Elizabeth McDermott, recent wide black flat frame, 7⅛ x 9⅛"**3,300.00**

Plaque, rectangular, decorated w/a panoramic winter landscape w/a frozen lake & a forest of fir trees to the left, in shades of dark & light blue & creamy white, Vellum glaze, 1917, Sallie Coyne, new wide frame, 7¼ x 9 ⅜" (small glaze losses on two edges)**3,300.00**

Plaque, rectangular, decorated w/a mountain landscape w/scattered trees & a lake in the foreground & a large pointed peak in the distance, in shades of dark blue, green, yellow & cream, Vellum glaze, 1929, Fred Rothenbusch, original paper logo & paper label w/"A Peak F. Rothenbusch," original wide frame, 7 ¾ x 9 ⅝"**5,060.00**

Plaque, rectangular, decorated w/a landscape scene w/a large fir tree in the foreground & a large lake & a lone snow-capped mountain in the distance in shades of dark blue, green & white, Vellum glaze, 1914, Katherine Van Horne, original wide oak wood frame, 8½ x 10 ¾"**4,290.00**

Plaque, rectangular, boldly embossed w/large white Easter lilies on dark green leafy stems against a light blue to cream to dark green ground, Vellum glaze, No. 6290, 1931, Lenore Asbury, original gilt frame w/paper logo label, 8 ⅝ x 11⅛"**9,900.00**

Large Vellum Plaque

Plaque, rectangular, a panoramic Venetian harbor scene w/water in the foreground & sailboat in the mid-ground, in shades of blue, pink & cream, Vellum glaze, 1921, Carl Schmidt, original wide frame, 8 ⅞ x 11 ⅞"**5,500.00** (Illustration: close-up)

Plaque, long rectangular form, decorated w/a wide winter woodland landscape at sunset in shades of dark & light blue, brown, pink & cream, Vellum glaze, original wide flat black frame, 1921, E.T. Hurley, frame w/original Rookwood label titled "Winter Woods E.T. Hurley, " 9⅛ x 14 ⅜" (some areas of loose glaze, areas of glaze loss at edge)**3,520.00**

Plaque, rectangular, a large mountain landscape w/a craggy snowcapped peak, possibly Long's Peak, Colorado, w/a waterfall & fir tree in the foreground, in shades of dark blue, green, brown, cream & white, Vellum glaze, 1928, Fred Rothenbusch, original wide black frame, 14⅛ x 16⅛...**17,600.00**

Plaque, rectangular, large Venetian harbor scene at sunrise in shades of pale blue, cream & green, Vellum glaze, in original antiqued gold shadowbox frame w/metal tag titled "Dawn," 1926, Carl Schmidt, 14¼ x 16 ⅜**35,200.00**

Trivet, square, molded w/a portrait of a young woman standing wearing a wide blue & white striped dress trimmed in blue ribbons, flanked by green & pink flowers against a pale yellow ground, Vellum glaze, No. 3070, recently framed, 5½"sq.**275.00**

Vellum Trivet with Swan

Trivet, square, incised w/a large white swimming swan on dark blue water w/green ringed ripples, Vellum glaze, No. 3202, 1924, newly framed, 5 ⅝"sq.**467.50** (Illustration)

Vase, 4 ⅞" h., bulbous ovoid body w/a wide flat mouth, decorated around the shoulder w/a repeating design of scattered small pink blossoms & green

leafy scrolls against a dark blue ground, deep rose interior, Vellum glaze, No. 1343, 1923, Lenore Asbury......................**550.00**

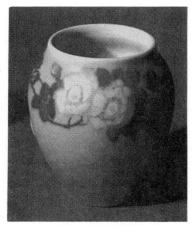

Vellum Vase with Wild Roses

Vase, 5" h., bulbous ovoid body tapering to a wide flat mouth, decorated w/a band of large pink & yellow wild rose blossoms & dark green leaves against a shaded cream to aqua ground, pale yellow interior, Vellum glaze, No. 1343, 1927, Ed Diers**1,430.00** (Illustration)

Vase, 5" h., bulbous ovoid body w/a closed mouth, decorated w/pale pink & white sweet peas & green leaves against a dark blue shaded to grey ground, Vellum glaze, No. 1120, 1929, Ed Diers**1,100.00**

Vase, 5½" h., wide ovoid body w/a wide shoulder to the tiny flared neck, decorated around the shoulder w/bluish white daisies on slender green stems against a blue shaded to pale green shaded to pink to blue ground, Vellum glaze, No. 750 C, 1910, Carrie Steinle (small glaze bubble on side)**660.00**

Vase, 5 ⅝" h., wide ovoid body tapering to a flat rim, decorated

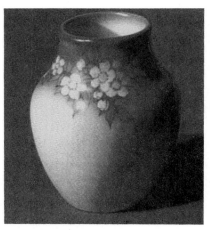

Vellum Vase with Cherry Blossoms

around the shoulder w/white & pink cherry blossoms & green leaves against a blue shaded to pink ground, Vellum glaze, No. 914 E, 1928, Lenore Asbury.................................**1,430.00** (Illustration)

Vase, 6" h., cylindrical body narrowing slightly at the flat mouth, decorated around the upper half w/pale pink & white cherry blossoms on dark blue stems against a pale creamy yellow ground, Vellum glaze, No. 952 F, 1907, Lorinda Epply**467.50**

Vase, 6¼" h., footed ovoid body tapering to a flaring rim, decorated w/a band of small stylized blue & pink blossoms around the neck & trailing down the sides forming panels of pale cream & green, Vellum glaze, No. 357F, 1923, Ed Diers**605.00**

Vase, 6¼" h., slightly tapering cylindrical body w/a flat rim, decorated w/a Venetian harbor scene in shades of blue, green & cream, Vellum glaze, No. 950 F,1920, Carl Schmidt**1,430.00**

Vase, 6 ⅜" h., slightly tapering conical body w/a short flaring

rim, decorated w/dark green &
cream autumn leaves against a
dark green to cream shaded
ground, Vellum glaze,
No. 1658 F, 1912,
Edith Wildman......................**330.00**

Vase, 6 ¾" h., bulbous ovoid
body tapering to a short rolled
neck, decorated around the
shoulder w/pairs of large pale
yellow wild roses & dark green
leaves against a bluish green
to pale yellow ground, Vellum
glaze, No. 2918 E, 1928,
Ed Diers**935.00**

Vase, 6 ¾" h., simple ovoid body
tapering to a wide flat mouth,
decorated w/a Venetian harbor
scene in shades of dark blue,
pale green & cream, Vellum
glaze, No. 551, 1922, Carl
Schmidt (small glaze
flaw at rim, two dimples in
glaze)**1,320.00**

Vase, 7⅛" h., slender ovoid
body tapering to a rolled rim,
decorated w/a band of large
pink blossoms & green leaves
on a blue shaded to creamy
white ground, Vellum glaze,
No. 925 E, 1928, Fred Rothen-
busch**825.00**

Vase, 7⅛" h., slightly swelled
cylindrical body tapering to a
short rolled neck, carved w/a
band of stylized peacock feath-
ers in yellow, green & blue
around the top against a dark
green Vellum glaze, No. 904 E,
1909, Sara Sax**4,730.00**

Vase, 7⅛" h., spherical body on
a small footring, the wide
shoulder tapering to a small
molded mouth, decorated
w/large white magnolia blos-
soms w/yellow centers & on
green stems against a blue &
white shaded ground, Vellum
glaze, No. 6204 C, 1945,
Kataro Shirayamadani**1,760.00**
(Illustration)

Bulbous Vellum Vase with Magnolia

Vase, 7¼" h., 3" d., tall slightly
swelled cylindrical body w/a
short rolled neck, decorated
around the shoulder w/large
white daisies w/yellow centers
atop long green stems down
the sides all on a shaded grey
to cream ground, Vellum glaze,
No. 904 E, 1908,
Edith Noonan**605.00**

Vase, 7⅜" h., ovoid body taper-
ing to a short rolled neck, deco-
rated w/an autumn landscape
in pale yellow, green, blue &
white, Vellum glaze, No. 922 D,
1948, E.T. Hurley**1,760.00**

Vase, 7⅜" h., simple ovoid body
tapering to a short rolled neck,
decorated w/a continuous win-
ter forest landscape w/two deer
in shades of pale blue, green,
cream & brown, Vellum glaze,
1947, E.T. Hurley**3,300.00**

Vase, 7½" h., 3½" d., baluster-
shaped body w/short angled
shoulder to flat mouth, decorat-
ed w/winter landscape at twi-
light w/shaded peach sky &
bluish green trees, Vellum
glaze, impressed flame mark
"XVII - 1356E - FR," 1917,
Fred Rothenbusch**1,375.00**

Vase, 7½" h., cylindrical body
w/a slightly tapering rim band,
twilight harbor scene w/fishing

boats in a small bay in dark blue & black against a dark green ground shaded to black at the top & bottom, Vellum glaze, No. 952 E, 1908, E.T. Hurley**2,860.00**

Vase, 7 ⅝" h., cylindrical body w/a slightly tapered band around the flat rim, decorated w/a continuous band of small yellow daffodils on tall dark green leafy stems against a shaded pale green to pink to pale yellow ground, Vellum glaze, No. 952 E, 1910, Kataro Shirayamadani (professionally repaired glaze skip at rim)**1,980.00**

Vase, 7 ⅝" h., slender ovoid body tapering to a short neck w/rolled rim, decorated w/a landscape of red flowering trees in shades of dark blue, green & cream, Vellum glaze, No. 922 D, 1914, Charles McLaughlin............................**660.00**

Vase, 7 ⅝" h., slender ovoid body w/a flaring foot & tapering to a wide closed rim, decorated around the top half w/a band of large pink nasturtium blossoms & green leafy vines against a blue shaded to cream ground, Vellum glaze, No. 1779, 1929, Fred Rothenbusch**1,650.00**

Vase, 7 ¾" h., wide ovoid body tapering slightly to a wide short rolled neck, decorated w/a forested landscape of green & pale gold trees against a shaded dark blue ground, Vellum glaze, No. 913 D, 1937, Fred Rothenbusch......................**1,980.00**

Vase, 7 ⅞" h., gently tapering cylindrical sides w/a short flaring neck, decorated w/a band of exotic stylized florals in pink, white & dark blue around the top against a greyish blue ground, Vellum glaze, No. 2069, 1922, Fred Rothenbusch**660.00**

Vase, 7 ⅞" h., slender ovoid body tapering slightly to a flat mouth, decorated w/white tulips on tall dark green leafy stems against a grey shaded to pale yellow shaded to dark grey ground, Vellum glaze, No. 901 D, 1915, Elizabeth McDermott (minor glaze pitting)**550.00**

Vase, 8⅛" h., simple ovoid body tapering to a rolled wide mouth, decorated w/white carnations on slender dark blue stems against a pale blue shaded to pale green ground, Vellum glaze, No. 2544, 1925, Ed Diers (very little crazing)**1,650.00**

Vellum Vase with Crocus

Vase, 8 ⅜" h., shouldered ovoid body tapering to a short flaring neck, decorated w/large pale purple crocuses on green leafy stems against a pink shaded to cream shaded to dark green ground, Vellum glaze, No. 614 E, 1926, Carl Schmidt**5,060.00** (Illustration)

Vase, 8 ⅝" h., cylindrical body flaring widely at the base, decorated w/large white wild roses on dark green leafy stems against a pale green to cream ground, Vellum glaze, No. 1358 D, 1908, Ed Diers**522.50**

Vase, 8 ¾" h., gently flaring cylindrical body w/a narrow flattened shoulder to the short, wide cylindrical neck, decorated w/a twilight landscape scene of silhouetted trees in shades of dark & light blue & grey, Vellum glaze, No. 1918, 1919, E. T. Hurley**1,870.00**

Vase, 8 ¾" h., gently flaring cylindrical sides to a wide flat shoulder & a short, wide cylindrical neck, decorated around the top half w/clusters of blackberries hanging from green leafy vines, dark blue around the neck & shoulder & creamy yellow around the lower body, Vellum glaze, No. 1918, 1926, Fred Rothenbusch**825.00**

Vase, 8 ¾" h., trumpet-form body w/a narrow angled shoulder to the flat mouth, decorated w/three tall flatly painted trees in green & brown against a pale creamy green to blue to green ground, Vellum glaze, No. 1356 D, Arthur Conant....................**2,200.00**

Vase, 8 ¾" h., wide ovoid body tapering to a short, wide mouth, decorated around the shoulder w/a wide rose pink band w/small flying bluebirds & a blue rim band about two blue medial pinstripes above the tan base, Vellum glaze, No. 1044, 1918, Charles Klinger (small areas of glaze loss)**412.50**

Vase, 8 ⅞" h., tall waisted cylindrical body, decorated w/fir forest landscape w/tall trees in the foreground, a lake in the center ground & further trees in the distance, in shades of dark blue, blue, lavender & cream, Vellum glaze, No. 1358 D, 1920, Sallie Coyne (underglaze skips at rim, some glaze pooling at base)**3,300.00**

Vase, 9" h., gently swelled cylindrical body tapering to a wide

Vellum Vase with Landscape

rolled mouth, decorated w/a landscape scene of a wooded meadow by a stream w/distant hills in dark blues, greens & cream, Vellum glaze, No. 892 C, 1923, Fred Rothenbusch**4,180.00** (Illustration)

Vase, 9" h., ovoid body w/a closed rim, decorated w/large pale cream & violet lotus blossoms & green stems against a shaded dark blue ground, Vellum glaze, No. 1126 C, 1908, Ed Diers**990.00**

Vase, 9⅛" h., simple ovoid body tapering to a short rolled neck, decorated around the shoulder w/large pink wild rose blossoms against a shaded blue band above a creamy white base, Vellum glaze, No. 922, 1911, E.T. Hurley**1,100.00**

Vase, 9¼" h., slender ovoid body tapering to a short rolled mouth, decorated w/a soft forest landscape w/tall leafy trees in the center ground & short trees in the background, in shades of dark & light blue, lavender, pale green & cream, Vellum glaze, No. 892 C, 1923, Lenore Asbury.........**1,980.00**

Vase, 9¼" h., slightly flaring cylindrical body tapering in at the shoulder to a wide, flat mouth, decorated around the shoulder w/stylized florals in green, dark blue, pink & cream, shaded dark blue neck & pale rose body, Vellum glaze, No. 1369 D, 1916, C.S. Todd (two tight lines at rim)..................**440.00**

Vase, 9¼" h., wide ovoid body tapering to a wide short rolled neck, decorated w/large white apple blossoms around the shoulder against a pale blue ground, Vellum glaze, No. 913 C, 1930, Ed Diers**2,420.00**

Vase, 9¼" h., 4 ¾" d., tall gently ovoid body tapering to a short flaring neck, decorated w/a landscape of dark green & blue trees against a stormy sky, Vellum glaze, No. 922C, 1918, E. Diers**2,530.00**

Vase, 9 ⅜" h., tall ovoid body w/a flat mouth, decorated w/a banded landscape scene w/trees in blues & greens on a moss green ground, Vellum glaze, No. 2040 D, 1917, Ed Diers**2,090.00**

Vase, 9½" h., slightly swelled cylindrical body w/a wide flat mouth, decorated w/a misty forested landscape in shades of tan, dark & light green, pale blue & cream, Vellum glaze, No. 951 D, 1919, E.T. Hurley**1,870.00**

Vase, 9½" h., wide bulbous ovoid shouldered body w/a molded ring neck, incised & painted around the shoulder w/buckeye leaves, stems & pods in browns & grey-green above an angular border above the dark blue body, Vellum glaze, No. 531, 1914, Sara Sax (small glaze bubbles in lower body)**2,860.00**

Vase, 9 ⅝" h., cylindrical w/short rolled neck, banded landscape of trees in shades of dark blue, green & cream, Vellum glaze, No. 1882, 1920, Fred Rothenbusch (minor glaze bubbles)...................**1,430.00**

Rookwood Vellum Landscape Vase

Vase, 10¼" h., simple ovoid body tapering to a short flaring neck, decorated w/a continuous lakeside autumn landscape in blues, greens & golds, Vellum glaze, No. 925C, 1929, Ed Diers**2,200.00** (Illustration)

Vase, 10¼" h., tall slender ovoid body tapering to a short flaring neck, decorated w/a twilight forest scene w/tall trees in the foreground, in shades of dark & light blue, dark green, pink & cream, Vellum glaze, No. 937, 1917, Lenore Asbury..........**4,290.00**

Vase, 10½" h., slender ovoid body tapering to a narrow neck w/a widely flaring flat rim, decorated around the neck w/a green leafy vine w/blue berries & one vine w/berries trailing down the side, Vellum glaze, No. 4 V, 1921, Lenore Asbury......................**990.00**

Vellum Scenic Landscape

Vase, 10½" h., wide ovoid body tapering to a short cylindrical neck, decorated w/a panoramic landscape w/large leafy trees in the foreground, in shades of greens, browns & creams, Vellum glaze, No. 940 C, 1919, Ed Diers, professionally repaired tight rim line**1,430.00** (Illustration)

Vase, 11⅛" h., bulbous ovoid body tapering to a short cylindrical neck w/flat rim, decorated w/pale pink poppy blossoms at the base below tall blue

columbines, all against a shaded grey ground, Vellum glaze, No. 1007 C, 1904, John Dee Wareham**4,190.00**

Vase, 11¼" h., swelled cylindrical body w/a rounded shoulder to the short rolled neck, decorated w/long repeating clusters of hanging creamy white leaves & maroon berries against a lime green ground, cream neck band, Vellum glaze, No. 922 B, 1915, Sara Sax**2,200.00**

Vase, 17 ⅜" h., tall slender slightly swelled cylindrical body w/a narrow shoulder to the short cylindrical neck, decorated w/a birch forest w/tall leafy trees beside a meadow, in shades of dark blue & green w/white, cream & a touch of pink Vellum glaze, No. 907 B, 1923, Lenore Asbury (neat drill hole in base)**3,520.00**

Vase, 18" h., tall slightly swelled cylindrical body tapering slightly to a short cylindrical neck, decorated w/an autumn woodland scene w/tall trees in dark blue, greens, brown & cream, Vellum glaze, No. 907 B, 1917, Ed Diers**3,740.00**

Vase, 8½" h., 3¼ d., gently swelled cylindrical body tapering to a short, cylindrical neck, decorated w/large lavender sweet peas on green stems against an ivory shaded to lavender ground, Iris glaze, No. 907 E, 1906, Lenore Asbury....................**1,320.00** (Illustration: No. 3 top next page)

Vase, 10" h., 5½" d., baluster-shaped w/short, flaring neck, decorated w/large chrysanthemum blossoms on a blue shaded to brown to cream ground, Vellum glaze, No. 546C, 1925, Fred Rothenbusch ...**4,180.00** (Illustration: No. 2 top next page)

Vase, 10½" h., 3½" d., tall slightly swelled cylindrical body w/a wide flat mouth, decorated w/large purple irises on tall green stems against a shaded black to lavender & green ground, Iris glaze, No. 821 C, 1907, Sallie E. Coyne**3,575.00** (Illustration: No. 1 top next page)

Vase, 11" h., 4" d., slightly swelled cylindrical body w/a wide flat mouth, decorated w/soft pink roses on thorny green stems on a shaded blue to ivory ground, uncrazed, Vellum glaze, No. 951 C, 1927, Frederick Rothenbusch........**302.50** (Illustration: No. 4 top next page)

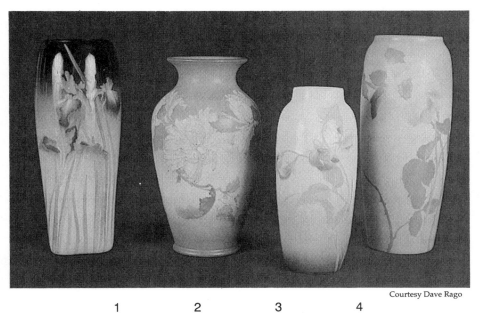

Courtesy Dave Rago

1 2 3 4

Rookwood Iris & Vellum Glaze Vases

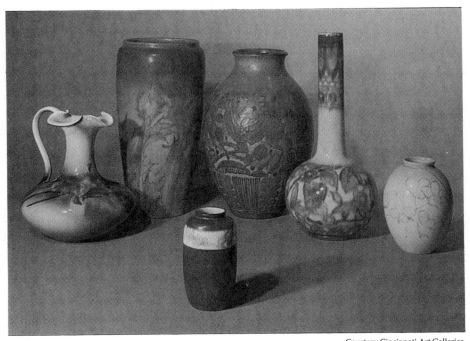

Courtesy Cincinnati Art Galleries

1 2 4 5 6

3

Rookwood Ewer & Vases

Ewer, wide squatty cushion-form base tapering to a tall slender neck w/a flaring tricorner rim, a long S-form handle from the rim to the shoulder, decorated w/a large cluster of English ivy in dark green against a gold shaded to rust ground, Standard glaze, No. 495, 1892, Anna Vanentien, 10" h.**605.00**
(Illustration: No. 1 bottom previous page)

Vase, 6" h., swelled cylindrical shouldered body w/a narrow low molded rim, decorated w/a white band w/pink cherry blossoms against a solid dark blue ground, Vellum glaze, No. 924, 1917, Carrie Steinle**495.00**
(Illustration: No. 3 bottom previous page)

Vase, 7" h., ovoid egg-form body tapering to a flat molded mouth, decorated w/stylized white dogwood blossom on thin green stems against a shaded pale blue ground, Vellum glaze, No. 6184 E, 1944, Kataro Shirayamadani, some minor glaze discoloration ...**1,100.00**
(Illustration: No. 6 bottom previous page)

Vase, 14 ⅜" h., Art Deco style, wide ovoid body tapering to a short flaring neck, decorated w/a design of three leaping deer amid exotic foliage, all accented & outlined w/slip trailing, slightly crystalline dark green, brown & blue Matte glazes, No. 2246, 1927, William Hentschel**2,420.00**
(Illustration: No. 4 bottom previous page)

Vase, 15⅛" h., slightly tapering cylindrical body w/a wide flat molded mouth, decorated w/tall thistles w/deep rose blossoms & yellowish green leafy stems against a dark blue shaded to pale rose ground, Matte glaze, No.1369 D, 1924, Elizabeth Lincoln...................**990.00**
(Illustration: No. 2 bottom previous page)

Vase, 16¼" h., bottle-form, spherical base below a tall 'stick' neck, decorated around the base & the top of the neck w/stylized, abstract flowers in soft blue, green, maroon & brown w/a pale grey band at the base of the neck, glossy glaze, No. 2825 A, 1925, Lorinda Epply**1,100.00**
(Illustration: No. 5 bottom previous page)

Book ends, figural, model of a mule standing w/head turned to the side, on a rectangular base, white Matte glaze, No. 6216, 1934, designed by William McDonald, 5 ⅞" h., pr.............................**715.00**
(Illustration: No. 2 top next page)

Vase, 6 ⅜" h., silver overlay, ovoid body tapering slightly to a short cylindrical neck, decorated w/a stem of goldenrod against a shaded brown ground, trimmed w/Art Nouveau silver overlay loops & bands by Gorham, Standard glaze, No. 30 F, 1907, Laura Lindeman**1,870.00**
(Illustration: No. 1 top next page)

Vase, 10 ⅜" h., ovoid body tapering to a short cylindrical neck, decorated w/large purplish blue orchids on pale green stem against a pale yellow shaded to cream shaded to pale green ground, Iris glaze, No. 907 D, 1903, Carl Schmidt**3,740.00**
(Illustration: No. 3 top next page)

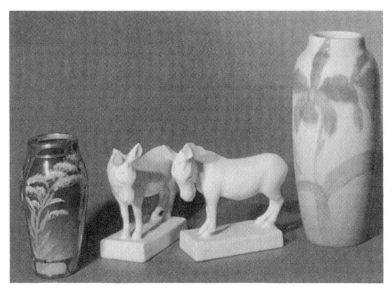

1 2 3
Rookwood Vases & Book Ends

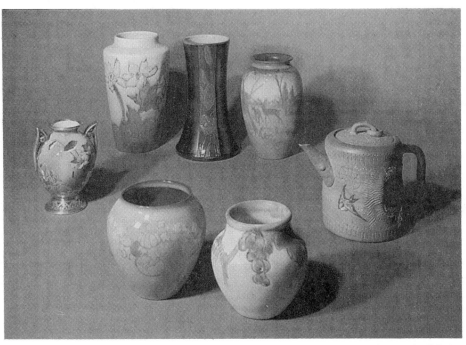

1 2 3 4
5 6 7
Various Rookwood Vases

Teapot, cov., cylindrical body w/pinched-in side & narrow rounded shoulder around an inset flat cover w/loop handle w/attached loose ring, short straight spout & thick D-form handle, dark reddish brown ground w/incised Japanesque decoration of chrysanthemums, birds & lines & symbols in grey & touched w/gold, No. 69, 1884, Laura Fry, minor spout restoration, 6" h.**4,180.00** (Illustration: No. 7 bottom previous page)

Vase, 4½" h., bulbous ovoid body tapering to a short cylindrical neck w/molded rim, incised & decorated w/purple grape clusters & leafy green vines against a pale yellow ground, Matte glaze, No.170Z, 1904, Rose Fechheimer........**495.00** (Illustration: No. 6 bottom previous page)

Vase, 4 ⅞" h., bulbous ovoid body tapering to a wide flat mouth, decorated w/a band of repeating groups of stylized flowers in blue & pink against a pink ground, glossy glaze, No.1343, 1923, Fred Rothenbusch**880.00** (Illustration: No. 5 bottom previous page)

Vase, 5 ⅜" h., silver overlay, footed ovoid body tapering to a short rolled neck, small yellow poppy-like blossoms on a shaded gold ground, decorated on a flaring foot & around the base w/ornate silver overlay loops & scrolls & on the pointed small loop handles & around the neck rim, silver marked "R 137 - Gorham Mfg. Co.," Standard glaze, No. 6 W, 1892, Mary Nourse**2,420.00** (Illustration: No. 1 bottom previous page)

Vase, 7 ⅜" h., simple ovoid body tapering to a short rolled neck, decorated w/a continuous winter forest landscape w/two deer in shades of pale blue, green, cream & brown, Vellum glaze, 1947, E.T. Hurley**3,300.00** (Illustration: No. 4 bottom previous page)

Vase, 8 ¾" h., slightly tapering cylindrical body w/a flat wide shoulder to a short cylindrical mouth, decorated w/bright pink flowers on dark pinkish green leaves against a shaded pink ground, Matte glaze, No.1918, 1927, Elizabeth Lincoln**1,320.00** (Illustration: No. 2 bottom previous page)

Vase, 8 ¾" h., waisted cylindrical body w/flaring base, French Red glaze w/dark pink interior & the exterior in dark charcoal grey w/alternating matte wide stripes & stripes incised w/dark rose tulips & greenish blue leaves w/a glossy glaze, No. 1358 D, 1922, Sara Sax**4,510.00** (Illustration: No. 3 bottom previous page)

Trivet, square, decorated w/a stylized Dutch harbor scene w/a woman & child, polychrome glazes, No. 3203, 1924, 6" sq.**247.50** (Illustration: No. 1)

Vase, 7" h., 3 ¾" d., porcelain, ovoid body w/a short cylindrical neck w/flaring rim, decorated w/brown & blue stylized flowers & leaves around the bottom half on a white glossy ground, uncrazed, 1934, Jens Jensen.........................**605.00** (Illustration: No. 3)

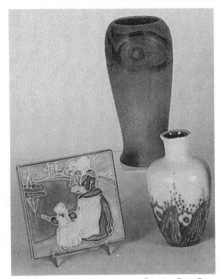

Courtesy Dave Rago

1 2 3
Rookwood Trivet & Vases

Vase, 9¼" h., 3 ¾" d., simple ovoid body w/flaring foot & closed rim, incised green & blue peacock feathers against a shaded butterfat dark blue shaded to pink ground, Wax Matte glaze, No. 2305, 1920, Elizabeth Lincoln**1,320.00**
(Illustration: No. 2)

TECO POTTERY

The American Terra Cotta and Ceramic Company of Terra Cotta (Crystal Lake), Illinois introduced their line of Teco Pottery in 1902. The company had been founded by William D. Gates in 1881 and originally produced only bricks and drain tile. The company had excellent facilities for experimentation, including a chemical laboratory, and was able to develop this art pottery line which featured matte green glazes. Later pieces were produced in a wider range of colors including metallic lustre and crystalline

glazes. Some hand-thrown pottery was produced but Gates preferred molded wares since they were less expensive to make. Teco Pottery was no longer produced by 1923 and the American Terra Cotta and Ceramic Company was sold in 1930. A good reference on this pottery is the book Teco: Art Pottery of the Prairie School, *by Sharon S. Darling (Erie Art Museum, 1990).*

Ashtray, round w/low sides crimped & flared at the rim, green matte glaze, designed by W.D. Gates, impressed marks, 4½" d.**$165.00**

Book ends, figural, modeled as a large seated gargoyle w/open wings & a spiny backbone, pointed ears & fierce open mouth, rectangular base, rich oatmeal matte glaze, impressed "American Terra Cotta Chicago," 8½" h., pr.**1,870.00**

Teco Twisting Low Bowl

Bowl, 9¼" d., 2½ h., twisting low form w/embossed slanting leaves, strong green & gunmetal glaze, die-stamped "TECO" twice**935.00**
(Illustration)

Bowl, 10½" d., 2½" h., saucer-shaped body, resting on a cross-shaped foot, smooth matte green glaze, die-stamped "Teco," w/paper label & original price tag**1,540.00**

Bowl-vase, squatty bulbous form w/closed wide mouth, prominent finger marks, green matte glaze, impressed marks, 4½" d., 2½" h............**357.50**

Chamberstick, a wide cushion foot supports a slender tapering baluster-form shaft molded w/stylized leaves & a blossom head socket, a loop handle at one side of the shaft, rich matte green & silver glaze, original paper label, 10¼" h.**660.00**

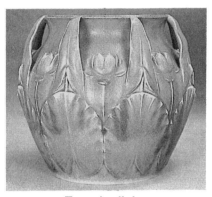

Teco Jardiniere

Jardiniere, wide ovoid body tapering to a short flaring neck, molded around the lower body w/eight lily pads below a row of water lily blossoms alternating w/pointed arrowroot leaf buttress-form open handles attaching to the neck rim, designed by W.J. Dodd, smooth matte glaze in shades of green & yellow, restoration to handles, hairlines in two handles**9,900.00** (Illustration)

Pitcher, 4" h., 5" d., squatty body w/narrow neck & swoop-ing handle, smooth matte green glaze, die-stamped "Teco," Model No. 56**330.00**

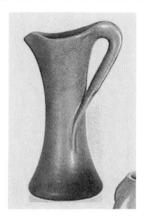

Teco Corseted-form Vase

Pitcher, 9" h., 4 ¾" d., corseted-form w/an organic wishbone handle & an undulating rim, matte green glaze, die-stamped "TECO" twice, Model No. 294......................**880.00** (Illustration)

Vase, 3½" h., footed squatty spherical body w/a small molded neck, medium green matte glaze, impressed mark..........**495.00**

Vase, 3 ¾" h., 3½" d., bulbous base, stovepipe neck & angular handles, smooth matte green glaze, die-stamped mark.......**522.50**

Vase, 4½" h., bulbous nearly spherical body tapering to a short three-sided neck, rich medium green matte glaze ...**440.00**

Vase, 4 ¾" h., 3" d., simple ovoid body tapering to a thick molded mouth, fine even matte green glaze w/gunmetal wash, die-stamped "TECO - 211"**385.00**

Vase, 5½" h., ovoid body tapering to a short cylindrical neck, angular buttress handles down the sides, medium green matte glaze, impressed mark (base chip repair)**495.00**

Vase, 5½" h., swelled cylindrical body w/a narrow shoulder to the short flaring neck, rich tan glossy glaze w/pale blue & violet highlights, Shape No. 60A, experimental glaze**550.00**

Vase, 5½" h., 3¼" d., ovoid body tapering to a short, flaring neck, smooth matte green glaze, Model No. 166C, impressed mark**522.50**

Vase, 5½" h., 3¼" d., ovoid body tapering to a flaring rim flanked by square buttressed handles at top & base, light pink matte glaze, designed by W.D. Gates, Model No. 427, die-stamped mark**660.00**

Vase, 5½" h., 4 ¾" d., compressed globular base & long slender neck flaring slightly at rim, light matte green glaze, die-stamped mark & "#50"**440.00**

Vase, 5½" h., 5¼" d., broad bulbous ovoid body, the wide shoulder tapering to a short neck w/rolled rim, smooth light green matte glaze, impressed "Teco - 76" (minute glaze nick at rim)**412.50**

Vase, 6½" h., 5½" d., double gourd-form w/four buttressed handles, leathery matte grey glaze, die-stamped "Teco" twice, Model No. 287**1,375.00**

Vase, 7" h. footed bulbous conical body tapering to a short slightly flaring cylindrical neck, green matte glaze, impressed marks..................**605.00**

Vase, 7" h., slender ovoid body framed by four low square buttress handles down the sides, beige matte glaze, impressed mark**770.00**

Vase, 7" h., 2½" d., slender ovoid body flanked by four small full-length buttress handles, green matte glaze,

designed by W.D. Gates, Model No. 436, die-stamped mark**1,210.00**

Vase, 7¼" h., 4½" d., tapering body w/four long upright buttressed handles, smooth matte green glaze, die-stamped mark (hairline to one handle)**825.00**

Teco Hourglass Vase

Vase, 7½" h., 4¼" d., angular hourglass shaped body w/four buttressed handles, rich matte green glaze, stamped "Teco".................................**1,925.00** (Illustration)

Vase, 8" h., 4"w., three-sided cylindrical body w/a wide flat shoulder to the molded mouth, smooth matte green glaze, mark partially obscured**880.00**

Vase, 9¼" h., 4½" d., conical w/bulbous neck, smooth matte light green glaze, die-stamped "Teco" twice**770.00**

Vase, 9½" h., 5" d., ovoid shouldered body tapering to a funnel-form neck flanked by long loop handles from rim to shoulder, smooth matte green glaze, die-stamped mark, designed by F. Albert, Model No. 283 ..**825.00**

Vase, 11½" h., tall baluster-form w/a thick foot, angled shoulder & flaring rim w/long S-scroll strap handles from under the

rim to the shoulder, green matte glaze w/heavy charcoaling, designed by Ian Paul, impressed marks...................**990.00**

Vase, 11½" h., 4¼" d., footed baluster-form body w/a trumpet-form neck, a band of narrow upright pierced leaves extending from the base to the shoulder & bent at right angles to attach to the neck, overall green glaze, stamped "Teco 85" (chip on one leaf, two touched-up nicks at top).....**4,400.00**

Vase, 11½" h., 4 ¾" d., ovoid body w/short flaring neck supporting a wide flat platform raised on four heavy buttresses connecting it to the shoulder, four buttress feet around the base, smooth matte green glaze, die-stamped mark (restoration to tips of feet)**1,980.00**

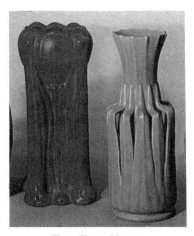

Two Teco Vases

Vase, 11 ⅝" h., a large cupped tulip blossom framed by four heavy buttress leaf-molded supports forming the squared body, dark blue matte glaze, stamped "Teco" twice, two short, tight lines at rim & one at base**990.00**
(Illustration: left)

Vase, 11 ⅝" h., ring-footed cylindrical body w/tall wide pierced leaves up the sides & forming an angled shoulder below the tall rib-molded trumpet neck, matte green glaze, designed by William J. Dodd, early 20th c., stamped twice "Teco," two small repaired glaze flakes at rim, small stilt pull at base**2,310.00**
(Illustration: right)

Vase, 11 ¾" h., 4 ¾" d., bulbous large open lotus blossom at the top framed w/four full-length buttresses flanking undulating stems, smooth matte green glaze, die-stamped "Teco 2X," designed by F. Moreau**3,850.00**

Vase, 12" h., a disc foot supporting a cupped lower body w/an angled shoulder to the tall flaring cylindrical neck flanked by four long thin serpentine handles running from the rim to the shoulder, dark black-green mottled glaze, Shape No. 89, "Teco" stamped twice, early 20th c.**1,760.00**

Teco Double-Gourd Vase

Vase, 13" h., double-gourd body w/low thick curved buttress handles from the rim to base, matte green glaze, designed

by W.B.Mundie..................**7,700.00**
(Illustration)

Vase, 13 ¾" h., 6¼" d., tall gently tapering cylindrical body molded w/four boldly flaring corner buttresses & a four-pointed, pinched rim, thick curdled matte peacock bluish green glaze, designed by F. Moreau, unmarked.........**1,430.00**

Vase, 14" h., cylindrical w/four broad inset handles at shoulder, matte mustard yellow glaze, designed by Fritz Albert, impressed "TECO" twice...................................**2,530.00**

Vase, 30" h., widely flaring trumpet-form body w/a rounded deep shoulder to a flat & widely flaring short neck, green w/a finely carved band of stylized lotus blossoms & buds around the shoulder w/the stems down

the side, shape No. 111, marked**9,200.00**

Wall pocket, wide conical form tapering to a pointed base drop, the sides molded w/long spiked leaves, a band of embossed small blossoms around the bottom, rich mottled green & black matte glaze, die-stamped "Teco (3X) - 156 - B," 6½" w., 15" h. (short hairline from hole on back rim, small glaze chip at bottom back)**550.00**

Vase, 6" h., nearly spherical lobed body w/four open handles from the shoulder to the flat closed mouth & the lip & shoulder pierced w/small quatrefoils, lightly molded swirls between the lobes on the lower body, matte green glaze, designed by F. Albert, Shape No. 113**2,530.00**
(Illustration: left below)

Unusual Teco Vases

Courtesy Don Treadway

Vase, 12" h., tall slightly swelled cylindrical body w/a wide shoulder to a short flaring neck, the neck & body flanked by four heavy angled buttress handles w/ribbing at the top & feet, a ribbed horizontal band near the bottom, matte green glaze, designed by Max Dunning, Shape No.285.....**4,950.00** (Illustration: right bottom previous page)

Courtesy Dave Rago

1 2 3

Three Teco Vases

Vase, 6½" h., 3" d., bulbous spherical base tapering to a tall cylindrical neck flanked by four buttress handles & ending in a flared rim, smooth matte green glaze, die-stamped marks**1,430.00** (Illustration: No.3)

Vase, 8½" h., 4" d., 'spaceship' style, long tapering ovoid body w/a small molded mouth, wide molded V-shaped fins at the base, even blue matte glaze, invisible repair to small chip on one fin, die-stamped mark**2,090.00** (Illustration: No. 2)

Vase, 9" h., 4¼"w.. square upright body w/molded panels down the sides & low wide handles at the shoulder to the low molded neck, smooth matte green glaze, die-stamped marks**2,310.00** (Illustration: No. 1)

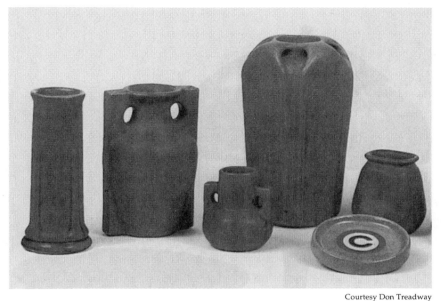

Courtesy Don Treadway

1 2 4 6
 3 5
Group of Teco Vases & Dish

Dish, flat round form w/molded edge, the center w/a large Chicago Cubs logo red "C" on a white ground surrounded by a bright blue band, all on a tan matte ground, impressed mark, 4½" d.**253.00**
(Illustration: No. 5)

Vase, 4" h., bulbous ovoid body pinched-in on two sides, tapering to a molded rolled rectangular mouth, rich medium green matte glaze, impressed mark & paper label**522.50**
(Illustration: No 6)

Vase, 4" h., squatty spherical base tapering to a tall cylindrical neck flanked by short square buttress handles, green matte glaze, designed by W.D. Gates, Shape No.425, impressed marks**990.00**
(Illustration: No 3)

Vase, 7" h., baluster-form body flanked by two heavy square

buttress handles, green matte glaze w/medium charcoaling, Shape No. 435, impressed marks, three tiny corner chips**825.00**
(Illustration: No. 2)

Vase, 7½" h., slightly tapering cylindrical body w/a ringed cushion base, the lower sides molded w/four narrow panels, designed by W.D. Gates, green matte glaze, Shape No.404, impressed mark, repaired rim chip **440.00**
(Illustration: No. 1)

Vase, 9" h., slightly flaring four-sided body molded w/four wide panels tapering to the rounded rim pierced to four low wide handles around the closed mouth, green matte glaze, designed by Fritz Albert, Shape No.184, impressed marks**2,310.00**
(Illustration: No. 4)

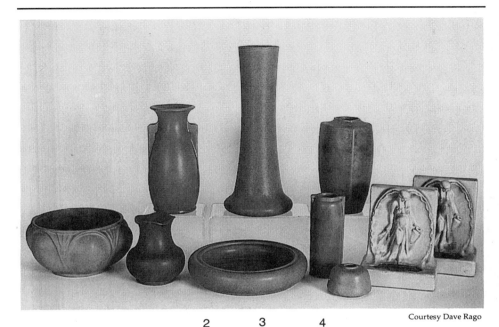

Courtesy Dave Rago

2 3 4
1 7 9
5 6 8

Large Grouping of Teco Pieces

Book ends, relief-molded figure of a maiden w/water jugs in brown & ivory against a green well, die-stamped "Teco," minor flake to back of one, 5½" w., 7" h.**522.50**
(Illustration: No. 9)

Bowl, 8" d., 4" h., round squatty bulbous sides composed of circular lobes alternating w/stylized fanned & ribbed leaf forms, smooth matte greyish green glaze, minute glaze flake at base, die-stamped "Teco".................................**605.00**
(Illustration: No. 1)

Bowl, 8½" d., 1 ¾" h., flat circular form w/recessed edge, even matte green glaze, die-stamped "Teco" twice............**357.50**
(Illustration: No. 6)

Inkwell, tapering sides w/rounded shoulder, low ringed opening, smooth matte green

glaze, die-stamped "TECO" twice, Model No. 128, 3" d., 2¼" h.**247.50**
(Illustration: No. 8)

Vase, 5" h., 4" d., squatty bulbous body on a narrow footring, tapering to a cylindrical flaring neck w/ruffled rim, matte speckled taupe glaze, die-stamped "Teco"**412.50**
(Illustration: No. 5)

Vase, 6½" h., 2½" d., cylindrical body tapering slightly at the top to a molded rim, thin square buttress handles down the sides, smooth matte green glaze, die-stamped "TECO" twice....................................**825.00**
(Illustration: No. 7)

Vase, 7 ¾" h, 4¼" w., triangular w/flat broad sides, a flat shoulder & short triangular rim, mottled green & black matte glaze, die-stamped "TECO (2x) - 120" & w/original paper label,

Model No. 336....................**1,430.00**
(Illustration: No. 4)

Vase, 8½" h, 4" d., pear-shaped
w/two angular buttressed han-
dles & a flaring rim, matte
green glaze, die-stamped
"Teco"..............................**1,100.00**
(Illustration: No. 2)

Vase, 13¼" h, 5½" d., tall slen-
der corseted cylindrical body
w/cushion foot, matte crys-
talline green glaze, Model
No. 120, die-stamped "TECO -
120," w/original paper
label**990.00**
(Illustration: No. 3)

TEPLITZ - AMPHORA

*Numerous potteries operated in
the vicinity of Teplitz in the
Bohemian region of what is now
The Czech Republic. During the late
l9th and early 20th centuries a wide
range of vases and figural pieces of
varying quality were manufactured
there by such companies as Riessner
& Kessel (Amphora), Ernst Wahliss
and Alfred Stellmacher. The wares
were originally low-priced, but the
best examples of Teplitz and
Amphora wares are bringing strong
prices today.*

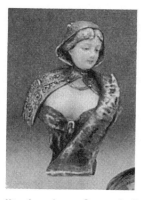

Teplitz-Amphora Ceramic Bust

Bowl, 10" d., 5" h., wide deep
rounded sides w/a wide flat
rim, the sides carved w/a wide
band of teal, black, blue, brown
& peach birds in flight on styl-
ized flower blossoms in rose,
dark blue, white, peach & light
blue, w/teal & green leaves,
against a pale blue & white
mottled ground, the top & base
w/dark teal & gold mottled
glossy bands w/white
impressed dots, wide dark blue
rim band, oval Amphora
mark**$302.50**

**Bust of young woman wearing
low-cut gown & a hooded
cape,** ivory w/shades of brown,
green & highlighting in gold,
impressed "Amphora" in a
lozenge, inscribed "4722 - 7" &
a crown inscribed "729 - B," ini-
tialed "E.S." minor base nick,
7" w., 4½ d., 10 ¾" h.**230.00**
(Illustration)

Bust of a young woman wear-
ing an elaborate off-the-shoul-
der dress in lavender & green,
her hair curled & coiffed w/flow-
ers & a large plume, Turn-
Teplitz marking, 17¼" h.**852.50**

**Bust of young woman wearing
low-cut blouse & headdress,**
on a rectangular base w/mold-
ed romantic landscape, gold &
bronze glaze w/green highlight-
ing, cream ground glaze,
impressed "Amphora - Austria"
in lozenge, a crown & "1431,"

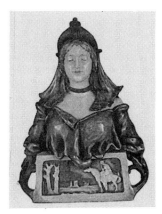

Amphora Art Nouveau Bust

initialed "A - TX - ES", hairline crack, 13½" wd., 18¼" h. ...**3,105.00** (Illustration)

Centerpiece, a wide shallow bowl w/closed rim raised on three figural seahorses on a round disc foot, the seahorses in tan & brown, the bowl carved w/a geometric band in white, rose, gold, green, deep teal & cornflower blue triangles, the disc foot in mottled yellow & gold w/dark blue & white triangles, Amphora circular ink mark & painted "VIII," impressed "52 - 12 - 8," 7" d., 5" h.**330.00**

Bird in Nest Centerpiece

Centerpiece, figural, modeled as a large round nest w/branched sides, a large exotic pheasant sitting to one side in the nest, its long tail feathers curling up along one rim, bird in mottled dark green, brown, blue & tan, nest in dark green, blue, muted gold, tan & cream, stamped Amphora mark, 11" l., 6" h.**605.00** (Illustration)

Creamer, h.p. scene of drummer boy, house, fence & trees, marked "Stellmacher", 3 ¾" h.**70.00**

Dish, cov., wide squatty conical base w/four wide tab feet, fitted domed cover w/loop handle, the base w/a patterned design of stylized birds in flights among blossoms & stems in grey, dark blue, yellow, lavender, brown, black, bright green, rose & teal against a tan & white mottled ground, the cover w/a wide rim band in a geometric triangle design of teal blue, rose, mottled tan & white, Amphora ink mark & impressed "15440-39," 5" h. (minor rim wear)**198.00**

Ewer, squatty bulbous base tapering to a tall slender tapering cylindrical body, a branched loop handle issuing from the base to the center of the neck, the sides molded w/a ribbed & webbed design w/a rich green matte glaze w/rose, tan, blue & brown highlights, incised Amphora mark & impressed "3552 - C - 2," 14" h.**1,320.00**

Ewer, footed slender ovoid body tapering to a small molded rim w/a cross-form handle running from side to side & from the shoulder to the tip of the short angled spout, one side carved w/three panels w/geometric flowerheads in bright green, dark blue, pale blue & white against a bright rose & brown mottled ground, the reverse w/a tan & brown horse & warrior, geometric bands in deep

Tall Amphora Ewer

teal, bright green, white &
pale blue at the base & top,
Amphora oval in mark,
impressed "18307 - 21 - M"
& artist's initials, 15" h.**385.00**
(Illustration)

Ewer, reticulated top & handle,
gold spider web design on
cobalt ground, 18" h.**350.00**

Figure group, three cherubs
struggle to carry three heavy
baskets draped w/floral gar-
lands, in pale pink & lavender
glaze, impressed Amphora
mark, 9½" h.**385.00**

Pitcher, tankard, 9 ⅜" h., cylin-
drical body molded in a coarse
dimpled & ribbed tree-trunk
form w/a heavy branch handle,
iridescent green glaze w/gold
highlighting, impressed
"Amphora" w/"RSt & K" &
"3550 -55," ca. 1905..............**402.50**

Pitcher, tankard, 9 ⅜" h., cylin-
drical body w/lightly scalloped
rim & small spout above a
heavy pierced branch-form
integral handle, iridescent
glaze in shades of green, red &
gold, low-relief large blossom
design issuing from the handle,

impressed "AMPHORA" in
lozenge & "3550 - 1C" & the
"R St K" monogram,
ca. 1905**920.00**

Pitcher, 10" h., wide ovoid body
tapering to a short neck below
the flaring pinched-together
spout rim, heavy strap handle
from neck to shoulder,
Limoges-style floral decoration
in yellow, red & green on a
shaded brown ground, incised
"R St K" & impressed "Austria
8866," Riessner, Stellmacher &
Kessel, ca. 1900**115.00**

Tray, figural, the shaped rectan-
gle cast w/the torso of a maid-
en at either end & decorated
w/garlands of blossoms, glazed
in pale blue & trimmed in gold,
printed marks of Ernst Wahliss
& impressed "MADE IN AUS-
TRIA - 4684," numbered in red
overglaze "4684 - 223 - 12,"
ca. 1900, 11¼" l.**805.00**

Vase, 5" h., 5½" d., squatty bul-
bous base w/the wide shoulder
tapering to a conical neck, dec-
orated w/an overall geometric
web design in gold w/random
raised ovals in blue & green to
simulated jewels, a band at the
base of the neck w/a raised
design of leaves, stems &
berries in red, gold & green, all
against a bluish grey ground,
impress oval Amphora mark &
"8911"...................................**286.00**

Vase, 5½" h., cylindrical w/wide
swollen base & small mouth,
applied handles, decorated
w/the figure of an elegant
woman reserved on a brown
ground w/metallic copper high-
lights, marked "Stellmacher
Teplitz"**110.00**

Vase, 5½" h., inverted pear-
shaped body w/a short narrow
flared neck, the ivory ground
decorated w/almond-form
reserves of spiders & spider

Small Amphora Vase

webs, glazed in orange, green,
black & blue trimmed w/gold,
printed maker's mark,
impressed "AUSTRIA
AMPHORA 686 41," glazed
"1636"................................**1,380.00**
(Illustration)

Vase, 5 ⅝" h., 6" d., wide squat-
ty bulbous body tapering to a
small short flaring neck, gold &
green enamel decoration on
the shoulder applied w/"jewels"
& low-relief spider webs above
a blue band w/repeating gold &
opalescent enamel moths &
flies, iridescent green resist
background, blue & gold foot,
red "R St K" stamp, impressed
"Amphora" in lozenge, "3267 -
25," inscribed "Fr." (base
nick)**690.00**

Vase, 5 ⅝" h., 6" d., wide squat-
ty bulbous body tapering to a
small short flaring neck, the
upper half decorated w/a
woodland scene in green &
pale blue w/a gold sun on a
cream ground, a cobalt blue
neck & medial band above a
lower design of stylized flowers
in red & brown trimmed w/gold,
red "R St K" mark, impressed
"475 - 12"**259.00**

Vase, 5 ¾" h., squatty bulbous
body tapering to a slender
bulbed neck, decorated w/styl-
ized cobalt blue trees & gold
sunburst at shoulder, lower
band of stylized insects in gold

& opalescent enamel, red "R St
K" mark, impressed "475,"
Amphora**316.00**

Vase, 6" h., Art Nouveau style
w/portrait of woman w/long
hair, scenic background, enam-
eling & jeweling, matte
finish.....................................**950.00**

Vase, 6" h., blue ground
w/green-decorated landscape
panels trimmed w/gilt, printed
Teplitz, Czechoslovakia mark,
early 20th c.**86.00**

Vase, 6" h., 6" d., bulbous, deco-
rated w/gold leaves & vines on
cobalt & green ground w/lustre
gold top, marked "Turn-
Vienna"..................................**325.00**

Vase, 6½" h., decorated w/gold
applied pine cones, reddish
leaves & green vines on mot-
tled tan ground**350.00**

Vase, 6 ¾" h., portrait scene of
girl w/long hair holding flowers,
cobalt & white enameling, gold
iridescent ground, "R St K"
mark**495.00**

Vase, 7" h., 'jeweled'-type, foot-
ed ovoid body tapering to a
short neck & heavy molded
rim, blue over green ground
glaze decorated w/a profile
bust portrait of an Art Nouveau
maiden & sun detailed in gold
enamel, her headdress high-
lighted w/four jewels & shades
of blue & red, partial "R St K"
decal & impressed "AMPHO-
RA" in lozenge & "0664 - 28"
& a crown, ca. 1900**1,840.00**

Vase, 7" h., a squatty bulbous
base tapering to a flaring cylin-
drical body w/flattened closed
rim, four loop handles from
sides of base to lower body,
decorated w/yellow & white
blossoms & buds on bluish
grey & white leaves, all
w/heavy black outlining on a
light green, olive & white crack-

Amphora Vase with Flowers

le ground w/gold highlights, impressed Amphora marks & "3888 - 44"**77.00** (Illustration)

Vase, 7¼" h., slender conical body w/open angled handles near the top, the pierced rim w/polychrome enamel & iridescent glaze of spots & stylized florals, impressed & incised marks, Amphora, ca. 1900....**316.00**

Vase, 8" h., wide cylindrical body tapering gently to a flat mouth, rectangular narrow panels up the sides below a top band of reticulated clover leaves, rich green over blue matte glaze, wafer mark of Stellmacher, Teplitz & "2019 - 5" (minute chip on one leaf)**385.00**

Unusual Amphora Vase

Vase, 8¼" h., 6½" d., ovoid body tapering sharply to widely flaring rim w/four handles from rim to shoulder, protruding ribs around body, forming an open gallery at the base, marked w/swastika & "EDDA" on raised triangular medallion, impressed "Amphora" in a lozenge & "3C22 - 1 - 222," ca. 1905.....**805.00** (Illustration: bottom previous column)

Vase, 8 ¾" h., decorated w/applied grapes on an iridescent blue ground**280.00**

Vase, 9" h., chalice-form, the deep cup raised on a cylindrical standard supported by four applied lily pads joined at the circular base, pale blue & white mottled glaze, impressed "Amphora Austria"**275.00**

Vase, 9" h., footed squatty bulbous body tapering to a flaring cylindrical neck w/molded crossed leafy bands & figural pierced double-loop gold cobra handles, the lower body decorated w/a woodland scene in shades of blue, green & white, red "R St K" mark & impressed "2069 - 44," ca. 1900.............**172.50**

Vase, 9" h., Art Nouveau style w/portrait of woman w/long blonde hair wearing a helmet w/eagle on the visor, gold background at back of head, jewelling on chest, scenic decoration on other side, impressed Amphora mark "R St K 524"**1,050.00**

Vase, 9" h., 6" d., oblong *bombé*-shaped sides & pierced rim w/ornate upswept handles & feet, decorated w/gold Japanese-style flowering branches on a cobalt blue ground (minor interior flake professionally restored).........**550.00**

Vase, 9¼" h., the cylindrical body swelling to a bulbous wide shoulder w/a small short rolled neck,

decorated overall w/large blue & white iris & leaves on a green ground all trimmed w/gold, marked "Turn - Teplitz - Bohemia - RStK - Made in Austria," ca. 1920s................................**385.00**

Vase, 9 ¾" h., decorated w/applied life-like pink & white roses on pearlized green & white ground, ca. 1905.........**425.00**

Vase, 9 ¾" h., salamander handles, decorated w/jeweled flowers on slate grey & cream background, impressed "Austria - Amphora" & crown mark**395.00**

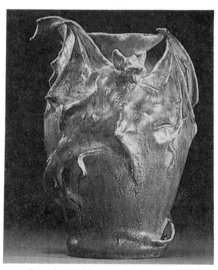

Amphora Vase with Large Bat

Vase, 10" h., baluster-form body molded in high-relief on the upper half w/a large bat, its wings outstretched, glazed in mottled olive brown & dark amber, stamped Amphora mark**4,025.00** (Illustration)

Vase, 10¼" h., 6¼ d., in the form of a broad stylized tree w/openwork flat handles supporting a wide cupped top w/a flat rim flanked by small loop rim handles, embossed laven-

der leaves on a gold ground, impressed "Austria - (crown mark) - 385858"**220.00**

Vase, 11½" h., wide rounded conical base tapering to a tall slender stick neck w/flared rim, decorated w/a wide base band in ivory & blue w/gold trim of large blossoms alternating w/an insect, the upper body & neck w/a landscape scene of the sun through trees in blue & green w/gold trim, stamped "Turn - Teplitz - Bohemia - RStK - Made in Austria" & impressed "467/6"**467.50**

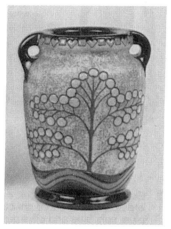

Large Amphora Vase with Tree

Vase, 12" h., footed wide swelled cylindrical body tapering at the top slightly to a wide short cylindrical neck flanked by small loop handles, deeply carved w/a stylized tree in dark brown w/round light green leaves, the reverse deeply carved w/a long-beaked bird in dark blue, cornflower blue, white, deep teal blue, gold, caramel, pale green & rose atop waves of tan & brown ground, all backed by a mottled tan & gold ground, a geometric band of caramel squares & light blue Vs at the rim & base,

dark blue handles, impressed oval Amphora marks, ink mark "Imperial Amphora"**357.50** (Illustration)

Vase, 12" h., tapering cylindrical body w/a thick molded mouth, decorated w/bands of stylized florals at the waist & neck in white, pink, rose, violet, mustard yellow, lavender, teal blue, olive green, light green, caramel, tan & dark blue, vertical geometric bands & wide rim in dark blue, all on a mottled matted gold & white ground, impressed "Amphora Austria" & crown mark & "15038"**330.00**

Vase, 15" h., decorated w/white enameled flowers, butterflies in flight, gold tracery on cobalt blue ground, artist-signed**575.00**

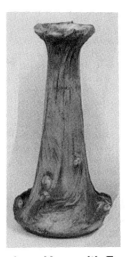

Amphora Vase with Faces

Vase, 15½" h., bulbous base tapering to a tall slender tapering body w/a widely flaring rim, molded around the base w/seven female heads w/long flowing brown hair, brown eyes & peach lips, against a bone white & greyish green ground w/subtle violet & gold highlights, Amphora wafer mark & "671.1029," impressed

"686 - 27"**1,320.00** (Illustration)

Vase, 15 ¾" h., double sinuous handles rising above rim, elongated ovoid body w/relief-molded stylized octopus & crab decoration w/matte mottled green glaze highlighted by gold & maroon, impressed marks, ca. 1918**4,125.00**

Vase, 16" h., ovoid body tapering to a very tall slender neck molded w/swirled stems ending in flared large blossoms around the rim, the body molded in high-relief w/groups of three female profile heads against a carved swirling ground, medium brown & greyish blue matte glaze, impressed Amphora marks & "BB - D - o - 3768 - b"..............................**880.00**

Vase, 17½" h., footed slightly tapering cylindrical body w/a thick flaring rim, molded glossy decoration of whimsical trees w/leaves in teal & light green on caramel trunks backed by teal, green, caramel & pink grasses & a mottled bone white & blue matte sky, the reverse w/a glossy decoration of a peasant man & woman in brown, lavender, bright blue, teal blue & pink, both figures wearing black wooden shoes on a teal ground backed by caramel & pink rushes & a mottled bone white & blue matte sky, the panels separated by stylized tree trunks in blue, circular Amphora ink mark & "3197 M"..............................**715.00**

Vase, 18" h., 10" d., tall thin ovoid body tapering to wide flat rim, heavily embossed landscape in cream, olive green & purple on one side w/harvesting peasants on reverse, impressed crown mark & "AUSTRIA - AMPHORA," chip repair at base**1,430.00** (Illustration: top next page)

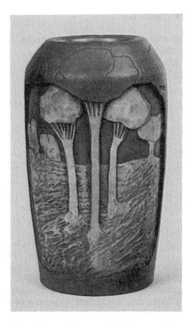

Amphora Vase with Peasants

Vase, 21¼" h., 6 ¾" d., Art Deco style, tall ovoid body tapering to a small mouth flanked by heavy, small loop rim handles, carved & polychromed scene of brightly colored birds on branches against a mottled tan & white matte ground, die-stamped "Amphora - Czechoslovakia," ca. 1920s**550.00**

***Vide poche* (figural dish),** the standing figure of a maiden dancing in flowing gown glazed in mottled ochre & green, waving a long length of drapery about her & forming two small trays, glazed in iridescent cream shaded w/blue & grey & heightened in gilt, impressed "AMPHORA - 776," printed "TURN-TEPLITZ-BOHEMIA - RSTK - MADE IN AUSTRIA," ca. 1900, 19¼" h.**4,313.00**

TIFFANY

Like Emile Gallé of France, Louis Comfort Tiffany is most famous for his art glass production, however, Tiffany also developed a line of art pottery, which he introduced in 1902. Usually molded rather than hand-thrown, Tiffany Pottery was carefully finished by hand. There was only limited production until about 1914 so pieces are scarce and desirable.

L.C.T. Emile Pottery

Bowl, 5" d., 2" h., bisque, decorated w/dogwood blossoms against a white ground (small rim chip, possibly in the making)**$247.00**

Bowl, 7" d., 4" h., organic form shaped as a large curled-up cabbage leaf, dark green & bluish green crystalline glaze, incised "LCT - P814" (restoration to base)**4,950.00**

Vase, 3¼" h., 4" d., squatty spherical body tapering to a short cylindrical neck, the sides molded w/narrow undulating banding & stylized flowers on serpentine vines, white bisque finish, incised monogram mark, ca. 1905**1,150.00**

Vase, bud, 5¼" h., 2½" d., cylindrical w/flared foot, embossed w/maple seed pods under a mustard satin matte finish, incised "LCT".....................**1,540.00**

Vase, 6" h., the squat base w/tapering cylindrical neck,

molded w/leafing vines in mottled natural glazes, incised "LCT" monogram**518.00**

Vase, 11¼" h., 5 d., artichoke blossom-form, squatty bulbous leaf-molded base below a tall slightly swelled cylindrical body w/incurved scalloped rim, lustred mint & olive green glaze, incised "LCT"......................**4,675.00**

Vase, 12¼" h., 7 ¾" h., deeply waisted cylindrical body w/swelled top & base, decorated w/large raised leaves atop long stems against a tooled body, light olive green matte glaze, incised "LCT - P 1036 L.C. Tiffany - Favrile - Pottery"**7,700.00**

Vase, 12 ⅝" h., cylindrical, molded in low-relief w/boughs of trumpet vines, blossoms & leafage, glazed in mottled shades of light green, inscribed "LCT - 192 - A-COLL. - L.C. Tiffany - Favrile Pottery," 1910**3,738.00**

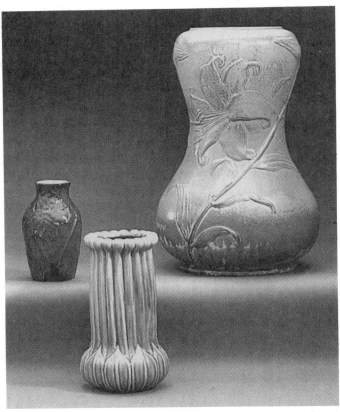

Courtesy Christie's

Three Tiffany Vases

Vase, 5½" h., small ovoid body tapering to a short flaring neck, bronze-clad, the clay molded overall w/leaves & branches, rich brown patina, incised "LCT"**2,990.00**
(Illustration: left)

Vase, 8¼" h., bulbous base w/cylindrical neck & flaring rim, molded w/stylized leaf motif ascending to organic stamen forms, covered in mottled green glaze, incised "LCT7"..............................**2,900.00**
(Illustration: center front)

Vase, 15" h., gourd-shaped body, molded w/flowering lily stems in mottled green glaze, incised "LCT7," & engraved "P1198 - Louis C. Tiffany-Favrile Pottery"...................**2,900.00**
(Illustration: right)

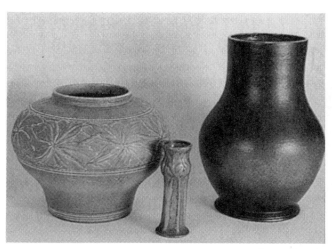

Courtesy Dave Rago

Tiffany Pottery Vases

Vase, 7" h., 2½" d., slender cylindrical body w/a flaring foot & swelled neck w/flared rim, embossed tulip blossoms around the top w/stems down the sides, bronze jacket w/a pewter finish, incised "L.C.T. - LCTiffany - Favrile Bronze Pottery - B.P. 116"**1,760.00**
(Illustration: center)

Vase, 10" h.,11½" d., wide inverted pear-shaped body w/a short cylindrical neck, decorated w/a wide heavily embossed band of poinsettia blossoms, green & black matte glaze, incised "LCT - P460 - L.C. Tiffany Pottery," two very short tight hairlines at rim...**1,430.00**
(Illustration: left)

Vase, 14" h., 9" d., footed baluster-form body w/cylindrical neck, matte black, brown & green glaze, incised "LCT"..................................**1,210.00**
(Illustration: right)

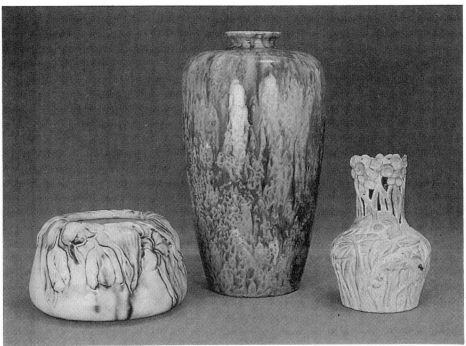

Group of Tiffany Vases

Bowl-vase, rounded slightly tapering cylindrical sides w/incurved mouth, embossed w/large tulips & leaves, "Old Ivory" glaze in satin ivory & olive green, incised "LCT - P226 - Tiffany - Favrile Pottery - 7- 7634," 7 ¾" d., 5½" h.**5,500.00**
(Illustration: left)

Vase, 8½" h., 5¼" d., bulbous ovoid body tapering to a pierced cylindrical neck, the lower body carved w/trillium leaves, the neck w/a band of blossoms on stems, brown & cream bisque exterior, green glazed interior, hand-incised "LCT - 7," two short hairlines, minor rim chip**3,630.00**
(Illustration: right)

Vase, 15" h., 7¼" d., shouldered tapering cylindrical body w/ short flaring neck, w/dripping dark brown, caramel & grey mottled crystalline & high-gloss glaze, hand incised "LCT - 7"............................**3,630.00**
(Illustration: center)

TILES

Since the late 19th century many American and foreign potteries have produced lines of decorative and utilitarian tiles. Many of the firms which featured art pottery wares included tiles as part of this production and such wares were often used to decorate fireplaces, floors and walls, as well as serving as tea tiles. We list a sampling of tiles from various companies below.

American Encaustic Tiling Co.
Zanesville, Ohio, profile portrait

of a woman in Classical head-dress, under an amber majolica glaze, die-stamped lozenge mark, framed, 8 x 8" plus frame..................................**$137.50**

American Encaustic Tiling Company, multicolored scene of shepherdess, 6 x 18"**550.00**

California Faience Company, cloisonné decoration of a Spanish galleon, in a matte mustard & brown & glossy turquoise glaze, incised mark, 5 ¾" sq.**88.00**

Chelsea Keramic Art Works, Chelsea, Massachusetts, rectangular, each w/different low-relief flowering plants under a glossy translucent blue glaze, impressed three-line mark, 5 ⅞ x 11 ⅞", pr.**1,035.00**

Cowan, woman's profile within a garland of flowers against a matte black ground, 6½" d. ...**176.00**

DeMorgan (William), London, England, stylized scrolling floral design in green & blue against a white ground, signed, framed,6" sq..........................**385.00**

Doulton, Lambeth, England, scene of a large standing black cat on a green & brown ground, press-molded w/hand-tooling, self-framed, embossed "FGRR" on front, die-stamped "DOULTON LAMBETH" on side, 17 x 21"**1,430.00**

Grueby Faience & Tile Company Boston, Massachusetts, scene depicting a Spanish ship in white & gold on a green sea, embossed "ARCHITECTUR-AL," artist-initialed, in wide oak frame, 4" sq. plus frame**550.00**

Grueby Faience & Tile Company, incised w/a stylized galleon under full-sail on calm seas, in pale blue, ivory &

green, matte glaze, impressed mark, ca. 1909, 4" sq.**345.00**

Grueby Faience & Tile Company, decorated w/an inlaid design of a three-sailed galleon in brown & ivory against a green background. marked & artist-initialed, 6" sq.**485.00**

Grueby Faience & Tile Company, a seated yellow rabbit among green grasses against a dark green ground, pewter framework, marked, 6" sq. (minor roughness on high points)**660.00**

Grueby Faience & Tile Company, a row of three square tiles forming a continuous scene of yellow & ivory water lilies & green lily pads against blue ground, matte finish, marked, each 6" sq., set of 3**880.00**

Grueby Faience & Tile Company, decorated in cuenca w/a yellow rabbit seated upright in a cabbage patch in shades of green, in a footed iron mount, signed "CA" on the back, 6" sq.**1,870.00**

Grueby Faience & Tile Company, decorated w/yellow water lily blossoms & green leaves in a matte glaze, paper label, artist's initials, 6" sq.**1,092.50**

Grueby Faience & Tile Company, a stylized design of a knight on horseback in brown, yellow, blue & green organic glazes, unmarked, 6" sq.**357.50**

Grueby Faience & Tile Company, a large center cross w/small crosses at each corner, all framed by angled bands, textured butterscotch & crackled white on a brick red ground, ink-stamped mark, 7 ¾" sq.**385.00**

Grueby Faience & Tile Company, blocked geometric designs in dark green within brick red clay walls, ink-stamped mark, 7 ¾" sq.**440.00**

Grueby Faience & Tile Company, a band of six rectangular tiles forming a Greek key border in green on ivory w/black outlining, the central tiles forming the inscription "Kelsey Ranch Lexington - Supplying Waldorf Lunches," matte finish, impressed company mark & artist-initialed, each tile 6" l., 3" h., the set**825.00**

Grueby Faience & Tile Company, each w/a geometric design in brown clay w/a blue matte background, die-stamped "GRUEBY" w/flower, 3" sq., set of 12**220.00**

Grueby Faience & Tile Company, scene of a sailing ship in brown, ivory & gold on ivory-capped blue waves below a matte blue sky, initialed "MD," 6⅛" l.**690.00**

Grueby Faience & Tile Company, a large stylized leafy tree in matte greens, ivory & blue, 8" sq. (one minor edge chip)**880.00**

Grueby Faience & Tile Company, forming a seascape scene w/curling waves, matte blue, green, ivory & brown glaze, artist-initialed, 8½" sq., set of 3**1,760.00**

Grueby Faience & Tile Company, rectangular, decorated w/a group of three slip-trailed mottled brown elephants on dark greenish yellow ground & below pale blue skies, wide black wood ogee frame, paper & fabric label, artist-initialed, 5 ⅜ x 8½"**4,510.00**

Grueby Faience & Tile Company, four-tile frieze depicting a sailing galleon in yellow & brown against a blue sky w/sea gulls, smooth matte glaze, in a gilded narrow frame, overall 8 ¾ x 27"**2,090.00**

Hamilton Tile Works Company, Hamilton, Ohio, classical profile of woman's head, green glaze, oak frame, 6" sq.**250.00**

Longwy Pottery, France, footed square form decorated w/an Art Deco style scene of a maiden standing next to a tree in a landscape, in shades of blue, white & trimmed w/mustard yellow & red, stamped & impressed mark, ca. 1925, 8⅛" w.**402.50**

Low (J. & J.G.) Art Tile Works, Chelsea, Massachusetts, bust portrait of Shakespeare's Shylock holding a bag of coins, impressed inscription in upper corner, glossy shaded glaze, signed, framed, 6" sq.**220.00**

Low (J. & J.G.) Art Tile Works, bust profile portrait of an old woman wearing a close-fitting bonnet, glossy olive green glaze, by Arthur Osborne, impressed mark on back & artist's initials on the front, 6" sq.**110.00**

Low (J. & J.G.) Art Tile Works, one w/a low-relief bust profile of a young woman wearing a tight-fitting cap, the other a bust profile of an elderly bearded man wearing cap, each w/glossy translucent green glaze, in original wide gold velvet frames w/paper label, ca. 1881, pr.**460.00**

Low (J. & J.G.) Art Tile Works, Four Seasons, each w/curled banner against a stylized blossom ground, each banner impressed either "Spring," "Summer," "Autumn" or "Winter," spring in yellow & gold, summer in blue, autumn

in green & winter in brown, impressed marks, ca. 1883, framed together, each tile 3 x 6", the set**575.00**

Low Beatrice Tile

Low, (J. & J.G.) Tile Works, relief molded profile portraits possibly of Dante and Beatrice, fine light green majolica glaze, original rames, impressed mark, 6" sq., pr**495.00** (Illustration: one of two)

Marblehead Pottery, Marblehead, Massachusetts, a large center diamond incised w/four oval reserves w/a stylized sailing galleon in each, pairs of oblong devices in each outer corner, a speckled matte glaze in ochre, bluish grey, navy blue & grey on a two-tone grey ground, unusual early ship mark, 6¼" sq. (small edge glaze nicks)**1,210.00**

Marblehead Pottery, incised woodland scene glazed in shades of green, impressed mark & paper label, 6⅛" sq. (chips)**385.00**

Mosaic Tile Company, Zanesville, Ohio, molded in low-relief w/a galleon w/a single large sail upon a curling wave sea, large round medallion in the sail w/the initials "MTC," in greyish blue, terra cotta, mustard yellow & blue,

matte glaze, ca. 1910, 6" sq. (minor edge nicks)**374.00**

Newcomb College Pottery, New Orleans, Louisiana, round, depicting a house in a landscape at twilight, in blue, green & ivory matte glazes, by Sadie Irvine, marked "NC - DM3 - KS" & artist's cipher & paper label, 1910, 4 ¾" d. ...**1,650.00**

Newcomb College Pottery, decorated w/a galleon under full sail in blue & ivory w/a clear glossy overglaze, by Henrietta Bailey, incised "LN - HCNB - M," 1902, 5½ x 5 ¾"**660.00**

Scenic Owens Pottery Tile

Owens Pottery, Zanesville, Ohio, scenic landscape tile, matte glaze in lavender, ivory and shades of brown, sides glazed green, unsigned, 6⅛" sq.**690.00** (Illustration)

Two Owens Tiles

Owens Pottery, scenic tile w/trees on the side of a rolling hill, matte glaze in shades of green, blue, lavender & brown,

unsigned, 6⅛" sq.**747.50**
(Illustration: left)

Owens Pottery, decorated
w/three geese in a row, matte
glaze in pale green, white, yel-
low, green & cobalt blue,
unsigned, 6 ⅜" sq.**690.00**
(Illustration: right)

Paul Revere Pottery, Boston,
Massachusetts, round w/a ring-
form stylized landscape in
green on a mustard & bright
yellow ground & a brown rim
band, outlined in black,
inscribed "FL 12-23,"
5½" d.**460.00**

Pewabic Pottery, souvenir-type,
round, the center w/a stylized
skyline view of Detroit in dark
red & greenish blue iridescent
glazes, dark red border band
impressed "Detroit - GF-W-C -
1935," impressed mark on
the back, 3⅛" d.**247.50**

Rookwood Pottery, Cincinnati,
Ohio, decorated in cuenca w/a
wooded landscape w/large
trees in the foreground &
mountains in the distance, a
lake in the center ground,
shades of brown, green, blue &
dark green, impressed
"ROOKWOOD FAIENCE -
1226YBI," 12" sq. (small flat
chip at edge, one small
corner chip)**1,980.00**

Trent Tile Company, Trenton,
New Jersey, rectangular,
scenic, decorated w/a molded
landscape scene of cows walk-
ing across a hillside toward a
distant sunset, overall dark
brownish green glossy glaze,
designed by Isaac Broome,
incised on the front "Broome
1882," framed,
10¼ x 12⅛"**1,100.00**

TORQUAY POTTERY

*Torquay Pottery is a general term
referring to the products of several
potteries which operated in the
Torquay area of South Devon,
England in the late 19th and early
20th centuries. Various decorative
techniques were used to decorate
these wares including sgraffito work,
slip-glazed decoration and molding.
Around the turn of the century hand-
decorated "Motto Ware" became a
popular product, often sold at area
resorts as souvenirs. These pieces are
among the most common and col-
lectible of the Torquay pottery wares
found on the U.S. market.*

*The three main Torquay potteries
were:*

*-The Watcombe Pottery
(The Watcombe Terracotta-
Clay Company (1869-1962)
-The Torquay Terracotta
Company (1875-1909)
-Aller Vale Art Pottery
(1865-1901)*

*The Longpark Pottery of Torre was
another noted maker of Motto Ware
and operated from 1905 to 1940.*

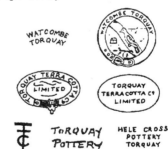

Torquay Basket

Basket, round w/the sides pinched in the middle & joined by a handle, Motto Ware, Cottage patt., "Gather roses while you may," 4 x 5¼", 4" h..**$65.00** (Illustration)

Torquay Bean Pot & Jam Jar

Bean pot, spherical body w/short cylindrical neck raised on three curved tab feet, Motto Ware, Pixie patt., decorated in yellow shaded to cream w/green trim, 2 ⅝" d., 4½" h..**65.00** (Illustration: left)

Candlestick, Motto Ware, "Hear All See All Say Nothing," 3½" h..**40.00**

Creamer, bulbous ovoid body tapering to a short cylindrical neck, Motto Ware, Cottage patt., "Take a Little Cream," 3" d., 3" h..**28.00**

Creamer, barrel-shaped, Motto Ware, Cottage patt., "No Path of Flowers Leads to Glory," 3½" d., 3½" h..**38.00**

Creamer, Motto Ware, Scandy patt., "...from the Cow"............**45.00**

Cup & saucer, Motto Ware, Cottage patt., "Wookey Hole" & "It's better to wear out than rust out," saucer 5 ⅜" d., cup 3 ⅜" d., 3" h.**45.00**

Cup & saucer, Motto Ware, Scandy patt.**55.00**

Jam dish, rounded fan-shaped ruffled bowl w/loop handle, Motto Ware, Cottage patt., "Take a little jam," 4½" d., 2" h..**45.00**

Torquay Jam Dish

Jam dish, skillet-shaped, handled, Motto Ware, Scandy patt., "elp yerzel tu jam," 5" d., ¾" h........................**45.00** (Illustration)

Jam jar, cov., spherical body w/slightly flaring rim, Motto Ware, Cottage patt., cream ground w/brown cover, 2 ¾" d., 2½" h........................**55.00** (Illustration: right)

Jam jar, cov., cylindrical, Motto Ware, Cottage patt., "Widecombe" & "Guid volks be scarce take care of me," 3⅛" d, 4" h........................**55.00**

Jam jar, cov., cylindrical, Motto Ware, Cottage patt., "Go aisy wi' it now," 3" d., 4¼" h............**50.00**

Loving cup, three handled, Motto Ware, Scandy patt., "...weakest goes to the wall"..**75.00**

Mug, cylindrical, Motto Ware, Cottage patt., "Haste makes waste," 2 ¾" d., 3" h.**35.00**

Mug, cylindrical, Motto Ware, Cottage patt., "Make hay while the sun shines," 3¼" d., 3 ¾" h.**45.00**

Torquay Mustard Pot

Mustard pot, cov., handled, cylindrical body, Motto Ware, Cottage patt., "Saltburn-By-The-Sea, Hot and Strong," 2½" d., 1 ¾" h..........................**50.00** (Illustration)

Pitcher, child's, 2" h., 2" d., spherical body, Motto Ware, Cottage patt., "Llandudno" & "For my dolly"**45.00**

Pitcher, 3½" h., 3" d., barrel-shaped, Motto Ware, Cottage patt., "A thing of beauty is a joy forever"....................................**50.00**

Torquay Cottage Pattern Pitcher

Pitcher, 4" h., 3" d., slightly tapering cylindrical body, Motto Ware, Cottage patt., "There's no fun like work"......................**45.00** (Illustration)

Pitcher, 6" h., Motto Ware, green & blue cockerel decoration ..**175.00**

Pitcher, 6½" h., Motto Ware, Cottage patt., "Elp yersel to more"......................................**25.00**

Pitcher, milk, large, Motto Ware, Cottage patt., "Men think they know, Women know better"**85.00**

Torquay Sailboats Pattern Handled Pot

Pot, handled, Motto Ware, Sailboats patt., "Sandown" on front, "More haste, less speed" on back, 3" d., 1 ¾" h.**45.00** (Illustration)

Salt & pepper shakers, footed, egg-shaped, Motto Ware, Cottage patt., "Kind words never die" on one, "Hope well have well" on other, 3" h., pr..**60.00**

Sugar bowl, open, pedestal base, Motto Ware, Cottage patt., "Do good in time of need," 3½" d., 2 ⅞" h.**45.00**

Teapot, cov., Motto Ware, Cottage patt., "...hinges on friendship"**110.00**

Tray, Motto Ware, "To Thine Own Self Be True," 3¼" sq.**38.00**

Trivet, round, Motto Ware, clover design, "None of your Blarney," Longpark mark, 5 ¾" d.**48.00**

Vase, 6" h., relief-molded peacock onblue ground, ca. 1917**165.00**

Vase, 7 ¾" h., three-handled, Daffodil patt., Longpark mark**165.00**

1 2 3 4

Group of Torquay Pieces

Mug, cylindrical body w/loop handle, Motto Ware, Cottage patt., "Love," "Drink and be Merry," 3 ⅜" d., 4 ⅜" h.**65.00** (Illustration: No. 2)

Pitcher, 2¼" h., 1 ¾" d., small ovoid body tapering to a flared rim w/spout, loop handle, Motto Ware, Cottage patt., "Gretna Green"....................................**45.00** (Illustration: No. 3)

Sugar basin, bell-shaped bowl on a low foot, Motto Ware, Cottage patt., "Do good in time of need," 3½" d., 2 ⅞" h.**45.00** (Illustration: No. 4)

Teapot, cov., bulbous ovoid body angling to a short cylindrical flat mouth w/curved spout, loop handle, Motto Ware, Cottage patt., "Daunt'ee Worry but 'ave a cup of tay," 5" d., 4 ¾" h.**95.00** (Illustration: No. 1)

VAN BRIGGLE

Potter Artus Van Briggle began his career as a decorator for the famous Rookwood Pottery of Cincinnati. Due to health problems he left Rookwood and moved to Colorado Springs, Colorado where he and his wife Anna founded The Van Briggle Pottery in 1900. Artus died in 1904 but Anna carried on production for several years before others took over the operation. Pieces were dated from 1900 until 1920. Van Briggle Pottery continues in production today in Colorado Springs.

Bowl, 5½" d., 2½" h., deep squatty bulbous sides w/a closed rim, embossed w/ivy leaves, feathered light blue matte glaze, Shape No. 211, 1903**$495.00**

Bowl, 6" d., 3" h., flaring low rounded sides w/a narrow incurved shoulder, molded w/vertical spindles up the sides to the shoulder & separating bands of stylized blossoms around the shoulder, thin aqua matte glaze, ca. 1907-12, incised**302.50**

Bowl, 6½" d., 2½" h., low wide form, carved design of rippled

leaves on wide stems, medium blue over deep rose matte glaze, incised marks, ca. 1920s - 30s**143.00**

Bowl, 6⅜" d., 2⅛" h., molded stylized leaves, Turquoise Ming glaze, Shape No. 776, ca. 1920**135.00**

Bowl, 8¼" d., 3¼" h., deep flat sides above a tapering bottom, the sides molded w/a continuous band of wide spade-shaped leaves, matte robin's-egg blue glaze, Shape No. 579, incised mark & "1907 - 579".......................................**440.00**

Bowl-vase, squatty bulbous body w/a closed rim, embossed around the rim w/four dragonflies, their bodies down the sides, mottled light blue glaze over reddish brown body, 1907-12, 3" h.**715.00**

Bowl-vase, wide cylindrical base flaring to a wide squatty bulbous top w/closed wide rim, embossed around the shoulder w/large red blossoms & leaves on a sheer matte green ground, Shape No. 204, dated 1903, 4¼" d., 3 ¾" h.**1,045.00**

Bowl-vase, wide squatty bulbous form w/a wide slightly angled shoulder to a wide flat mouth, the shoulder heavily embossed w/daisies, red oatmeal-textured glaze on a matte green ground, Shape No. 289, dated 1905, 9½" d., 4 ¾" h.**1,540.00**

Bowl-vase, squatty bulbous body w/closed mouth, molded in relief on each side w/large pairs of pine cones & pine sprigs, purple matte glaze w/dark blue highlights, Shape No. 762, 1915, 5¼" h.**825.00**

Center bowl & flower frog, large scallop shell-form bowl w/a large mermaid reclining along one edge, an embossed flying fish & large reticulated flower frog in the center, leathery matte blue shaded glaze, ca. 1930, 15" l., 8 ¾" h., 2 pcs.**825.00**

Flower frog, model of a duck, blue glaze, 10" h.**50.00**

Lamp base, figural, kneeling Indian woman holding urn on shoulders, purple & lavender glaze, 19" h.**275.00**

Mug, Phi Gamma Delta fraternity, Greek letters painted in gold on a purple matte ground, 1907-12, incised "AA - VAN BRIGGLE - COLO SPGS. - 28B," 5¼" d., 4½" h.**302.50**

Paperweight, figural, model of a stylized rabbit, Turquoise Ming glaze, 3¼" l., 2 ¾" h.**137.50**

Pitcher, 4" h., copper-clad, the spherical body on a small footring, a thick molded mouth w/pinched spout, heavy C-form handle, original dark brown & black patina, incised marks, ca. 1907-12**660.00**

Plaque, round, molded in relief w/a large stylized spider, molded rim, matte green-black glaze, Shape No. 491, 1906, 5¼" d.**715.00**

Plate, 5½" d., incised around the rim w/stylized mistletoe, speckled matte green glaze, Shape No. 60B, 1903**467.50**

Plate, 8½" d., molded w/large poppy blossoms & swirled leaves & vines, apple green matte glaze, Shape No. 20, incised "Van Briggle 1903 - 20," 1903..............................**825.00**

Vase, 3½" h., 3½" d., ovoid body w/a short, rolled neck, each side boldly embossed w/a large monarch butterfly, sheer turquoise blue matte glaze, Shape No. 688, 1907-12.......**330.00**

Vase, 3½" h., 5" d., spherical body w/closed rim, embossed around the rim w/three large dragonflies, their bodies trailing down the sides, leathery green to brown matte glaze, Shape No. 837, 1914**440.00**

Vase, miniature, 3 ¾" h., 3 ¾" d., bulbous ovoid body w/a wide molded mouth, molded around the shoulder w/mistletoe blossoms & berries, even matte celadon green glaze, Shape No. 421, 1906, incised mark "AA - VAN BRIGGLE - 1906 - 8 - 421"................................**330.00**

Vase, 4" h., 4½" d., squat bulbous body w/sharply defined stylized leaves around the shoulder, fine alligatored dark green to dark blue matte glaze, incised "AA - VAN BRIGGLE - COLO SPGS.," 1907-12**935.00**

Vase, 4⅛" h., spherical body w/a low, molded flat rim, molded w/a repeating design of stylized rayed hearts, variegated matte green glaze, Shape No. 148, 1904**880.00**

Vase, 4½" h., 2 ¾" d., waisted cylindrical body tapering to a short cylindrical neck, carved w/large spiderwort blossoms & long flowing leaves, rich flowing matte green glaze, Shape No. 26, dated 1901**6,325.00**

Vase, 4½" h., 4½" d., squatty ovoid body w/an angled shoulder tapering to a thick, short molded neck, the sides embossed w/long swirled leaves on stems, blue feathery matte blue glaze, Shape No. 389, incised company mark "Van Briggle - Colo. Spgs. - 380," 1907-12........................**467.50**

Vase, 4½" h., 7" d., broad body w/a wide rim w/a carved design of broad leaves on wide stems,

medium blue over bluish grey matte glaze, incised marks, ca. 1920s**286.00**

Vase, 4 ¾" h., 2½" d., cylindrical w/two 'ear' handles, lightly embossed spiderwort leaves, soft mauve & grey feathered glaze, Shape No. 506, incised "AA - COLO - SPGS - 506," 1907-12...............................**330.00**

Vase, 4 ¾" h., 5" d., wide cylindrical body deeply molded w/upright tulips & leafy stems in pink on a French blue ground, Shape No. 90, dated 1906**715.00**

Vase, 5" h., 10" d., very wide squatty bulbous form w/a closed mouth, boldly molded on each side w/large pine cones in blue against a burgundy ground, ca. 1930**385.00**

Vase, 5½" h., ovoid body, molded w/stylized leaves, green matte glaze, signed & dated "1904"..................................**690.00**

Vase, 5½" h., 4" d., baluster-form w/flaring short neck, embossed trefoils & stems, curdled raspberry matte glaze, ca. 1908-11**522.50**

Vase, 5½" h., 6" d., spherical w/sloping shoulders, deeply embossed flowers under a peacock green glaze w/some white showing through, incised "18AA7 VAN BRIGGLE - COLO. SPGS. - 829"**900.00**

Vase, 6" h., 4" d., ovoid body tapering to a short tapering cylindrical neck, the sides molded w/four wide panels below stylized embossed flowers around the shoulder, chocolate brown matte glaze incised "11 - 15 -4," 1907-12**550.00**

Vase, 6" h., 4" d., swelled cylindrical body w/the shoulder forming a closed rim, deeply

molded w/large swirled chest-
nut leaves around the sides,
smooth matte green glaze,
Shape No. 8, dated 1902 ...**2,640.00**

Vase, 6" h., 5½" d., spherical
body w/a pinched-in waist band
& a wide molded mouth, tex-
tured dark blue & green matte
glaze, incised "AA - Van
Briggle - 1904 - V - B809"**550.00**

Vase, 6" h., 7½" d., wide squatty
bulbous flat-bottomed body
tapering to a flat mouth flanked
by small loop handles, shaded
red to bluish green matte
glaze, Shape No. 238,
dated 1903**632.50**

Vase, bud, 6¼" h., 3 ¾" d., squat
base & long swollen neck,
veined chartreuse matte glaze,
incised "AA - VAN BRIGGLE -
1902 - III - 88," 1902**500.00**

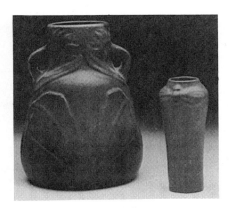

Van Briggle Vases

Vase, 6½" h., gently tapering
cylindrical body w/a swelled
shoulder tapering to a flat rim,
molded w/spread-winged drag-
onflies around the top, their
bodies extending down the
sides, matte blue glaze,
dated 1920**374.00**
(Illustration: right)

Vase, 6½" h., 3½" d., simple
ovoid body w/the narrow round
shoulder tapering to a short

cylindrical neck flanked by
molded dragonflies above wide
rounded panels up the sides,
soft light blue matte glaze
w/red clay showing through,
Shape No. 489, dated
1907**2,200.00**

Vase, 6 ¾" h., 3½" d., corseted
form, decorated w/stylized
embossed daisies, feathered
green to purple matte glaze
w/brown clay body showing
through, incised "AA - VAN
BRIGGLE - Colo. Spgs.," num-
ber obscured, 1907-12**467.50**

Vase, 7⅛" h., squatty bulbous
base boldly molded w/four
wide, pointed leaves tapering
to a tall cylindrical neck, mot-
tled dark blue glaze, marked,
1914**440.00**

Vase, 7¼" h., 3¼" d., slightly
swelled cylindrical body w/a
swelled rim, embossed w/long
leaves & blossoms, dark blue
on a maroon ground,
ca. 1925**275.00**

Vase, 7½" h., simple ovoid body
tapering to a short cylindrical
neck, overall matte green
glaze, Shape No. 29, 1902 ...**990.00**

Vase, 7½" h., 3½" d., cylindrical
w/narrow shoulder & short wide
neck, band of embossed poppy
pods around the neck, the long
sinewy stems continuing to
base, dark blue matte glaze,
incised "AA - VAN BRIGGLE -
COLO.SPGS. - 830", ca.
1908-11**700.00**

Vase, 7½" h., 4½" d., "Dos
Cabesos," the ovoid body
molded w/two figures of
women in flowing gowns, plum
matte glaze, incised "AA - 0,"
ca. 1915-20 (bruise &
short line to rim)**1,430.00**

Vase, 8"h., 2 ⅞" d., slender
cylindrical body w/flat rim, dec-
orated w/cobalt blue blossoms,

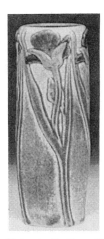

Van Briggle Pottery Vase

green stems & leaves shaded
in rose on a greyish white
ground, matte glaze, Shape
No.131, 1903**6,900.00**
(Illustration)

Vase, 8" h., 5½" d., bulbous
ovoid body tapering to a short
neck, molded acanthus blos-
soms & leaves, blue matte
glaze, ca. 1920-40**357.00**

Vase, 8½" h., bulbous body
tapering to a short neck & flat
rim flanked by heavy loop han-
dles from the rim to the shoul-
der, embossed band of leaves
around the neck, Turquoise
Ming glaze, Shape No. 756,
ca. 1920**200.00**

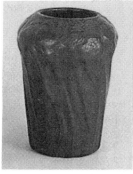

Shouldered Van Briggle Vase

Vase, 9" h., 5 ¾" d., cylindrical
body slightly flaring to a
swollen shoulder, covered in
thick green to gun-metal matte
glaze, Shape No. 18, incised
"Van Briggle - AA - 1905 - 18 -
V," 1905, three cracks at top
rim**1,980.00**
(Illustration)

Vase, 9¼" h., 4" d., ovoid body
tapering to a slender, flaring
neck, molded w/tall slender
stylized leaves up the sides,
mauve matte glaze, incised
"AA - VAN BRIGGLE -
1905"**770.00**

Vase, 9¼" h., 4½" d., tapering
cylindrical form, stylized daf-
fodils atop long swirling stems,
feathered burgundy & medium
green matte glaze, Shape No.
367, incised "AA - VAN BRIG-
GLE - 367 - 1906 - 3,"
1906**1,650.00**

Vase, 9½" h., 3 ¾" d., "Lorelei,"
baluster-form body molded w/a
nude woman around the sides,
her head w/flowing hair & her
arms around the rim, rich yel-
low matte glaze, Shape No. 17,
ca 1907-12 (small repaired
base chip)**4,125.00**

Vase, 9½" h., 3 ¾" d., slender
ovoid body tapering to a
swelled cylindrical short neck,
embossed w/tall iris blossoms
in violet on tall bluish green
leafy stems on a light green
ground, Shape No.161,
dated 1903**4,400.00**

Vase, 9½" h., 4¼" d., tapering
cylindrical body lightly molded
w/flower buds around the rim
w/tall flowing stems down the
sides, heavily mottled mustard
yellow matte glaze, incised "AA
- Van Briggle - 3 - 367 -
1906"**1,210.00**

Vase, 9 ¾" h., bulbous tapering
body w/a waisted neck flanked
by small heavy loop handles,

the sides molded w/wide leaves & the neck molded w/slender curved leaves & blossoms, maroon glaze w/greenish brown highlights, Shape No. 39, designed by Artus Van Briggle, dated 1904 & impressed "49"**1,725.00** (Illustration: left with dragonfly vase)

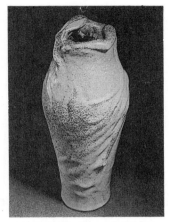

Van Briggle "Lorelei" Vase

Vase, 9 ¾" h., "Lorelei," ovoid body w/female figure, her arms, head & her hair forming the rim & her body continuing with the form, covered in a rich olive green glaze, incised w/firm's mark and "VAN BRIGGLE 1902 111," 1902**11,000.00** (Illustration)

Vase, 9 ¾" h., 8" d., bulbous ovoid body tapering to a flat rim, molded w/large swirling poppies & stems around the sides in matte ochre against a brown & green 'hammered' ground, Shape No. 143, 1904..................................**11,000.00**

Vase, 10¼" h., tall ovoid shoul-dered body tapering to a short molded neck, molded around the shoulder w/a band of large stylized columbine blossoms on tall slender stems down the sides, overall dark blue matte glaze w/maroon highlights,

dated 1916 (minor grinding on base)**770.00**

Vase, 10½" h., "Lorelei," the baluster-form body molded up the sides & around the rim w/the figure of a nude female w/swirling hair, rich rose matte glaze, incised marks, ca. 1920s-30s**770.00**

Vase, 11 ⅜" h., "Three-Headed Indian," tall baluster-form body molded in bold-relief around the top w/three American Indian heads, Turquoise Ming glaze**517.50**

Peacock Feather Van Briggle Vase

Vase, 11½" h., slightly swelled cylindrical body, molded around the sides w/large pea-cock feathers in pale rose atop a narrow vertical stem in pale blue, rich cream background, mounted on a footed bronze base, dated 1904**2,310.00** (Illustration)

Vase, 11½" h., tall slender swelled cylindrical body tapering to a small short cylindrical neck, molded around the top w/morning glory blossoms atop long swirling leafy stems, slate blue over rich rose matte glaze, dated 1919, incised logo**1,210.00**

Vase, 11½" h., 5" d., slightly tapering cylinder, rich mottled bluish green feathered matte glaze over heavily embossed daisies, incised "Van Briggle Colo Spgs. 10,145," 1907-12**1,800.00**

Vase, 13½" h., "Despondency," tall baluster-form body molded around the top w/a reclining nude male, rich greyish blue over deep burgundy matte glaze, ca. 1920s-30s, incised marks (minute base chip)...**1,100.00**

Vase, 13½" h., 5½" d., corseted form, decorated w/sharply defined purple iris & green leaves on a cream ground w/light brown clay showing through, Shape No. 140, incised AA - VAN BRIGGLE - 1906 - 140," 1906...............**2,750.00** (Illustration: top next column)

Vase, 14" h., 5" d., tall bullet-form body, smooth burgundy matte glaze, marked "Van Briggle - 1903 - III -134," 1903.....................................**1,100.00**

Tall Van Briggle Vase

Vase, 16½" h., 6" d., tall ovoid body w/a squatty bulbous rim above the waisted neck joined to the rim by four small loop handles, embossed w/long peacock feathers, light & dark blue matte glaze, ca. 1920-40**412.50**

Vase, 17" h., tall tapering cylindrical body, each side molded in relief w/a spray of three tulips, dappled blue & green glazes, incised mark "Van Briggle 1905 - V," ca. 1905**2,640.00**

Vase, 4½" h., squatty bulbous base tapering to a cylindrical neck, molded w/stylized blossoms, leaves & swirling stems, rich caramel matte glaze, incised marks, ca. 1920s (Illustration: No. 3).................**132.00**

Vase, 5½" h., conical form w/a squatty base tapering to a cylindrical neck, molded w/four vertical spines, blue matte

glaze, Shape No. 347, dated 1905**660.00** (Illustration: No. 7)

Vase, 7" h., waisted cylindrical body w/a swelled shoulder tapering to a short flaring neck, molded around the sides w/a band of broad pointed leaves, deep rose matte glaze, incised marks, ca. 1916**605.00** (Illustration: No. 4)

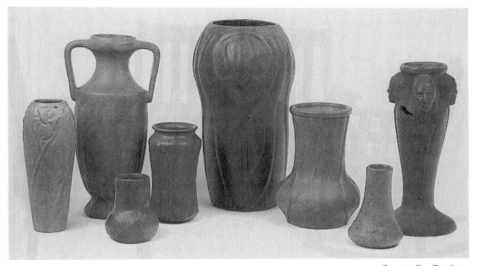

Courtesy Don Treadway

2 5 6 8
1 3 4 7

A Variety of Van Briggle Vases

Vase, 8½" h., squatty bulbous base tapering to a wide slightly flaring cylindrical neck w/molded rim, molded around the base w/broad leaves w/their slender pointed tips running up the sides, curdled medium blue under green matte glaze, incised signature, ca. 1907-12**880.00** (Illustration: No. 6)

Vase, 9" h., slender ovoid body w/a closed rim, molded down the sides w/daffodil blossoms & leaves swirling around the body, unusual pale blue over lavender grey matte glaze, incised marks, post-1930**176.00** (Illustration: No. 1)

Vase, 12" h., "Three-Headed Indian," tall baluster-form body molded at the top w/three heads of Indian braves each w/a different facial expression, slate blue over rose matte glaze, incised marks, ca. 1920s-30s**825.00** (Illustration: No. 8)

Vase, 13½" h., classic slender urn-form body w/angled handles from rim to shoulder, molded w/tall slender pointed overlapping leaves, pale green over cocoa brown matte glaze, incised marks, ca. 1920s-30s**467.50** (Illustration: No. 2)

Vase, 13½" h., wide inverted gourd-form body molded w/three large irises on vertical stems surrounded by broad stylized leaves, slate blue over rose matte glaze, incised marks, ca. 1920s-30s............**825.00** (Illustration: No.5)

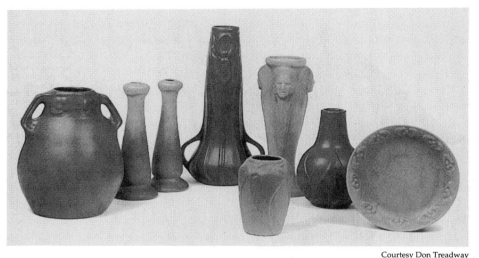

1 2 3 5 6 7
 4
Large Group of Van Briggle Pieces

Candlesticks, slender baluster-form standard on a widely flaring foot, w/a compressed candle socket, pale aqua to blue matte glaze, incised marks, ca. 1920s-30s, 9" h., pr.**220.00** (Illustration: No. 2)

Plate w/flanged rim, 8" d., molded around the rim w/a band of stylized leaves & berries, pale brown over lime green matte glaze, Shape No. 60A, dated 1902**1,430.00** (Illustration: No. 7)

Vase, 5" h., ovoid body w/a tapering shoulder to the closed rim, molded w/large overlapping pointed leaves, pale blue matte glaze, incised mark, ca. 1920s-30s**165.00** (Illustration: No. 4)

Vase, 7½" h., bulbous spherical body tapering to a tapering cylindrical neck, molded w/wide pointed vertical leaves, vibrant rose matte glaze, ca. 1907-12, incised marks**825.00** (Illustration: No. 6)

Vase, 9" h., 7" d., bulbous ovoid body tapering to a short neck molded w/stylized blossoms flanked by short angled handles, medium blue over rich rose matte glaze, incised marks, ca. 1915-25**660.00** (Illustration: No. 1)

Vase, 11" h., "Three-Headed Indian," tall baluster-form body molded at the top w/three heads of Indian braves w/long braids, each w/a different facial expression, pale blue & aqua matte glaze, incised mark, ca. 1920s-30s**412.50** (Illustration: No. 5)

Vase, 13" h., squatty bulbous base flanked by loop handles, slender tapering cylindrical sides molded around the top w/large iris blossoms w/leaves down the sides, deep rose & violet matte glaze, incised mark, ca. 1920s**605.00** (Illustration: No. 3)

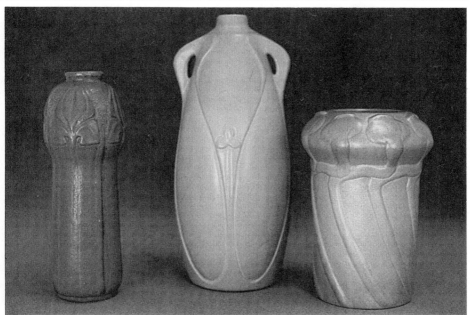

1 2 3

Group of Van Briggle Vases

Vase, 10 ¾" h., 6 ¾" d., squatty bulbous top w/closed mouth above a cylindrical body, the top molded w/large poppy pods w/the stems spiralling down the sides, leathery matte raspberry pink glaze, Shape No. 86, impressed mark & dated 1903**5,500.00** (Illustration: No. 3)

Vase, 12 ¾" h., 4½" d., small molded mouth above a swelled body molded w/stylized iris tapering to cylindrical sides molded w/stems, red clay showing through a veined matte bluish grey glaze, Shape No. 280, incised mark, ca. 1904-07.............................**3,300.00** (Illustration: No. 1)

Vase, 16" h., 6¼" d., tall ovoid body tapering to a small flat mouth, the shoulders flanked by small loop handles, the body molded w/a tall stylized spiderwort plant on each side, smooth matte olive yellow glaze, Shape No. 229, incised mark & dated 1904.............**4,400.00** (Illustration: No. 2)

VOLKMAR

Charles Volkmar came from an artistic family background and was able to study abroad in Europe, remaining there for fourteen years before returning home in 1875. He became intrigued by the French art pottery he saw at the 1876 Centennial Exposition and returned to France for further study in the ceramics field.

In 1879 Volkmar returned to the United States and opened his first kiln in Greenpoint, Long Island in 1879. By 1882 he had established his own studio, kilns, salesroom and home at Tremont, New York.

Early Volkmar wares were decorated with applied and underglaze

decoration either done by Volkmar
or by an assistant using his designs.
A system of divided labor developed
with independent potting and deco-
rating departments. In the follow-
ing years Charles Volkmar worked
in several partnerships finally
establishing the Volkmar Keramic
Company in Brooklyn in 1895.
Later that year he was joined by
Miss Kate Cory, a fine artist, and
formed a partnership known as
Volkmar & Cory which began pro-
duction in Corona (Queens), New
York. Finally, in 1902, Volkmar was
joined by his son Leon and they
established the Volkmar Kilns in
Metuchen, New Jersey in 1903.
Charles Volkmar died in 1914 and
Leon continued production for some
years.

Lamp base, wide baluster-form
on a short flaring foot & taper-
ing to a flaring, molded rim,
decorated w/large yellow
chrysanthemums on a streaky
brown & yellow ground, glossy
glaze, stamped "VOLKMAR -
CPW - V," 6¼" d., 11" h.**$467.50**

Vase, 3½" h., 4½" d., faceted
squatty bulbous base & short
flaring neck............................**165.00**

Vase, 5¼" h., 4 d., wide ovoid
body tapering to a short neck
w/molded rim, fine 'orange
peel' texture covered w/a *sang-
de-boeuf* & white flambé glaze,
incised "Volkmar - 1949
- 2T," dated 1949**440.00**

Vase, 6½" h., 3½" d., simple tall
ovoid body tapering to a short
cylindrical neck w/serpentine
rim, decorated in barbotine
w/large white & pink blossoms
w/green foliage against a mot-

tled black & brown ground,
impressed "VOLKMAR -
120"......................................**357.50**

Vase, 8"h., slender ovoid body
tapering to a short widely flar-
ing neck, carved decoration of
tall narrow arches forming pan-
els, unusual pale green & tan
glossy glaze w/orange high-
lights, raised "V" mark
(chips to rim)**292.50**

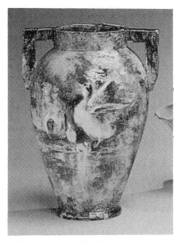

Decorated Volkmar Vase

Vase, 11½" h., footed ovoid
body tapering to a short cylin-
drical neck flanked by flat
angled handles, slip-painted
w/a waterfowl scene in shades
of green, yellow, blue, cream &
brown, signed "Chas.
Volkmar," ca. 1900
(minor chips)**3,737.00**
(Illustration)

WELLER

*The Weller Pottery was estab-
lished by Samuel A. Weller in 1872
and operated until 1945. Originally
located in Fultonham, Ohio, the fac-
tory moved to Zanesville in 1882. A
wide range of lines, both of art pot-
tery and commercial quality, were*

produced over the years and we list a sampling here.

Reference books on Weller include The Collectors Encyclopedia of Weller Pottery, *by Sharon & Bob Huxford (Collector Books, 1979) and* All About Weller *by Ann Gilbert McDonald (Antique Publications, 1989)*

WELLER

Weller
Pottery

ALVIN (1928)

Various shapes with molded fruits, branches or vines with a matte glaze.

Vase, triple bud, 6 ¾" h.**$65.00**

Vase, 12" h., tall cylindrical tree trunk form w/handles at top...**125.00**

ANSONIA (late 1920s)

Simple finely-ringed pieces with a matte tan or two-tone brown and green finish. Made in the same shapes as Velvetone but without the pastel colors.

Vase, floor-type, 23½" h., Arts & Crafts style, tall baluster-form body w/flaring rim, thick loop handles at the shoulder, thin ringed design down the sides covered in a mottled green, yellow & raspberry glaze, incised "Weller Hand Made" in script, early 20th c.**715.00**

ARDSLEY (1928)

Various shapes molded as cattails among rushes with water lilies at the bottom. Matte glaze.

Candleholders, 3" h., bulbous lotus-blossom shape, on petal base, pr.**85.00**

Console set, 9 x 15" oblong irregular console bowl w/iris

flower frog and pair of 2" h. candleholders, 3 pcs.**325.00**

Console set: 16" d., 3½" h. console bowl, figural kingfisher flower frog & a pair of candleholders; the wide shallow bowl molded on the interior w/narrow green cattails, the candleholders w/a lily pad & blossom disc base centered by a flaring blossom-form socket, black ink kiln mark, the set..................**522.50**

AURELIAN (1898-1910)

Similar to Louwelsa line but brighter colors and a glossy glaze.

Lamp, kerosene table-type, a wide baluster-form body on small knob feet, the deep shoulder w/a wide short molded neck supporting a collar w/a kerosene burner & glass globe shade, the body decorated w/bold grape clusters & leaves on a fiery gold, green & mahogany ground, decorated by Eugene Roberts, incised "Aurelian" on the base, electrified, base only 9½" d., 11" h.**660.00**

Plaque, rectangular, decorated w/life-sized red apples hanging on leafy branches against a streaky brown, orange & yellow background, decorated by Frank Ferrell, ca. 1898, w/old metal framework & hanging chain, 10 ⅞ x 16½" (several glaze scratches, small patch of glaze loss, some bubbles in glaze)**935.00**

Vase, 5½" h., 5 ¾" d., spherical w/pinched neck, decorated w/yellow, brown & green roses on a fiery yellow & brown ground**467.50**

Vase, 7"h., bulbous ovoid body tapering to a trumpet neck, decorated w/yellow & orange rose blossoms & green leaves against a dark brown ground,

the neck & rim mounted w/a foliate-cast sterling silver mount, decorated by Hattie Mitchell, artist-initials & impressed "WELLER - 838 - 6," silver impressed "STERLING - 634" w/hallmark, ca. 1900-10**1,840.00**

BALDIN (about 1915-20)

Rustic designs with relief-molded apples and leaves on branches wrapped around each piece.

Bowl, 4" d., blue......................**150.00**

Baldin Jardiniere & Pedestal

Jardiniere & pedestal base, overall 39" h., 2 pcs............**1,800.00** (Illustration)

Vase, 6" h., bulbous base tapering to a cylindrical neck...........**85.00**

Vase, 7" h., bulbous base**82.00**

Vase, 11"h., wide cylindrical body swelling at base, blue ground...................................**395.00**

Vase, 19" h., floor-type, apple decoration w/closed twig han-

dles, turquoise high glaze w/blue, red and yellow drip ...**650.00**

BARCELONA (late 1920s)

Colorful Spanish peasant-style designs on buff ground.

Vase, 6½" h., angular baluster-form w/loop handles form flared rim to waist**115.00 to 145.00**

Vase, 18" h., floor-type............**775.00**

BESLINE (about 1920-25)

Simple elegant shapes with a bright lustre orange glaze decorated with acid-etched vining leaves and berries.

Vase, 8 ⅜" h., wide ovoid body w/a wide shoulder tapering to a thick molded small mouth, acid-etched overall w/Virginia creeper vine against an orange lustre ground, unmarked**412.50**

BLOSSOM (mid-late 1930s)

Pale pink flowers & green leaves on blue or green matte glazed ground.

Jardiniere & pedestal base, graduated brownish salmon ground w/fine mottling, artist-signed, overall 31¼" h., 2 pcs.**675.00**

Vases, 12" h., blue ground, pr...**150.00**

Wall pocket, glossy blue**65.00**

BLUE DRAPERY (ca. 1915-20)

Overall vertically pleated surface with molded clusters of roses down the sides. Matte glaze.

Bowl, 5½" d.**59.00**

Vase, 6" h................................**55.00**

Wall pocket, 9" l.**125.00**

BONITO (1927-33)

Hand-painted florals and foliage in soft tones on cream ground.

Bowl, 8½" d.**70.00**

Vase, 4" h................................**70.00**

Vase, 6" h., slightly flaring cylindrical body on short flaring foot, artist-signed**110.00**

Vases, 7" h., 6½" d., two-handled, tall cylinder flaring toward base & then tapering to round foot, two slender scrolled handles down sides, pr.**275.00**

BRIGHTON (1915)

Various bird or butterfly figurals colorfully decorated and with glossy glazes.

Kingfisher flower frog, 9" h.**350.00 to 375.00**

Pair of Brighton Parakeets

Brighton Parrot

Model of a Parakeet

Model of a parakeet, on tapering cylindrical pedestal perch, bird in polychrome colors of pink, yellow & blue, on a green perch, 5 ¾" d., 7½" h., unmarked **825.00** (Illustration)

Model of parakeets, perched on a curving branch, birds brightly colored in red, yellow & blue, brown perch, glossy finish.................................. **1,100.00** (Illustration: top next column)

Model of a parrot, bright raspberry red & blue, yellow & green, on a tall swirled brown upright perch, die-stamped mark, 9" w., 14" h.**1,760.00** (Illustration)

Model of a woodpecker, perched on a base of entwined branches, blue & orange bird on a green perch, glossy glaze, unmarked, 3½" d., 6¼" h.**125.00 to 175.00** (Illustration: top next page)

Model of a Woodpecker

Name card holder w/figural butterfly & attached bud vase**395.00**

BURNT WOOD (1910)

Etched designs on a light tan ground with dark brown trim. Similar to Claywood but no vertical bands.

Basket, hanging-type..............**150.00**

Burntwood 'Dechiwo' Vase

Vase, 6½" h., early 'Dechiwo' line, ovoid body tapering to a thick rolled rim, incised decoration of children blowing bubbles on one side & playing ball on the other, band of flowering trees branches around the shoulder**1,900.00**
(Illustration)

Vase, 8" h., birds decoration .. **175.00**

Vase, 9" h., 4½" d., ovoid w/short neck, overall stylized floral decoration, light beige on a chocolate brown ground.... **220.00**

CACTUS (early 1930s)

Various humorous stylized animal figures with a reddish brown, blue-green or golden glaze.

Figure of Pan w/rust colored lily, 5" h..**65.00**

Planter, model of a Dachshund dog, 5½" l.................**55.00 to 60.00**

Planter, model of a Dachshund dog, 8½" l., 4½" h....................**60.00**

CAMEO (1935-late 1930s)

White relief-molded flower and leaf bouquets on pastel blue, green or deep buff ground.

Bowl, three-footed, squat bulbous slightly ribbed body, blue ground....................................**35.00**

Vase, 6½" h., ruffled lilly-form body on oblong domed foot, small scrolled loop handles at base, deep buff ground**25.00 to 35.00**

CHASE (late 1920s)

White relief fox hunt scenes usually on a deep blue ground.

Ginger jar, cov.**300.00**

Vase, 6 ¾" h., 7" d., pillow-type, relief fox hunting scene on a cobalt blue ground**247.50**

Vase, 9" h...............................**345.00**

CHENGTU (1925-36)

Simple graceful shapes covered with an overall deep Chinese red glaze.

Vase, 8½" h.............................**125.00**

Vase, 10" h., hexagonal**150.00**

Vase, 10½" h., round**145.00 to 150.00**

Urn, bulbous, w/short, wide flat neck, w/paper label, 5½"**75.00 to 100.00**

CLAYWOOD (ca. 1910)

Etched designs against a light tan ground, divided by dark brown bands. Matte glaze.

Basket, hanging-type, etched
flowers.....................................**45.00**

Planter, hanging-type**125.00**

Vase, 8½" h., oak leaves deco-
ration......................................**45.00**

Vase, 9" h................................**95.00**

CLOUDBURST (1921)

Overall crackle glaze with a lustre finish on a simple rounded shapes.

Vase, 6" h., red ground**85.00**

Vase, bud, 7" h..........................**65.00**

Vase, 7" h., red ground**95.00**

COPPERTONE (late 1920s)

Various shapes with an overall mottled green glaze. Some pieces with figural frog or fish handles. Models of frogs also included.

Bowl, 9" d., 3 ¾" h., two raised
open square handles on flat
rim, mottled green & brown
matte glaze (two pinhead glaze
nicks to rim).............................**66.00**

Bowl, 9 ¾" l., 5½" h. deep
rounded sides w/an undulating
oblong molded rim molded at
one side w/a frog, each side
embossed w/a carp, rich mot-
tled green & brown glaze, ink
kiln mark "191-G"**935.00**

Candleholder, model of a
turtle w/lily blossom,
3" h.**175.00 to 200.00**

Card tray, in the form of a lily
pad leaf w/shallow dished
sides, molded at one side w/a
crouching frog on the rim, ink
kiln mark, 6" l., 2¼" h.**247.50**

Center bowl, deep w/irregular
rim, frog perched on one edge,
mottled green & brown glaze,
5½" h., 10½" w.**385.00**

Cigarette stand, model of a
frog, 5" h................................**155.00**

Console bowl, long narrow
oblong form w/undulating rim,
molded at one end w/a small
figural frog & at the opposite
end w/a water lily & leaves, ink
kiln mark, 15½" l., 3½" h.**990.00**

Console bowl w/figural lily pad
& frog flower frog, oblong bowl,
8 x 10½", 2 pcs.**475.00**

Coppertone Flower Frog

Flower frog, model of a lily pad
bloom w/seated frog, 5½" w.,
4½" h.**330.00**
(Illustration)

Weller Fishing Boy Fountain

Fountain, tall boy holding fishing
pole standing on pedestal sur-
rounded by four upright fish on

flared base, all on round pedestal base, rich mottled green and brown semi-gloss finish glaze, boy and fish are fitted w/water nozzles.........**4,125.00** (Illustration)

Model of a frog, 2" h.**150.00 to 200.00**

Model of a frog, 4" h.**275.00 to 300.00**

Model of a frog, the large stylized animal w/a hole at its mouth & on a round base, mottled green & brown glaze, probably used as a fountain, 6½" d., 5¼" h. (short tight line at factory hole in base)**605.00**

Coppertone Frog Model

Model of a frog, large animal w/a hole in its mouth to accommodate a sprinkler, dark mottled green & brown w/ivory chest, 10¼"l., 8½" h.**2,860.00** (Illustration)

Vase, bud, 9" h., 3¼" d., slender body w/flaring irregular rim, frog crawling up the side, mottled green & brown glaze**357.50**

Vase, 10" h., trumpet-shaped w/molded lily pads.................**325.00**

Vase, 19" h., floor-type............**750.00**

COPRA (1915)

Simple ovoid forms, often with molded ring handles near the rim. Usually hand-decorated with flowers on a mottled ground.

Basket, 12½" h.**375.00**

Jardiniere, tulip decoration & ring handles, 8" h.**250.00**

CORNISH (1933)

Various shapes with large leaves & small berry clusters pendent from the rims against slightly mottled, variously colored semigloss grounds.

Vase, 5½" h..............................**60.00**

Vase, 6" h., brown....................**60.00**

Vase, 8½" h., brown.................**85.00**

CRETONE (ca. 1930s)

Hand-decorated novelty line featuring leaping gazelles amid locust leaves and flowers. Produced in white with black, black with white and yellow with brown. Matte finish.

Urn, ivory & black, artist-signed, 6" h.......................................**495.00**

Vase, 6" h., 6" d., bulbous body tapering to wide molded mouth on small footring, white w/black gazelle decoration, artist-signed**600.00**

DICKENSWARE 1st LINE (1897-98)

Underglaze slip-decorated designs on a brown, green or blue ground. Glossy glaze.

Jardiniere & pedestal, the

squatty bulbous jardiniere w/a wide, rolled rim & tapering to a flared foot, the sides in black decorated w/a flock of walking yellow geese, the tall cylindrical pedestal flared at the rim & base & decorated w/a scene of a little girl feeding geese all against a black ground, glossy glaze, signed, ca. 1907, 41½" h., 2 pcs.**2,310.00**

Lamp base, kerosene-type, lily of the valley decoration on dark green ground, artist-signed, 12" h.....................................**495.00**

Mug, h.p. deer head, tall**95.00**

DICKENSWARE 2nd Line (early 1900s)

Various incised "sgraffito" designs usually with a matte glaze.

Mug, bust portrait of American Indian "Tame Wolf," artist-signed, 6¼" h.,**625.00**

Mug, monk drinking ale scene, 5½" h.**225.00 to 275.00**

Mug, scene of a deer**175.00**

Pitcher, 10½" h., portrait of monk, blue & white, marked "X" (experimental)**625.00**

Vase, 5¼" h., 5¼" w., pocket-form, flattened bulbous ovoid sides tapering to a short flaring rim pinched together at the center, sgraffito marsh scene w/a duck & reeds by a lake in shades of brown & green, die-stamped "Dickensware - Weller - X352"**220.00**

Vase, 9¼" h., golfer decoration, unmarked**1,500.00**

Vase, 16" h., etched scene w/hunting dogs**1,400.00**

Vase, 17 ⅞" h., very tall slender cylindrical body w/a narrow rounded shoulder to the short rolled neck, decorated w/a standing monk tasting wine, in browns & yellow against a shaded brown to gold ground, glossy glaze, decorated by Mary Gellier, ca. 1900, marked & artist-signed**1,650.00**

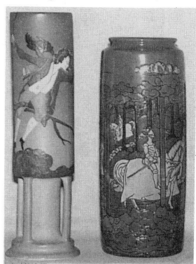

Two Tall Dickensware Vases

Vase, tall slender cylindrical body raised on four slender pillars flanking a pedestal base on a stepped flaring foot, incised scene of man on a branch from "Barnaby Rudge"**950.00** (Illustration: left)

Vase, 12½" h., tall cylindrical body w/a narrow shoulder to the short rolled rim, continuous landscape scene of white mounted knights in deep woods, blue sky above, glossy glaze**3,100.00** (Illustration: right)

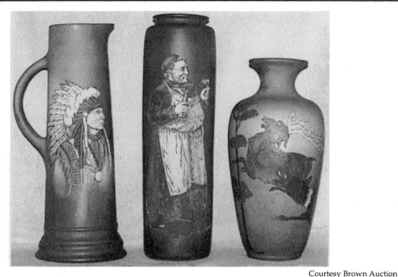

1 2 3

Courtesy Brown Auction

Dickensware Ewer & Vases

Ewer, tall slender cylindrical body w/flaring ringed foot, C-form handle, decorated w/a bust profile portrait of "Chief Hollowhorn Bear," shaded tan to dark green ground, 16"**650.00** (Illustration: No. 1)

Vase, 14" h., baluster-form w/trumpet neck w/flattened rim, decorated w/a scene of an elk being attacked by a pack of wolves in brown & green against a shaded green, yellow & brown ground..................**1,000.00** (Illustration: No. 3)

Vase, 17" h., tall slender cylindrical body w/the narrow flat shoulder tapering to a short rolled neck, decorated w/the standing figure of a monk holding a glass of wine, titled "The Winemakers," 17" h...........**3,100.00** (Illustration: No. 2)

DRESDEN (ca. 1907)

Slip decoration of dark blue windmills, sailboats and Dutch boys and girls against a blue or green matte ground.

Jardiniere, wide squatty bulbous body w/a wide, flat molded mouth, decorated in blues & pale green w/a Dutch harbor scene w/sailboats & windmills, ca. 1908, base incised "Weller Matt," 10" d., 7" h.,**660.00**

Vase, 9 ⅜" h., slender ovoid body tapering to a short neck w/molded rim, decorated in blues & pale green w/a Dutch harbor scene w/sailboats & several windmills, decorated by Levi J. Burgess, ca. 1907, incised "Weller Matt X 314" & artist's initials**550.00**

EOCEAN and EOCEAN ROSE (1898-1925)

Early art line with various hand-painted flowers on shaded grounds, usually with a glossy glaze.

Vase, miniature, 5⅛" h., squared shape, pink, white & blue flowers on slate blue ground, ca. 1910**165.00**

Vase, bud, 5½" h., slip-painted florals on shaded pale blue to grey ground**75.00**

Vase, 6" h., 5" d., swelled cylindrical body w/a wide flat shoulder to the short cylindrical neck, decorated w/dogwood branches in white & purple against a shaded dark blue to ivory ground, glossy glaze, marked, Eocean Rose**330.00**

Vase, 6½" h., 3" d., simple cylindrical body, decorated w/a large polychrome stork standing on one leg against a shaded dark grey to white ground, incised "Eosian - Weller" (crazed)**495.00**

Vase, 8" h., 2½" d., slender cylindrical body w/a narrow round shoulder & short rolled neck, decorated w/purple & green lily-of-the-valley against a shaded black to light green ground, die-stamped circle mark**412.50**

Vase, 10½" h., decorated w/daisies on grey ground**150.00**

Vase, 10 ⅝" h., wide slightly tapering cylindrical body w/a wide shoulder to the compressed incurved short neck, decorated w/a band of swimming green fish against a shaded dark green to cream ground, signed, ca. 1905, Eocean Rose**2,420.00**

Vase, 12 ¾" h., 4 ¾" d., slender tapering body w/six open handles rising from narrow shoulder to flared rim, decorated w/large green & violet leaves against a shaded pale pink & dark green ground.................**880.00**

Vase, 12 ⅝" h., tall slender slightly waisted cylindrical body, decorated around the top w/large mauve Virginia creeper leaves w/the green vines down the sides, against a black to

pale green ground, decorated by Levi J. Burgess, ca. 1905, stamped "801 - 10," incised "F"**880.00**

ETCHED & MODELED MATT (ca. 1905)

Incised or molded designs against a light ground and using a light clay. Comparable to 2nd Line Dickensware.

Vase, 10¼" h., 4¼" d., cylindrical w/slightly flared foot & rim, yellow tulips & green foliage outlined in black on a caramel ground w/some dripping to the black.....................................**412.50**

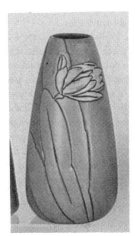

Etched Matte Cylindrical Vase

Vase, 11" h., 5" d., slender tapering cylindrical body w/a small closed rim, incised w/large yellow flowers & long green leaves on a burnt orange ground, by Frank Ferrell, incised in blue "Weller" w/"Ferrell" on the side**715.00** (Illustration)

ETHEL (ca. 1915)

Cream-colored bodies with most pieces featuring an oval reserve with a profile bust of Ethel Weller sniffing a rose; vertical bands of stylized blos-

soms around the sides and diamond trellis bands at the top and bottom.

Vase, 9" h., cylindrical w/flat ring handles, fan-shaped top, square low-footed base.........**115.00**

Vase, 13" h..............................**300.00**

ETNA (1906)

Similar to Eocean line but designs are molded in low-relief and colored.

Lemonade set: a 14" h. tankard pitcher & two cylindrical mugs, each w/an angled handle; decorated w/a large cluster of deep reddish purple grapes & green leaves at the top against a shaded grey to pink ground, signed, 3 pcs. (hairline in one mug)**220.00**

Vase, 6½" h., footed angular bulbous body tapering to a wide cylindrical neck w/slightly flaring rim, slip-painted floral design**125.00**

Vase, 7" h., cylindrical, decorated w/yellow dandelions on grey ground...................................**165.00**

Vase, 11" h., tall ovoid body w/bulbous short neck w/closed rim flanked by short twisted strap handles, low-relief floral bouquet in rosy red & pale green leafy stems against a shaded grey ground**300.00**

Vase, 14 ⅝" h., tall gently flaring cylindrical body w/a wide rounded shoulder tapering to a flat mouth, decorated around the top w/a large cluster of purple grapes & green leaves & vines on a shaded blue to pale lavender ground, marked (two flat chips on the base)**412.50**

FLEMISH (mid-Teens to 1928)

Clusters of pink roses and green leaves, often against a molded light

brown basketweave ground. Some pieces molded with fruit or small figural birds. Matte glaze.

Basket, hanging-type w/chains, 7" h.......................................**125.00**

Jardiniere, birds on wire scene, 7½" h. **250.00**

Jardiniere, wide slightly swelled cylindrical body, pink floral decoration on cream ground, 8½" h.**175.00**

Jardiniere, decorated w/four lion heads & garlands, 13" d., 10" h..................................**250.00**

Jardiniere, decorated w/four lion's heads & garlands, 11" h. **275.00**

Planter, figural log, 4½" h.**35.00**

FLORAL (late 1930s)

White flowers on a lightly paneled background in pastel colors. Semi-gloss finish.

Vase, 4½" h., aqua...................**55.00**

Wall pocket, blue.....................**95.00**

FLORALA (about 1915-20)

Embossed colored flowers in square panels on a cream ground. Matte finish.

Candleholder**28.00**

Mug, cylindrical, molded grapes, overall dark brown glaze**55.00**

FOREST (mid-Teens -1928)

Realistically molded and painted forest scene

Basket, hanging-type, 9" d.**295.00**

Jardiniere, full kiln mark, 6½" d....................................**150.00**

Jardiniere & pedestal, 26" h.,

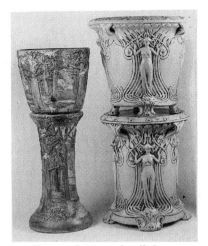

**Forest & Ivory Jardinieres
& Pedestals**

tapering jardiniere bowl, on
waisted cylindrical pedestal ..**990.00**
(Illustration: left)

Pitcher, 5¼" h., 6¼" d., cylindri-
cal body slightly flared at the
base & rim, molded forest land-
scape in browns & greens
against a creamy ground,
marked**220.00**

Vase, 10¼" h.............................**250.00**

Vase, 12" h., waisted cylindrical
form**200.00 to 225.00**

GLENDALE (early to late 1920s)

*Various relief-molded birds in their
natural habitats, life-like coloring*

Vase, 6" h., cylindrical, large
standing marsh bird**400.00**

Vase, 6½" h., ovoid body
w/slightly tapering neck and a
flat rim, decorated w/outdoor
scene of a bird in flight**450.00**

Vase, 7" h., baluster-form body
w/gently flaring rim, decorated
w/a brown bird standing beside
its ground nest w/eggs, green
grass & white & yellow daisies
under a blue sky in back-
ground....................................**450.00**

Vase, double-bud, 7" h., tree
trunk-form vases flank a
panel embossed w/a bird &
nest w/four eggs, original
label**325.00 to 350.00**

Vase, 8½" h., swelled cylindrical
body w/a narrow round shoul-
der to the short cylindrical
neck, decorated w/two large
blue & gold lovebirds among
green leaves**875.00**

Wall pocket, bird w/chicks in
nest, long conical form
w/curved & pointed base,
12½" h.**395.00**

GREORA (early 1930s)

*Various shapes with a bicolor orange
shaded to green glaze splashed over-
all with brighter green. Semigloss
glaze.*

Vase, 5" h., tapering cylindrical
side above a molded bulbous
base on a flaring
foot...........................**50.00 to 75.00**

Vase, 9" h., wide ovoid body
tapering to a wide flat mouth
flanked by small angled hook
handles**275.00**

HOBART (early to late 1920s)

*Figural women, children and birds
on various shaped bowls in solid
pastel colors. Matte glaze.*

Flower frog, figural girl & duck,
blue matte**100.00**

Flower frog, model of a
kingfisher**150.00 to 170.00**

Wall pocket, figural lady holding
her skirt out at the sides,
turquoise glaze, 12" h.**350.00**

HUDSON (1917-34)

Underglaze slip-painted decoration.

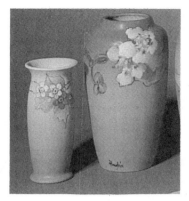

Pair of Hudson Vases

Vase, 7" h., swelled cylindrical body w/a flaring base & widely flaring rim, decorated around the top w/a pink, yellow & blue blossom against a group of pale green leaves all against a shaded white to pale green ground, decorated by Sara Timberlake, ca. 1920, marked**220.00** (Illustration, left)

Vase, 7" h., 3½" d., ovoid, decorated w/white & pink dogwood blossoms against a blue shading to cream to pink ground, artist-signed**302.50**

Vase, 8¼" h., 3½" d., baluster-form, decorated w/slip-painted trefoil blossoms in dark & light blue w/green leaves on a blue to cream ground, die-stamped "WELLER"**357.50**

Vase, 8⅞" h., swelled cylindrical body w/a short molded mouth, decorated w/large white jonquils on pale green leafy stems against a green to pale cream ground, stamped "Weller" in block letters.......................... **467.50**

Vase, 9⅜" h., swelled cylindrical shouldered body w/a short rounded neck w/flat rim, decorated around the top half w/large creamy white nasturtium blossoms & green leaves & vines against a shaded blue to pale green ground, decorated by Sarah McLaughlin, ca. 1920, artist-signed & marked**522.50** (Illustration, right)

Vase, 9½" h., 5" d., swelling cylindrical body w/a wide shoulder tapering to a short wide mouth, decorated around the upper half w/large white & blue morning glories & green leaves against a shaded blue to green ground, decorated by Hester Pillsbury, artist's initials on side, black kiln mark on base**605.00**

Vase, 11" h., 'Hudson Light,' tall slender ovoid body tapering to a molded rim, decorated w/large pastel pink & white iris blossoms w/pale green leaves & stems against a shaded dark to light green ground, signed (few small glaze imperfections in the making)**385.00**

Vase, 13½" h., bulbous ovoid body tapering to a short cylindrical neck w/rolled rim, strap handles from the sides of the neck to the shoulder, decorated w/large quince & blackberries in red, pink & blue on leafy branches against a shaded blue to pink ground, decorated by Hester Pillsbury, ca. 1925, signed (two very tight lines at the rim)**1,320.00**

Vase, 13½" h., urn-form, the wide ovoid body tapering to a short cylindrical neck w/rolled rim, wide strap handles from neck to shoulder, decorated w/a scenic design of a large peacock resting near a large wrought-iron gate & stone fence in shades of blue, white, yellow, green & black against a mottled blue-green to tan ground, attributed to Mae Timberlake, the base marked w/a letter "A" in black slip ...**5,060.00**

HUNTER (before 1910)

Brown with under-the-glaze slip decoration of ducks, butterflies and probably other outdoor subjects. Signed only "HUNTER." High gloss glaze.

Vase, 4¼" h., 6" w., a squatty bulbous body formed as six incurved panels, the wide top centered by a short flaring neck, sgraffito decoration w/a fish under water in brown & greens, glossy glaze, by Upjohn, incised "UJ" on the side, die-stamped "N36-2" on the base**495.00**

Vase, 6" h., flattened tapering three-sided body w/rounded corners below an incurvate round rim, three applied strap handles, decorated w/swimming fish in bluish water against a shaded green ground, incised "Hunter" & stamped "356 - 3 - X," artist-initialed**385.00**

IVORY (1910 to late 1920s)

Ivory-colored body with various shallow embossed designs with rubbed-on brown highlights.

Jardiniere & pedestal, tapering jardiniere bowl on scrolled feet w/molded Art Nouveau women and scrolling on sides, on matching pedestal**2,090.00** (Illustration: right with Forest)

Vase, 11" h., decorated w/molded peacocks design**80.00**

Vase, 12" h., decorated w/peacocks....................................**110.00**

Window box, embossed Victorian nudes, 7 x 13"**295.00**

JAP BIRDIMAL (1904)

Stylized Japanese-inspired figural, bird or animal designs on various solid colored grounds.

Jardiniere, wide ovoid body tapering slightly to a widely flaring mouth, decorated w/dark blue stylized trees on blue ground, 9" h...........................**280.00**

Vase, 4 ¾" h., ovoid body tapering to a short bulbous neck, tree decoration**200.00**

KENOVA (1920)

Usually a dark green ground with embossed scrolling vines & pink blossoms.

Vase, 6 ¾" h., 4 ¾" d., bulbous ovoid body tapering to a short, widely flaring neck, an embossed frog climbing up the side, dark brown matte glaze, impressed mark (minute burst bubbles on rim)**522.50**

KLYRO (early to late 1920s)

Most pieces feature molded wood framing around panels topped by double pink blossoms and dark purple berries against a finely ribbed ground, often trimmed in tan, brown, cream or olive green.

Bowl, 3½" d., tan ground w/brown trim...........................**95.00**

Planter, 4" sq.**60.00**

Wall pocket, brown ground, 7" h.......................................**120.00**

KNIFEWOOD (late Teens)

Pieces feature deeply molded designs of dogs, swans, and other birds and animals or flowers in white or cream against dark brown grounds.

Bowl, 5¼" d., decorated w/daffodils, matte finish**55.00**

Tobacco jar, cov., ovoid body slightly tapering to rim, molded design of hunting dog on brown ground, 7" h...........................**425.00**

Vase, 9" h., decorated w/owls,
green ground**450.00 to 475.00**

L'ART NOUVEAU (1903-04)

*Various figural and floral-embossed
Art Nouveau designs.*

Bank, figural sunflower,
2 x 4"**175.00**

Vase, 13¼" h., floral deco-
ration**425.00**

LASA (1920-25)

*Various landscapes on a banded red-
dish and gold iridescent ground.*

Vase, 7¼" h., wide disc foot sup-
porting a slender trumpet-form
body, decorated w/a landscape
of bare trees (small nick on
base)**137.50**

Lasa Trumpet-shaped Vase

Vase, 7 ⅝" h., slender trumpet-
shaped body w/widely flaring
foot, decorated w/landscape
done in gold, reddish & green
gold, iridescent metallic
glaze**402.50**
(Illustration)

LEBANON (1910)

*A decorated version of the Burnt
Wood line. Relief designs colored in
browns, blues, greens & cream.*

Lebanon "Wise Men" Vase

Vase, 9" h., slender conical body
tapering to a wide cupped rim
supported by three wings,
molded design of the Three
Wise Men on camels,
brown, green & cream
decoration**2,500.00**
(Illustration)

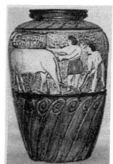

Lebanon Vase with Egyptians

Vase, 10" h., ovoid body w/the
wide shoulder tapering to a
short flaring neck, incised
upper band w/a scene of
Egyptians plowing w/oxen,
curved tall leaf band around
the bottom, decorated in tan,
dark green, black & mottled
brown**2,100.00**
(Illustration)

LORBEEK (mid-1920s to '28)

*Modernistic forms, usually geometric
fan shapes, with a creamy white
matte or glossy lavender pink glaze.*

Console set, 14" l., 3" h., bowl w/flower frog & pair of 2½" h. step-based candleholders, 4 pcs.**350.00**

Vase, 7" h., wide fan shape....................**120.00 to 140.00**

LOUWELSA (1896-1924)

Hand-painted underglaze slip decoration on dark brown shading to yellow ground; glossy glaze.

Candlestick, decorated w/pansies, 10" h.**225.00**

Louwelsa Table Clock

Clock, table model, scalloped case decorated w/yellow daffodils, artist-signed, tiny base repair.....................................**650.00** (Illustration)

Lamp base, wide squatty baluster-form body on scrolled tab feet, decorated w/large yellow iris & green leaves on a shaded dark brown to yellow ground, early 20th c., original oil font & burner adapted for electricity, marked on the base, 10 ⅞" h.**880.00**

Mug, slightly tapering cylindrical body w/a thick D-form handle, decorated w/a bust portrait of an American Indian in dark brown & rust against a dark brown ground, decorated by

Levi J. Burgess, ca. 1898, stamped on base "562 - 5," 5 ⅞" h.**825.00**

Mug, slightly tapering cylindrical body w/a thick D-form handle, decorated w/the bust portrait of a smiling monk in dark brown, rust & blue against a dark brown ground, decorated by Levi J. Burgess, ca. 1898, marked, 5 ⅞" h. (very minor glaze scratches)**247.50**

Vase, 5½" h., globular body w/stick neck, decorated w/wild rose, artist-signed**250.00**

Vase, 6 ⅝" h., 'Blue Louwelsa,' plain cylindrical body decorated in shades of dark blue w/large poppies, base stamped "Louwelsa Weller" & "X 516", & incised "7," ca. 1900..............**605.00**

Louwelsa Vase with Cavalier

Vase, 13½" h., tall slender cylindrical body w/a narrow flat shoulder to a short rolled neck, h.p. bust portrait of a Cavalier in brown, black, tan & cream

against a black shaded to green shaded to brown ground**3,300.00** (Illustration)

Louwelsa Floor Vase

Vase, 24" h., 8 ¾" d., floor model, baluster-shaped body w/a tall flaring neck, decorated w/yellow & orange carnations w/green foliage, on a shaded brown ground, decorated by Eugene Roberts, artist's initials**1,210.00** (Illustration)

Louwelsa Vase with Fish

Vase, tall very slender cylindrical body w/a slightly flaring foot, the narrow shoulder tapering to a short flaring neck, decorated w/a long swirled school of grey

& white fish down the sides against a shaded black to dark green to pale yellowish green ground**4,000.00** (Illustration)

LUSTRE (1922)

Various shapes with plain solid or marbled lustre glazes.

Bowl, 8" d., green**40.00**

Console set: bowl, flower frog & pr. of candlesticks; artist signed, 4 pcs.**225.00**

MAMMY LINE (1935)

Figural black mammy pieces or pieces with figural black children as handles.

Courtesy Brown Auction

| 1 | 2 |
| 3 | 4 |

Weller Mammy Line Pieces

Batter bowl, large ..**900.00 to 975.00**

Cookie jar, 11" h..................**3,500.00**

Creamer, little black boy figural handle, 3½" h.**495.00** (Illustration: No. 3)

Sugar bowl, cov., 3½" h.,**975.00** (Illustration: No. 4)

Syrup pitcher, cov., 6" h.**700.00 to 775.00** (Illustration: No. 2)

Teapot, cov.**800.00** (Illustration: No. 1)

MARBLEIZED (Bo Marblo, 1915)

Simple shapes with swirled "mar-bleized" clays, usually in browns & blues.

Bowl, 5½" d., 1½" h., squatty bulbous w/closed rim, brown & white**55.00**

Vase, 7½" h., handled, brown & white**75.00**

Vase, 10¼" h., grey................**135.00**

Vase, 10½" h., red, grey & black....................................**175.00**

MARENGO (1920-25)

Lustre glaze in pastel colors with line drawings of trees.

Vase, 13" h., tall slender balus-ter-form body w/flaring neck, decorated w/tall, slender styl-ized trees & distant low hills in dark maroon against a dark pink ground, unmarked (minor glaze abrasions)....................**605.00**

MARVO (mid-1920s-'33)

Molded overall fern and leaf design on various matte background colors.

Candleholder, two-light............**90.00**

Jardiniere, 7" h.**65.00**

Jardiniere, green ground, 8½" d., 8" h............................**125.00**

Vase, 12" h., waisted cylindrical body w/widely flaring rim, green.....................................**65.00**

MATT GREEN (ca. 1904)

Various shapes with slightly shaded dark green matte glaze and molded with leaves and other natural forms.

Ewer, spherical body molded w/a lizard around the sides below a cylindrical neck w/pinched spout & long angled handle, rich mottled matte

greenish blue glaze, die-stamped "WELLER," 3¼" d., 5" h.......................................**605.00**

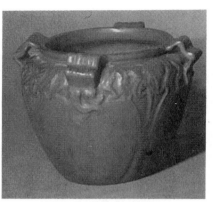

Matt Green Jardiniere

Jardiniere, bulbous ovoid body w/a wide molded mouth flanked by four small ribbon handles, molded around the shoulder w/stylized florals, unmarked, 7¼" h...................**522.50** (Illustration)

Jardiniere, decorated w/embossed hosta leaves, 8" h.......................................**250.00**

Large Matte Green Jardiniere

Jardiniere, wide cylindrical body w/molded rim flanked by four small loop handles, four wide ribs down the sides to the rounded bottom edge, embossed w/a wide center band of repeating herringbone, unmarked 11" d., 8¼" h.........**357.50** (Illustration)

Matt Green Lamp Base

Lamp base, wide bulbous multi-lobed gourd-form body tapering sharply to a slender cylindrical neck w/a molded rim, embossed on each side of the base w/grotesque 'devil' heads, raised on a narrow flaring base w/four 'knob' feet, smooth matte green glaze, complete w/original gas fittings, unmarked, 8½" d., 14½" h.........**440.00** (Illustration)

Vase, 11" h., 10" d., compressed globular lower section on a low foot, broad stovepipe neck, covered in a leathery green to terra cotta matte glaze**275.00**

Vase, 11 ¾" h., footed tall slender cylindrical body w/a wide flattened rim overhanging small square loop handles, dark green blaze, marked **880.00**

MINERVA

Various classical and naturalistic designs in terra cotta against a dark brownish black ground. Matte and semigloss glazes.

Vase, 9½" h., 4½" d., slender ovoid body, the round shoulder tapering to a short rolled neck, decorated w/an orange full-length nude under a richly textured matte green & brown glaze, die-stamped "WELLER".........................**2,090.00**

MUSKOTA (1915-late 1920s)

Figural pieces with human figures, birds, animals or frogs. Matte glaze.

Figure, Fishing Boy, boy seated on rockwork, 6½" h.**225.00**

Flower frog, figural, a small nude boy kneeling on a large green rock base, unmarked, 4¼" w., 4¼" h.**275.00**

Flower frog, figural frog half immersed in water lily, 4½" h.**200.00 to 250.00**

Flower frog, model of a kingfisher, 9" h.**375.00**

Muskota Southern Belle Powder Jar

Powder jar, cov., figural, modeled as a lady standing wearing a wide hoop skirt, her arms down touching the front of the skirt, her torso & upper half of dress forming the cover, decorated w/red roses & blue bows on a glossy yellow ground, marked only "27," 5" d., 7½" h. **302.50** (Illustration)

Vase, 7½" h., boy fishing**200.00**

NILE (early 1930s)

Simple classical forms with streaky glazes.

Vase, 6½" h............................**120.00**

Vase, 7½" h., 6½" w., two-handled**125.00**

NOVELTY LINE (1930s)

Planter, dog, three-nosed**65.00**

Planter, rabbit & duck**55.00**

ORRIS (about 1922)

Various molded blossoms and leaves sometimes framed in panels. With a matte green glaze having an antique metal effect.

Bowl, lily pad decoration...........**50.00**

Wall pocket...............**75.00 to 85.00**

PERFECTO or LOUWELSA PERFECTO (1903-04)

Early art line featuring pale ground usually of shaded greens or green to pink with hand-painted designs of fruits, flowers, animals or portraits in pastel shades; matte or unglazed finish.

Vase, 9 ⅝" h., very wide bulbous ovoid body tapering w/a short cylindrical neck, decorated w/large bright pink peony blossoms & blue leaves against a shaded pale blue ground, marked & artist-signed, cast hole in base..........................**825.00**

PUMILA (early 1920s-'28)

Panels of large lily pad leaves form an eight-scallop top. Bowls in the form of water lily blossoms. Matte glazes in green, yellows and browns.

Bowl, 4" h., bulbous water lily shape w/attached leaf base, dark green..............................**40.00**

Flower frog, figural water lily w/bud**85.00**

ROMA

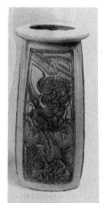

Weller Roma Vase

Vase, 10" h., slightly swelled cylindrical body w/a wide flattened rim, a paneled decoration of carved leaves, twisting stems & berries in pale pink pale green against a bone white ground, marked**176.00** (Illustration)

ROSEMONT - 1st Line (late teens to late 1920s)

Incised and colored birds on branches or flowers against a solid black or white background all with a glossy glaze.

Bowl, 12" d., 2½" h., shallow squatty body w/rolled rim, sitting on four short feet**120.00**

Jardiniere, peony decoration, 8 x 10"..................................**225.00**

Jardiniere, pomegranates decoration on ivory ground, 8 x 10"..................................**125.00**

Umbrella stand, 21" h.**950.00**

SABRINIAN (late 1920s)

Pieces modeled as seashells with sea plant trim and figural sea horse handles. In pastel shades of violet, blue, green and brown.

Bowl, 9" d., 4" h.**225.00**

Pitcher, 10½" h.**475.00**

Vase, 10½" h., slender ribbed baluster-form body w/serrated loop handles flanking neck & shoulder**265.00**

SICARDO (1902-07)

Various shapes with iridescent glaze of metallic shadings in greens, blues, crimson, purple or coppertone decorated with vines, flowers, stars or free-form geometric lines.

Jardiniere, very wide bulbous body raised on short arcaded feet, the sides boldly embossed w/large Moorish arabesques, tapering to a wide short flaring scalloped neck, iridescent purple, gold & green glaze, painted "Weller SICARD" on the side, 14½" d., 12½" h..................**1,650.00**

Vase, 3¼" h., 5 ¾" d., footed wide & low cushion-form body centered by a short widely flaring trefoil neck, bright satiny decoration of gold arabesques against a lustred green & burgundy ground, signed on the side**715.00**

Vase, 5" h., baluster-form, a multicolored iridescent glaze decorated w/mistletoe branches, signed.............................**437.00**

Vase, 6½" h., 4¼" d., tapering ovoid body w/a bulbous compressed & closed neck flanked by small loop handles, iridescent gold flowers on a deep purple ground, unmarked...**1,017.50**

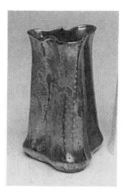

Tri-lobed Sicardo Vase

Vase, 7" h., tall tri-lobed upright undulating body, floral designs on sides, covered in iridescent glaze in shades of green & gold**1,150.00** (Illustration)

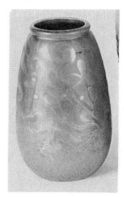

Ovoid Sicardo Vase

Vase, 7" h., 3 ¾" d., ovoid body tapering to a short thick rim, decorated w/swirling mistletoe, iridescent gold & lavender glaze**605.00** (Illustration)

Vase, 13" h., 5 ¾" d., bulbous top w/closed small mouth above tapering cylindrical sides, embossed w/large, tall irises, rich burgundy & gold lustre glaze, unmarked.......**7,700.00** (Illustration: top next page)

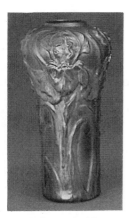

Tall Sicardo Vase

Vase, 19½" h., 13" d., Art Nouveau style, ovoid body on scroll-molded feet, the sides tapering to a bulbous, pierced rim molded w/whiplash swirls above large pendent blossoms above the relief-molded figures of two swirling Art Nouveau maidens flanked by long scrolls, the body flanked by large, long pierced scrolling handles continuing down to the scrolled feet, gold, green, blue & purple iridescent glaze, signed "Weller - Sicard"**7,700.00**

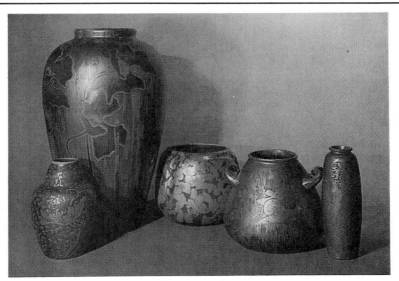

Courtesy Cincinnati Art Galleries

Grouping of Sicardo Pieces

Jardiniere, bulbous, nearly spherical body w/gently lobed sides & a closed rim, decorated w/overall stylized florals in gold iridescent against a purple iridescent ground, tight line at rim, stamped "32" & "Weller," 8" h.**550.00**
(Illustration: No. 3)

Vase, 8 ⅝" h., wide bulbous ovoid body tapering sharply to a molded flat mouth, incurved loop handles on the sides, decorated w/several snails amid leafy vegetation, base cut "36," glaze flaw from bottom up side ½", signed "Weller Sicard," ca. 1905**1,045.00**
(Illustration: No. 4)

Vase, 9" h., wide ovoid shouldered body tapering to a short rounded neck w/flat rim, deco-

rated w/flowing chrysanthe-
mums & buds against a back-
ground of scattered dots,
ca. 1904**2,310.00**
(Illustration: No. 1)

Vase, 10⅛" h., slender slightly
swelled cylindrical body w/a
narrow shoulder to the very
short neck w/molded rim, over-
all swirled floral decoration in

blues & dark green iridescent
glazes, marked, ca.
1905**2,750.00**
(Illustration: No. 5)

Vase, floor-type, 21 ¾" h., wide
ovoid body w/a molded mouth,
decorated w/large Art Nouveau
stylized poppies against a
streaked ground, ca. 1905,
signed**12,100.00**
(Illustration: No. 2)

SILVERTONE (1928)

*Various flowers, fruits or butterflies
molded on a pale purple-blue matte
pebbled ground.*

Candleholders, pr.**285.00**

Console bowl w/flower frog,
12" l.**325.00**

Flower frog............................**100.00**

Jardiniere, 10"**350.00**

Vase, 5½" h., molded
irises**125.00 to 175.00**

Vase, 7" h., **250.00 to 295.00**

Vase, 8½" h., footed, bulbous
body w/heavy loop handles
below a short neck w/ruffled
rim, decorated w/molded
pink & yellow flowers,
green leaves & brown
branches..............**395.00 to 475.00**

Vase, 10" h., molded calla
lilies (in-the-making base
chip)**250.00 to 300.00**

Vase, 12" h., decorated w/pop-
pies & butterflies (two profes-
sional chip repairs)**395.00**

Vase, 15" h., molded calla
lilies**500.00**

SOFTONE (late 1930s)

*Modernistic shapes molded with
three to four raised swirls converging*

*with other swirls at the center. Semi-
gloss glaze in pink, tan or blue.*

Planter, pink, 4 x 8"**35.00**

Vase, 7" h., blue ground...........**30.00**

Vase, 10" h., wide ovoid body
w/a short, flat neck, blue**75.00**

SOUEVO (1907-10)

*Unglazed redware bodies with glossy
black interiors. The exterior decorat-
ed with black & white American
Indian geometric designs.*

Basket, hanging-
type......................**150.00 to 200.00**

Vase, 3½" h..............................**75.00**

Vase, 7½" h...........................**195.00**

Vase, 7½" h., Greek key decora-
tion**250.00**

Wall pocket**195.00**

SYDONIA (1931)

*Pleated blossom or fan shapes on a
leaf-molded foot. Mottled blue or
dark green glaze.*

Console bowl, 17" l.**150.00**

Vase, 8½" h., triple bud, cornu-
copia shapes joined by scrolls,
mottled blue glaze..................**95.00**

Wall pocket, blue ground**225.00**

TURADA

Early line with glossy black, dark brown or mottled tan and black ground decorated around the middle or the rim with a delicate slip-trailed scroll band usually in white or dark pink. On some pieces the band is domed and pierced.

Bowl, 5½" d., 3" h., footed squatty bulbous body tapering to a short & wide cylindrical neck, rust ground decorated w/an enameled garland of tassels in green, yellow & blue around the base of the neck, glossy glaze**110.00**

Jardiniere, 9" h.**325.00**

Lamp base, kerosene table model, a wide squatty bulbous base tapering to wide cylindrical sides supporting a wide-rimmed metal oil canister insert w/burner, a dark brown ground decorated w/delicate lacy bands in light blue, orange & cream, impressed "Turada - Weller -560," 9¾" h.**440.00**

TURKIS (early 1930s)

Simple shapes decorated with overall glossy drip glazes in mottled yellowish green against a red ground.

Bowl-vase, wide bulbous body w/upright tab rim handles, 5" h. ..**85.00**

Flowerpot, 3½" h.**45.00**

VELVA (ca. 1933)

Simple shapes with tiny curled handles at the sides and molded down the sides with a long narrow panel of flowers or berries and leaves. Rich green, blue or shaded tan semigloss glaze.

Vase, 6" h.**90.00**

Vase, 8½" h., brown ground....**128.00**

VELVETONE (late 1920s)

Simple shapes with finely ringed sides. Decorated with a shaded green to pink, yellow to pink or brown to green matte glaze.

Sand jar**475.00**

Vase, 8" h., bulbous body**140.00**

VOILE (1911-20s)

Small fruit-laden apple trees molded on a creamy ground.

Vase, 7" h.**55.00**

Vase, 7" h., fan-shaped.............**75.00**

Vase, 8" h., fan-shaped...........**185.00**

WHITE & DECORATED HUDSON

A version of the Hudson line with dark colored floral designs against a creamy white ground.

Vase, 10" h., 5¼" d., octagonal, decorated w/stylized blossoms in black, burgundy & grey in slip relief on a cream ground, die-stamped "WELLER"**302.50**

Wall pocket, decorated w/roses, 10" h.**495.00**

WILD ROSE (early to mid-1930s)

An open white rose on a light tan or green background. Matte glaze.

Flowerpot, hanging-type, green ground**69.00**

Vase, 6" h., double, two cylinders angle up from arched feet, joined at top by arched handle, green ground...........................**50.00**

Vase, 6½" h., tan ground**60.00**

Vase, 8" h., green ground**27.00**

WOODCRAFT (1917)

Rustic designs simulating the appearance of stumps, logs and tree

trunks. Some pieces are adorned with owls, squirrels, dogs and other animals.

Candlestick, double, modeled as an owl perched at the top of an apple tree between candle nozzles, 8" w., 13½" h.**357.50**

Flower frog, figural lobster**120.00**

Jardiniere, slightly tapering cylindrical tree trunk form w/molded branch, acorns & leaves, figural squirrel on one side & figural woodpecker on other side, 9½" h.**675.00**

Lawn ornament, figural, model of a large squirrel seated & holding an acorn, mottled brown & green, stamped "WELLER POTTERY," 11½" w., 11 ¾" h. (restoration to ears, tight hairline in tail)**2,530.00**

Planter, "Cats on Fence," w/flowerpots**795.00**

Planter, log-form w/molded leaf & narrow strap handle at top center, 11" l.**95.00**

Vase, 12" h., smooth tree trunk form w/molded leafy branch around rim & down sides w/hanging purple plums**195.00**

Vase, 13" h., waisted cylindrical tree trunk form w/relief-molded branch, apple & leaves down the front**395.00**

Vase, double bud, 13½" h., tall slender tree trunks flanking apple blossom branch topped by small owl**450.00 to 550.00**

Vase, 15¼" h., 7" d., tall cylindrical tree trunk-form, pierced w/a large hole on one side, a large figural owl to one side of the hole & a cluster of apples & leaves above, polychrome matte glaze, die-stamped "WELLER"**1,045.00**

Wall hanging, model of a large climbing squirrel, matte brown & green glaze, black ink kiln mark, 4 ¾" w., 13½" h.**935.00**

Wall pocket, conical tree trunk form w/relief-molded branch down front & figural squirrel seated at base, 9" h.**300.00 to 350.00**

Wall pocket, smooth tree trunk form w/molded leaves & hanging purple plums at base, 9" h.**400.00**

Wall pocket, conical, molded owl head in trunk opening, 10" h.**250.00 to 350.00**

WOODROSE (pre-1920)

Rustic oaken bucket forms with rose clusters or berries near the rim. Matte glaze.

Wall pocket, model of a tall slender oaken bucket w/pendent red roses & green leaves at front center, brown matte ground**100.00 to 125.00**

XENIA (about 1920)

Simple shapes decorated with stylized florals on muted semigloss backgrounds.

Vase, 10 ¾" h., 5" d., low rounded foot, cylindrical flaring at base & rim, inlaid w/stylized poppies in burgundy & sage green on a greyish blue ground....................................**880.00**

ZONA (about 1920)

Red apples and green leaves on brown branches all on a cream-colored ground; some pieces with molded florals or birds with various glazes.

A line of children's dishes was also produced featuring hand-painted or

molded animals. This is referred to as the "Zona Baby Line."

Pitcher, 8" h., kingfisher decoration, green glaze ...**130.00 to 150.00**

Zona Child's Plate

Plate w/rolled edge, Juvenile line, decorated w/ducks, 7" d..**85.00** (Illustration)

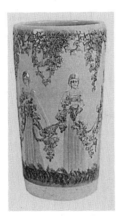

Zona Umbrella Stand

Umbrella stand, 10" d., 20" h., tall cylindrical slightly flaring body, decorated w/women in purple dresses holding long garlands of red flowers under grapevines, white ground......**715.00** (Illustration)

WHEATLEY POTTERY

Thomas J. Wheatley was one of the original founders of the art pottery movement in Cincinnati, Ohio in the early 1880s. In 1879 the Cincinnati Art Pottery was formed and after some legal problems operated under the name T.J. Wheatley & Company. Their production featured Limoges-style hand-painted decorations and most pieces were carefully marked and often dated.

In 1882 Wheatley disassociated himself from the Cincinnati Art Pottery and opened another pottery which was destroyed in 1884. Finally in about 1900 Wheatley resumed making art pottery in Cincinnati and in 1903 joined Isaac Kahn to found the Wheatley Pottery Company.

The art pottery of this firm featured colored matte glazes over relief work designs and green, yellow and blue were the most commonly used colors. Imitations of Grueby pottery wares were produced as well as artware, garden pottery and architectural pieces. Artware was not apparently produced much after 1907. A fire destroyed the plant in 1910 but it was rebuilt and operated by Wheatley until his death in 1917. Much Wheatley Pottery Company artware was unmarked except for a paper label.

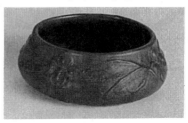

Wheatley Bowl with Blossoms

Bowl, 7½" d., 3" h., wide flat bottom w/rounded rim & tapering low sides, heavily embossed around the sides w/dogwood blossoms & leaves, thick matte green glaze, impressed "WP - 642"..........................**$385.00** (Illustration)

Bowl, 7½" d., 3¼" h., relief decorated w/open-petaled flowers & leaves, matte green glaze, raised mark & "642," retail label, ca. 1900......................**880.00**

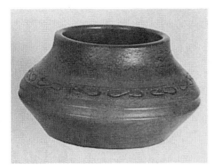

Wheatley Bowl-Vase

Bowl-vase, squatty body w/protruding mid-section, an incised curvilinear design, feathered thick matte green glaze, mark obscured by glaze, 9" d., 5½" h.....................................**495.00** (Illustration)

Bust of Dante, shown wearing a close-fitting cap, his shoulders forming the wide base, rich matte green glaze, unmarked, 14½" l., 11½" h......................**605.00**

Mug, tall cylindrical body deeply molded on the front w/a crown & shield incised "Can't Lose," applied pretzel handle, medium green matte glaze, incised "Compliments of the Fleischman Co.," 7½" h. (flake at rim, chip at base).....**121.00**

Vase, 4¼" h., 5½" d., squatty spherical body molded w/long rounded overlapping leaves

tapering to a short wide cylindrical neck, matte green glaze, mark obscured by glaze**385.00**

Vase, 7" h., 8½" d., wide squatty ovoid body tapering to a short cylindrical rim, four short twisting loop handles around the rim, rich textured matte green glaze, impressed "WP".........**495.00**

Vase, 11" h., 10" d., squatty bulbous base below a bulbous body tapering slightly to a wide, flat mouth, applied w/four leafy scroll electroplated silver bands up the sides & w/plated leaves & scrolls between each of these, over a leathery matte green glaze, incised mark**1,650.00**

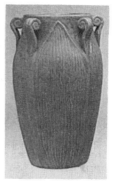

Wheatley Vase with Curled Handles

Vase, 11½" h., ovoid body tapering to a flat wide mouth, molded around the sides w/broad pointed & finely ribbed leaves alternating w/tightly curled small handles around the rim, matte green glaze, ca.1905, unsigned**1,840.00** (Illustration)

Vase, 12½" h., 6" d., ovoid body tapering to a short cylindrical flat rim, embossed leaves and pussy willows covered by a rich, flowing matte green glaze, mark obscured by glaze.....**1,650.00** (Illustration: top next column)

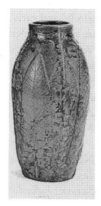

Ovoid Wheatley Vase

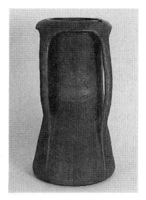

Large Wheatley Floor Vase

Vase, 17 ¾" h., 9" d., slightly
tapering cylindrical body
w/rolled rim issuing four long
strap handles, covered in a rich
green textured flowing glaze,
incised "WP" mark covered
w/glaze**6,050.00**
(Illustration)

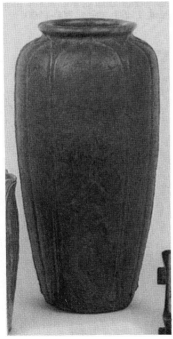

Tall Wheatley Vase

Vase, 14" h., tall ovoid shoul-
dered body w/a short rolled
neck, molded w/tall broad
leaves alternating w/narrower
leaves, textured dark green
matte glaze w/deep teal high-
lights, raised "W" mark**2,310.00**
(Illustration)

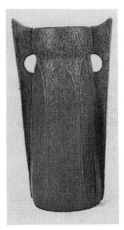

Two-handled Wheatley Vase

Vase, 19½" h., 10¼" d., slightly
tapering cylindrical body
w/tipped buttressed handles,
decorated w/long flat leaves &
green buds, covered by a
feathered flowing dark green
matte glaze, embossed "WP"
mark, invisible repair to drill
hole on side at bottom**3,300.00**
(Illustration)

Wall pocket, bulbous form molded in relief w/large grape leaves enveloping bunches of grapes, thick organic matte green glaze, unmarked, 7" w., 7¼" h. (minor glaze flakes at edges)**880.00**

ZSOLNAY

Pecs, Hungary was the site of a pottery factory founded in 1862 by Vilmos Zsolnay. At first utilitarian earthenware was produced but by the turn of the century, ornamental wares in the Art Nouveau style were being produced and featured bright colors and lustre decoration. It is these pieces which are most sought-after today. Today pottery production continues at a new factory.

Shallow Zsolnay Bowl

Bowl, 9⅛" d., 1 ⅝" h., shallow form w/gold iridescent interior decorated w/an exotic bird on a flowering branch in green, red & ivory, iridescent brick red exterior, impressed "Zsolnay 24C... - 17"**$402.50** (Illustration)

Ewer, squatty bulbous green body centered by a swelled cylindrical pierced neck w/a high arched spout & angular handle all in cream, incised "Zsolnay - PECS - 4752 - 1 - 5/8 - 26," 5" d., 7" h.**165.00**

Bulbous Zsolnay Ewer

Ewer, footed wide bulbous ovoid body tapering to a small pinched neck, a long handle from neck to lower body, decorated w/raised dots & forked scrolls in bright pink & gold on a pink & white curdled ground, artist-initialed & impressed "Zsolnay Pecs - 962 -2," 12½" h.**121.00** (Illustration)

Figure group, modeled as a seated little boy w/a cat on his shoulder eating from his plate, peacock blue iridescent glaze, stamped company mark & artist's name incised on side, 6" h......................................**403.00**

Figure group, model of wrestling bears, iridescent green & blue glaze, incised original sculptor's name & "1911," stamped w/five towers & "Zsolnay Hungary," 13" h..................................**1,265.00** (Illustration: top next column)

Wrestling Bears Figure Group

Stein, baluster-form w/figural &
floral bas-relief decoration,
patinated metal cover, late l9th
c.,11 ¾" h. (glaze imperfec-
tions)**230.00**

Vase, 4 ⅜" h., tapering cylindri-
cal body w/flaring rim, irides-
cent eggplant-colored glaze
w/pierced outer layer depicting
frogs above stylized pierced
pods in green iridescent glaze,
stamped w/trademark &
"8822"...............................**1,610.00**

Vase, 6 ⅞" h., double-gourd
shape w/four molded handles,
red & ochre iridescent glaze
decorated w/four mice,
impressed company mark &
"6020" (hairline in neck)**748.00**

Vase, 8"h., squatty bulbous
body tapering to a slightly
undulating wide mouth flanked
by round holes, the sides cast
w/three gold lizards peering
into the top openings, the exte-
rior in shades of iridescent
chartreuse, yellow, brown &
blue, the interior glazed in
chartreuse, impressed & print-
ed factory marks (firing
crack in base)....................**8,050.00**

Vase, 8¼" h., 7" d., squatty bul-
bous body reticulated overall
w/Arabic scrollwork, reticulated
side handles, cream & gold

w/horizontal beaded bands,
incised "Zsolnay - PECS -
2771" & impressed tower
mark**275.00**

Vase, 10¼" h., wide ovoid body
tapering to a wide cylindrical
neck, mottled silvery red irides-
cent ground elaborately deco-
rated w/a stylized hawk in flight
& fruiting trees & branches,
glazed in violet, amber, brick
red & pale green, stamped
company mark & "36 48
5385"..............................**2,300.00**

Unusual Zsolnay Vase

Vase, 11½" h., slender ovoid
body tapering to a short flaring
neck, the sides applied w/open
swirls forming eight twisted
handles rising to an applied
collar w/a carved linear design,
vivid green, slate grey, wine
red, aqua & yellow glossy
glaze, wafer mark & impressed
"6193 - M"**2,640.00**
(Illustration)

Vase, 17" h., figural, a footed
cushion base w/a wide shoul-
der to a tall, tapering cylindrical
body, the base molded w/wild
waves below the tall full-figure
of a standing maiden
w/diaphanous gown & long hair
clutching the sides, iridescent
gold, green & brown glaze,
raised medallion mark, ca.
1903 (minor glaze chip)**2,640.00**

GLOSSARY OF SELECTED
ART POTTERY TERMS

Bas relief - Literally "low relief," referring to lightly molded decorations on ceramic pieces.

Bisquit - Unglazed pottery or porcelain left undecorated or sometimes trimmed with colors. Also known as **bisque.**

Bowl-vase - A deep bulbous bowl-form vase, often with a fairly small rim opening.

Buttress - A heavy angular handle that forms a thick supporting rib down the sides of a piece. Named for the "flying buttresses" used in early Gothic architecture.

Closed rim - A rim on a vase or bowl which curves in or downward.

Crackled glaze - A glaze with an intentional network of fine lines produced by uneven contracting of the glaze after firing. First popular on Chinese wares.

Crazing - The fine network of cracks in a glaze produced by uneven contracting of the glaze after firing or later reheating of a piece during usage. An unintentional defect usually found on earthenwares.

Crystalline glaze - A glaze containing fine crystals resulting from the presence of mineral salts in the mixture. It was a popular glaze on American art pottery of the late 19th century and early 20th century.

Flambé glaze - A special type of glaze featuring splashed or streaked deep reds and purples, often dripping over another base color. Popular with some American art pottery makers but also used on porcelain wares.

Glaze - The general term for a vitreous (glass-like) coating fired on to pottery and porcelain to produce an impervious surface and protect underglaze decoration.

Jardiniere - A French term for a planter, usually a wide or deep bulbous shape.

Mission Ware - A decorative line of pottery developed by the Niloak Pottery of Benton, Arkansas. It featured variously colored clays swirled together and was used to produce such decorative pieces as vases and candlesticks.

Mouth - The top rim of a ceramic piece.

Pilgrim flask vase - A vase in the form of an ancient pilgrim flask, a flattened round body with a short neck and small loop handles at the shoulder. Sometimes called a *moon flask* since it resembles a full moon.

Pillow vase - A form of vase designed to resemble a flattened round or oblong pillow. Generally an upright form with flattened sides. A similar form to a pilgrim flask vase.

Porcelain - The general category of translucent, vitrified ceramics first developed by the Chinese and later widely produced in Europe and America. Hard-paste is 'true' porcelain, while soft-paste is an 'artificial' version developed to imitate hard-paste using other ingredients.

Pottery - The very general category of ceramics produced from various types of clay. It includes redware, yellowware, stoneware and various earthenwares. It is generally fired at a much lower temperature than porcelain.

Sang-de-boeuf - Literally French for "ox blood," it refers to a deep red glaze produced with copper oxide. It was first produced by the Chinese and imitated by European and American potters in the late 19th and early 20th century.

Sgrafitto - An Italian-inspired term for decorative designs scratched or cut through a layer of slip before firing. Generally used on earthenware forms and especially with the Pennsylvania-German potters of America.

Slip - The liquid form of clay, often used to decorate earthenware pieces in a process known as **slip-trailing** or **slip-quilling.**

Standard glaze - The most common form of glazing used on Rookwood Pottery pieces. It is a clear, shiny glaze usually on pieces decorated with florals or portraits against a dark shaded background.

Stoneware - A class of hard, high-fired pottery usually made from dense grey clay and most often decorated with a salt glaze. American 19th century stoneware was often decorated with slip-quilled or hand-brushed cobalt blue decorations.

Vellum glaze - A Rookwood glaze with a satiny matte finish, often used on pieces with landscape scenes.

APPENDIX I
Collector Groups

American Ceramic Circle
Grand Central Station
P.O. Box 1495
New York, New York 10163

American Ceramic Arts Society
71 W. 23rd St.
New York, New York 10010

American Art Pottery Association
125 E. Rose Ave.
St. Louis, Missouri 63119

Pottery Lovers Reunion
4969 Hudson Dr.
Stow, Ohio 44224

Clarice Cliff Collector's Club
Fantasque House
Tennis Drive, the Park
Nottingham, NGI IAE England

The Dedham Pottery Collectors
Society Newsletter
248 Highland St.
Dedham, MA 02026

Heartland Doulton Collectors
P.O. Box 2434
Joliet, IL 60434

Mid-America Doulton Collectors
P.O. Box 483
McHenry, IL 60050

Collectors of Illinois Pottery &
Stoneware
1527 East Converse St.
Springfield, IL 62702

Foundation for Historial Research of
Illinois Potteries
704 E. Twelfth St.
Streator, IL 61364

Arkansas Pottery Collectors Society
(Niloak)
12 Normandy Rd.
Little Rock, AR 72207

North Dakota Pottery Collectors
Society
P.O. Box 14
Beach, ND 58621

North American Torquay Society
P.O. Box 397
Dalton, GA 30722

Torquay Pottery Collectors Society
P.O. Box 373
Schoolcraft, MI 49087-0373

APPENDIX II

Museums & Libraries with Art Pottery Collections

Cincinnati Art Museum
Eden Park
Cincinnati, Ohio 45202

Cowan Pottery Museum at the Rocky
 River Public Library
1600 Hampton Rd.
Rocky River, OH 44116-2699

Dedham Historical Society
612 High St.
Dedham, MA

Newcomb College Art Gallery
1229 Broadway
New Orleans, LA 70118

Zanesville Art Center
620 Military Rd.
Zanesville, OH 43701

General Collections

The Bayou Bend Collection
#I Wescott
Houston, TX

Greenfield Village and
 The Henry Ford Museum
Oakwood Blvd.
Dearborn, MI 48121

The Margaret Woodbury Strong
 Museum
700 Allen Creek Rd.
Rochester, NY 14618

APPENDIX III
Specialized Art Pottery Auctioneers and Shows

Auctioneers Specializing in Art Pottery

Cincinnati Art Galleries
635 Main St.
Cincinnati, OH 45202
(513) 381-2128

Davie Rago Arts & Crafts
9 So. Main St.
Lambertville, NJ 08530
(609) 397-9374

Don Treadway Gallery
2128 Madison Rd.
Cincinnati, OH 45208
(513) 321-6742

General Auctioneers offering some Art Pottery

Christie's
502 Park Ave.
New York, New York 10022
(212) 546-1000

Skinner, Inc.
357 Main St.
Bolton, MA 01740
(508) 779-6241

Sotheby's
1334 York Ave.
New York, New York 10021
(212) 606-7000

Art Pottery Shows

American Art Pottery Assoc.
Convention & Show - April
Jean Oberkirsch
125 E. Rose Ave.
St. Louis, MO 63119
(314) 842-9119

Pottery Lovers Reunion Pottery Show
Marvin & Jen Stofft, Managers
45 - 12th St.
Tell City, IN 47586
(812) 547-5707
Zanesville, Ohio area, July

Pottery Show - Calif.
Al Nobel, Manager
Glendale Civic Auditorium
1401 No. Verdugo Rd.
Glendale, CA
(213) 380-2626
October each year

Bay Area Pottery Show
Martha & Steve Sanford, Managers
Italian Gardens
1500 Almaden Rd.
San Jose, CA
(408) 978-8408
February each year

Orange County Pottery Show
Bobbi Murphy & Bob Shupe, Managers
Retail Clerk's Union Auditorium
8530 Stanton Ave.
Buena Park, CA
(714) 447-1050
May each year

ART POTTERY SELECT BIBLIOGRAPHY

General References:

Eidelberg, Martin, editor. *From Our Native Clay - Art Pottery From The Collections of The American Ceramic Arts Society*. New York, New York: The American Ceramic Arts Society, 1987.

Evans, Paul. *Art Pottery of the United States*. New York, New York: Feingold & Lewis Publishing Group, 1987.

Henzke, Lucile. *American Art Pottery*. New York, New York: Thomas Nelson, Inc., 1970.

Henzke, Lucile. *Art Pottery of America*. Exton, Pennsylvania: Schiffer Publishing, Ltd., 1982.

Kovel, Ralph and Terry. *The Kovels' Collector's Guide to American Art Pottery*. New York, New York: Crown Publishers, 1974.

Cowan

Saloff, Tim and Jamie. *The Collector's Encyclopedia of Cowan Pottery*. Paducah, Kentucky: Collector Books, 1994.

Fulper

Hibel, John and Carole Goldman Hibel and Robert DeFalco and Dave Rago. *The Fulper Book*. Lambertville, New Jersey: Dave Rago, undated.

Hampshire

Pappas, Joan and A. Harold Kendall. *Hampshire Pottery manufactured by J.S. Taft & Company, Keene, New Hampshire*. Manchester, Vermont: Forward's Color Productions, Inc., 1971.

Hampshire Ware - A Portfolio of Pottery. Catalog reprint. Keene, New Hampshire: Towar Arnold, 1971.

Newcomb College

Poesch, Jessie. *Newcomb Pottery: An Enterprise for Southern Women*. Exton, Pennsylvania: Schiffer Publishing, Ltd., 1984.

Niloak

Gifford, David Edwin. *The Collector's Encyclopedia of Niloak*. Paducah, Kentucky: Collector Books, 1993.

Niloak Pottery Catalog (reprint). Dumas, Arkansas: Kenneth Mauney, 1971.

North Dakota School of Mines

Barr, Margaret Libby and Robert Barr and Donald Miller. *University of North Dakota Pottery - The Cable Years*. Grand Forks, North Dakota: self-published, 1977.

Rookwood

Cummins, Virginia Raymond. *Rook-wood Pottery Potpourri*. Silver Spring, Maryland: Nothing New, 1980.

Ellis, Anita J. *The Collectors Series - Rookwood Pottery* - Video program adapted from "Rookwood Pottery - The Glorious Gamble." Sarasota, Florida: Award Video and Film Distributors, 1994.

Peck, Herbert. *The Book of Rookwood Pottery*. New York, New York: Bonanza Books, 1968.

Peck, Herbert. *The Second Book of Rookwood Pottery*. Tucson, Arizona: self-published, 1985.

Teco

Darling, Sharon S. *Chicago Ceramics and Glass, An Illustrated History From 1871 to 1933*. Chicago, Illinois: The Chicago Historical Society, 1980.

Darling, Sharon S. *Teco - Art Pottery of The Prairie School*. Erie, Pennsylvania: Erie Art Museum, 1989.

Van Briggle

Bogue, Dorothy McGraw. *The Van Briggle Story*. Colorado Springs, Colorado: self-published, 1976.

Carlton, Carol and Jim. *Collector's Encyclopedia of Colorado Pottery*. Paducah, Kentucky: Collector Books, 1994.

Nelson, Scott H. and Lois K. Crouch, Euphemia B. Demmin and Robert Wyman Newton. *A Collector's Guide to Van Briggle Pottery*. Indiana, Pennsylvania: The A.G. Halldin Publishing Co., 1986.

Sasicki, Richard and Josie Fania. *The Collector's Encyclopedia of Van Briggle Art Pottery*. Paducah, Kentucky: Collector Books, 1993.

Weller

Huxford, Sharon and Bob. *The Collectors Encyclopedia of Weller Pottery*. Paducah, Kentucky: Collector Books, 1979.

McDonald, Ann Gilbert. *All About Weller, A History and Collector's Guide to Weller Pottery, Zanesville, Ohio*. Marietta, Ohio: Antique Publications, 1989.

English and European Art Pottery

Atterbury, Paul and Louise Irvine. *The Doulton Story*. Stoke on Trent, England: Royal Doulton Tableware, Ltd., 1979.

Bartlett, John A. *British Ceramic Art, 1870-1940*. Atglen, Pennsylvania: Schiffer Publishing, Ltd., 1993.

Bergesen, Victoria. *Encyclopedia of British Art Pottery, 1870-1920*. London, England: Barrie & Jenkins, 1991.

Coysh, A.W. *British Art Pottery*. Rutland, Vermont: Charles E. Tuttle Company, 1976.

Godden, Geoffrey A. *British Pottery, An Illustrated Guide*. New York, New York: Clarkson N. Potter, Inc., 1975.

Schwartzman, Paulette. *A Collector's Guide to European and American Art Pottery*. Paducah, Kentucky: Collector Books, 1978.

Watson, Howard and Pat. *Collecting Clarice Cliff*. London, England: Kevin Francis Publishing, Ltd., 1991.

Watson, Howard and Pat. *The Colourful World of Clarice Cliff*. London, England: Kevin Francis Publishing, Ltd., 1992.

AMERICAN & EUROPEAN
ART POTTERY INDEX